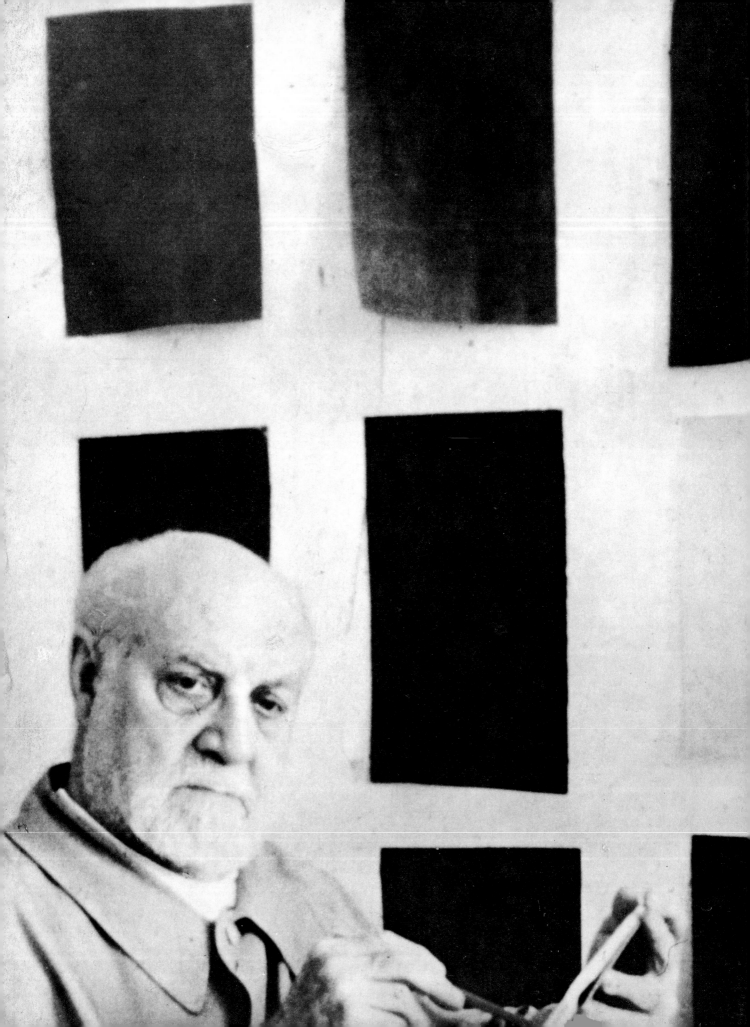

Henri Matisse Paper Cut-Outs

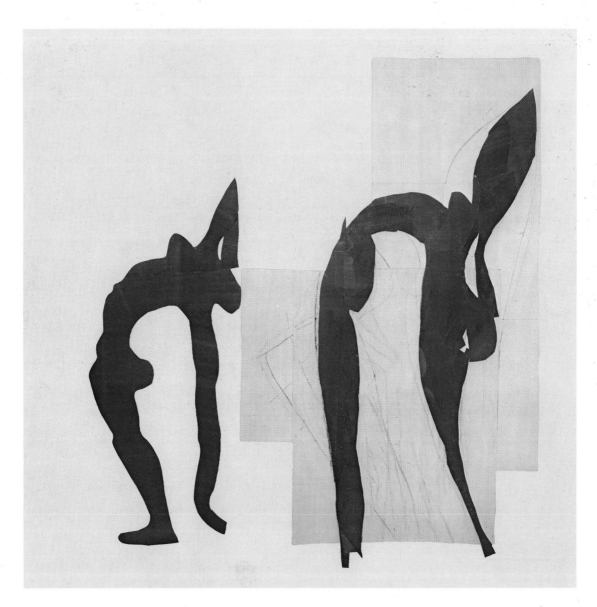

Frontispiece. **Acrobates**, 1952, no. 175.

Henri Matisse *Paper Cut-Outs*

Jack Cowart

Jack D. Flam

Dominique Fourcade

John Hallmark Neff

Published by
The St. Louis Art Museum and
The Detroit Institute of Arts

Distributed by
Harry N. Abrams, Inc.,
Publishers, New York

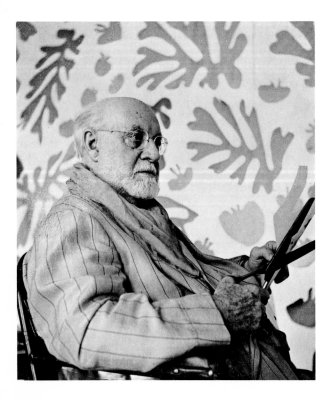

Fig. 2.

Contributors

Jack Cowart. Curator of 19th & 20th Century Art,
The St. Louis Art Museum.

Jack D. Flam. Associate Professor of Art History,
Brooklyn College of the City University of
New York.

Dominique Fourcade. French poet and essayist.
Involved for the last six years with diverse
research, publications, and exhibitions on Matisse.

John Haletsky. Graduate student, History of Art,
Institute of Fine Arts, New York University,
New York.

Antoinette King. Senior Paper Conservator, The
Museum of Modern Art, New York.

John Hallmark Neff. Curator of Modern Art, The
Detroit Institute of Arts.

Cover: **Amphitrite**, 1947, no. 61.

Fig. 1. (Half-title page). Henri Matisse, Hôtel Régina,
Nice, c. 1952. On wall: sheets of gouached papers
of various colors, drying.

This book is published in connection with the
exhibition "Henri Matisse Paper Cut-Outs."
Originated by The St. Louis Art Museum,
co-sponsored with the Founders Society
Detroit Institute of Arts, and presented at:

National Gallery of Art, Washington, D.C.
September 10-October 23, 1977

The Detroit Institute of Arts
November 23, 1977-January 8, 1978

The St. Louis Art Museum
January 29-March 12, 1978

This book and the exhibition it accompanies
have been supported by generous grants from
the National Endowment for the Arts,
a Federal Agency; the National Foundation on
the Arts and Humanities, Arts and Artifacts
Indemnity Act; the Missouri Arts Council; and
the Michigan Council for the Arts.

Clothbound ISBN 0-8109-1301-1

Paperbound ISBN 0-89558-001-2

Designed by Malcolm Grear Designers, Inc.

Typesetting by Dumar Typesetting, Inc.

Printing by the Meriden Gravure Company

Color printing by Princeton Polychrome Press

Clothbound distributed by Harry N. Abrams,
Incorporated, New York

Library of Congress Cataloging in Publication Data
Main entry under title:

Henri Matisse Paper Cut-Outs.

Bibliography: p. 289
1. Matisse, Henri, 1869-1954. I. Cowart, Jack.
II. St. Louis Art Museum. III. Detroit. Institute
of Arts.
N6853.M33H46 709'.2'4 77-9084
ISBN 0-89558-001-2
ISBN 0-8109-1301-1

Table of Contents

Figs. 2-3. Henri Matisse, Hôtel Régina, Nice, c. 1952. On wall: *La Perruche et la sirène*, no. 183.

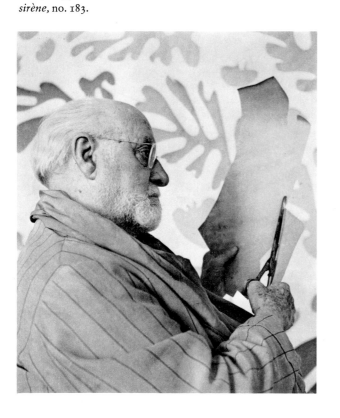

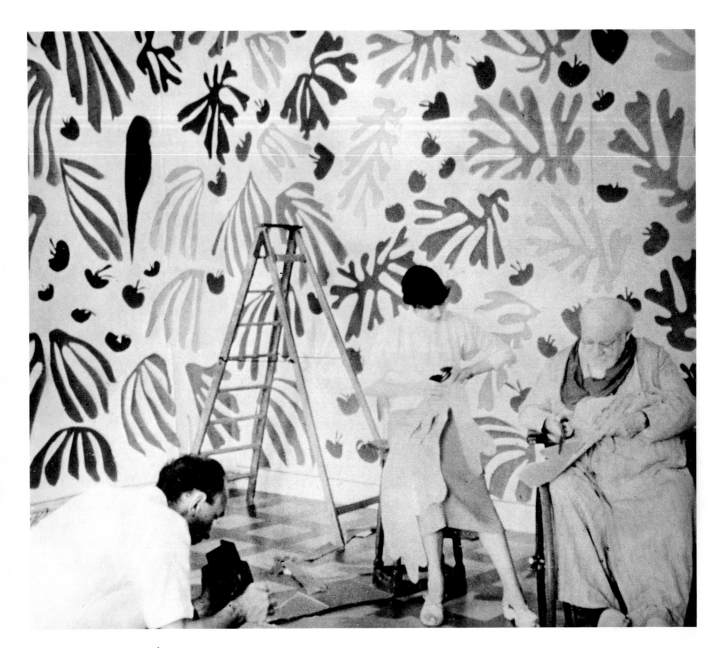

Fig. 4. Henri Matisse, assistant Paule Martin, and unidentified photographer, Hôtel Régina, Nice, c. 1952. On wall: *La Perruche et la sirène*, no. 183.

Preface

As one of the great masters of our century Henri Matisse has been, understandably, the subject for numerous articles, books, and exhibitions. Until now, however, there has been no attempt to provide either a comprehensive survey catalogue or a retrospective showing of his significant compositions of painted, cut, and pasted paper.

"Henri Matisse Paper Cut-Outs" is designed to fill this obvious need. Evolving through the mutual concern and enthusiastic cooperation of The St. Louis Art Museum and The Detroit Institute of Arts, this project has successfully used the combined resources of the three participating museums. The results are a tribute to Henri Matisse and a credit to all of the staff members and special consultants who worked on the many complex aspects of this publication and coinciding exhibition.

Drs. Jack Cowart and John Hallmark Neff have spent the last three years preparing this reference catalogue and retrospective exhibition while competently handling the myriad other curatorial obligations at their respective museums. Their Matisse "team" of Dominique Fourcade, Dr. Jack Flam, Antoinette King, and others performed admirably and they are more appropriately recognized in Dr. Cowart's acknowledgments, below. Our thanks are also due Richard Oldenburg, Director,

The Museum of Modern Art, for allowing Antoinette King, that museum's Senior Paper Conservator, the time to travel, research, and prepare the technical appendix published here.

We are grateful to the National Gallery staff, particularly C. Parkhurst, J. C. Spinx, E. A. Carmean, Jr., G. F. Ravenel, and P. Davidock.

Important financial aid has been received from the National Endowment for the Arts, the Missouri Arts Council, and the Michigan Council for the Arts. Overseas loan insurance has been largely defrayed by the National Foundation on the Arts and Humanities Arts and Artifacts Indemnity. Without such assistance, both the publication and this exhibition would have been impossible.

J. CARTER BROWN
Director, National Gallery of Art

FREDERICK J. CUMMINGS
Director, The Detroit Institute of Arts

JAMES N. WOOD
Director, The St. Louis Art Museum

Acknowledgments

In the course of this extensive venture we have spoken or corresponded with many people who have had some effective contact with Matisse or his cut-outs. We can only hope that the success of this project and its service to the memory of Henri Matisse will justify the time and the effort so generously contributed by these scores of helpful colleagues, collectors, researchers, and friends.

Most particularly we would like to thank Mr. Pierre Matisse for his crucial assistance with this publication and exhibition. We are also profoundly grateful to Mme. Lydia Delectorskaya, whose constant kindness and responses to our inquiries provided much indispensable first-hand information.

We further wish to express our gratitude to: Hélène Adant, Sigmund Ascher, Heinz Berggruen, Jacques Blanc, Torgils Börjesson, Mrs. Sidney F. Brody, Paule Caen, Gérald Cramer, François Daulte, Sonia Delaunay, Hanne Finsen, Hubert de Givenchy, Jean Guichard-Meili, Jacqueline Hyde, Sister Jacques-Marie, Mrs. Albert D. Lasker, Maurice Lefebvre-Foinet, Aimé Maeght, Léonide Massine, Steingrim Laursen, Gérard Matisse, Mme. Jean Matisse, Mme. Gianni Mattioli, Jean-Michel Meurice, Régine Pernoud, E. Tériade, David Willis, Juliet Wilson.

We sincerely thank the museum and private collectors listed on pages 81-82 for their support; without their generous loans and enthusiastic willingness, this first retrospective showing of the cut-outs would not have been possible.

For generous access to documentary archives we are deeply grateful to: Ronald Alley, Tate Gallery, London; Isabelle Fontaine and Antoinette Rezé, Musée National d'Art Moderne, Paris; Martine Kahane, Bibliothèque de l'Opéra, Paris; Edy de Wilde, André Georges van Oort, and J. M. Joosten, Stedelijk Museum, Amsterdam; Genevieve Oswald and Madeline Nichols, Museum of Performing Arts, Lincoln Center, New York; Monawee Richards, The Museum of Modern Art, New York; Jacqueline Worms de Romilly, Galerie Maeght, Paris; Jorgen Schou-Christensen and Erik Lassen, Det Danske Kunstindustrimuseum, Copenhagen; Carol K. Uht and Curtis J. Clow, Rockefeller Archives, New York.

Among the many museum directors and curators visited, we were particularly well received and assisted

by: Colette Audibert, Musée Matisse, Cimiez; Phillip Dyer, The Victoria and Albert Museum, London: Ulf Linde, Moderna Museet, Stockholm; Robert Murdoch, Dallas Museum of Fine Arts; Gerald Nordland, Frederick S. Wight Galleries, Los Angeles; Richard Oldenburg, William Rubin, and William S. Lieberman, The Museum of Modern Art, New York; Harald Olsen, Statens Museum for Kunst, Copenhagen.

The staffs of The St. Louis Art Museum and The Detroit Institute of Arts have made significant contributions to this project. The Detroit Publications Department, under the direction of Susan F. Rossen, patiently directed this book through the complexities of editing and printing. To be thanked are Terry Ann R. Neff, Rollyn O. Krichbaum, and Marcella Christopher. Ann Abid and her St. Louis library staff verified and brought order to the extensive bibliography. The curatorial assistants and secretaries, public information departments, registrars, installation crews, and designers of St. Louis and Detroit have all offered their vital assistance. In St. Louis we are especially grateful to Mary-Edgar Patton, Patricia M. Tarpoff, and Susan Baerwald. In Detroit we wish to thank in particular Mary Jane Jacob, Gerry Baskin, Kay Douglas, Linda Downs, and Nemo Warr.

This publication and exhibition came into being only because each of the colleague researcher/writers successfully performed numbers of often unrelated tasks. In response to such challenges, John Hallmark Neff, Dominique Fourcade, and Jack D. Flam displayed their highest personal and professional commitment. Antoinette King and John Haletsky have also provided writings of special value to the study of Matisse. During these last three years it has been my joy to direct this team effort and to work, discover, and discuss Matisse with them. They have my most sincere thanks for their untiring, daily dedication to this seemingly endless project. They have helped make this collaboration full of rewarding moments, theories, entertaining anecdotes, and valuable advances for Matisse scholarship.

Those close to us have lovingly provided positive support while enduring remove and neglect. They are due more than sincere recognition or thanks.

JACK COWART

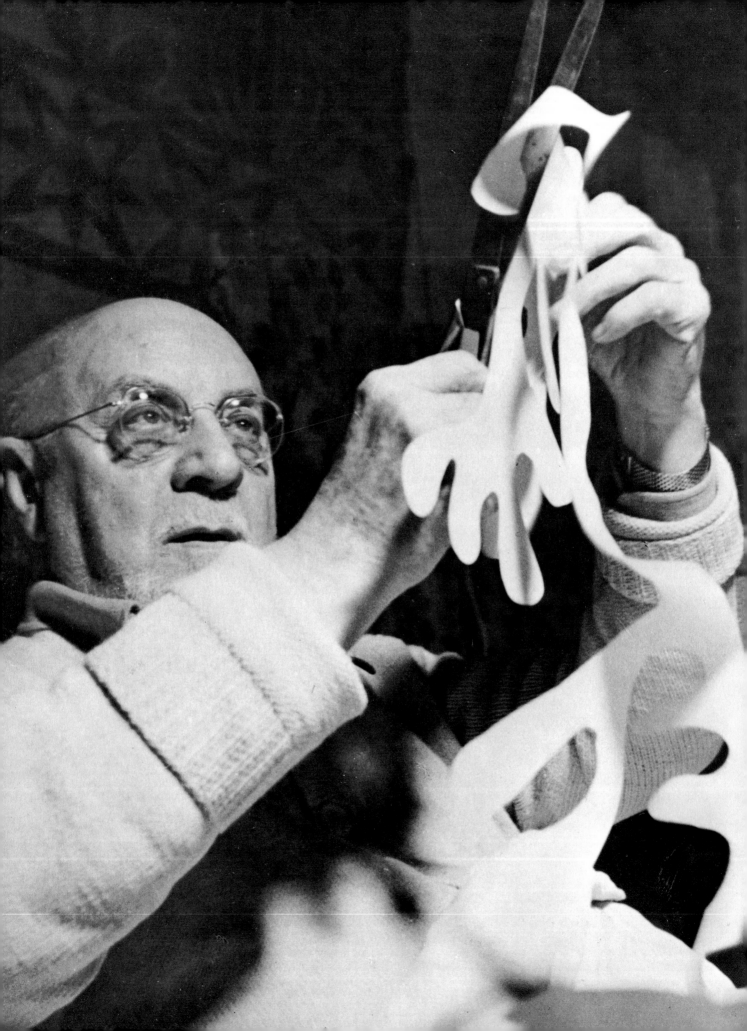

Introduction

BY JACK COWART

During the last twenty years of his long life, Henri Matisse developed a significant new technique: the paper cut-out. His works in this medium are of a remarkable beauty and have important aesthetic consequences. The direct, visible process and provocative thematic decisions involved in their creation reveal additional aspects of the otherwise elusive Matisse. The paper cut-outs, furthermore, successfully embody central points of the artist's previous intense researches in color, line, space, and texture—without being a closed, ultimate statement. Rather, they were taken by Matisse as an opening up of entire new vistas for creative expression and the making of art.

To work with scissors in this paper is an occupation in which I can lose myself.[1]

From 1940 on, paper cut-outs were Matisse's strongest exploratory medium of work, even while he continued to paint, draw, and sculpt—though these to lesser degrees than before. The cut-outs served as independent compositions or studies and also as project maquettes for later execution in stencil printing, textiles, glass, ceramics, or color lithography. Certain qualities of the cut-outs were particularly well-suited for such translation. For Matisse the cut-out proved to be an optimum material for evoking the technical considerations posed by the media variations, as well as a joyous solution to his artistic needs.

Matisse's cut-outs have not until now been closely catalogued or studied, despite the fact that they are artistically revealing. Most previous investigation into Matisse's work has centered on his painting, drawing, or sculpture in limited relation to his own forcefully controlled public personality and to his apparently inward-looking aesthetic comments or writings. The present publication, through its specialized essays, extensive catalogue, and reference materials, will show how the cut-outs combine many aspects of Matisse's more personal side with his works in other media, demonstrating how the cut-outs offer further tantalizing clues to the richness of this artist's stylistic matrix.

Fig. 5. Henri Matisse at his villa, Le Rêve, Vence, 1946/47.

The paper cut-outs of Henri Matisse are paper painted with opaque watercolor ("gouache"), cut with scissors ("découpé"), pinned, and then glued upon a support when finished ("collé"). In French they have been called "papiers découpés; gouaches découpées; découpages; papiers gouachés, découpés, contracollés." Paper cut-outs is used here as an approximate English equivalent for the various French terms.

Matisse had used cut and pinned or pasted papers on occasion during the 1930s in relation to the composition of paintings and decorative projects, if not before (see Precursors A-C and nos. 1-12). But it was only during his recuperation from traumatic surgery in 1941-42 that he began more fully to develop the technique and to explore its independent expressive qualities. A general system was then devised whereby his studio assistants brushed Linel gouaches on sheets of white paper. The dried, colored papers, stockpiled as supplies (fig. 1) were available to Matisse at any given time. He often quite spontaneously cut out elements and placed them into compositions. As the play between consciously sought-for and the fortuitously-arrived-at effects worked into their balances, the projects moved toward completion. In the meantime many of them were posted about the studio walls (fig. 6).

The scale of the cut-outs was exclusively intimate before the mid-1940s. Central to this period was the *Jazz* suite, nos. 16-35, whose book-like format was well suited to Matisse's desire for a personal artistic narrative. By 1945 at least one large cut-out existed (no. 39). Matisse's ability to work comfortably with individual cut-out pieces, one at a time, regardless of composite scale, resulted in a full range of works, from whimsical miniatures (nos. 70, 120), to the increasingly dramatic creations of his last years, with the two room-size projects, *La Perruche et la sirène,* no. 183, and *La Piscine,* no. 177, being the final extension of the artist's impetus to create a personal expressive environment.

Matisse's works in cut paper should not be categorized as *collages* in the most precise sense of the term. *Collage* for the history of twentieth-century art has meant that specific use of diverse, often pre-existing objects or object components within paintings, drawings, or assemblages. The technique has played a dominant role in many modern experimental movements, including Cubism, Futurism, Constructivism, Dada, Surrealism and, to an extent, Expressionism. Typical collages from these avant-garde movements are a medley of combattant images, composed in a strident, alogical fashion.

Fig. 6. Matisse studio at his villa, Le Rêve, Vence, 1946/47. See Documents Appendix, 24 and fig. 78, p. 283 for identification of illustrated works.

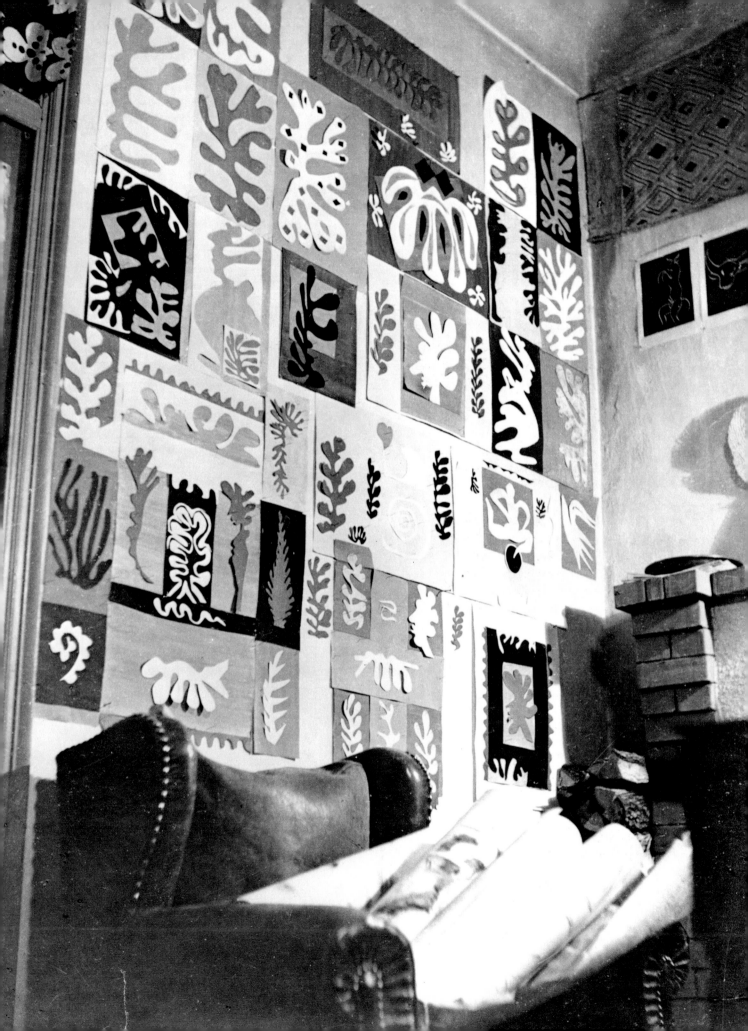

Multi-layered textural, illustrative, typographical, and material juxtapositions attempt to upset visual and interpretative coherence. Natural proportions are often displaced through the inclusion of torn, cut, additive, or portrayed elements. The composition is sometimes left to the laws of chance, or it is more consciously established by the artist. The flexibilities of collage are such that these approaches have had provocative results.

Matisse's paper cut-outs differ from collages because of the artist's distinctive formative intentions and conservative methods. Nevertheless, when Matisse developed his personal technique of colored, cut, and pasted paper, he knowingly entered into an activity strongly preconditioned by the stylistic formulations of the then-contemporary "decorative/applied arts" as well as the movements listed above. It becomes increasingly clear that Matisse was involved (at least as a receptor) in a complex flow of influences from various Parisian art/literary movements. Several of Matisse's indirect technical assumptions concerning the paper cut-out seem certainly to approach those of his more polemical collage-oriented contemporaries (including Miró, Braque, Kandinsky, and Picasso, see fig. 7).

From another angle, Matisse's cut-outs should not be understood merely as solutions to formal or compositional problems. They are, more importantly, images which emerged from his vast and special fund of experience, personal feelings, narrative inclinations, and his own sense of parody. Thus, when Matisse's descriptive works were dependent upon being legible, the results seem somewhat rigid in characterization (e.g., nos. 165-166). Yet, as the artist took increasing liberties in making more evocative, poignant cut-out forms and elliptical compositions, the medium becomes something worthy of the most serious study and admiration (e.g., nos. 156, 181, 199).

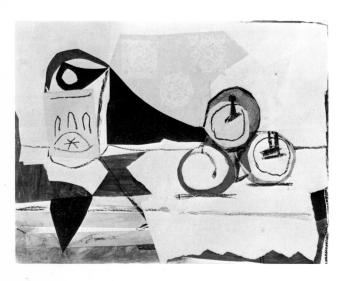

Fig. 7. Pablo Picasso (1881-1973). *Nature morte aux trois pommes et verre*, 1945. Charcoal, colored and painted cut and torn papers; 33 x 43.2 cm. (13 x 17 in.). Peter Ludwig Collection, Aachen.

In 1943, threatened by the war, Matisse moved from Nice to the more remote hilltown of Vence. At his villa there, Le Rêve (The Dream), he evolved intensely personal, almost romantic expressions in the paper cut-outs. First came the *Jazz* suite (1943-44), followed by an effusion of geometric studies, 1944-46 (see nos. 38-54), and more complex and provocative compositions, 1946-47 (see nos. 61-83, fig. 6 and remarks preceding no. 61). Matisse's stay in Vence ended in early 1949 with his work on the designs for the Chapelle du Rosaire for the Dominican nuns.

White paper covered with color offered Matisse a number of advantages for the making of cut-outs. He used Linel gouaches initially because they directly corresponded to commercial printers' ink colors and thus gave exact renditions when printed by *pochoir* or stencil, as in the *Jazz* suite or many of his book covers and posters.

> *For* Jazz, *despite the contours of the images not having the purity of my scissor-strokes, the colors are good and the forms exactly like the original ones that I cut in the sheets of paper that I had had covered with gouache colors Even though the result doesn't retain the charm of the cut-out procedure, the same colors are nevertheless put together in the same energetic and harmonious relationships.* (Matisse to Rouveyre, 1948)[2]

After *Jazz*, the Chapelle du Rosaire was to be his most comprehensive single project. There he would further rely extensively on cut-outs and would continue to develop their multiple potentials. He used the medium for no fewer than three separate window maquette groups, nos. 89-90, 94-95; numerous maquettes for the six chasuble groups, nos. 128-155; and the maquette for the tabernacle door, no. 96.

The windows—the chapel's architectural color elements—are in clear contrast to the walls, which have black brush drawings in glazed white tiles. While the windows are always luminous in the Mediterranean climate, they nonetheless seem denser, more solid than the tile walls. Matisse consciously effected this reversal in the sense of the materials by using cut-paper as if he were sculpting and building with colored blocks of light.

The painted paper functioned procedurally and aesthetically to unify contour, color, and mass. The gouache applied to the heavy Arches or Canson paper produced a surface slightly grainy to the touch and gave a distinct resistance to Matisse's cutting shears while heightening the artist's sensation of sculpting. Cutting into the pigment left a clean, firm edge reminiscent of drawing.

> *I am now turned toward more immediate, more mat materials, which lead me to look for new ways of expression. The cut-out paper allows me to draw in color. It is a simplification. Instead of drawing an outline and filling in the color—in which case one modified the other—I am drawing directly in color, which will be the more measured as it will not be transposed. This simplification ensures an accuracy in the union of two means It is not a starting point but a culmination.* (Matisse to Lejard, 1951)[3]

The water-based gouache could be mixed and laid on in varying densities with effects ranging from mat to luminous. The brush striations were occasionally exploited to give a subtly perceived sense of volume or stratification within the composition as well as stressing the cut-outs' "hand-made" character. In this new personal development Matisse recognized the important physical roles of the real paper. A common material, this paper was now transformed by the applied water and vibrant chemical colors into an entity which, before being pasted down, exuded a heightened "aliveness." The sheets (in French, "feuilles," which also means leaves) literally became natural leaves for Matisse. They could be supple and responsive to environmental changes or crinkled and dried, with attendant, wistfully poetic, organic implications (see nos. 66, 212-213).

Matisse's cut-outs have pertinent affinities with his drawings—another of his vital paper-based activities. Some of the artist's earliest training included emphasis on drawing from memory ("le dessin de mémoire").[4] A mind-eye-hand discipline, this procedure resulted in a *spiritually* just rendering of a subject, after the fact. This internalizing process may indeed have proven seminal for the development of the cut-outs. Matisse then progressively amplified his repertoire of forms in the cut-outs toward multiple associations. Instead of remaining detailed renditions from memory, the cuttings eventually became essential, more profound "signs":

> *The cut-out is what I have now found the simplest and most direct way to express myself. One must study an object a long time to know what its sign is. Yet in a composition the object becomes a new sign which helps to maintain the force of the whole. In a word, each work of art is a collection of signs invented during the picture's execution to suit the needs of their position.* (Matisse to Luz, 1951)[5]

It is significant that the artist was producing the pivotal drawing series *Thèmes et variations* in 1941-42, just as he was beginning to explore the imaginative aspects of paper cut-outs. In *Thèmes et variations* he would first make an acute charcoal study drawing directly from the model or object—the "theme." Having thus "fixed" the form, a number of freer drawings followed as subconscious expressions without the immediate support of the object. At base Matisse was searching for an independence, a freedom from the model.

The blue nude series, nos. 167-170, follows this system. *Nu bleu IV* started as a heavily drawn-over "theme" and *Nu bleu I-III* followed quickly in condensed fashion

Fig. 8. Front cover design for Baude-
laire's *Les Fleurs du Mal,* 1947. Pen and
ink, 27.2 x 21.1 cm. (10¾ x 8⁵⁄₁₆ in.).
State Hermitage Museum, Leningrad.

(see introductory remarks to nos. 167-170 and remarks
no. 170). But for the majority of the cut-outs such a
program was avoided. Matisse's new cutting technique
and the medium itself effectively further sidestepped the
model and any residual orthodoxies inherent in draw-
ing. Throughout, the spontaneous venture of making
cut-out forms purely by one's impulses seems a clear
extension of Matisse's desires for depictive, referential,
and material freedom. Cutting and the artist's memory,
hand, and scissors had become the primary involve-
ments. The artist, watching the birds he kept in his
studio, said:

> These repeated figures of doves, their spheres, their
> curves, glide in one as in a large interior space. When
> I am doing the cut-outs, you cannot imagine to what
> degree the sensation of flight which comes to me helps
> me better to adjust my hand as it guides the path of
> my scissors. It's hard to explain. I would say that it is
> a kind of linear equivalence of the sensation of flight.
> There is also the question of vibrant space. To give life
> to a feature, to a line, to make a form exist[6]

In cutting paper it is explicit that a remainder element
with a matching edge will result. This cut-away piece is
the so-called "negative" to the primary "positive" form.
If the two mate elements are kept in the same composi-
tion and merely pulled away from each other, the inter-
vening space becomes capable of strong visual activity.
This also occurs when monochromatic positive forms
(or forms-in-interval) are placed upon solid color nega-
tive backgrounds. Visual, hence interpretive, confusions
are created as the forms alternate compositional func-
tions depending on point of view.

Such peculiarities were recognized by nineteenth-
century folk art collagists and silhouette-makers and
have been constant aesthetic considerations ever since.
Matisse's instinctive sense of the interval and positive-
negative is well known, and his cut-outs show a strong
exploitation of the tensions created by their use. A shift-
ing sense of what should be read as foreground and
background contributes further to the vibrant composi-
tions with their sure balance of unequals. These qualities
are found not only in the cut-outs but also in Matisse's
lino-cut illustrations for de Montherlant's *Pasiphaé—
Chant de Minos,* 1944, and his drawings for Baudelaire's
Les Fleurs du Mal, 1947 (fig. 8).

Matisse's placing of the cut-out element and its cut-
away part within the same composition clearly empha-
sizes the "process" and his economy of means. The
evident common relationships of these mates establish an

internal unity within an individual composition. Matisse also took recognizable cut-away parts from one work and placed them in another. This assertive act created a tight conceptual link among all the cut-outs. The simple explanation for this practice might be that if Matisse liked one element, he would have found its mate equally agreeable. But in truth the issue can only have been more nuanced. One need only study the hitherto unpublished illustration (fig. 6) to see the compounding dramatic play of these conscious positive-negatives and the cut-out and cut-away form.

This book treats principal aspects of Matisse's involvement with the paper cut-out. The three following essays study complex historical and aesthetic concerns relating to the development and significance of Matisse's cut-out images and techniques. Related areas emerge in these inquiries despite the writers' various points of view and acknowledged personal differences. The result is a positive resonance happily quite in keeping with both the actual nature of the cut-outs and the fundamental creative spirit of Henri Matisse.

The essays are followed by the list of lenders of those cut-outs selected for the retrospective exhibition coinciding with this publication. Each of the exhibited works is treated more completely in the catalogue of cut-outs.

The largest section, the catalogue proper, is the first extensive survey of Matisse's paper cut-out production: from the early design precursors of 1920 through Matisse's major works of the 1937-54 period. A technical appendix follows dealing with the materials, procedures, preservation, and restoration of the cut-outs. An appendix of unpublished documents in their original language relating to the cut-outs is also included. The documents are followed by a list of cut-out-derived book, magazine, and catalogue covers. An extensive bibliography focusing on the cut-outs is preceded by a critical listing of those exhibitions in which cut-outs were included. There has been an imbalance in the public's awareness of the exhibition history of the cut-outs. The 1949 Paris Musée National d'Art Moderne exhibition was the first to present a number of small-sized to medium-sized cut-outs. There was not one major retrospective exhibition during Matisse's lifetime where the artist allowed a full showing of his cut-outs. He reserved their presentation instead for smaller exhibitions with "advanced" art connotations, usually in Paris (e.g. Paris 1949 and 1953). After Matisse's death, the exhibition focus switched almost exclusively to the late, large compositions—in the Bern 1959 exhibition, followed by the Amsterdam 1960, Paris 1961, and New York 1961 showings. This trend seems to have been inspired by the well-intentioned but misinterpreted 1958 *Verve* special edition which featured these works.

It is hoped that the information gathered for presentation in this study will establish the importance of Matisse's work in paper cut-outs and stimulate subsequent interest and research into this significant last expression of one of the twentieth century's greatest artists.

Notes

1. Matisse to Jedlicka, "Begegnung mit Henri Matisse," 1952, tr. Fourcade 1976, p. 113.

2. Matisse, letter to Rouveyre, February 22, 1948, Matisse 1972, p. 241.

3. *Ibid.*, p. 243.

4. Cowart 1972, pp. 40-43.

5. Matisse, "Témoinage," 1952, Matisse 1972, p. 248; tr. Flam 1973, p. 137.

6. Verdet 1952, in Matisse 1972, pp. 250-251.

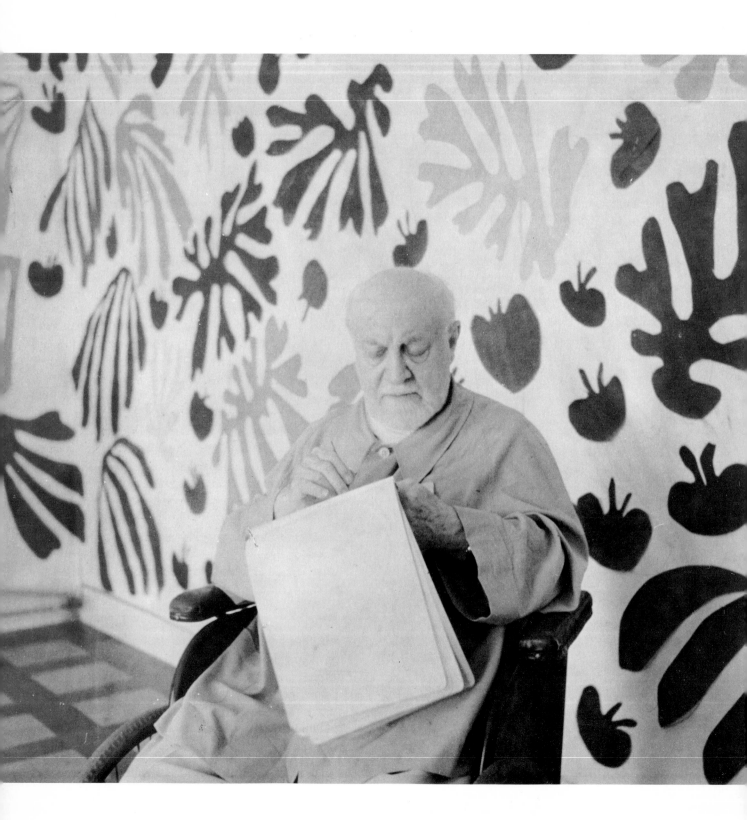

Matisse, His Cut-Outs and the Ultimate Method

BY JOHN HALLMARK NEFF

It was always in view of a complete possession of my mind, a sort of hierarchy of all my sensations that I kept working in the hope of finding an ultimate method.[1]

I

One can follow in Matisse's work and in his writings and statements a continuity of prevailing ideas and goals: the importance of nature, the purity of means, the necessity for discipline, the need for feeling, among others. At the same time, one is aware of his ongoing search for synthesis, for an "ultimate method" to allow him the fullest possible expression of the feeling he had for life. Synthesis not for its own sake but because he required a means which would permit him to reconcile and express the full intensity of his feelings with the elements at his disposal: line, form, and color. One cannot but be moved by the works and thoughts of this man, at once lucid, rational, concise, a model of applied intelligence, the grand bourgeois. Yet, there was another side to Matisse, not inconsistent with the first but its complement: Matisse as sage, the passionate believer in his inner eye, intuition, the encyclopedic mind and ceaseless curiosity not always in keeping with science, the artist who believed in the power of his work to heal.[2]

It was perhaps this less familiar, more mystical side of Matisse which determined the main direction of his career, led him to color and to his researches in decoration, which culminated in the paper cut-outs. Indeed, the cut-outs lose their full meaning if divorced from those ideas which helped bring them about. It is true that Matisse once rejected the suggestion that his work came from the mind, responding that everything that he had done had been done from passion. Yet, in properly rejecting a theoretical basis for his art, he perhaps overstated himself, for it is clear that his long career is more than a cumulative catalogue of unrelated objects: if the basis for specific works was a profound emotional response to his experience of particular things, the forms

his expression took were nonetheless consistent with his ideas, including a credo which he expressed often and eloquently. In 1908, at the age of thirty-nine, he explained it in detail:

What I dream of is an art of balance, of purity and serenity, devoid of troubling or depressing subject matter, an art which could be for every mental worker, for the businessman as well as for the man of letters, for example, a soothing, calming influence on the mind, something like a good armchair which provides relaxation from physical fatigue.[3]

At the age of eighty-two he could say simply that "I believe my role is to provide calm. Because I myself have need of peace";[4] but the ideal remained: "I have looked for the same things which I have perhaps realized by different means."[5]

Matisse clearly understood his task as an artist to be the revelation of inner truths by the creation of visual equivalents for experience. Art was the means both to order those symbols and to express his response to a sensual world, to Nature. What he expressed was his emotion stimulated by an object—by Nature (for Matisse understood Nature to be everything which was not art). He understood Nature as a basic energy, which was perceived in various objects by their different rhythms that also determined their infinite range of external forms. His was a world view reflecting the intellectual ambiance of his personality, his circle, and his time.

From his early career to his final years one can detect a shift in Matisse's understanding of Nature, not a change in conception but in emphasis. He always insisted that Nature was the source of his art, stressed the importance of working from Nature, and studied it in order to "possess" and make it his own: to identify with his subject so completely that he was free in his knowledge to improvise, to distort its appearance without losing its fundamental character, its "rhythm" or "timbre."[6] Matisse continually refined his technical skills to enable himself to create his images with a minimum of conscious control—the better to intuit its essence or "sign," that visual symbol which was the simplest, most evocative record of its character. Only by going far beyond the specific details of visual appearance could he evoke his subject in its entirety, through all the senses: touch, taste, smell, even sound.[7]

The paper cut-outs differ from Matisse's earlier work in the degree to which he removed himself from the immediate stimulus of nature and relied increasingly on memory. Matisse was well aware of the shift—he took pains to explain the apparent simplicity of his work to students, reminding them that it was the result of years of discipline and hard work. Yet one must stress that Matisse removed himself from the natural motif only in degree and seems never to have completely left it behind, even in seemingly abstract compositions (see remarks no. 199). The difference is that the cut-outs were generally made without direct reference to a model unlike the paintings, for example, which were done almost always from life. It was before he actually began to cut that Matisse worked from the model, either in numerous drawings, imaginary tracings in the air, or occasionally on the cut-out itself. By the time he was actually ready to begin to cut out his shapes, he had already captured the essence of the motif and extracted its sign.[8] He was then free to improvise with his scissors, to reconstitute his motif with pure color, to evoke with a visual equivalent its other sensory associations.

The importance of being free to work without reference to the model is key to the success of Matisse's cut-outs because each cut-out is a gesture, a continuous contour whose "rightness" depends on his ability to sustain the rhythm of his act, the flow of scissors through painted paper, a momentum which ensured the integrity and wholeness of each shape (see remarks no. 183). The physical implications of Matisse's methods generally have been overlooked.[9] Yet, it was the harmony of conception and act which he sought, the conviction of his gesture being the only means possible both to free himself of the emotional charge he carried and to achieve an image which embodied the complex of the specific and the universal that made it "real."

Matisse's career might be likened to one of his arabesques, a series of variations, fast and slow curves, of crossings and overlaps, a certain order, yes, but a meandering line, a line in search of possibilities, wary of taking the most direct path or using theory as a map. The paper cut-outs are generally viewed as a synthesis not only of painting, drawing, and sculpture, but of Matisse's career as a whole. One could say that Matisse always had the impulse toward the cut-out within him, clear in his feeling for pattern and the tension of an equivalent figure-ground. It is present in *Nature morte aux oignons,* 1906 (Copenhagen, Statens Museum for Kunst) and in both versions of *La Danse,* 1909-10 (New York, MOMA; Leningrad, State Hermitage Museum)

and *La Musique,* 1909-10 (The Hermitage). Certainly the rows of leaves on the left edge of his large painting *Baigneuses à la rivière* (fig. 10) anticipate the cut-outs: the motif reappeared in the window designs for the Vence chapel, no. 95. Moreover, Matisse formed his leaves in *Baigneuses* by scraping away the black paint with his palette knife. This gesture was perhaps inspired by his 1916 sculpture *Le Dos III* (which is reinterpreted in the painting in the standing figure at left), a work he evolved by cutting away a more rounded version in vertical planes. This early intermingling of sculptural procedures in a painting anticipates the synthesis in the cut-outs, which were, like scraping out, an elimination of nonessentials.

Less well-understood, however, has been just how literal a synthesis the cut-outs were, embodying in themselves not only his formal means of expression but also his aspirations as an artist. The striking continuity between the cut-outs and his earlier work and the degree to which the cut-outs were used to fulfill lifelong ideas concerning the function of his art indicate that Matisse developed his paper cut-outs with some purpose, that they were not merely the result of poor health which made it uncomfortable for him to paint. Rather, the cut-outs were a remarkable, if logical, extension of Matisse's basic ideas and methods.

Matisse was not a prodigy; he developed slowly, steadily, ever conscious of where he stood in relation to his own past. He did not hesitate to return to his beginnings. The period from the late 1940s to his death in 1954 was analogous to the 1905-14 years in his career, in some basic respects parallel ("My drawing and my painting are coming apart"),[10] and he responded with a similar effort to study singly the constituent elements of his art in order to be able to unite them, renewed, once again. In both periods Matisse undertook a wide variety of experiments in many different mediums, including ceramics and stained glass for the first and only times.[11] At no other times in his career were his various researches in painting, sculpture, drawing, printmaking, and ceramics so complementary and so clearly directed towards synthesis, in both cases in large-scale decoration: the Vence chapel and the environmental murals of 1952-53, *La Piscine, La Perruche et la sirène, Grande Décoration aux masques,* nos. 177, 183, 203. They are the outcome of concepts Matisse had expressed some forty years before in *La Danse* and *La Musique, L'Atelier rouge,* 1911 (fig. 19), *L'Atelier rose,* 1911 (Moscow, State Pushkin Museum), and the Moroccan paintings of 1911-13: the primacy of color as a means of creating a harmonious environment in which to live.

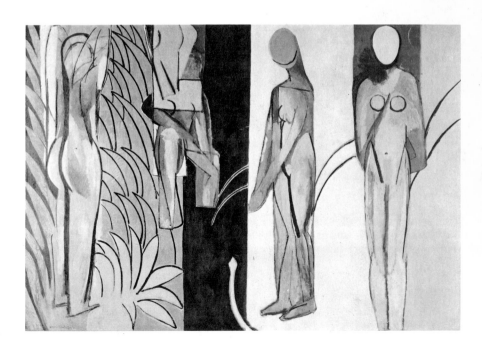

Fig. 10. *Baigneuses à la rivière,* 1916-17. Oil on canvas; 210.8 x 391.1 cm. (83 x 154 in.). Courtesy of The Art Institute of Chicago.

Matisse had used the cut-out technique since the early 1930s, but only as a specialized remedy for his paintings or as maquettes for various kinds of commissions or decorations (see Precursors A-C). It is apparent from his letters and statements that Matisse then saw himself foremost as a painter and that he considered his cut-outs distinct from (and, by implication, not equal to) his works on canvas. Not until *Jazz* (1943-44) did he seem to recognize the potential for the cut-outs as a means of expression in their own right, and perhaps not really until after the Vence chapel was dedicated in 1951 did he equate them with his paintings. In 1950 he made his last sculpture and in 1951 his last modest paintings; thereafter, he made only drawings and *gouaches découpées*.

In retrospect, one cannot see the late paintings as quite the same as his earlier work, even when Matisse succeeded in reuniting painting and drawing in masterpieces such as *Intérieur au rideau égyptien* of 1948 (fig. 11). This is perhaps because Matisse seems to have understood more completely than before the extraordinary implications of his paper cut-outs: that painting and drawing could be more than integrated. They could, with sculpture, be synthesized into one new medium. Indeed, once he had completed the Vence chapel, a decorative situation with quite specific demands (see remarks preceding no. 128 and remarks nos. 128-155), he apparently began to give serious attention to developing the full potential of the cut-out itself which had become gradually, indirectly, his most important means of self-expression. Matisse never really gave up "sculpture" or "painting"; rather, he merely ceased to make sculptures or paintings, consolidating his interest in both into the paper cut-outs, which synthesized the intrinsic characteristics of each.

II

. . . drawing with scissors on sheets of paper coloured in advance, one movement linking line with colour, contour with surface [12]

When Matisse once referred to himself as a "juggler,"[13] he implied more than the pictorial balancing of line, color, and form: he meant also his mind. Before a work of art could come into being, the mind had to be in order, a process both mental and physical; and to find the conviction which he called "a kind of meditation,"[14] Matisse drew.

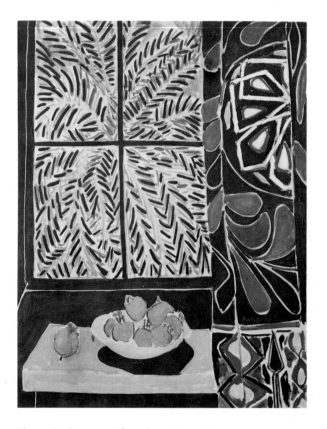

Fig. 11. *Intérieur au rideau égyptien*, 1948. Oil on canvas; 115.6 x 88.9 cm. (45½ x 35 in.). The Phillips Collection, Washington, D.C.

Drawing had always been at the heart of Matisse's work as an artist, for itself and to mediate between sculpture and painting; drawing was able to suggest physical mass and to imply color, yet in different terms —with reduced means. More abstract than either painting or sculpture, drawing lent itself naturally to the artist's gradual condensation of color and form in the cut-outs so that, even after he gave up making paintings and sculpture, Matisse never ceased to draw. He relied on drawing to "nourish" himself through the direct study of nature, to generate the activity and concentration required to identify himself with his subject and thereby, in his sketches, to discover its special sign. It was this preparation through drawing which made the cut-outs possible, not in the limited sense of serving as literal studies to which Matisse directly referred, but as a mental and physical conditioning which cleared his mind of extraneous details and freed his hand from needless gesture.

Drawing (understood as a concentrated, coordinated activity between eye, mind, and hand) served frequently as that direct experience of things—of Nature—which Matisse believed to be essential for an artist as the source of memory. Memory not as hazy recollections but memory as the re-experience of sensations consciously felt at the time, almost as though being filed away for future use. Memory could not recapture that which was not truly experienced the first time; it could evoke only what had been intuited and sincerely felt— only what had been absorbed into one's inner being.[15] Only then could it continue to exist as a personal reality, a source from the past for the present and for the future.

Certain of Matisse's drawings are specifically related to certain works in *gouache découpée*. The best known example is the sketchbook of drawings (Matisse 1955-2) of twenty-eight seated nudes (fig. 12) and other studies which anticipate not only *Nu bleu I-IV*, nos. 167-170 (see remarks no. 170), but their variants and derivatives as well (nos. 171, 173-181). In these drawings Matisse tried out the same basic figure in various arrangements corresponding to the distinctly different treatment of the figure in each *Nu bleu*. The sequence of these drawings suggests that Matisse made them over a period of several months as he worked on the much larger cut-outs. Another example is the series of six large brush and ink drawings contemporary with the cut-out of the same subject.[16] So closely related are these and other rapidly executed brush drawings to the energetic gesture implicit

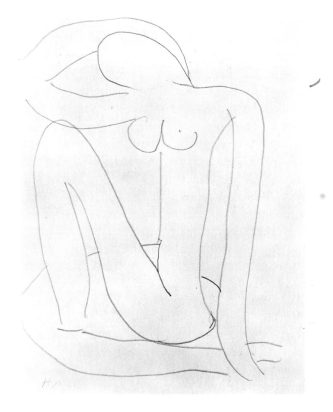

Fig. 12. *Woman Seated with Arm on Head,* 1952. Pencil on paper; 27 x 21 cm. (10⅝ x 8¼ in.). Courtesy of The Detroit Institute of Arts, Gift of John S. Newberry.

in the later *gouaches découpées* that Matisse could turn one of them into a *de facto* cut-out by the addition of three cut-out fruits (no. 207). Conversely, a number of Matisse's maquettes also consist of drawn lines over cut-out elements (e.g. nos. 123, 185, 217). Others, such as *Grande Décoration aux masques,* no. 203, incorporate separate drawings, made for the composition, into the overall design.

Matisse also drew directly on the background papers of certain cut-outs to guide the placement of the cut paper or to work out the rhythm of a pose to scale (see *Zulma,* no. 109; *Poissons chinois,* no. 127; *Souvenir d'Océanie,* no. 199; *Nu bleu IV,* no. 170; and *Acrobates,* no. 175). Not all the "drawing" on a cut-out may be by Matisse. His drawing on the cut-out ground of colored or white paper should be distinguished from the pencil notations or traced outlines made by his assistants during transfer of the cut shapes prior to gluing down the composition (see Technical Appendix). Extensive charcoal drawing on no. 175 indicates that just as Matisse had earlier relied on cut paper to facilitate the revision process in several of his paintings (Precursors A-C), he later resorted to drawing to work out particularly difficult problems in certain cut-outs. In each instance these complications involved the nude figure, the archetypal subject of sculpture.

III

Matisse said of his sculpture that he did it as "the complement of my studies . . . but I sculpted as a painter. I did not sculpt as a sculptor."[17] Instead Matisse modeled the figure not strictly as a physical object but also as an "image." For despite the small, intimate size of most of his sculpture (fig. 13), Matisse "consciously *modeled the figure seen at a distance.*"[18] The result is sculpture whose general mass and support of physical weight are traditional, often academic, but in which the articulation of the limbs in particular embodies some of the spatial conventions not of sculpture but of pictorial art: "The sculpture is made as if felt near by the hand (fullness, solidity, graspability) and as if seen by the eye (foreshortening, perspective diminution, flattening, etc.)."[19]

Modeled in clay, Matisse's sculpture made of foreshortening a literal as well as a perceptual experience; the illusion in a painting—of an upraised arm bent backward, for example—took physical form. The result is an object which physically—as sculpture—thwarts one's ex-

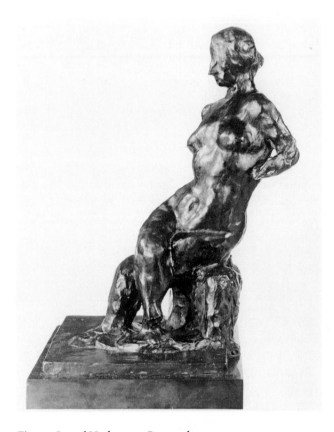

Fig. 13. *Seated Nude,* 1909. Bronze; h. 29.2 cm. (11½ in.). Courtesy of The Detroit Institute of Arts, Robert H. Tannahill Bequest.

pectations of what the body should be, yet which conforms to our visual reading of the figure, as though we are looking at it across the room. Although his small sculptures are extremely tactile and solid, Matisse, the painter, favored the eye before the hand, for it was vision as much as modeling which finally determined his sculpture's form.

The ambiguities in Matisse's sculpture, or rather what he sought in sculpture, made it possible for him to invest his sculptural aspirations in his paper cut-outs. What William Tucker has so well expressed as "the tension between the perceived and the grasped"[20] in Matisse's small sculpture is also at work in the paper cut-outs, where he pushed it to an extreme not possible in his paintings on canvas.

Matisse's sculpture—working in the round—kept him in touch, literally, with real as opposed to illusory volumes, as Matisse said, "the force of reality."[21] When he felt his painting or drawing verging on stylization—the symmetrical treatment of subjects according to type—he sometimes regained his feel for the specific by working in clay. As a result of this conscious effort, shape (which implies two dimensions) in Matisse's art is never really completely flat; instead shapes retain a sense of a specific, three-dimensional form.

Matisse's sense of a real, weighty thing, understood in the sculpture in all its aspects, is retained primarily in the contour, the sculptural edge around each paper cut-out. A drawn contour is an irregular, undulating, but continuous line which records the swelling and recession of an object's volume at its perimeter in relation to the surface plane of the paper: it is a sculptural line which conveys a rudimentary illusion of an object in space, of something seen and touched. By contrast, a simple outline (an even line) delimits only the boundary of an object, not its give and take with surrounding space. Outlines separate objects from the background, but contour lines integrate them as though the object is not merely a series of connected abstract lines, but a physical entity occupying (and being modified by) our actual space.

In his cut-outs Matisse limited illusion primarily to the edges, or the contours, of his colored shapes, the contour itself a condensation of sculptural mass to line. Although a drawn contour line has two sides, and a cut paper edge only one, the fact that this single cut edge is physical (however thin the paper) compensates for the apparent disparity in illusion: in fact, Matisse's cut-outs are, by definition, half-real and half-illusion—physical forms rendered in pictorial terms, a further extension of his own concept of sculpture in the round.

His cut-outs retain the vestiges of sculptural form—of real objects—while functioning primarily as colored shapes, as both individualized portraits of specific things and as pattern. As physically distinct pieces of paper (each cut-out in the round), Matisse's colored cut-out shapes are also perceptually distinguished from similar shapes rendered in paint: painted images tend to read spatially only from the paint surface back into illusory space; paper cut-outs, as real pieces of paper on top of the paper acting as the picture plane, are perceived as physically present in our space before we read them as parts of an overall composition across the surface. To this extent Matisse's cut-outs technically remain "sculpture" or thin relief.

It is the physical presence of specific things which keeps Matisse's cut-outs "expressive" even when the seeming repetition and geometrical composition of the shapes in certain cut-outs ought to make of them neutral ornament. And it is this retention of the individuality of each flower or leaf through Matisse's condensation of it to drawn "sign" and then to cut-out "shape"—by drawing and sculpture—which keep the cut-outs from becoming "merely decorative."

Even before 1950, when Matisse made his last sculpture, he had transferred his need for an interest in making sculpture to his cut-outs. It is clear that the series of various blue nudes (particularly *Nu bleu IV*, no. 170 and *Acrobates,* no. 175) not only functioned as sculptural "preparations" for other cut-outs but literally became Matisse's "sculptures" for the final three years of his life. That he considered the series of blue nudes as "sculpture" rather than "painting" cut-outs is indicated by their sculptural conception, minimum use of background and motifs, and the fact that they are executed almost exclusively in terms of a monolithic blue (which he also used for the architectural elements of his maquettes for ceramic murals, nos. 203-205).

Some of the blue nudes are more "sculptural" than others. The seated pose of the early blue nudes (nos. 167-170) concentrated the implied weight of the body in the lower half of the composition, like a traditional sculpture with most of its weight centered near the base. From this rather literal rendering of a sculpture in cut paper, Matisse introduced within the series new poses more in keeping with the pictorial emphasis of the new

medium. Activities such as jumping rope (nos. 173-174), back bends (no. 175) and swimming and diving (no. 177) lift the figure off the ground, distributing the weight of the figure more evenly across the composition, or balancing or suspending it altogether. In later works such as *Nu debout*, no. 179, *La Grenouille*, no. 180; *Vénus*, no. 181, and the two versions of *Femme à l'amphore*, nos. 201-202, Matisse returned to static and even seated poses. However, he continued to minimize the traditional sculptural associations of the nude (and heightened its pictorial qualities as shape) by separating the parts of the body (nos. 179-180) or by questioning the relation of the figure to its ground (nos. 176, 181). Thus, the nude swimmers in *La Piscine*, no. 177, buoyed or partially obscured by the water, were free to be rendered as gestural silhouettes. Frequently in an ambiguous (and therefore less sculptural) relationship to its support, the nude, the most traditional, representational, and complex of Matisse's subjects, was thus eventually transformed from a predominantly sculptural motif to function pre-eminently as yet another "sign" within Matisse's visual language of the paper cut-out.

IV

Colors are forces[22]

Color for Matisse was always the means to something else. He pursued it not for its own sake or to demonstrate a theory but because color is an acute source of visual sensation with the power to affect one's emotions. Like Charles Baudelaire and others before him, Matisse knew that color is independent of the will, that it works subliminally before we consciously allow it to act. He seems to have understood this early in his career, recognizing that before line, texture, or tonal contrasts, color can express feelings whose immediacy and intensity are an equivalent for our experience of nature, where we perceive not only colored surfaces but are also aware of things sharing our space within a matrix of everchanging sensations. Precisely because color is not fixed, Matisse discovered that it could, in certain combinations, evoke the other senses; that color by itself could trigger that flow of feeling or shock which was most like the passion he had originally experienced in the presence of a landscape, a bouquet of flowers, an open window, or a beautiful woman.

Matisse, in the great tradition of colorists, learned to use color to bypass the intellect and to engage the imagination. For the intellectual, rational illusion of tonal gradations and perspective, he substituted an illusion constructed of color: volumes, weights, and spaces which were immediately felt—intuited—rather than logically deduced. He built his art on color because color was a more intense equivalent of the totality of experience than either line or tone; color appealed directly to the senses: color was the means to convey the inner, emotional reality of things.

The paper cut-outs are significant in this development not only because Matisse made them at the end of a long and productive life, but because he distinguished in them—perhaps for the first time in modern Western art—between "color" and "painting," two concepts which had been assumed to be, if not identical, then synonymous. Cut from papers painted not by Matisse but by his assistants, the paper cut-outs literally manifest the distinction between "painting" as an essentially physical procedure of selecting, mixing, and applying pigments, and "color" as a critical activity: color as composition.

Working increasingly from memory in his cut-outs, Matisse shifted the balance between life/subject and art/object even more emphatically to art. He spent less time with the motif (the cutting) and devoted himself increasingly to the arrangement of the whole, to color. In this shift Matisse distinguished more explicitly than ever before between manual dexterity and judgment, between the intense physical and mental coordination concentrated in making individual colored shapes, and the more distanced, intellectual activity of combining those shapes to make a work of art. Matisse always emphasized that color by itself meant very little, even in quantity, that a colorist must establish "relationships" between colors to give them expression. "It is not quantity which counts," he said, "but choice and organization."[23]

Matisse made explicit in the cut-outs the further distinction between paint and color, between color as *matière*—substance—and color as perception, the result of proportion, placement, quantity, shape, and scale. But oil paint—whether opaque, transparent, glossy, mat, smooth, or impasto—invariably imposed its presence as material at the same time that it acted as hue. Color as "space" was often the result of the artist's sense of touch as much as the selection and organization of specific color accords. Despite the fact that Matisse used oil paint with extraordinary freedom, he apparently felt that oil paint was too active and imposed too much of itself for him ever to have given it serious consideration for his cut-outs. Gouache, however, which he had used

periodically during his career for large decorative paintings, was a relatively neutral medium that provided an even, saturated hue. Paper painted with flat gouache colors neutralized much of the surface effect of *matière* and brushwork and placed a premium instead on the artist's placement of his cut shapes. And because Matisse most often directed his assistants in pinning the colored shapes to the wall, he removed himself yet again from all but the initial physical phase of the actual cut-out procedure—the cutting—and directed his energies where his assistants could not follow: using his lifetime of experience, sensibility, and, perhaps most important of all, his need to express his emotions by re-creating them in his art.

Matisse's success as a colorist in painting was due in no small measure to his use of tints (colors mixed with white and often nearly invisible to the eye) which allowed his brighter colors to work at high intensity. In the cut-outs, mixed colors are rare; instead, neutrals exist through the optical interaction of his primary and secondary hues. Working with a relatively small number of colors, he exploited variables of size, shape, and surface to achieve chromatic effects not strictly accounted for by the papers themselves, a characteristic of his painting as well but more explicit in the open structure of the cut-outs. Because the cut-out shapes could be moved freely across the surface and rearranged or removed at will, Matisse could concentrate on the interaction of the color alone. Absorbed by the sunny ambiance of his studio, surrounded by his windows and white walls, textiles, plants, shadows—the cut-outs growing everywhere—Matisse seemed the embodiment of van Gogh's prediction that "the painter of the future will be a *colorist such as never yet existed.*"[24] Color became for Matisse very real, imbued with personality, a thing whose particular resonance he could feel:

I don't cut the oranges and the reds like the greens or blues: in this green there is a tenderness[25]

Color works you over more and more. A certain blue enters your soul. A certain red has an effect on your blood-pressure. A certain color tones you up. It's the concentration of timbres. A new era is opening up.[26]

That color had become for Matisse both a more immediate and abstract conception—independent of a particular medium—is indicated by his use of paper cut-outs as design maquettes for an astonishing variety of projects. With a single material Matisse made maquettes or preparations for mural paintings, stage designs, ballet

costumes, book, magazine, and catalogue covers, illustrations, posters, scarves, wall hangings, tapestries and a rug, stained glass, liturgical vestments, roof tiles, gallery announcements, a theater program, a note card, and ceramic murals. Cut paper, painted with mat colors, was the source for designs to be translated in deep wool pile, Beauvais tapestry, silk appliqué, vitreous ceramic tile, and translucent and transparent stained glass. This was in addition to the many cut-outs intended for reproduction with graphic techniques (stencils, lithography) closely approximating the actual appearance of the paper cut-outs themselves.

Paper cut-outs could serve as maquettes for all of these myriad projects because Matisse realized that the purpose of a maquette was to establish the composition and color relationships of the design and not to imitate the appearance of wool, ceramic, or glass. He nevertheless considered his maquettes as independent works in their own right; indeed, he apparently made no distinction between them and his other cut-outs. For he understood that the execution of the design in another material was a separate procedure with its own requirements and usually carried out by artisan specialists under his supervision. The cut-outs were thus well-conceived as a maquette material; the gouached paper was a neutral source upon which the artisans could base their calculations for preserving Matisse's color accords and shapes within their respective crafts. One measure of how far Matisse came in his understanding of color is that his 1911 proposal for a window design was rendered in watercolor, the transparent washes simulating the effect of stained glass; by 1948 he could visualize his colored windows exclusively in terms of *gouache découpée.*[27]

The more simplified shapes and use of fewer colors in the late cut-outs may reflect not only their larger scale but Matisse's concern that his designs could be translated accurately in other materials. It is likely, for example, that he eliminated fuschia from his series of mural proposals for the Brody ceramic wall (nos. 203-206) because this color was unstable and its effects unpredictable in glaze. It is one measure of Matisse's interest in his ceramic mural projects that he gave up fuschia, one of his favorite (and most characteristic) colors. Perhaps to avoid such restrictions he shifted his interest during 1953-54 to stained glass. Indeed, the characteristic "frames" of his later documented glass commissions (nos. 127, 212) suggest that such important late compositions as *Souvenir d'Océanie* and *L'Escargot,* nos. 198, 199, were originally conceived as potential

windows, as sources of that "light" which Matisse had predicted would be the future of art.[28]

V

Although the possible sources for Matisse's cut-outs are as varied as for his painting, there are two which relate directly to his technique: the tradition of the silhouette and appliqué textiles. Both were familiar to him and each found rather liberal expression in certain cut-out designs.

The silhouette is basically a drawing following the outline of a cast shadow (fig. 14). Silhouette also connotes a bust-length profile view (which eliminates most foreshortening and simplifies the image), although there are numerous examples of quite complex compositions conceived as silhouette. Whether a drawing filled in with ink or cut from paper (either from a tracing or freehand), silhouettes are traditionally done in black. All internal detail and color are eliminated. Characterization is restricted to the general shape and details of coiffure and costume around the edges. By reducing objects to flat shapes, silhouettes render objects in their most basic visual terms. And by using the object's own shadow as the source of the image, the direct link with nature was maintained. (Matisse seems to have observed shadows

when cutting his silhouettes of palm fronds in nos. 157, 187.) As a means of expressing something in its essentials, silhouette is closely related also to caricature, which exaggerates prominent physical features for the sake of vivid characterization. Both traditions are present in Matisse's *Silhouette, fond jaune*, no. 70, one of the very few cut-outs which actually resembles a traditional silhouette. It may reflect also the tradition of shadow puppets, another use of silhouette practiced in the Orient and in European popular entertainments.

The silhouette tradition itself, however, seems to have had little direct influence on Matisse's cut-outs apart from the general resemblance of monochrome cut-out paper shapes against a plain background—indeed the cut-outs before 1952 were most often composed with backgrounds of many colors. Nor did Matisse restrict himself to profile views, but frequently used foreshortened images, as in his sculpture. And, though most silhouettes reflect their origin as flat shadows, Matisse conceived his cut-outs as real objects: he used his scissors to inflect the contours of the paper, responding to the resistance of the paper and its particular color as material substance. Compared to silhouettes, Matisse's cut-outs are not flat, which underscores the most essential difference between the cut-outs and traditional silhouettes—color. Matisse did use black shapes but in conjunction

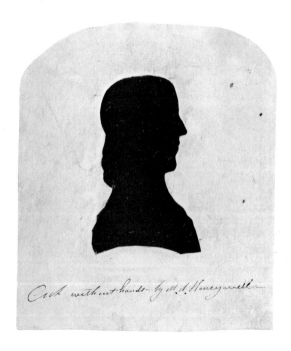

Fig. 14. *Henry Ford Moffat*, date unknown. Black paper on white; 8.7 x 7.3 cm. (3 7/16 x 2 7/8 in.). Silhouette cut by M.A. Honeywell (American, active c. 1806-48). Courtesy of The Detroit Institute of Arts, Gift of Miss Catherine E. Moffat.

with other colors or for descriptive or symbolic value (see *L'Enterrement de Pierrot, Le Boxeur nègre, La Négresse,* nos. 26, 73, 200). Blue or green, however, reduced the sharp contrast with the background, softened the edges, and served to flesh out the shape still further.[29]

A more likely influence of the silhouette on Matisse's cut-outs is indirect, through decorative arts such as textiles, rugs, and wallpaper—all of which are based in part on the simplification of natural forms through silhouette. Matisse was well-informed and interested in the decorative arts and principles of decoration from the beginning of his career. On one level, he acquired examples of textiles, for example, to use in his paintings and to decorate his walls. Photographs of his various studios show a wide variety of textiles represented, including Congolese bark cloth, Tahitian tapas, Chinese rugs, Algerian hangings, and an Egyptian curtain (fig. 15). The last in particular, consisting of floral shapes of garish colored cotton cloth sewn to a plain background, resembles Matisse's cut-outs in many respects: freely cut forms, bright colors, and assembly onto another surface. Many forms of appliqué also share these characteristics, including Congolese appliqués with backgrounds of colored squares.

Ceramic tile is still another of the decorative arts based on patterns related to silhouette, often translating designs from textiles and rugs. Matisse's concern to be appropriate to the needs of this particular medium suggests in turn a likely source for his own designs for ceramic murals such as *Grande Décoration aux masques,* no. 203, one of the most tightly organized of all Matisse's cut-outs. Its basic design element, a rosette square consisting of four petals and four cloves, is a self-contained unit like a gigantic ceramic tile. Assembled, the squares interact, the adjacent cloves forming rosettes of their own which become the positive to the negative of the white channels between the petals.

The singular design for *Grande Décoration aux masques* seems to have a specific source of inspiration: the Alhambra in Granada, Spain, the fourteenth-century palace of the Moorish kings, long considered one of the greatest examples of architectural ceramic tile decoration. During the fall of 1910 Matisse went to Munich to see an important exhibition of Islamic art. He then spent the next months in Moorish Spain, working there until early 1911. Based in Seville, he made trips to Cordova and to Granada, where he obtained some tiles from the Alhambra.[30] The Alhambra complex of buildings and gardens had long been immortalized in numerous books, including one probably familiar to Matisse, Owen Jones' *The Grammar of Ornament* of 1856, a classic manual of decorative principles and sources from world cultures.

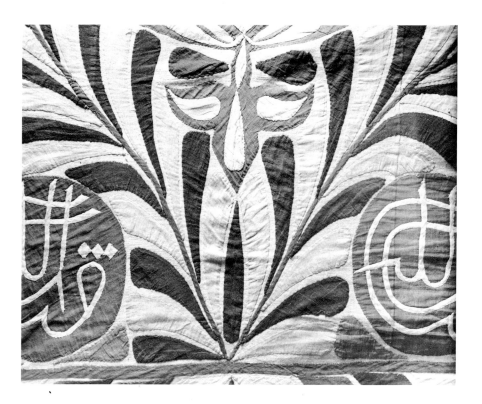

Fig. 15. Egyptian Curtain, c. 1900, detail. Cotton appliqué; 292.1 x 144.8 cm. (115 x 56 in.). Private Collection, Detroit.

Elaborately illustrated with colored plates of architectural details, Jones devoted a separate, lengthy chapter to the "Moresque Ornament from the Alhambra," which he had personally studied for some eleven years and considered "the very summit of perfection of Moorish art."[31]

This trip to Spain followed immediately the completion for Matisse's Russian patron Shchukin of the murals, *La Danse* and *La Musique,* the artist's first attempt at large-scale decorations.[32] It is fair to say that Matisse steeped himself in Moorish art at a time when he was most receptive to what the Alhambra had to offer. Not only did ceramic tile decoration reach its highest development there in designs unique to the site, but the Alhambra was famous also for its gardens in the Arab style which combined fountains and pools with aromatic plants and trees to create a sunny ambiance of repose and meditation. Numerous windows opened onto the enclosed gardens which had in turn inspired the extraordinary floral architectural décor. A continuity of exterior and interior, an equilibrium of the senses and the intellect, the Alhambra was a harmony of nature and of art. It was precisely this kind of environment which Matisse had admired all his life and sought to re-create in his studio, or in the room darkened with pierced hangings similar to the *jalousies* of the harem, its walls draped with textiles, Oriental props, the models attired as odalisques. But whereas these works were somewhat literal in their evocation of the East, in the late projects such as *Grande Décoration aux masques,* Matisse sought instead the ambiance of color, light, and well-being which he associated with this tradition. In the Alhambra Matisse seems to have discovered both the atmosphere of calm and the superb decorative models with which to inform his own means of expression forty years later.

For example, *Grande Décoration aux masques* (and *Décoration fruits,* no. 204) closely resemble the mosaic tile dado walls in the Baths of the Alhambra (fig. 16), specifically the rosette pattern which Matisse opened up in his own rosette/clove design.[33] The expansive mural effect of the cut-out and its apparently casual distribution of large, brightly-colored rosettes, also resembles the long mosaic dado around the Court of Myrtles,[34] known also as the Fish Pond (fig. 17). These decorations resemble the paper cut-outs also in conception, for unlike painted tiles, mosaic tile designs are assembled from shapes separately formed and glazed.

The center panels of nos. 203-204 also have possible sources in Islamic tile decoration, specifically the arched, blind windows and portals surrounding the great Iwan of the Shah Mosque.[35] The irregular border may suggest the folds of gathered curtains or hangings around the portal; Matisse himself had earlier translated a supple draped textile into an architectural design with his *L'Arbre de vie* window for the Vence chapel, no. 95. The simple blue rosettes in Matisse's center panels echo in simplified form the gold interlace rosettes of the Isfahan façade. The curious blue columns in nos. 203-204 (used again in no. 205) also have parallels in the two domed minarets behind the Iwan or in the columnar enframements one perceives through the arcades in the Court of the Myrtles. In each case Matisse has adapted the general principles of the decorative schemes rather than merely copying their details, reworking his sources in his own terms—here apparently combining elements from related but quite distinct cultures.

VI

The cut-outs, so emotional and founded in the direct experience and love of nature, are nevertheless Matisse's most conceptual works. His studio procedure even resembled that of the great decorative masters of the past, such as Peter Paul Rubens, where the Master's sketches often provided the basis for a painting to which he added the final important details. It is, of course, not the same with the cut-outs: Matisse conceived them, cut them, composed them. Only the physical painting of the papers and the pinning and eventual gluing of the cut shapes was left to his assistants. In the process, however, Matisse gave up over sixty years of using a brush, a technique and feel for oil paint possibly unrivaled in the twentieth century. In exchange he gained a more direct experience and use of what intrigued him most: color, and through its interaction, a sense of light and space.

Matisse's concept of space was one of continuity and expanse. He proposed that painting ought to expand surfaces, to make them seem larger than they were; in effect, to transcend the physical limitations of the frame or of architecture.[36]

What Matisse had in mind can be inferred from the nave of the Vence chapel (his most comprehensive completed project), where the blue, green, and yellow glass combine to create a warm glow which may vary from pink to rose to violet.[37] "Each group of colors has a particular atmosphere," he told Verdet. "It is what I will call the expressive atmosphere." Red, he explained,

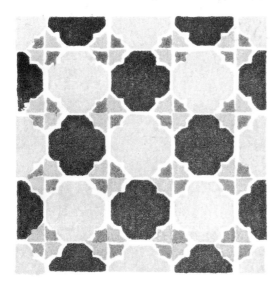

Fig. 16. Mosaic tile pattern for dado wall, Baths, The Alhambra, Granada, 14th century. Illustration from Owen Jones, *The Grammar of Ornament*, London, 1880, pl. XLIII, no. 15.

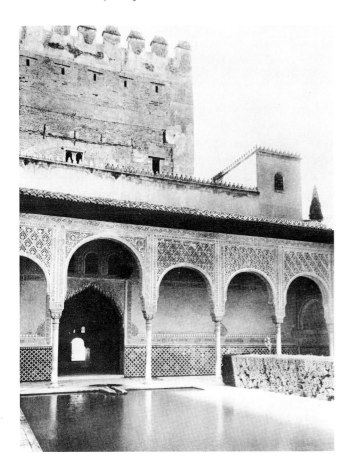

Fig. 17. Court of the Myrtles (Court of the Fish Pond), The Alhambra, Granada, 14th century.

could not be introduced into the chapel. "However, this red exists and it exists by virtue of the contrast of the colors which are there. It exists by reaction in the mind of the observer.[38] Color then was not an end in itself but the means to a color not confined to walls—to light itself:

Color helps to express light, not the physical phenomenon, but the only light that really exists, that in the artist's brain.[39]

Matisse had long favored in his paintings a triad of red, blue, and green, the primary colors not of pigment but rather of light, the solar spectrum. On several occasions—believing his paintings capable of emanating their own light—he endeavored to perk up sick friends by surrounding their beds with his canvases as though they were icons exuding a "beneficent radiation."[40] He saw in light the source of health, happiness, and life itself.

Thus the *gouaches découpées* were an important option for Matisse in several specific respects. On the one hand, the paper cut-out was both the means and the result of his ongoing effort to purify color, to disassociate it from paint and painting, to use color as a more direct extension of himself: as expression. And, by making of color something more abstract, "like music which is built on only seven notes,"[41] the cut-paper gouaches became an ideal technique for the maquettes by means of which Matisse could extend his designs to other materials—to entire walls. "The characteristic of modern art," he had said, "is to participate in our life."[42] And the cut-out freed him to approach that "perfect unity" which he realized had necessarily to be architectural and environmental in conception.

One might suggest that Matisse had found his "ultimate method" and "perfect unity" within the cut-out technique itself—a literal synthesis of means. What he sought and seems to have been working towards in 1954, however, was more spiritual, that "expressive atmosphere" which he felt he could best approach through the scale of architectural decoration in ceramics and glass. That Matisse made so few late cut-outs which were not maquettes for actual or potential commissions suggests that he was far beyond the discovery of merely a more pure equivalent for his easel painting. He had recognized in his cut-outs a means to something much more comprehensive and fundamental to his aspirations as an artist: a luminous environmental art capable of evoking the calm, untroubled ambiance he had always sought to create. The paper cut-outs were not his ultimate method but a beginning.

Notes

1. Matisse to Courthion, Guichard-Meili 1967, p. 168.

2. Escholier (1956, pp. 117-118) noted that Mme. Albert Marquet told him that Matisse had also arranged his paintings around her husband's sick bed. Gowing (New York 1966, p. 17) cited an unpublished memoir by Simon Bussy, another old friend of Matisse's, recounting how Matisse used his paintings to illuminate a room. Gowing also discussed (*idem.*) the healing aspect of Matisse's art in the context of a very fine essay on color. See also Bromberg 1963, p. 7 ("Psychology of the Healer"), who saw in "the wish to cure . . . the tenuous residue of narcissistic omnipotence." Aragon (1965, p. 138) said as much when he wrote, "N'était-il pas, lui aussi, un peu sorcier? N'avait-il pas toute la vie prétention de régenter l'humeur de ceux qui voyaient sa peinture . . .?" (Wasn't there also something of a sorcerer in him? Didn't he throughout his life claim to be able to control the moods of those who saw his paintings?)

3. Matisse, "Notes d'un Peintre," 1908, tr. Flam 1973, p. 38.

4. Charbonnier, "Entretien avec Henri Matisse," 1951, tr. Flam 1973, p. 140. Matisse did not intend his art to be a visual Musak but an art both expressive and harmonious, a stimulus, to meditation and elevation of the spirit. He envisioned an art fusing easel and mural painting, making quite revolutionary use of principles of decoration (see Neff 1974-2, 1975-2). One can only wonder what Matisse (who said that his cut-outs were not his final statement) would have done next. A secular Vence, a larger version of the small room he made for Tériade (see no. 127)? It is important to remember that an artist's "final phase" is a retrospective convention, unmindful of arbitrary death, a notion which implies a conscious summation, a purposeful grand finale. Although his letters reveal his keen awareness of mortality and an urge to synthesize, Matisse had always insisted that each stage of his career, each work, had itself to be complete; nothing could be postponed.

5. Matisse, "Témoinage," 1951, tr. Flam 1973, p. 136.

6. "An artist must possess Nature. He must identify himself with her rhythm . . ." (Matisse, "Letter to Clifford," 1948, Flam 1973, p. 121).

7. Matisse said, "One must find the tone of the correct quantity and quality to make an impression on the eye, the sense of smell, and the mind. To make someone fully enjoy a jasmine plant, for example" (Verdet 1952, tr. Flam 1973, p. 145).

8. Matisse explained this procedure in reference to *L'Escargot*, no. 182 (*ibid.*, p. 146).

9. It is evident, for example, that the figures in *La Danse I,* 1909 and *La Danse II,* 1910 (New York, MOMA; Leningrad, State Hermitage Museum, respectively) were drawn in with sweeping strokes of the brush, Matisse standing on his toes to reach the top of the canvas. To avoid the deadening effect of squaring up his designs in order to enlarge them, he amplified his gestures instead: he used a long bamboo pole with a thick piece of charcoal attached to the end to work on the Barnes murals (1932-33, Merion, Pa., Barnes Foundation) and again for his tile designs for Vence (Barr 1951, ill. p. 31). And to judge from the drawing in *Zulma,* no. 109, and *Souvenir d'Océanie,* no. 199, for example, he used this technique in the early stages of cut-outs as well. Matisse also must have used different-sized scissors for the cut-outs: smaller scissors for the many lacy designs of the 1940s and heavy shears for the larger and more simple later works. See remarks no. 183 for a description of the process based on the wonderful sequence in Maeght's 1952 film.

10. Matisse, letter to Bonnard, January 13, 1940, Matisse 1970, I, p. 92.

11. During 1911-12 Matisse began work on a stained glass commission for Karl-Ernst Osthaus, founder of the Folkwang Museum in Hagen, Germany, for whom he had made c. 1907 a large ceramic triptych (see Neff 1972-2, Neff 1974-2). He worked with glass samples and made a watercolor design for a window; the design was never executed (see *idem.* and also note 27, below).

12. Verdet 1952, tr. Flam 1973, p. 147.

13. See Matisse 1972, pp. 166, 168, 211, 261.

14. Matisse, "Portraits," 1954, tr. Flam 1973, p. 153.

15. See Bergson 1903, pp. 32-33 for a similar view.

16. The six *Acrobate* drawings are reproduced in *Verve* 1958, pp. 71, 82, 110, and in Paris 1975, pp. 182-183.

17. Charbonnier, "Entretien avec Henri Matisse," tr. Flam 1973, p. 141.

18. Tucker 1975, p. 65. This is an exceptionally fine article on Matisse's sculpture.

19. *Ibid.*

20. *Ibid.*, p. 66.

21. "I have never left the object. The object is not interesting in itself. It's the environment which creates the object. Thus I have worked for years before the same objects which continued to give me the force of reality by engaging my spirit towards everything that these objects had gone through for me and with me . . ." (Matisse, "Témoinage," 1951, tr. Flam 1973, p. 136).

22. Matisse, "Le Chemin de la couleur," 1947, tr. Flam 1973, p. 116.

23. Cf., for example, Josef Albers' recommendations for the use of colored papers for color study ("Why color paper— instead of pigment and paint," Albers 1971, pp. 6-7). Like Matisse, Albers was interested in the interaction of color, but Albers wanted to demonstrate a kind of perceptual color illusion in which flat tones seem to be transparent overlays or to change color as a result of their juxtaposition.

Matisse saw color interaction primarily as a stimulus of the imagination and the means to generate an illusion of objects and light.

24. Van Gogh, letter to Théo van Gogh, May 5, 1888, Gogh 1963, p. 289.

25. Matisse to Fr. Couturier, Matisse 1972, p. 247, n. 13.

26. Verdet 1952, tr. Flam 1973, p. 143.

27. See Neff 1972-2 and Neff 1974-2, pp. 189-190 and n. 27. The watercolor Matisse sent to Osthaus recently reappeared. See Sotheby, London, *Important Impressionist and Modern Drawings and Watercolours*, December 1, 1976, lot 191, ill. color, entitled *Cressons des Indes*.

28. In a 1953 interview, "Matisse answers twenty questions" (*Look*, August 25), Matisse, in answer to a question about what direction modern art would take, said, "Light" (see Fourcade 1976, p. 115).

29. Matisse's cut-outs have numerous historical antecedents. For the silhouette, see Boehn 1970, esp. p. 183. For examples of early cut-outs and collages, see Blanc 1870, pp. 567, and Wescher 1968, pp. 7-19: see esp. *Red Head with Shadows*, c. 1900, by Christian Morgenstern which Wescher, ill. p. 16, compared to Matisse and which is especially close to his *Composition, noir et rouge*, no. 69. Compare also the remarkable 1915 collage *Josephine Baker* by Matisse's friend Henri Laurens (*idem.*, ill. p. 45) with Matisse's own cut-out inspired by Baker, *La Négresse*, no. 200, both reducing the figure to simple geometry.

30. Matisse sent Charles Camoin a postcard stamped Seville, October 3, 1910, concluding with: "Je pars demain pour Grenade" (I am leaving tomorrow for Granada) and indicating: "Poste restante, Grenade" (forwarding address, Granada) (Giraudy 1971, p. 11). The dates of the Spanish trip are not precisely known; Barr cited a postcard (1951, p. 134 n. 5) from Matisse to Gertrude Stein from Seville on November 20, 1910, and another (*idem.* p. 109 and n. 5) postmarked Garmisch (Bavaria) October 11, 1910. Mme. Marguerite Duthuit told the author that Matisse brought back some tiles from the Alhambra (interview, May 17, 1971; see Neff 1974-2, p. 62 n. 2, p. 121).

31. Jones 1880, p. 66. Meaning "Red Palace," the Alhambra was actively studied and restored during the nineteenth century, particularly after a fire damaged it in 1890 (see Calvert 1907-2, pp. viii-ix).
In 1909 the Alhambra became a topic of discussion in the Parisian press (see "Les Fresques arabes de l'Alhambra," *Les Nouvelles*, July 30, 1909, p. 4). In 1832 Washington Irving had written a romantic account of the Alhambra filled with evocations of the gardens in the moonlight. Calvert (1907-2, p. xxxvi) cited an Alhambra scholar, Richard Ford, who asked "Is the Alhambra a palace of the Arabian Nights...?" —a question one might raise with reference to Matisse's own cut-out, *Les Mille et Une Nuits*, no. 111.

32. See Neff 1974-2, p. 121 and n. 7.

33. See Jones 1880 and Calvert 1907-2 for photographs and charts. The rosette design from the Baths was published in Jones 1880, pl. XLIII no. 15, and was used again in Calvert 1907-2, pl. LXXII no. 99. These reproductions vary: in Jones the rosettes are blue and yellow. A variant on the diagonal, also from the Baths, is illustrated in Calvert 1907-2, pl. XLVII no. 56.

34. See Calvert 1907-2, pp. 177 (faint), 183 (variant), 193 (elevation drawing in which the pattern, if not the effect, is clear). See also *The Encyclopedia of World Art*, 1965, X, pl. 166, for a view of the end wall of the Court of the Myrtles framed by the arcade. An idea of the color and light generated by the tiles is conveyed by a color reproduction of another wall in Sordo 1963, pl. 54. The author has not seen the Alhambra and wishes to thank Vicci Sperry for sharing with him her experience of the architecture and grounds.

35. Seherr-Thoss 1968, pl. 82 (color). The reversal of figure-ground which one finds in such cut-outs as *La Cloche*, no. 156, also has ample precedent in Islamic architectural decor (cf. Magne 1913, p. 97, showing a niche in the Mosque of Rustam-pacha, Istanbul).

36. "The role of painting I think, the role of all decorative painting, is to enlarge surfaces, to work so that one no longer feels the dimensions of the wall" (Matisse to Charbonnier, "Entretien avec Henri Matisse," 1951, tr. Flam 1973, p. 139).

37. Matisse had created a similar pervasive pink light in his 1911 painting *L'Atelier rose* (Moscow, State Pushkin Museum). The pink-violet atmosphere in both is the result of blue, yellow, and green light sources. Although there is no indication that Matisse was specifically aware of theories of color healing, it is interesting to note that violet was considered by color healer Roland Hunt "the ideal Purifier," a "stimulative mainly to the Intuitive (Spiritual) nature" with great inspirational effect in the arts (Hunt 1971, pp. 103-105). Hunt (*idem.*) cited Leonardo da Vinci as saying: "Our power of meditation can be increased tenfold if we meditate under the rays of the Violet light falling softly through the stained-glass windows of a quiet church." He recommended, furthermore, violet for curing nervous tension. Matisse's use of violet in a portrait of his studio and later in the Vence chapel would have been considered appropriate by Hunt, who pointed out that "the principles of Colour" were used in hospitals and clinics around the world.

38. Verdet 1952, tr. Flam 1973, p. 144.

39. Matisse, "Rôle et modalités de la couleur," 1945, tr. Flam 1973, p. 100.

40. See note 2 above. Gowing (New York 1966, p. 17) used the phrase "beneficent radiation" in his very useful essay on Matisse's color.

41. Matisse, "Le Chemin de la couleur," 1947, tr. Flam 1973, p. 116.

42. Matisse to Degand, 1945, tr. Flam 1973, p. 106.

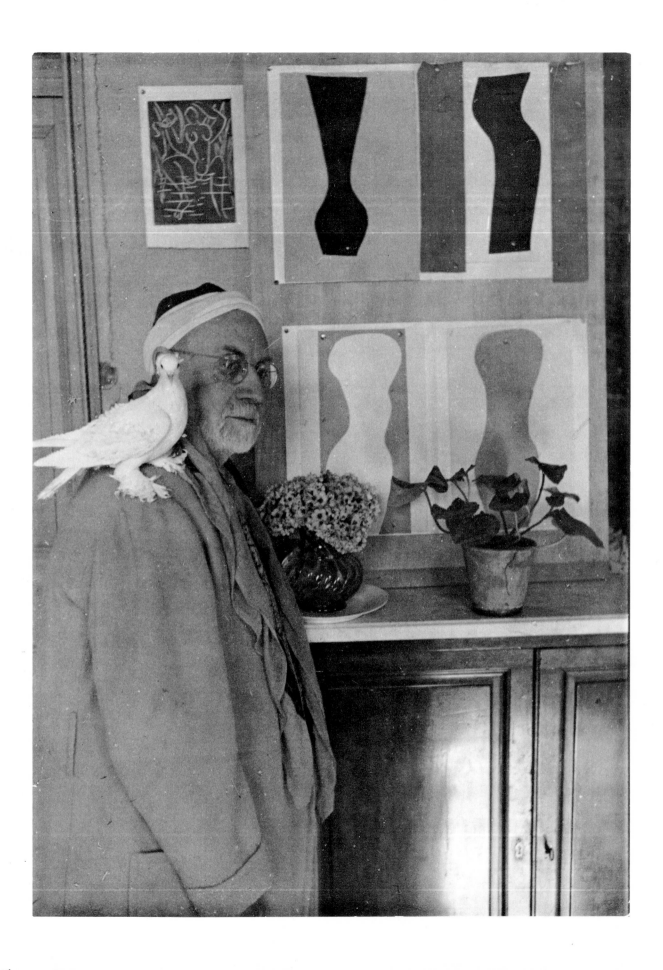

Jazz

BY JACK D. FLAM

Matisse executed the cut and pasted designs for *Jazz* in 1943-44, and the book was published in September 1947 as a folio of twenty color plates—the subject matter of which is taken largely from the circus, the music hall, folklore, and travel—with a text composed by the artist and reproduced in his own large handwriting.[1] *Jazz* is Matisse's first major cut-out project, and a pivotal work in his transition from oil painting to the cut-out technique that would dominate the last decade of his life. *Jazz* is also very much a *book*: an ensemble of pictures and text apparently intended as a prospectus or apologia for the cut-out technique in general—a bold combination of credo and manifesto.

I

I want at the same time to render that which is typical and that which is individual, a resumé of everything that I see and that I feel before a subject. (Matisse to Ragnar Hoppe, 1919)[2]

It is not merely fortuitous that Matisse's first major cut-out project was a suite of book illustrations for which he also wrote the text. Much of his energy during the previous decade had been devoted to graphic and theater projects,[3] and *Jazz*, combining as it does his preoccupations with poetry, graphic design, and theater, was as much part of a slow move *away* from easel painting as it was a move *toward* something new.

Throughout the 1930s, Matisse's interest in easel painting, previously the central concern of his art, ebbed and flowed. The decade is replete with evidence of his personal and artistic restlessness, and of his desire for new experiences and different media: the trips to Tahiti and to the United States (1930-33); the mural, book, and tapestry commissions (1931-36); the large and varied output of drawings (1935-37); and the costume and decor designs for the ballet *Rouge et Noir* (1937-38). Even Matisse's painting procedure seems to have been open to intense self-questioning, as witnessed by his new practice of having works systematically photographed

Fig. 18. Henri Matisse at his villa, Le Rêve, Vence, c. 1944. On wall: *Composition,* no. 36, *Formes,* no. 25; upper left, a lino cut.

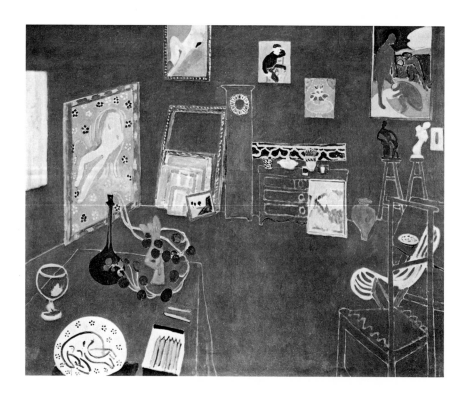

Fig. 19. *L'Atelier rouge*, 1911. Oil on canvas; 180 x 220 cm. (71¼ x 86¼ in.). Collection, The Museum of Modern Art, New York, Mrs. Simon Guggenheim Fund.

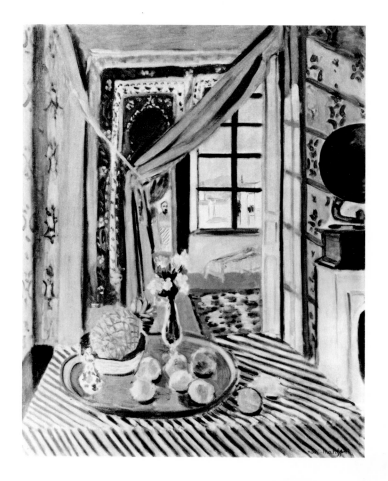

Fig. 20. *Intérieur à Nice (Intérieur au phonograph)*, 1924. Oil on canvas; 100.5 x 80 cm. (39½ x 31½ in.). Private Collection.

while still in progress—as if, having begun to feel a certain dissatisfaction with his usual method, he were trying to diagnose its component parts.[4]

One of Matisse's major preoccupations at this time was the dichotomy between design and color—between drawing and painting.[5] This is a matter of particular significance, since the tension between drawing and painting—the simultaneous affirmation and denial of three-dimensional space through dynamic interaction of line and color—was a key element in the structure of Matisse's paintings during the great period from 1904 to 1917, and continued to be so through the so-called Nice period, 1917 to 1929. In the paintings executed during this quarter of a century, the process by which the image is realized—usually in terms of a running dialogue between drawing and color—and the pentimento effects which reveal this process, are important aspects of the final image; the visible traces of constant redrawing and repainting constitute a record of the artist's struggle to balance his perceptions and his ideas, and give his picture-space a weight, density, and amplitude akin to that achieved by Cézanne. Like Cézanne, Matisse rarely tries to invent what he has not actually seen with his own eyes; he invents instead a painted space that expresses an equivalence of his vision. The crucial point of realization lies in the balance between what is seen and what is felt, between the urgency of direct experience and the complexity of one's reactions to such experience. Thus, with the notable exception of a few decorative compositions (such as *La Danse* and *La Musique* of 1909-10; Leningrad, State Hermitage Museum),[6] the picture-space of his paintings is presented in terms of a fairly specific physical viewpoint—as *seen* by the artist and *witnessed* by the viewer.

An important aspect of this kind of imagery, based on the rendering of complex motifs seen from a single viewpoint, is the evocation of complex temporal rhythms. In paintings like *L'Atelier rouge* (fig. 19), *Intérieur aux aubergines* of 1911 (Grenoble, Musée des Beaux-Arts), or *La Leçon de piano* of 1916 (New York, MOMA), we are made constantly aware of the contrast between the past, the present, and the immediate future of the space described. In part, this is achieved by the frequent presence in the picture-space of representations of other framed spaces—windows, mirrors, and paintings-within-the-painting—which evoke other frameworks of occurrence: windows into other worlds, mirror images charged with the energy of immanent movement, earlier paint-

ings by Matisse which evoke other moments in the history of his own vision. Even more significantly, temporal metaphors are often suggested by the different states of being embodied in the painted surface itself. The combination of varied brushstrokes, raw canvas, and opaque and transparent forms, and the contrast between relatively broad, still areas of color and the dynamic linearity of plant forms and arabesques, evoke, in an almost Bergsonian fashion, the formative history (or "duration") of the space described. Simple subjects, such as interiors, still lifes, portraits, and nudes take on resonant symbolic overtones; yet the symbolism is always indirect, and understated. The viewer seems to share, rather than merely observe, the sensibility of the artist's vision.

This sort of imagery was very much grounded in Matisse's technical procedure. The flexibility of the oil paint medium provided an excellent means for the constant modification and restatement of the way form *occurs* within a space; objects are presented within the sometimes ambiguous context of their amplitude; meaning (one almost hesitates to apply the word to such unliterary images) is inextricably bound to the language of form itself. The paintings of the Nice period, so often and so wrongly viewed as evidence of a slack moment in Matisse's development, are particularly rich in this respect (fig. 20). In them, Matisse explored the uncertain nature of the luminous world, the tension between how we see and how we react to what we see, the balance between the literal and the metaphorical significations of vision itself.

Matisse's movement away from easel painting during the 1930s is indicative of an important change in his notion of what pictorial space may signify. The pen and ink drawings of the period stress spontaneity and barely-arrested motion—moments of actuality that could be endlessly varied (fig. 21); yet the paintings of this period are often laboriously distilled, and suggest a sense of timeless stasis. When in 1936 Matisse spoke of a return to the bold color of Fauvism—a return to "the purity of the means"[7]—he was no longer thinking in terms of Fauve space, in which the violent, often unpredictable, interaction of color and drawing was of paramount importance, but of a flatter, more static, conception in which color and drawing are set against each other in measured counterpoint. The most important paintings of this period, such as *Nu rose*, 1935 (Baltimore Museum of Art), or *Grande Robe bleue, fond noir* (fig. 22), are

39

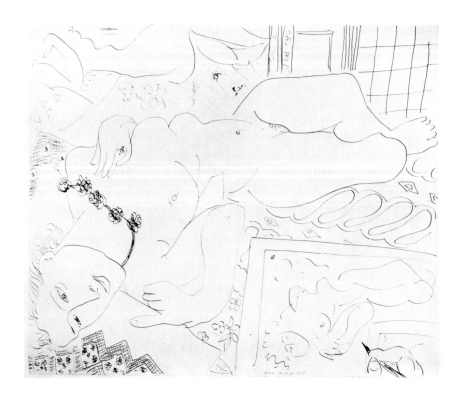

Fig. 21. *Nu dans l'atelier,* 1935. Pen and black ink; 45.1 x 56.8 cm. (17¾ x 22⅜ in.). Mr. and Mrs. Nathan Halpern Collection, New York.

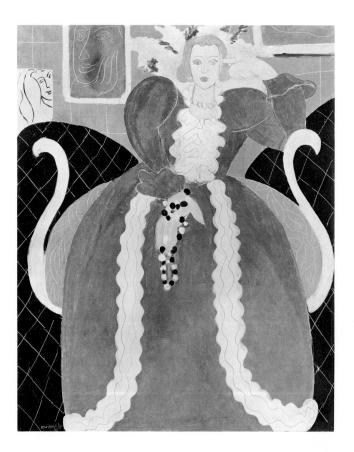

Fig. 22. *Grande Robe bleue, fond noir,* 1937. Oil on canvas; 92 x 73 cm. (36¼ x 28¾ in.). Mrs. John Wintersteen Collection, Philadelphia.

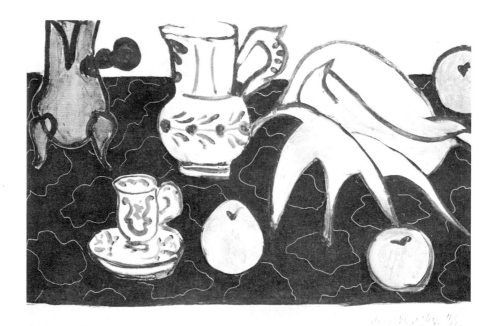

Fig. 23. *Nature morte au coquillage,* 1940. Oil on canvas; 55 x 81 cm. (21¼ x 31⅞ in.). Moscow, State Pushkin Museum.

eloquent evidence of this change; they are extraordinarily flat, still images; drawing is limited to the definition of contour and pattern, and the viewer's physical relationship to the image is unusually nonspecific. Although still working from life, Matisse is already moving toward the kind of imagery that will characterize the early cut-outs, moving from the description of objects in their surrounding space to the evocation of objects by signs; from a modeled space to a suggested space; from images based on what is directly seen and felt, to images based on what is recollected and thought: from the individual to the typical. Spontaneity *or* density, movement *or* arrest from movement—this is the new formulation that seems to underlie the conflict between drawing and color in the late 1930s. It is precisely Matisse's awareness of the different temporal implications of his imagery —the distilled, archetypal quality of the paintings, on the one hand, and the extraordinary spontaneity of the drawings, on the other—that allows him in 1941 to speak of his drawings as "the cinema of my sensibility."[8]

The medium of oil paint was an important factor in the conflict Matisse felt between painting and drawing. Because of the "painterly" manner in which he habitually employed it, the medium emphasized, rather than reduced, the need to combine spontaneity and density in a single image. In December 1940, shortly after he finished *Nature morte au coquillage* (fig. 23), a work which, significantly, he would later render in cut paper (no. 11), Matisse wrote to the Romanian painter Théodore Pallady:

I believe I have gone as far as I can in this abstract direction—by means of meditations, of reverberations on different vertical planes, of stripping down At present I cannot go further, and I cannot even—it is out of the question—repeat myself. Thus I am obliged to remain in a less uncommon, less spiritual conception—and I am brought closer to the physical substance of things. So I painted oysters [Nature morte aux huitres, Basel, Kunstmuseum; Roses de Noël et huitres, Paris, P. Petridès Collection]. *For that my friend you need to use your taste sensations. An oyster when represented must remain a bit what it is, a bit in the Dutch manner I have kept myself bridled; that required a great effort and I finally managed to find some natural properties that I should have bridled a long time ago, the savor of savorous painting which I think will interest you. I don't know what will follow; I'm not sure what I just did is worth, for the child has just been birthed. But I am certain that these paintings however bright in color could not be rendered except in oil paint, whereas for a long time I have*

41

been interested only in lines and colors and the medium was unimportant, watercolor, gouache; it was only a matter of the expressive marriage of differently colored and proportioned surfaces. I believe that this is a conclusion. I should like to live long enough to return to my previous conception and see what my new work can add to it.[9]

As it turned out, certain extra-artistic factors were to play a role in the final move to the cut-out medium that would resolve (if not completely solve) this conflict between substance and spirit. In January 1941, Matisse underwent an operation which, with its ensuing complications, almost took his life, and which had a profound psychological effect upon him.[10] Seriously weakened and frequently bedridden during the next two years, he by necessity turned to projects that were physically less demanding than oil painting: drawings and book illustrations. Yet his involvement with these media cannot be attributed only to his physical infirmity; his involvement with poetry and the graphic arts is intimately related to interests that had engaged his attention throughout the 1930s: his interest in narrative images, and in images based on memory.

First by their small physical size, and later by their physical grandeur, these images were to give a new impetus to Matisse's move away from easel painting. The cut-out technique used for their execution would also provide a new resolution of what Matisse had called "this eternal conflict of drawing and color."[11]

II

The importance of an artist is to be measured by the number of new signs he has introduced into the language of art ... It was absolutely necessary that I prepare, by the search for signs, for a new development in my life as a painter ... Perhaps after all I believe, without being aware of it, in a second life ... some paradise where I shall paint frescoes ... (Matisse to Aragon, 1943)[12]

The new medium of cut and pasted paper allowed Matisse to resolve the problem of simultaneous drawing and color in a new way: by virtually eliminating the painting process.

With the cut-out technique, the artist no longer applies color to a surface, but shapes color which will then be applied to a surface. (According to Matisse's assistant, Matisse almost never colored the paper himself.) Color pre-exists as an abstract entity, unshaped and as yet uncommitted to a particular place within the image. "Cutting straight into color reminds me of the direct carving of the sculptor," Matisse wrote in *Jazz*. He also referred to the process as *drawing with scissors*, "one movement linking line with color, contour with surface."[13]

Analogies with both sculpture and drawing, however, can be somewhat misleading. For although Matisse may indeed be said to have sculpted or drawn with scissors, the act of cutting comprised only part of the total procedure. The artist had still to set his forms within a context. This *delay* between the shaping of the form and the placement of the form within the picture is an important one; it introduces an element of procedural discontinuity that is retained in the images themselves.

We have seen how Matisse used cut paper and in-progress photographs as diagnostic devices for his paintings in the 1930s; in the fully developed cut-out technique, the opportunity for diagnosis and quick revision is built right into the medium. A form is invented (not depicted) and put whole into the picture; sometimes it works, sometimes it does not; if it does not, it can be lifted and placed somewhere else. The process of invention is spontaneous and improvisational—as in jazz.

The cut-out technique, by introducing decorative, all-over imagery, also projects a new sense of time: everything happens at once. The spontaneous feeling and new narrative subject matter of the images removes them from the context of actual experience that is at least partially subject to the temporal rhythms of the natural world. Form—all form, space itself—is translated into a kind of sign language, which is similar, in its abstractness, to written language. The implications of this new kind of figuration are manifold.

Every time a shape is cut in paper, another shape, a negative image of the first, is also cut. This is an aspect of the medium that Matisse exploited right from the beginning in *Jazz*: the yellow curtain in *Le Clown*, no. 16, and the red and white entrance in *Le Cirque*, no. 18, are created simply by separating and setting askew adjacent parts of the same sheet of cut paper; the two torsos in *Formes*, no. 25, are negative and (slightly-modified) positive shapes cut from the same blue; many of the plant forms in the three *Lagon* compositions, nos. 33-35, are made from different pieces of the same cut paper; and several of the forms in *Le Clown, Le Toboggan,* and *Monsieur Loyal,* nos. 16-17, 19, are made of pieces saved from earlier cuttings. The artist is thus able to create something like a repertory of forms, which can be rearranged, interchanged, and even stored away for future use. The forms therefore function as signs not only in the connotative, but in the syntactical, sense: the

artist can save, reuse, and rearrange specific forms the way a poet reuses and recombines previously discarded words, phrases, or images.

The "sign" aspect of the individual forms cut for *Jazz* extends to the total images as well. Unlike the imagery of most of Matisse's earlier paintings and drawings (the book illustrations are a significant exception), the *Jazz* pictures do not imply the specific physical position of the viewer in relation to the space of the image. The imagery occurs, like that of poetry, "in the mind."

In addition to poetry and book illustration, another kind of imagery must be mentioned here—that of mural compositions. The subject matter and the nonspecific, imagined space of the *Jazz* pictures, in fact, are much closer to Matisse's earlier murals (*La Danse* and *La Musique* of 1909-10, the Barnes murals of 1931-33) than to his easel paintings. At the same time that he invented a way to create graphic works in color, Matisse also opened the way for the large mural compositions of the later cut-outs. What the small book illustrations and the large murals have in common is the nonspecificity of their physical space. Their scale is to a large degree psychological, disembodied.

In a very important sense, the *Jazz* pictures are a transition between the imagery of Matisse's easel paintings and that of the late cut-outs. As in the paintings, most of the *Jazz* pictures are composed in terms of highly saturated color, with little clear distinction between figure and ground. The space of most of the *Jazz* pictures is denser, more tense, and more complex than that of the later cut-outs—largely because it *is* still conceived in chromatic terms.

Later, developing a format already present in the three *Lagon* compositions, and in *Le Lanceur de couteaux*, no. 31, Matisse will use a white ground on which to set his repetitive forms; the figure-ground relationships will become simpler and clearer, and the white ground will function somewhat like the white ground in a drawing—as a neutral, refulgent surface that unifies disparate signs.

Finally, the play of the color plates against the black and white text of *Jazz* (written, as if drawn, with a brush) also anticipates the imagery of the chapel at Vence, where the black and white tile compositions—like the *Jazz* text—provide a graphic (and narrative) contrast to the luminous near-abstract color of the windows.

The images of *Jazz*, then, are a transition from the "old" to the "new" Matisse. The book *Jazz* appears to have been something like a public announcement of this change.

III

My terrible operation . . . has completely rejuvenated and made a philosopher of me I had so completely prepared for my exit from life, that it seems to me that I am in a second life. (Matisse to Marquet, 1942)[14]

What I did before this illness, before this operation, always has the feeling of too much effort; before this, I always lived with my belt tightened. What I created afterwards represents me myself: free and detached. (Matisse to Jedlicka, 1952)[15]

The text for *Jazz* was written in the summer of 1946, some two years after Matisse had finished the pictures, and, significantly, while he was already at work on the first mural-scale cut-outs (nos. 55-56). If the pictures for *Jazz* were started in a somewhat tentative and experimental spirit, the text coincides with the beginning of Matisse's extended cut-out production, and acts as a bridge between his past and his projected future.

In the introduction to *Jazz*, Matisse says that the written pages are meant to "serve only as an accompaniment to my colors THEIR ROLE IS THUS PURELY VISUAL." But even a casual perusal of the book makes it clear that this is not so.[16] The text in fact "illustrates" the pictures—much as the pictures in a normal illustrated book are done after, and illustrate, the written text. And as in any well-illustrated book, the text and pictures of *Jazz* enrich and illuminate each others' meaning. The statement that the writing is unimportant is merely a device that gives Matisse, whose earlier writings are cautious and expository, the freedom to ramble and to speak in metaphors.

The text of *Jazz* is built around one of the cornerstones of Matisse's artistic belief: that the artist must always strive for fresh perceptions of nature and approach each new picture with a completely free mind, eye, and hand; that the act of creation results from the synthesis of instinct and intellect, guided by discipline.[17] But the emphasis in *Jazz* has changed; the emphasis is on liberation from one's own past habits, on freedom from one's own past accomplishments.

In the opening section, *Le Bouquet*, Matisse speaks of gathering flowers in a garden, with the idea of arranging them in a bouquet and painting them. But after he has brought them inside and arranged them, he is disappointed:

all their charm is lost in this arrangement. What has happened? The unconscious grouping made as I gath-

ered the flowers has been replaced by a conscious arrangement, the result of remembered bouquets long since dead, which have left in my memory a bygone charm with which I have burdened this new bouquet.

Renoir told me: "When I have arranged a bouquet in order to paint it, I go around to the side that I have not looked at."

The other sections of *Jazz* also elaborate upon this theme of liberation from the habitual and the expected, with an emphasis on discipline and technical accomplishment:

In art, truth and reality begin when you no longer understand anything you do or know, and there remains in you an energy, that much stronger for being balanced by opposition, compressed, condensed.... You clearly must have all your accomplishments behind you, and have known how to keep your Instinct fresh.

In several other sections of *Jazz*, Matisse, in a somewhat pedagogical tone,[18] discusses such matters as the training of the hand to obey the artist, the imposition of the vertical as a norm, and the careful study of different aspects of nature—in short, the mental disciplines which, as a painter, he had imposed upon himself, and by which his instincts were paradoxically heightened by being held in check: the understanding of nature that he considers indispensable to the creation of abstract form, the balance and opposition that he feels necessary to the production of significant art.

The text of *Jazz,* then, is a testament of a very particular sort. In it, Matisse does not propound a specific theory of new art, but offers *himself* as an example to the young of what the artist should do and be. In this sense, the *Jazz* text is a credo which serves as a manifesto. It is also an artistic autobiography.

The succeeding sections of *Jazz* are a condensed, metaphorical account of the artist's own progress from sensation to perception to idea. They also specifically allude to important landmarks in his personal and artistic development: his law training; his study of nature and the necessary balance between experience and imagination; his early technical procedure; his meeting with the aged Renoir; his trip to Tahiti; the discovery of the new technique of drawing with scissors; his faith in constant renewal; the importance to him of metaphysical love; the necessity for the artist to work without rancor, even when he has not been successful; and, finally, the neces-

sity for the artist not to be seduced by success when it finally comes.[19] "An artist must never be a prisoner of himself, prisoner of a style, prisoner of a reputation, prisoner of success," the seventy-six-year-old Matisse writes, with a certain note of triumph, in one of the closing sections of *Jazz*. Five years later a critic would remark, "Never has Matisse seemed to me so young."[20]

Obliqueness and indirection are one of the hallmarks of Matisse's art. Throughout his career, images and symbols of himself are hidden in his pictures; his face is seen framed in mirrors or drawings, or his presence is suggested by his works or his violin. His is an art almost obsessively concerned with "attitudes and poses"[21]—full of allusions to the theme of art and artifice that also constitutes the dominant theme of *Jazz*.

Formally, this theme is expressed in the evident delight that Matisse takes in the economy of means with which he evokes the various images. The abbreviated signs are full of witty double entendres and visual puns: the yellow circles that suggest the costume of the DeGaulle-like *Monsieur Loyal*; the positive-negative images of the torsos in *Formes*; the centaur image of the cowboy and his horse, no. 30; the throwing-knife shape of the knife thrower; and the disquieting double-profile face of Destiny, no. 32. In a sense, the sign language of the *Jazz* images is a commentary on image-making itself. The reading of the forms, with their overtones, metamorphoses, and transferred qualities, is one of the principal delights of the pictures. The complex system of condensed, multivalent images—similar in ways to the imagery of Symbolist poetry—will be one of the main expressive features of the later cut-outs.[22]

Thematically, many of the *Jazz* images are metaphors for two related motifs that have a long history in Matisse's art: the artist, and the artist and model. Each of these motifs is expressed within a distinctive compositional format: the isolated figure, a metaphor for the artist; and the "active-passive" double-figure composition, a metaphor for the artist and his model. The *Jazz* pictures are full of "artists": the clown in *Le Clown*, no. 16; the trapeze artist (or high-wire walker) in *Le Cirque*, no. 18; the performing elephant in *Le Cauchemar de l'éléphant blanc*, no. 20; the red-hearted Icarus in *Icare*, no. 24; the red-hearted Pierrot in *L'Enterrement de Pierrot*, no. 26; the trapeze artist in *Les Codomas*, no. 27; and the sword swallower in *L'Avaleur de sabres*,

no. 29—each of these performers represents a different aspect of "l'artiste." (Matisse on several occasions had compared his role as artist to that of a juggler, an acrobat, and a tightrope walker.)[23] The relationship between artist and model is suggested by the red-faced observer watching the swimmer in *La Nageuse*, no. 28;[24] by the cowboy lassoing a woman in *Le Cow-Boy*, no. 30; and by the knife thrower and the woman in *Le Lanceur de couteaux*, no. 31. These wide-ranging, sometimes ominous, sometimes antic, variations on the themes of artist and artist and model relate in turn to the varied, but complementary, roles of the artist discussed in the *Jazz* text.[25]

Images of the circus, the music hall, folklore, travel: the subject matter of the *Jazz* plates is as new to Matisse's art as the technique of cut and pasted paper, the imaginative reformulation as important as the formal one. Instead of painting what he sees before him, the aging artist calls forth images from his mind. Recollections. Objects and situations removed not only in space, but in time. Experience has been replaced by memory, vision by imagination. The time of the clock has been replaced by narrative time, fictional time, mythical time.

As he begins to move toward his most abstract imagery, Matisse, working in the shadow of his own death, seems to be making a concrete statement of rebirth and liberation—as if, after having been more or less relegated to "old master" status, he had come once again to identify himself with the avant-garde.

The septuagenarian Matisse's re-identification with the avant-garde seems to be intimately associated with a certain nostalgia,[26] and also with a veritable treasure trove of images of art and artifice: the circus and theater. From the beginning, the imagery of *Jazz* had roots in Matisse's experience with the theater. The figure of the clown in *Le Clown* is clearly based upon the male costume designs for *Rouge et Noir*, nos. 4-8, and the subject of at least one of the *Jazz* plates, *Le Destin*, seems to be based on the program of that ballet.[27] Even more significantly, some of the tenor, and even the title, of *Jazz* (which was originally to have been entitled *Le Cirque*)[28] seems to refer to another theater piece: Erik Satie's *Parade* of 1917.[29]

Parade and *Jazz* have much in common. Both are composed of somewhat cacophonous vignettes, seemingly unrelated, but part of a subtly unified totality.

Parade was modeled after the literal Larousse definition of the French word "parade": "a comic act, put on at the entrance of a travelling theater to attract a crowd"; and Satie's collaborator, Jean Cocteau, noted that it was to be "a rough simple action which combines the charms of the circus and the music hall."[30] The first *Jazz* plate represents the *parade* of a circus, and *Jazz* also combines scenes from the circus and the music hall. Both *Parade* and *Jazz* were war-time productions, and reflect a certain "exhilaration in the absurd."[31] Even more important, *Parade* included the first concert treatment of American jazz in French music,[32] a feature that likely associated it in Matisse's mind with jazz.[33]

There are also striking parallels between the imagery of *Jazz* and the decor and costumes that Picasso designed for the first performance of *Parade*.[34] The *Parade* designs provide a precedent for the flat, angular planes of Matisse's later *Jazz* imagery, and several of the *Parade* costumes, especially those for the Acrobat, the Chinese Magician, the American and French Managers, and even the horse, appear to be prototypes for the personages in *Jazz*.

During the first World War, Matisse and Satie had been in fairly close contact with each other, and in 1916 Matisse and Picasso had sponsored a Granados-Satie concert.[35] Matisse is known to have attended the first performance of *Parade*, one of the great theater events—and scandals—of the epoch, on May 18, 1917.[36]

The year 1917 marked the climax of what was perhaps the most innovative period of Matisse's mature art. In 1943, having recently come very close to death, and with a new war raging in Europe, Matisse had again moved to a position which, despite his age, could be called avant-garde. It seems that when Matisse toward the end of his life gathered his energies for a new foray into the uncharted, the example of jazz music fused in his mind with his memories of *Parade*, the music hall, the circus, and the excitement of the vital Parisian ambiance in which he had participated some twenty-five years earlier.

Jazz may thus be seen as both a summing up and an anticipation: Matisse's synthesis of his past and his projected future. A daring combination of testament, theater, and manifesto, full of subtlety and fraught with innuendo, at once brash and gay and tragic (Satie had said of jazz that "it shouts its sorrows"), *Jazz* is perhaps the closest thing to an autobiography that Matisse has left us.

Notes

1. For details on the history of the book, see introductory remarks nos. 16-35.

2. As cited in Fourcade 1976, p. 94.

3. Matisse undertook several book-illustration projects shortly before he did *Jazz* (see Barr 1951, pp. 270-275), as well as nonpainting commissions and drawings (*ibid.*, pp. 224-246, 249-254).

4. See especially the in-progress photographs of the Barnes murals (Diehl 1954, pl. 103; see Precursor B), the twenty-one in-progress photographs of *Nu rose*, 1935 (Russell 1969, pp. 134-35; see Precursor C), the ten different stages of *Grande Robe bleue, fond noir,* 1937 (*Magazine of Art,* July 1939), and the numerous stages of *La Blouse roumaine,* 1939-40 (Aragon 1971, I, pp. 18-21). "At each stage I reach a balance, a conclusion," Matisse told Tériade in 1936. "If I find a weakness in the whole, I find my way back into the picture by means of the weakness—I re-enter through the breach—and reconceive the whole" (Matisse 1972, p. 129; tr. Flam 1973, p. 74).

5. "My drawing and my painting are coming apart," Matisse wrote to Pierre Bonnard in January 1940, "...a drawing by a colorist is not a painting. He must produce an equivalent in color. It is this that I do not achieve" (Matisse 1972, pp. 182-183; tr. Flam 1973, p. 168, n. 33). See also Matisse's numerous other letters on this subject in Matisse 1972, pp. 182-194.

6. The relationship between the late cut-outs and the decorative compositions of 1905-10 (*Le Bonheur de vivre,* 1905-06, Merion, Pa. Barnes Foundation; *Les Joueurs de boules,* Leningrad, State Hermitage Museum, and *Baigneuses à la tortue,* 1908, The St. Louis Art Museum, and related works) would constitute the subject of another study, as would the relationship between the cut-outs and such works as *Les Morocains,* 1916 (New York, MOMA), and *Baigneuses à la rivière,* 1910-1916/17 (The Art Institute of Chicago), which are composed in terms of a similarly ideational space. In 1910, and again around 1916/17, Matisse brought "imagined" subjects and abstract space to a high state of development; in each case, he chose not to follow up fully the implications of such imagery, but returned to painting from life. A similar, but less intensive development may be seen in his works of the 1930s, which eventually led to the imagined, abstract space of the cut-outs.

7. Tériade (see note 4 above).

8. Carco, "Conversation avec Matisse," tr. Flam 1973, p. 84. Matisse's comments on the serial images of the *Thèmes et variations* drawings here referred to (see Aragon 1943), provide an interesting contrast with his remarks in "Notes d'un peintre," 1908, concerning the importance of suggesting duration in a single image which will "give to reality a more lasting interpretation." Matisse's interest in time and duration at this period is reflected in his renewed interest in Bergson (see Escholier 1956, pp. 232-233). Cf. Bergson's remarks on the cinematographical mechanisms of the intellect, and on the creation of signs, in *L'Evolution Créatice,* Paris, 1907.

9. Letter of December 7, 1940 (Matisse 1972, pp. 186-187). Pallady and Matisse had known each other since their student days at Gustave Moreau's studio.

10. For an excellent selection of letters by Matisse, written before, during, and after his illness, see Matisse 1972, pp. 277-299.

11. Matisse to André Rouveyre, October 6, 1941, in Matisse 1972, p. 182.

12. Matisse 1943, pp. 26-27; reprinted in Aragon 1971, I, pp. 111-112.

13. Verdet 1952, tr. Flam 1973, p. 147. The concepts of drawing and carving with scissors are both expressed in the *Jazz* text, "*Dessiner avec des ciseaux.*"

14. Letter of January 16, 1942, in Matisse 1972, p. 288.

15. As cited in Fourcade 1976, p. 114.

16. The complex allusions and symbolism of the *Jazz* text can be mentioned only in passing here. See note 19 and remarks nos. 16-35. The complete *Jazz* text is given in Matisse 1972, pp. 235-239, and tr. in Flam 1973, pp. 110-113.

17. See, for example, "Notes d'un peintre," 1908, and "Notes d'un peintre sur son dessin," 1939 (Matisse 1972, pp. 40-53, 159-163; tr. Flam 1973, pp. 32-39, 80-82).

18. Matisse's writings at this time were often pedagogical and explicitly addressed to young artists. Cf. the well-known letter to Henry Clifford, in Philadelphia 1948, pp. 15-16 (Flam 1973, pp. 120-121).

19. The mixture of personal and artistic events is typical of Matisse, whose "life" was his art. Matisse's recounting, in the *Jazz* text, of having copied La Fontaine's fables into his law briefs is a wry allusion to the "artifice" of the *Jazz* text itself. His mention of his visit to the ill and aged Renoir is especially poignant at this stage of Matisse's own career. See Dominique Fourcade's excellent discussion of Matisse's visits to Renoir in Fourcade 1976, pp. 101-106.

20. Barr 1951, p. 12.

21. New York 1966, p. 20.

22. See for example *Boxeur nègre,* no. 73, and *La Cloche,* no. 156. The Surrealist overtones of many of these images, and their relationship to Joan Mirò, should be noted. (For a telling comment by Matisse with regard to Mirò, see Aragon 1971, I, p. 147).

23. See remarks no. 27.

24. The association of the artist with the color red is fascinating (see nos. 23-24, 28); it goes back at least as far as the mirror reflection of the red-shirted Matisse in *Carmelina,* 1903 (Boston, Museum of Fine Arts).

25. The artist and model theme, here as in the paintings, also alludes to the theme of male-female. While working on *Jazz,* Matisse is said to have referred to the book as "un livre d'enfant"; the theme of such plates as *Le Coeur,* no. 23, and

Le Destin, no. 32, seen in light of the circumstances of their composition, and in conjunction with the extensive *Jazz* text on love, suggests that *Jazz* is in a certain sense also "un livre d'amour."

26. Matisse's nostalgia at this time is also reflected in the 1943 posthumous portrait head that he did of his friend and early champion, the poet Guillaume Apollinaire, who died in 1918.

27. See remarks no. 7.

28. As late as the spring of 1944, *Le Cirque* seems to have been the preferred title for the book (see Diehl 1944, and introduction to *Jazz* catalogue entries, nos. 16-35). The *Jazz* plate *Le Cirque*, no. 18, appears to have been done originally as the cover for the subsequently retitled book.

29. Satie wrote the music for *Parade*; the scenario was done by Jean Cocteau and the costumes and decor were designed by Pablo Picasso. *Parade* was choreographed by Léonide Massine and produced by Serge Diaghilev, with whom Matisse would later collaborate on *Le Chant du rossignol*, 1919-20 (see Precursor A). The program notes for *Parade*, in which the word "sur-réalisme" is used for the first time, were written by Guillaume Apollinaire (see New York 1968, p. 192 n. 67).

30. Shattuck 1969, p. 155.

31. *Ibid.*

32. *Ibid.*

33. The association between jazz music, the avant-garde, and artistic freedom was not uncommon among European artists at the time (cf. Piet Mondrian, "Le jazz et le néo-plasticisme," *macula*, 1, 1976, pp. 82, 86). Matisse was quite fond of American jazz, especially, it seems, of Sidney Bechet, a black American soprano saxophonist and clarinetist popular in Paris.

34. See Cooper 1967, pls. 78, 83-87, 89, 99-100. Other Picassian influences in *Jazz* are noted in the *Jazz* catalogue entries, below.

35. Shattuck 1969, p. 151.

36. Mme. Marguerite Duthuit (in conversation with the author, Paris, December 21, 1972). In a generally despairing letter (see Cooper 1967, p. 342) to Cocteau in August 1917, Satie, who was still involved in legal battles resulting from the *Parade* scandal (and who had been deserted by many of his friends), wrote, "If you see Matisse give him my very best and tell him how much I love him" ("dites lui mille choses de ma part et combien je l'aime"). Matisse, clearly, had not deserted him.

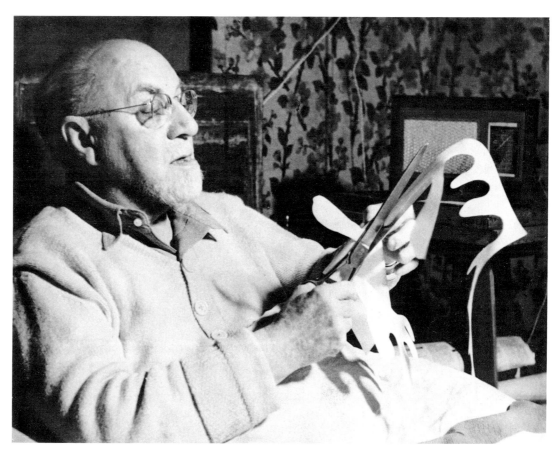

Fig. 24. Henri Matisse at his villa, Le Rêve, Vence, 1946/47.

Fig. 25. Matisse studio, Boulevard Montparnasse, Paris, c. 1946. On wall: left, *Océanie, le ciel*, no. 55, early state; right, *Océanie, la mer*, no. 56. Note the five cut-outs over the door which were instrumental in completing the environmental effect.

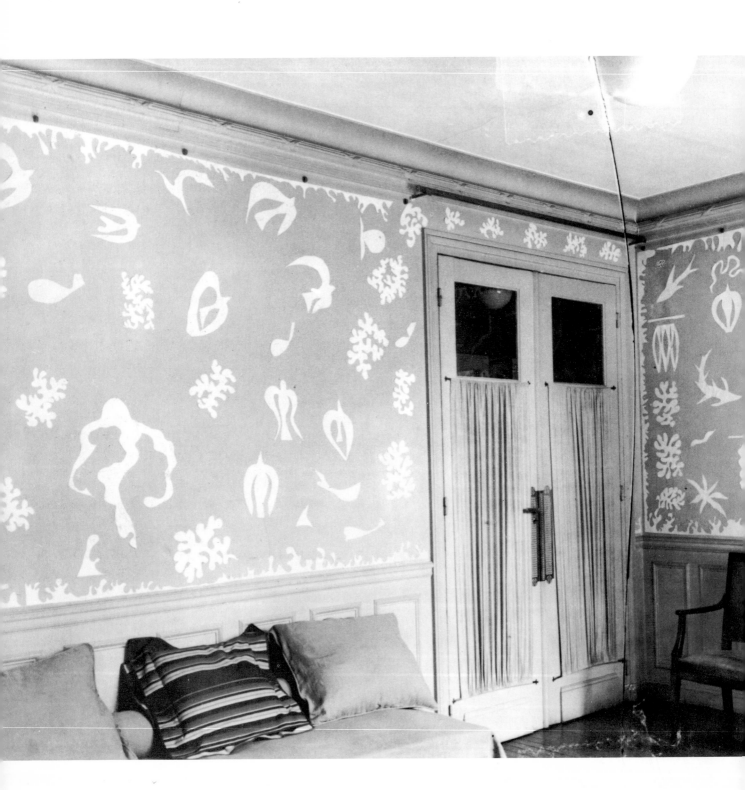

Something Else

BY DOMINIQUE FOURCADE

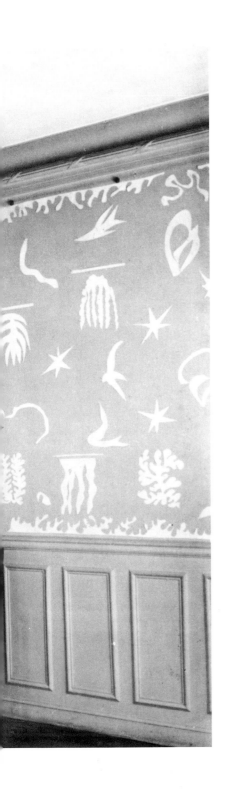

"*Drawing with scissors*. Cutting straight into color reminds me of the direct carving of the sculptor." These two statements, today so well known, were published in 1947 in *Jazz*—at a time when Matisse had for ten years been using scissors to cut forms out of pre-colored sheets of paper. "I arrived at the cut-outs in order to link drawing and color in a single movement,"[1] he wrote later. And we cannot but be somewhat surprised: Matisse speaks as if he had not, well before his cut-outs, achieved precisely what he had also achieved with his cut-outs. Whereas in fact, in whatever medium he worked, and well before the cut-outs, Matisse, in a revolutionary way, had treated space as color bounded by drawing; and had treated (also in a revolutionary way) every form as a mass of a color (or colors). I should thus like to stress the fact that Henri Matisse's cut-outs are not the mode in which his drawing and color are most effectively linked; they are not, in this respect, the best part of his oeuvre. Nor, despite the artist's specific intentions (or perhaps, as we shall see, because of them), are his cut-outs the work in which drawing was achieved by color in the most effective way! Yet it is only fair to say that in the cut-outs Matisse was trying his hand at something he had never done before. Something else. A new approach to art, which he did not refer to as such; a new departure, so radically modern, that it effectively cut him off from his own past as well as from the past of painting. At the threshold of a retrospective show of these cut-outs, I should like to point out the nature of their extremism.

The drawing-color conflict, if indeed it ever truly existed, was one that Matisse was born to resolve—or, even better, to nullify. There is no need here to examine his entire oeuvre in the light of that conflict; the essential points are obvious. In his Collioure canvases, painted in 1905 and 1906, in those Fauve landscapes and still-lifes which altered our way of seeing things, Matisse did not first draw the outline and then put the color between the

lines of the form that had previously been drawn. It was the actual painting of the color that gave any form its form; it was the placing of the color that constructed the space. *Les Joueurs de boule* (Leningrad, State Hermitage Museum), *Baigneuses à la tortue* of 1908 (The St. Louis Art Museum), or even *La Danse* and, most especially, *La Musique* of 1910 (Leningrad, The Hermitage) cannot be looked at in any way other than as the product of "the direct carving of the sculptor."

From 1911 to 1917 Matisse's canvases were so many attempts (strictly speaking, so many thrusts) at creating space through color and *as* color—one general color or a juxtaposition of colors, the number of which, significantly, was gradually to decrease. These canvases introduced space as color, as fields and areas of colors, rather than as colored forms. *Une Vue de Notre-Dame*, 1914 (New York, MOMA), with its large blue breathing surface, is already an example of what Clement Greenberg has called "area drawing."[2] But though Matisse's paintings at the time were fiercely experimental, they did not seem so. The canvases of those giddy years are definitely nonproblematical. They are the product of intense research, of a break in the existing state of things, and, at the same time, the most hoped-for painting imaginable. At the core of what was newest in their novelty, those paintings fulfilled an expectation and took their natural place within ourselves—one that, till then, had been empty. No doubt because they had taken into account the entire history of painting and all the conventions involved in that history, and because none of those conventions was relinquished prematurely. When Matisse gave up a solution which he was the very first to give up, he did so with such sensitive reticence that the viewer perceives his reasons and shares in the experience. From Manet to Cézanne, everything that had preceded those canvases of 1911-17 called for their creation (yet did not for all that, anticipate them). Matisse, it must be reiterated, was then the most constantly viable of painters, at the very time he was being the most innovative. This is a point that must be stressed, for that balance may well have been upset at the time of the cut-outs.

Also of the utmost importance to Matisse's drawing in color is his work in black and white. Consider then—from the viewpoint of an artist wielding a pair of scissors—the prodigious series of pen drawings of 1935-37: in them, Matisse clearly cuts into color—nothing more, and nothing less. The black stroke moves into the white of the paper and generates a polychromy as the pen moves forward, in the very act of drawing. Black and white. The stroke organizes various surfaces, and thus determines relationships; and the play of relationships among the various flat surfaces is enough to produce color. In Matisse's words: "What counts most with color is relationships. Thanks to them, and to them alone, a drawing may be vividly colored without there being any need for actual colors."[3]

Matisse pursued and systematized this adventure in 1941, with the pencil drawings of *Thèmes et variations*. And the adventure took on a new face—though still black and white—with the brush-and-ink drawings of 1948 (the series that culminated in *Nu debout et fougère noire* (Paris, MNAM), executed concurrently with the cut-outs. Matisse emphasized "the special quality of brush drawing, which, through a restricted medium, has all the qualities of a painting or a painted mural. The quality of the white derives from the black. It is always color that is put into play, even when the drawing consists of merely one continuous stroke. Black brush-drawings contain, in small, the same elements as colored paintings—that is to say, differentiations in the quality of the surfaces unified by light."[4] In 1951 and 1952 Matisse made large drawings of trees (brush, black ink, and white gouache) in preparation for the ceramic piece he was doing for Tériade. Those drawings—and, most especially, the resulting ceramic piece—played in turn an essential part in his study of cut-out color.

Clearly, then, Matisse had worked at drawing in color in all sorts of ways; but in his cut-outs, he did it more deliberately and more radically than anywhere else. There is no longer any material intermediary, and (it is one of the distinctive characteristics of the cut-outs), in this case Matisse leaves the painting to others! He leaves the painting of the sheets of paper to his assistants, so that he confronts a world that is already painted. He confronts the world as if it were made of paint; he carves into the world *as* paint. He is alone with large sheets of color and a pair of scissors.

The physical, as well as the mental, novelty of that decision must be appraised. The world had no longer to be painted: it *was* painted. And it was touchable; indeed, it had to be handled; those sheets of gouache-covered paper had to be held in one's hands.

In the cutting phase, time was no longer an intermediary either (yet another characteristic of the cut-outs): painting takes time; it involves a lot of equipment, and it imposes a distance. In this case, the thing itself was already executed. All that was left for the artist to do was to cut, and that could be done in a flash. One

has to see[5] how Matisse's scissors fly, how they run through the sheets of gouache-covered paper: the scissors cut almost without working; even to say that they were cutting sounds wrong. They glide into the color like someone doing a sidestroke in a calm sea, without a wave, without foam. Matisse never really cuts by working the scissor blades except to carve through a sharp curve or angle; otherwise, he goes about it like a tailor dividing a piece of fabric in two, along the warp. He works with the scissors wide open, and the paper touches only the point at which the cutting edges of the blades meet. It all takes place with inconceivable resolve and fluidity. As if Romanesque sculpture had required no effort—only Grace. "A pair of scissors is a marvelous instrument,"[6] Matisse confided to an on-looker. How well we understand the pleasure he felt!

But drawing *in* color is meaningful only if it is a preparation for drawing *with* color—something Gauguin never managed to achieve, and which was Matisse's great contribution: organizing with color. That, however, was no longer true of the cut-outs. Of his large and most ambitious compositions, only *L'Escargot*, no. 198, and *Souvenir d'Océanie*, no. 199, have chromatic structure as their base. In the others, strangely enough—from his most beautiful and most vibrant, *La Perruche et la sirène*, no. 183, to the one in which virtually nothing happens, *Décoration fruits*, no. 204—and in all those others, including *Grande Décoration aux masques, Apollon, La Gerbe*, nos. 203, 205-206, etc., a principle of symmetry takes the place of drawing with color. I say "strangely enough" because Matisse's work over a period of fifty years had, once and for all—or so we thought—broken us of the habit of accepting that particular principle of symmetry. In order to get some idea of the degree to which he must have felt attracted to a principle of that nature (a symmetry which was completed and even worsened by still another need he seems to have felt at the time—that of uniformly filling in a surface), one has merely to compare the final state of *Lierre en fleur*, no. 212, with a photograph of a previous state of the same composition.[7] In the early state, the cut-out elements, massed into a triangle, take up only about two-thirds of the surface; what is left of it, the diagonal upper third, is (is *only*?—no, *is*) white. A white that lightens the compact grouping of forms, lifts it, breaks its symmetry, transports it, makes it breathe, and transforms the composition into a magnetic field. Matisse considered that intermediary state, called *Lierre*, significant enough to have it photographed in color and to allow it (either

he himself, or his close relations after his death, surely acting in accordance with his wishes) to be published in the 1958 issue of *Verve* that brought the majority of his large compositions to the public's notice. He did not stop there, however; instead he proceeded to complete his *Lierre en fleur* by covering the entire surface with cut-outs. In relation to *Lierre*, which breathes and is thus infinitely superior, *Lierre en fleur* is choked, extinguished.

The same absence of organizing with color characterizes most of the middle and small-sized cut-outs. That *Les Bêtes de la mer*, no. 114, and *La Vis*, no. 157, say, are veritable feasts of color does not mean that color is what holds those compositions together; it means only that Matisse was the greatest colorist of his time, which everyone knows. Obviously, there are exceptions to the rule. Two such exceptions are *Jerusalem Céleste*, no. 89 (Hans Hofmann must have seen it!) and *Nu bleu aux bas verts*, no. 173. Among the compositions in very small formats, the catalogue covers for two exhibitions at the Galerie Berggruen—*Henri Matisse Gravures Récentes*, no. 184, and *Henri Matisse, papiers découpés*, no. 197—also work because of color alone. The most outstanding example of that phenomenon is the composition for the review *Domus*, no. 104: where the space is an anvil between the two cut-out forms, the violet at the lower left and the blue that strikes from the upper right-hand corner. Matisse, "master of the hammer-blue"? That suits him. But in fact, what makes the cut-outs appear so modern and so virulent is something other than drawing with color. What gives them their originality (and which remains to be seen) is the same thing that made them so full of risk and that accounts for their being such a fascinating bundle of contradictions.

It was from Cézanne that Matisse inherited one of the greatest concerns of modern art—the need to make painting breathe (which is inseparable from the concern of presenting the world as one's theme—and of expressing the theme of the world). It was also from Cézanne that he inherited the dramatic process which makes all things possible: getting painting to breathe through the use of whites. In his cut-outs, Henri Matisse carried that device to an extreme, with far-reaching consequences. Early in 1942, in a very beautiful letter to André Rouveyre, Matisse wrote: "I had noticed that in the work of the Orientals the drawing of the empty spaces left around leaves counted as much as the drawing of the leaves themselves."[8] With his large cut-outs, he went one step further: the drawing of the empty spaces counted

more than the drawing of the actual cut paper. It is not, as Matisse would have wished, the arabesque of colored cut paper that gives the ambient white its quality; it is, on the contrary, the ambient white—a rather crushing white—that governs the impact made by the cut-out forms and sometimes even goes so far as to impede their integration. Matisse's intention itself, and the excessive nature of that intention, turned against him. From the very beginning of his life as an artist, he had understood that the empty spaces that flow around objects contribute as much to a picture as the space occupied by those objects, and may serve as a counterbalance. All of his painting had, in a sense, illustrated an attitude that was as anti-Cubist as possible, and which consisted in refusing to define the space between each object. It is touching (and very suggestive) to see Matisse, at the end of his life, bringing his own revolution to its logical conclusion, the result of which (and this is characteristic of all revolutions brought to their logical conclusions) was a glaring contradiction. He had the courage to propose whiteness as a primary and omnipresent element. He had the incredible courage to practice painting as a system of giving shape and breath to the world, a world in which whiteness—that is, nonpaint—had its ineluctable place. He was thus among those who realized that art encompasses the painted and the nonpainted alike. He tried to balance one against the other. And in the end, he was no longer in control of the vast whiteness he had unloosed.

Matisse liked to claim that there was no break between his former paintings and his cut-outs: he was both right and wrong. He was right in the sense that his cut-outs were the gradual culmination of the course he had been taking for fifty years—the culmination of one of the most articulated roads ever; and the fact that the road was coherent despite its being constantly renewed makes it almost unique in the history of painting. The cut-outs take into account all the steps along that road, without exception. But Matisse was wrong in the sense that, when you take a course, and, like him, follow it unceasingly for fifty years, when you reach the finish, you are necessarily very far from your starting point—in fact, at such a distance from it (since every road is an itinerary of metamorphosis) that it is tantamount to a break. For us, the cut-outs are evidence of Matisse's ultimate break with himself.

One of the signs of that break was seen in the fact that Matisse substituted a principle of symmetrical placement for his drawing with color. And there is an-other sign: in keeping with the whole modern tradition of painting, from Géricault and Daumier to Manet and to Cézanne, Matisse in his paintings had portrayed the object in the complexity of its space. More precisely: carrying his research to a point that his elders had been a long way from foreseeing, Matisse made his painting into a lengthy meditation on how forms cut and bite—and make their way—into the space that surrounds them. But with his cut-outs, Matisse began explicitly to distill the form. Indeed, he concentrated to such a degree on distilling it that nothing remained but the sign. The next step was to place that sign in the general whiteness of the world. Against it he juxtaposed—at a certain distance which he calculated with infinite care (I shall come back to the matter of the time it took him)—yet another form-sign. As a result, the white that was meant to receive them in fact repelled them! The end product of those forms as a whole was meant to have been something other than the sum total of all the units; the end product of them as a whole should have been a vibration into which those signs would have melded. Except for *La Perruche et la sirène*, the fusion process never worked; the vibration never took place. The forms remained signs isolated from one another, applied to a white surface which they cluttered and violated. The old distinction between form and substance, which Matisse had nullified in 1905, had to be reckoned with again in 1950, when Matisse began to experiment with a new way of resolving it. It had to be reckoned with again precisely because of the extreme nature of the endeavor; the reason for it was the process itself: the form was cut out of color and then detached from its context; and its context, under the circumstances, was the sheet of paper out of which it had been cut; in other words, its context was the painting, which—as we have seen—had been executed by others, not by Matisse himself. Thus detached, the form was transplanted into surroundings which haunted Matisse, but which nevertheless remained —as any universe would to its discoverer—foreign to him: the unpainted. The cut-out forms never became integrated into it; the graft would not take, for the forms could never rid themselves of their built-in defect— namely, a contour which was so clearly defined, an edge so bluntly cut, that it turned the form back on itself, isolated it, deprived it of any communication with the surrounding space—trapped it, fatally.

Another contradiction: it was at the time that Matisse was working on his biggest formats that his essential nature as an easel painter most clearly came to light.

Matisse had more of a sense of scale than any of his contemporaries; the best of his paintings, however small, give a feeling of vastness. It is very likely that a 35 x 30 cm. painting of his will give the impression of covering an entire wall. But in these very large cut-out panels it is impossible to read the whole as a whole: a crowd of isolated compositions, so many small pictures, forms against a background, thrust themselves upon the viewer in a dialectic so persistent that it constantly surprises.

A further contradiction: I have mentioned the lightning speed at which Matisse's scissors ran through the paper, and how relatively short the time seemed during the cutting process. Quite the opposite was true when it came to the organization of the compositions and the placement of the cut-outs, one in relation to the other: that process implied an endless amount of calculating and readjustment; it took an enormous amount of time —and in such cases time is the enemy. As time goes by, spontaneity is lost (fury, element of the unknown), and spontaneity is a vital factor in art. Matisse was not to be a Titian. The time taken by the craftsmanship needed to complete the large cut-outs obliterated them; to re-invest them with a feeling of the instantaneous and a rhythm of combat, he would have had to turn his back on the contrivance itself; he would have had to blind himself to it. That possibility would be available only to a painter who came after Matisse.

Yet another contradiction: as he was working to distill the forms, to such an extent that they became signs, Matisse reached the limits of abstraction (abstraction in the sense of the nonfigurative). Every one of his cut-out compositions is, as he himself explained, "an assemblage of signs invented during the work's execution to suit the needs of their positions."[9] Matisse offers the viewer a kind of semaphore which the viewer cannot help trying to decipher. This is a distinctive feature of the cut-outs, and only of the cut-outs. Matisse's paintings require no such effort at deciphering on the part of the viewer; the "reality" portrayed in them, in fact, is always directly perceptible and identifiable. At the other extreme, resolutely abstract paintings of the Mondrian type rule out any notion of a representational system. But Matisse always took care not to cross the boundaries of abstraction; he worked rooted in reality. When it came to his cut-outs, he remained, as it were, between two worlds— the figurative and nonfigurative. Thus the viewer, disconcerted at being presented with a constant mixture of the recognizable and the unrecognizable, experiences a feeling of being tugged at. He is unable to refrain from

trying to read the forms (the "real" calls out to him, pulls him by the sleeve), nor can he refrain from being bothered by it, for reading them almost invariably involves certain difficulties.[10] The need for deciphering the cut-outs runs counter to the efficacy that Matisse had in mind when he repeatedly claimed: "I found cut-outs to be the simplest and most direct way of expressing myself."[11]

My aim in analyzing several of the contradictions characteristic of the cut-outs is not to linger over the possible failures to which those contradictions may have led, but rather to face the great risks Matisse had been willing to run, as well as the newness of the conflicts with which he—tireless artist that he was—wished to struggle until his last breath. The success of certain of the cut-outs is, I might add, commensurate with the adventure itself. As for the failures—and some of them *are* failures—they, at the most, make it possible to verify the rule according to which quality in art does not necessarily go hand in hand with the avant-garde. Most of the people concerned with art these days tend to credit only the avant-garde. The corollary of that state of mind (in addition to an incredible confusion about the avant-garde itself) is that anything created this very day invalidates anything that was created yesterday, and the principle of innovation takes the place of all criteria of evaluation. That way of looking at things is simplistic and does not take into account the actual core of the matter. The fact that something is recent in no way implies that it is new and young. That something is new in no way implies that it is modern. That something is modern does not ipso facto guarantee its quality—just barely its raison d'être. All of these notions are separate from one another. And comprehension has everything to lose by taking them to mean the same thing. For the last century and a half, most especially, and for reasons it would be inappropriate to go into here, such notions have had an effect upon art, and from time to time have been in harmony; but most often they have clashed and one of them has been embodied at the expense of the others. They may, of course, be united within a work of art or within a given period of an artist's oeuvre.

Saying that this is not *generally* the case with regard to the cut-outs *as such* does not mean disparaging them, but seeing them. It is to discern which elements in a work make it, and to what degree, so full of new perspectives, yet not, for all that, the best of its kind. It means understanding that we must sometimes await another generation for those discoveries to be utilizable. It is not only

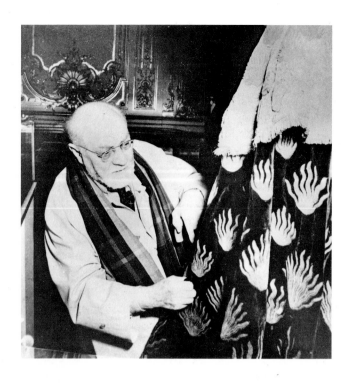

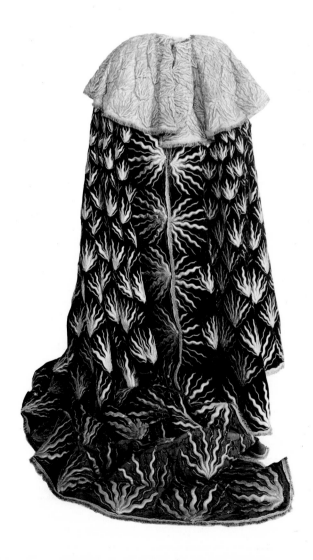

Fig. 26. Matisse examining the mantle of the Chevaliers de l'Ordre du Saint-Esprit (see fig. 27), which Fr. M.-A. Couturier tried on for him during a private visit to the exhibition "L'Art et la vie au Moyen Age à travers les blasons et les sceaux," Paris, Archives Nationales, Palais Soubise, summer 1950. This mantle was exhibited, cat. no. 319.

Fig. 27. Mantle of the Chevaliers de l'Ordre du Saint-Esprit, 18th century, following the original 16th-century design. Musée du Louvre, Paris.

in geography that discoverers of continents turn out to have been clumsy in certain ways. There is obviously— if I may be allowed to simplify—an absence of any such clumsiness in all of Matisse's endeavors from 1904 to 1917; he then is the one who, parallel to the Cubists, and with inspired inventiveness, brought a whole chunk of the history of painting to its conclusion. Nor is there any trace of such clumsiness in Matisse's art of the 1918-30 period; the canvases he painted during those years are perhaps, of all his works, those that give proof of the highest pictorial quality. They may also be those in which there is the clearest absence of any notion of the avant-garde. (Because at that time Matisse had no intention of moving ahead of anyone. He quite simply made his works more complete than those of anyone else by including an element he had not mastered until then.) Those paintings are nevertheless modern, but so discreetly modern that the fact escapes the least observant eyes—in other words, most peoples'. One of the reasons his paintings of that so-called "Nice" period are modern is that Matisse exposed the colors in them to a unity of light. He underlaid and organized an entire canvas with light, which gradually took the place of color . . .

Between 1930 and 1933 Matisse made three trips to the United States—three trips of paramount importance (it is amazing that this has not been stressed until now), for there Matisse was exposed to American light. And

nothing (in any case, not the light of Nice) had prepared him for its beauty, its newness, its *whiteness,* and its specific harshness. For his cut-outs, Matisse did not cut into color so much as he cut into light—but not into the light of Nice: he cut into the sharpness and into the glare of American light. Once more, he wrenched himself out of his habits, as he had had to do during every crucial period of his life. Feeling the need of regeneration, he uprooted himself from his surrounding environment, having probably exhausted all its pictorial possibilities. He thus cut into a foreign light. Moreover, he carried light to the extreme point of insulation, something which no one else in modern times had done. He carried light to such an extreme that the surface of his compositions became as taut as a drumhead. And how very different from Morris Louis's modulation of that same light. In fact, Matisse was then clearly (and no doubt consciously) deviating from the direction taken by contemporary painters in the wake of Monet's last works. That direction—and Pollock is the best example of it—consisted in loosening the surface of paintings (which does not mean unstructuring the painted surface, and even less, ceasing to organize it). Matisse—the same painter who, from 1904 to 1917, had done so much to further that loosening process—took another road with his cut-outs. He was attempting something else, and two of his works exemplify it more than any of the others: *Vénus* and *La Piscine,* nos. 181, 177.

Both of these works are a reflection on the nature of the work of art. Both of them deal with a basic reversal of poles, between which is a record of the artist's activity. Needless to say, the idea was no longer to create a central figure and insert it as well as possible into a background; nor was it to produce an image, however abstract. The artist was henceforth relegated to the periphery of the subject of art, which itself had become increasingly peripheral. At that stage artistic activity consisted in no more than minute and scarcely necessary interventions—as if the form had already been formed before the artist intervened, and his role was merely that of making the form visible. Indeed, after *Vénus* and after *La Piscine,* what was a form? Henceforth, an indifference rather than a difference. More a negative than a positive. Something tolerated by space. A white area, flanked with paint—a process that immediately negated itself into paint floating in white. The privileged space on which art comes into being exists no longer; art is taking place elsewhere as well as anywhere, elsewhere being quite simply: beside the former frame, which it has virtually overflowed. Can that which operates out-

side any frame still be called art? Can it bear the same name as that which preceded it and which was so clearly something else? After all, why not? But the question is posed by the cut-outs: did Matisse not open the door to art's leaping outside itself, to art's wrenching itself free from itself so as not to be art any more? Toward a profession that would be more universally applicable, whereas almost anything, however slight, would be enough to bring all the particles of life to art, were they just a bit magnetized? Our sphere: the question of such a permutation would seem to be posed, which is in fact why that sphere is our sphere.

Contrary to Monet, did Matisse's mastery at the end of his life prevail over his vision? The most beautiful and most winning of his cut-outs are those which do not give that feeling. *Océanie, le ciel* and *Océanie, la mer,* nos. 55-56: white forms pinned right onto the beige walls of a large room in his apartment (all the surfaces of which, in the end, were entirely covered by them, including the overdoors), they were the first two of Matisse's large cut-out compositions.[12] That they are so very sober and discrete accounts for the fact that they have been neglected, even to the present day. Yet one gets the feeling that they represent Matisse as inspired, in a state of constant improvisation and invention, moving ahead into the unknown areas of his problem with a kind of simplicity and freshness of approach that were to fade out, fatally, in his large subsequent compositions. One finds oneself surrounded—with almost nothing, yet well and truly surrounded all the same, immersed in that "almost nothing," and what a fine thing it would have been had Matisse not deviated from it. Later on, in quite another context, the inspiration of the most Matissean work in the Louvre—the cloak of the Order of the Knights of the Holy Ghost (figs. 26-27), which Matisse had known all his life—was reincarnated. As he had often done, he incorporated all that he had found most striking and most modern in the art of the past,[13] and incorporated it long after he had seen it; he had taken it, had absorbed it, and he gave it back with no evasions. The result, which is as resonant as *Océanie, le ciel* and *Océanie, la mer* were not, is the mortuary chasuble *Esperlucat,* no. 148 (a Provençal word meaning "to unseal," "to open the eyes"). The work for that chasuble is the one cut-out, among all the others, that we shall always remember for its quality, its solemnity, the clarity of its message, and its beauty. A bit of white (here, a very warm white) on a great deal of black (a very luminous black).

(Translated from the French by June Guicharnaud)

55

Notes

1. Matisse to Fr. Couturier, 1948, Matisse 1972, p. 242 n. 8.

2. Greenberg 1961, p. 45. Greenberg, in a magnificent passage, contrasts "area drawing" with "sculptural drawing." A distinction, however, must be made between the notion of "sculptural drawing" and that of "the direct carving of the sculptor" so dear to Matisse. The former is concerned with a contour-drawing which determines the whole and precedes color by marking out, beforehand, what its scope will be, thus restricting its range, the role it plays, and its significance; in this case, color merely complements the drawing. Matisse's "direct carving of the sculptor" means precisely the opposite: a drawing which is no longer confined by color but moves ahead through it and is determined by it.

3. Matisse, "Rôle et modalités de la couleur," 1945, Matisse 1972, p. 199; tr. Flam 1973, p. 99.

4. Paris 1949, p. 21.

5. And the few films that show Matisse cutting (most especially, the short sequences filmed by Aimé Maeght in 1952) were, for those of us lucky enough to have seen them, one of the many happy moments in preparing for the present exhibition.

6. Jedlicka, "Begegnung mit Henri Matisse," 1952, tr. Fourcade 1976, p. 113.

7. Published in Verve 1958, nos. 35-36, p. 152.

8. Matisse 1972, p. 168.

9. Matisse, "Témoinage," 1951, Matisse 1972, p. 248; tr. Flam 1973, p. 137.

10. Here is an example of those difficulties—one chosen intentionally from among the least troublesome. Matisse once showed Gotthard Jedlicka a wall on which there was a blue cut-out. "I looked at it," wrote Jedlicka, "but I was unable to make out what it represented. I could feel that he was growing impatient. 'A parakeet. You shouldn't have any trouble seeing that! With the greatest simplicity possible, I portrayed a parakeet.' 'I see,' said I. But I didn't see." (Jedlicka, see note 6 above, p. 114). Today, were the cut-out not entitled *La Perruche et la sirène*, what would we see in that blue form that would make us recognize it? What Matisse called "simplicity" was in fact the ultimate in elaboration, alchemy to the highest degree, a purification that took sixty years of work—not so simple as all that . . .

11. See note 9 above.

12. Although the linen canvases for which they were models are familiar, the cut-outs themselves are known today only through the very eloquent photographs of them taken by Hélène Adant (figs. 25, 41).

13. Philippe de Champaigne had already seized upon those cloaks and made a "Matisse" out of them (*Louis XIV reçevant Philippe d'Anjou dans l'Ordre du Saint-Esprit le 8 juin 1654*, 1665, Grenoble, Musée de Peinture et de Sculpture).

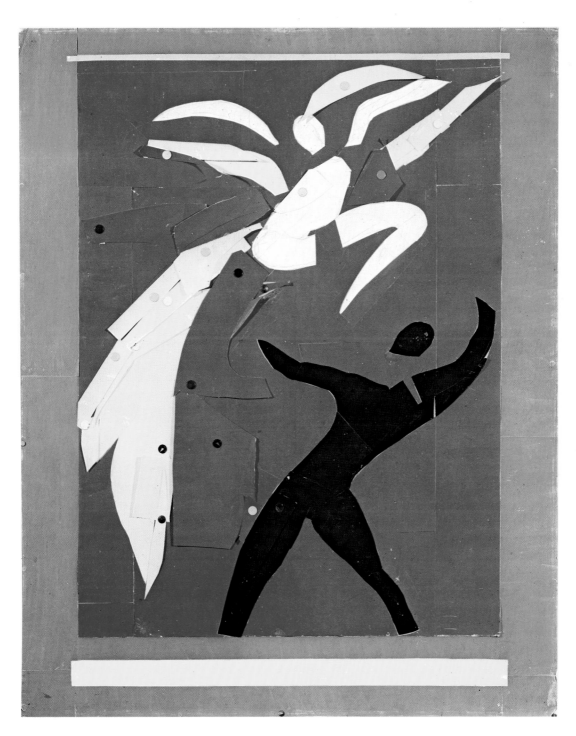

I. Deux Danseurs, 1937/38, no. 4.

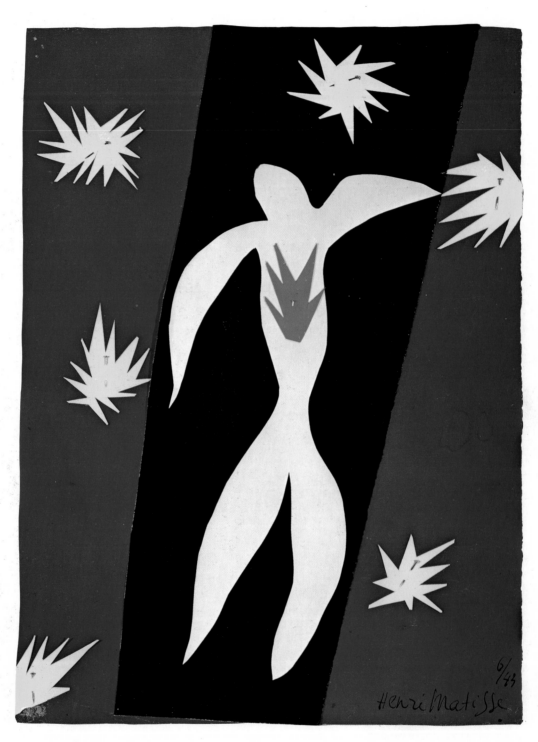

II. La Chute d'Icare, 1943, no. 14.

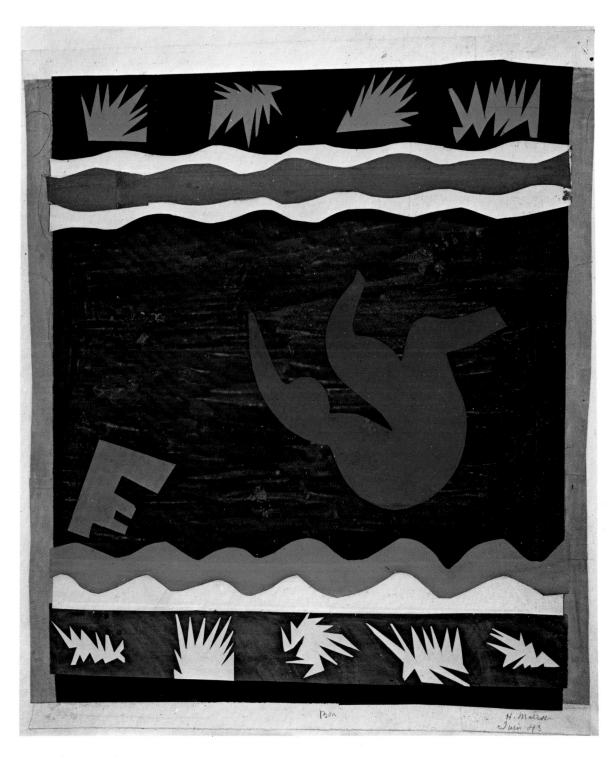

III. **Le Toboggan,** early 1943, no. 17.

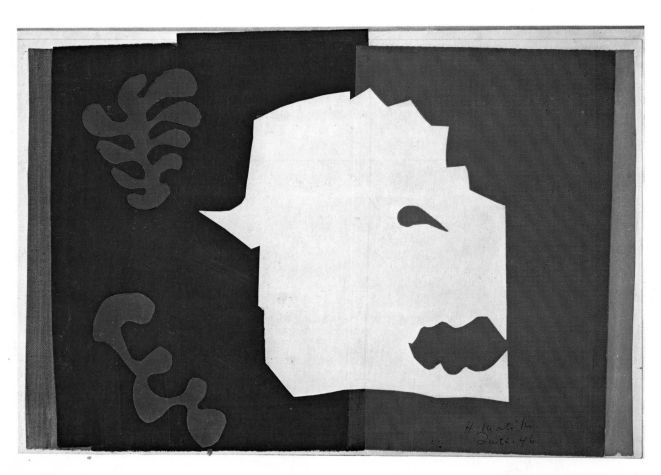

IV. Le Loup, 1944, no. 22.

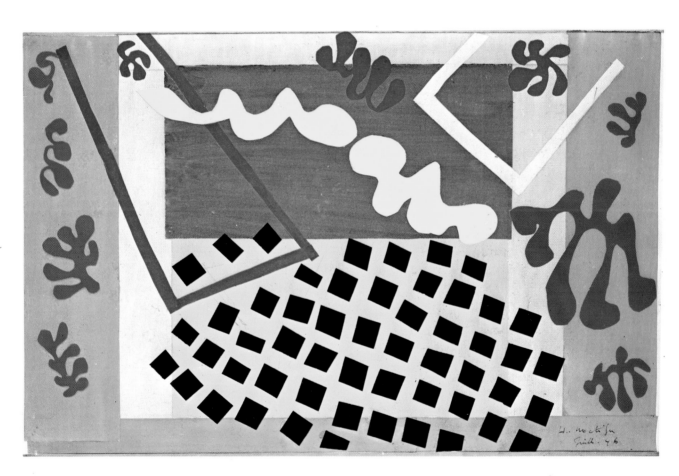

v. **Les Codomas,** early 1944, no. 27.

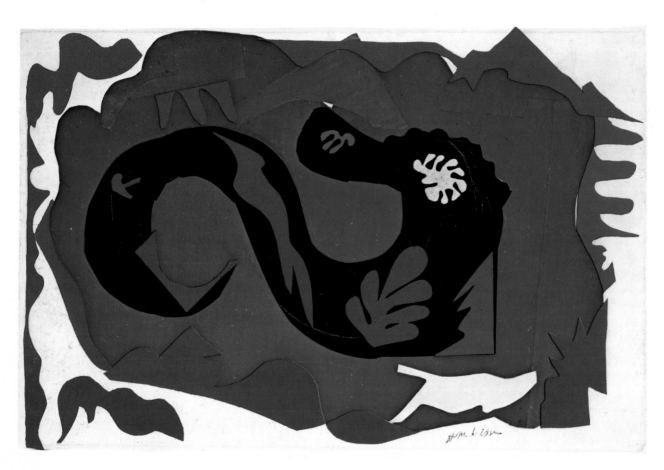

VI. Le Dragon, 1943/44, no. 37.

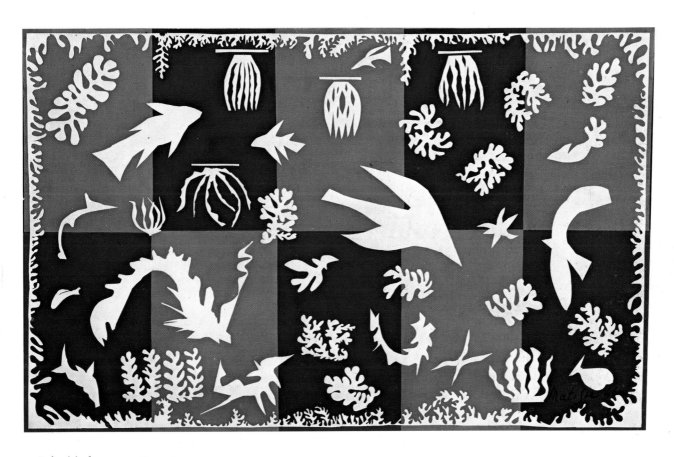

VII. **Polynésie, la mer,** 1946, no. 60.

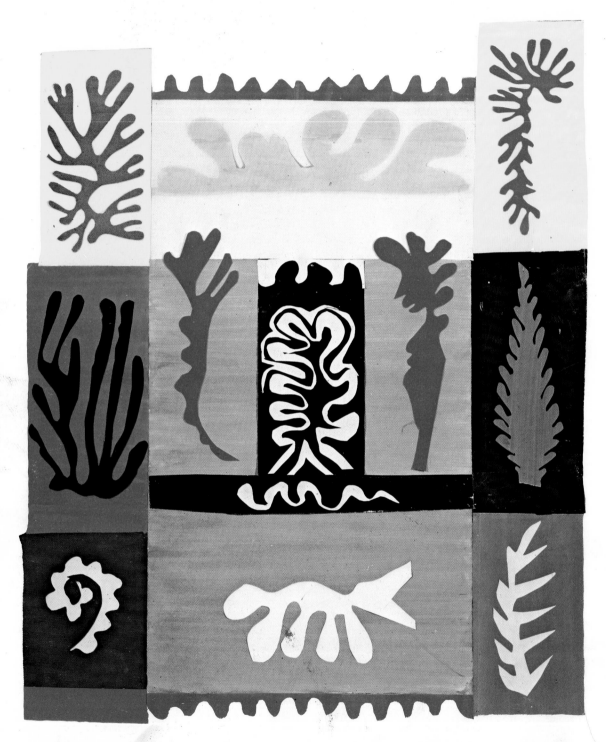

VIII. **Amphitrite**, 1947, no. 61.

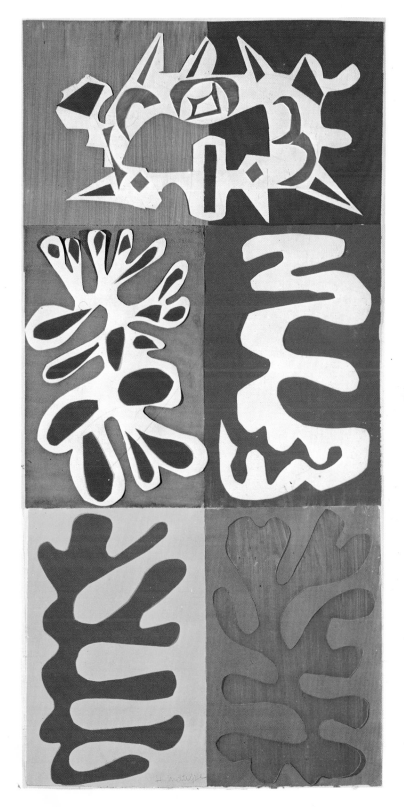

IX. Le Panneau au masque, 1947, no. 66.

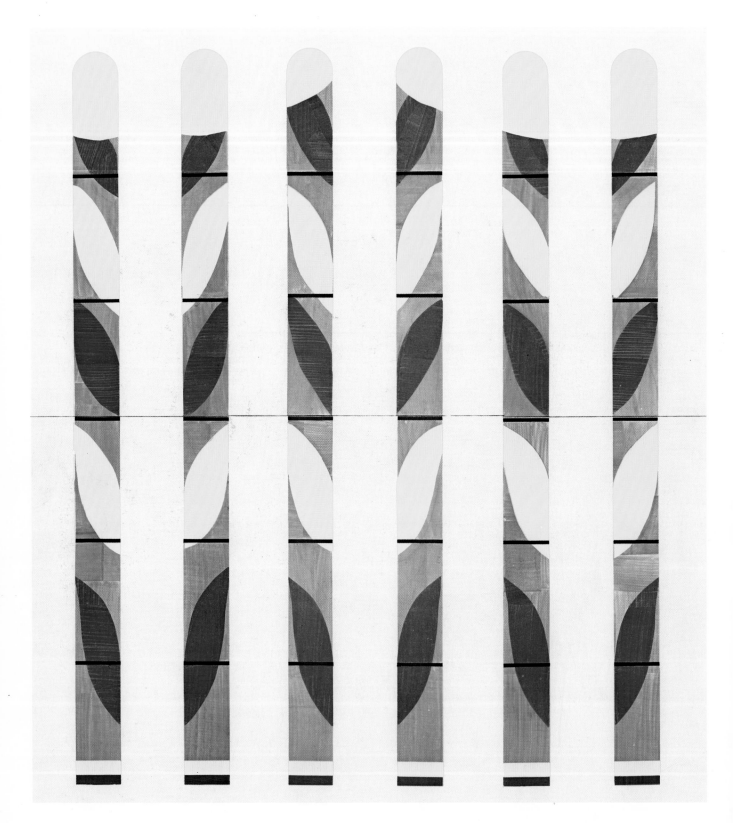

x. L'Arbre de vie, 1949, no. 95, nave window.

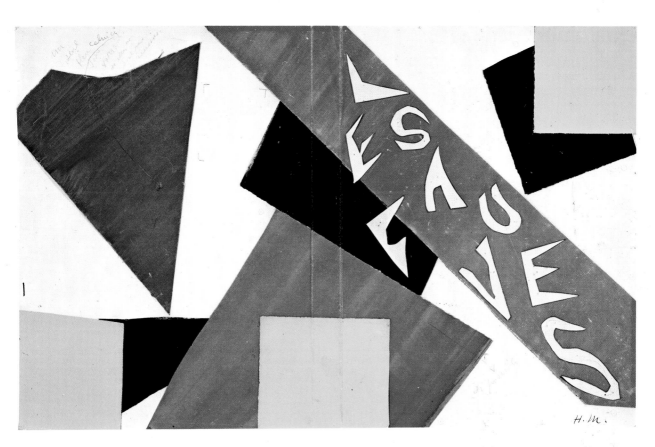

XI. Les Fauves, 1949, no. 100.

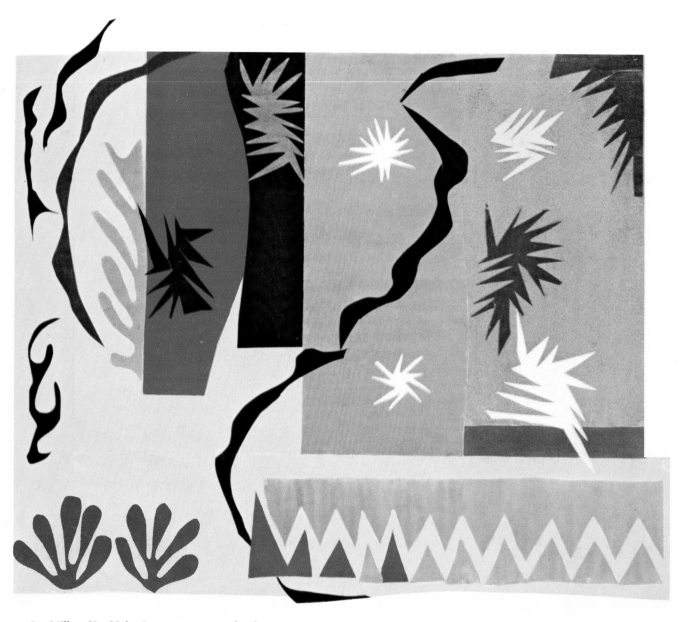

XII. **Les Mille et Une Nuits**, June 1950, no. 111, detail.

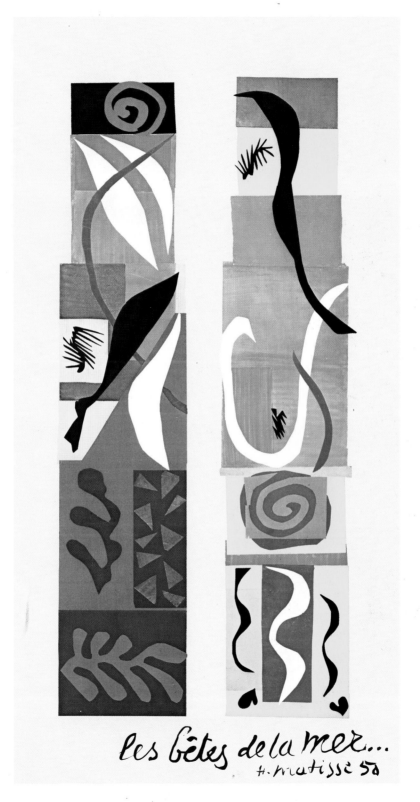

XIII. Les Bêtes de la mer . . . , 1950, no. 114.

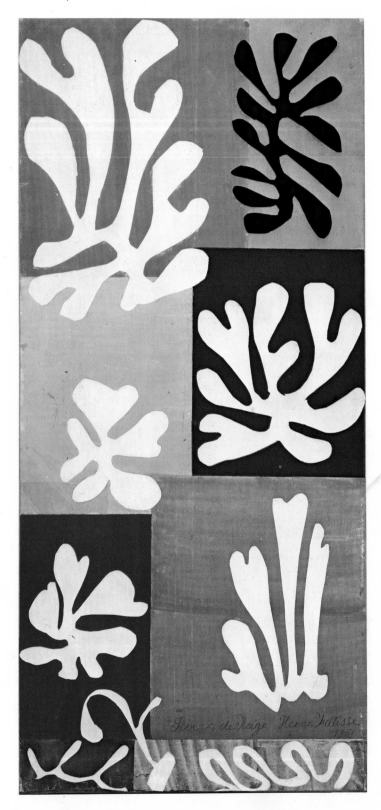

XIV. **Fleurs de neige**, 1951, no. 117.

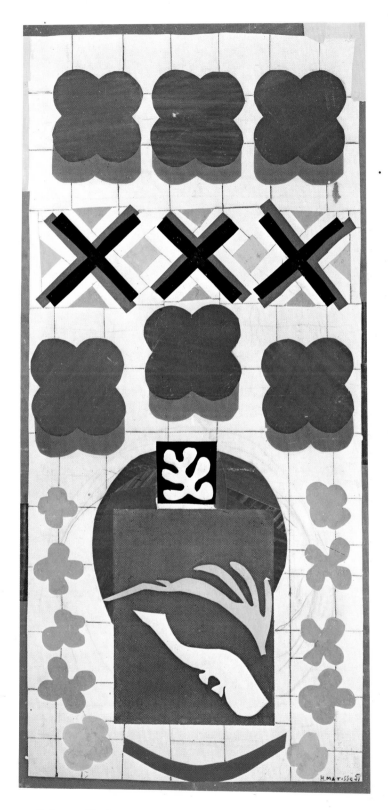

xv. Poissons chinois, 1951, no. 127.

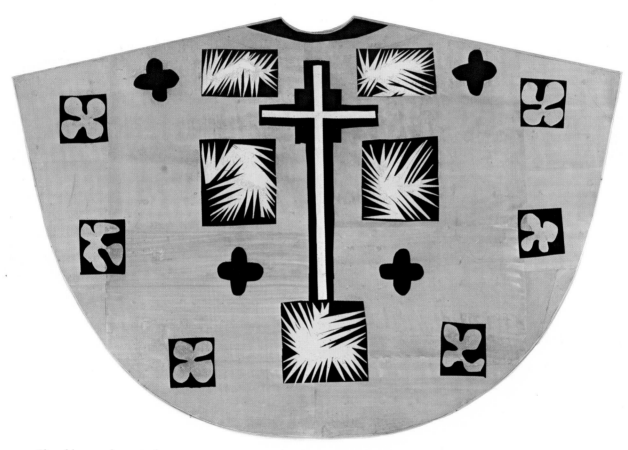

XVI. **Chasuble verte,** late 1950/52, no. 134.

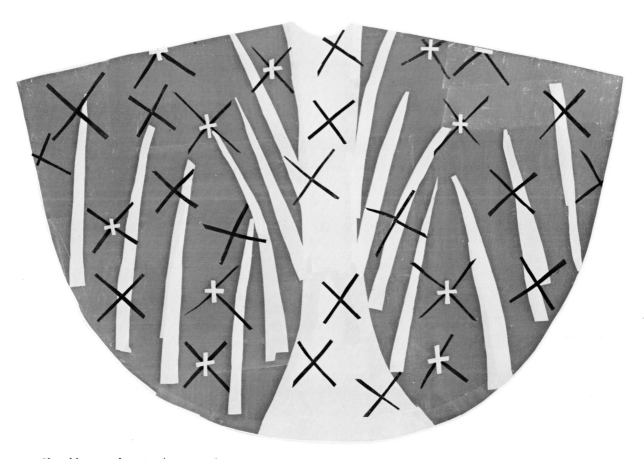

XVII. **Chasuble rouge**, late 1950/52, no. 146.

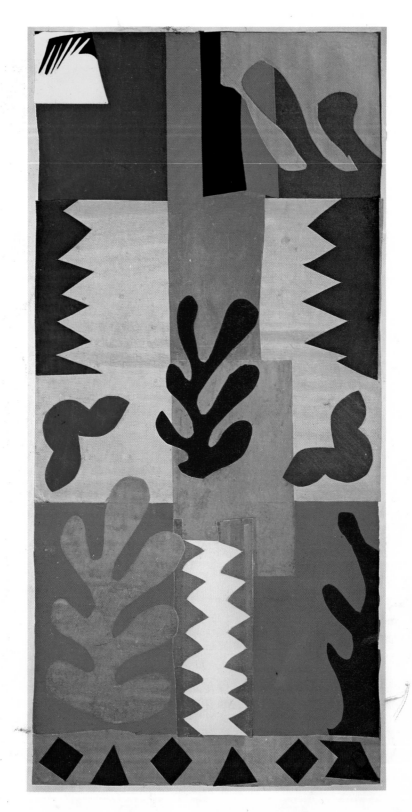

XVIII. La Vis, c. 1951, no. 157.

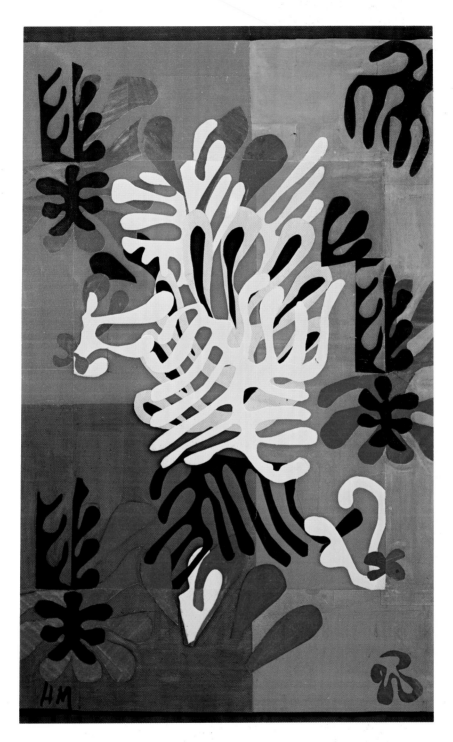

XIX. **Mimosa**, 1949/51, no. 158.

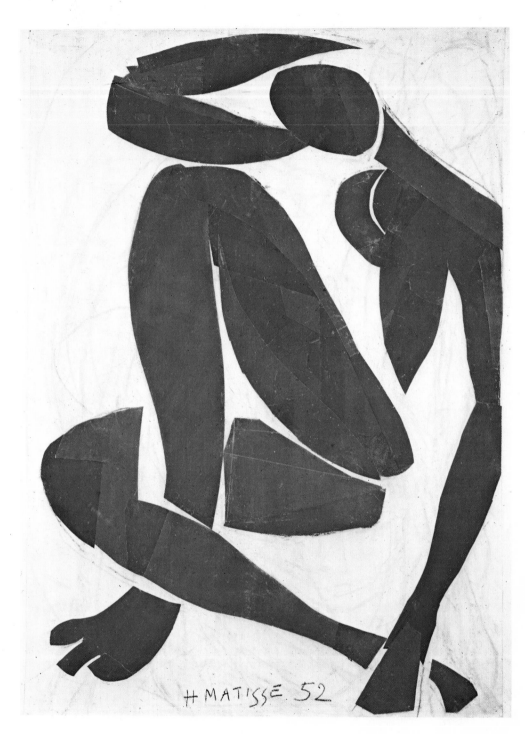

XX. Nu bleu IV, 1952, no. 170.

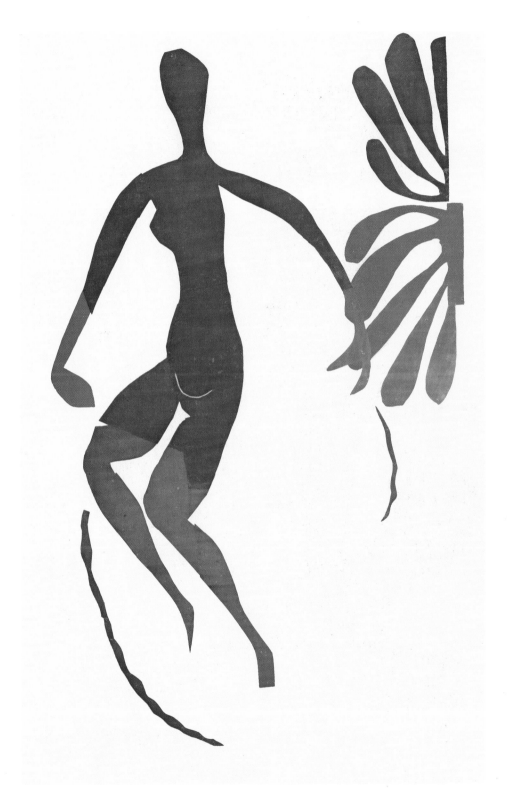

XXI. **Nu bleu aux bas verts**, 1952, no. 173.

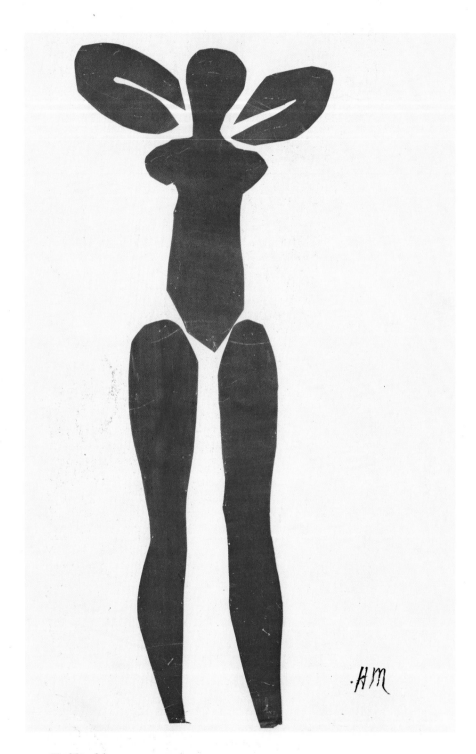

XXII. **Nu bleu debout,** 1952, no. 179.

XXIII. Henri Matisse Papiers Découpés, 1952, no. 197, detail.

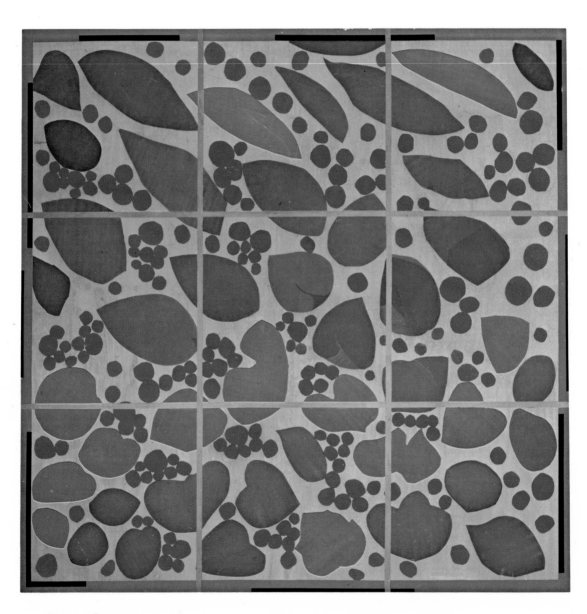

XXIV. Lierre en fleur, 1953, no. 212.

Exhibition Checklist and Lenders to the Exhibition

Notes to the Catalogue

The following catalogue provides the first survey of Matisse's paper cut-outs, from before 1935 to 1954. Up to now, the breadth and scope of Matisse's cut-out production has been largely unknown; consequently, the historical development of these works, and the richness and complexity of their imagery has only begun to be explored. The 218 entries listed here probably represent about four-fifths of Matisse's extant works in this medium. Their order is more or less chronological.

Titles are given first in French, then in English, if appropriate. Those works included in the present exhibition are denoted by an asterisk to the left of their title. If two years, separated by a hyphen, are given for the date of a work of art, the entire period indicated is involved; if separated by a slash, any time within the period indicated could apply.

Unless otherwise noted, the works are composed of paper painted with gouache color, cut and pasted; white papers are sometimes painted, sometimes not. Height precedes width; dimensions are given in centimeters (cm.) followed by inches (in.). "Approx." indicates size determined through photomechanical measurement, or, in the case of a cut-out-based work, dimensions of the original maquette estimated from the finished project. (Matisse almost always insisted on a one-to-one scale.) Exhibitions and bibliography are abbreviated in the entries and listed fully in the List of Exhibitions and/or Bibliography beginning on p. 286 and p. 289, respectively. Catalogue or book titles are listed without punctuation when none appears.

Collections are listed chronologically, from the earliest to the most recent.

Every effort has been made to publish photographs of the actual paper cut-outs. When this has not been possible, the symbol □ appears to indicate that the photograph used was made from a secondary rendition, such as a silkscreen or poster.

Further abbreviations used in this catalogue include: MOMA (New York, The Museum of Modern Art), MNAM (Paris, Musée National d'Art Moderne), Bib. Nat. (Paris, Bibliothèque Nationale), n.d.a. (no date available).

Fig. 28. Fortunato Depero (1892-1960). *Chinese Man,* proposed costume design (not used) for the ballet *Le Chant du rossignol,* c. 1916/17. Colored, cut, and pasted paper; 48 x 30 cm. (19⅜ x 12 in.). Dr. and Mrs. Gianni Mattioli Collection, Milan.

Precursor A

Le Chant du rossignol, 1920

Le Chant du rossignol was first staged as an opera in Paris, May 1914, produced by Sergei Diaghilev with costumes and décor by Alexandre Benois. By 1916 Diaghilev had decided to adapt it as a ballet and contracted the Italian Futurist Fortunato Depero to design the costumes and décor. Depero produced a number of maquettes in cut and pasted colored paper during 1916 and 1917 (fig. 28). The resulting designs were composed of geometrically derived forms: cones, tubes, circular masks, and disks. Later, however, Diaghilev changed his mind and offered the project to Matisse, despite the fact that many of the Depero costumes and set items were already completed. Matisse's designs were used in the production, choreographed by Léonide Massine, which opened in Paris on February 2, 1920.

Matisse must have known about not only the Benois projects but, more importantly, the Depero designs and working methods. He may well have had them in mind as he worked on his own costumes and décor.

The costume for the Mourners (fig. 29), a long-skirted, long-sleeved Chinese robe of white felt with midnight-blue velvet triangles, has a hood with projecting horns and ear flaps, and a long, hanging rear panel with midnight-blue velvet chevrons. The appliqué chevrons and triangles strongly retain their "cut form" quality, and do not seem unrelated to the later cut-outs.

Certain panels on the Warriors' costume skirts also seem to contain this quality, and Matisse's use elsewhere in the ballet design of color disks, rosettes, and masks (either real or painted, as on the curtain and tunics), also has echoes in the later cut-outs. A particularly interesting connection here is the *Square of Silk,* which has been described as follows:

Painted in dye so that the basic white of the silk forms a lozenge pattern on a Sèvres blue ground with a black border and a black lozenge in the center. At the corners, long black woolen tassels. Note: the pattern is subtly asymmetrical which suggests that the painter either executed the work himself or supervised its execution; the result being similar to one of his collages. (Sotheby, London, sale, 1968-2, lot 85iii)

Le Chant du rossignol was re-choreographed by Georges Balanchine for its 1925 production and Matisse re-designed the Nightingale's costume for the new prima ballerina, Alicia Markova.

A number of important experimental ballet stage sets and costumes, done prior to Matisse's *Le Chant du rossignol,* and which may have influenced him, include the following: *Le Coq d'or,* 1914 (costumes and décor by Gontcharova); *Le Soleil de minuit,* 1915 (costumes by Larionov); *Feu d'artifice,* 1917 (décor and special light effects by Balla); *Parade,* 1917 (costumes by Picasso); *Cléopatre,* 1918 (costumes and décor by Sonia and Robert Delaunay); and *Le Tricorne,* 1919 (costumes by Picasso).

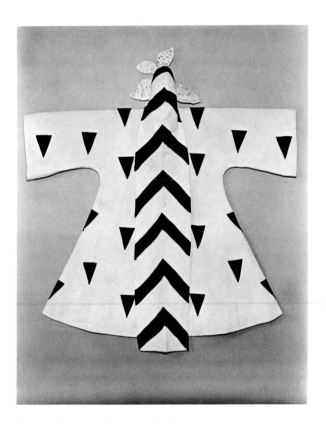

Fig. 29. *Mourner's Costume,* back view, for the ballet *Le Chant du rossignol,* 1920. David P. Willis Collection, New York.

Precursor B

La Danse I & II, 1931-33, projects for the Barnes Foundation mural

Matisse used cut paper for the Barnes murals (Merion, Pa.), but differently—both technically and esthetically—from the way he would use it in the later cut-outs.

The colored paper was employed as a convenient means of temporarily re-defining zones of color without having repeatedly to scratch out and paint over. The paper was colored by a house painter, using the same four hues (black, pink, blue, and pale gray) as were being used for the painted canvas. As Matisse redrew his canvas design, pieces of paper were cut to fit the altered forms, until the final composition was established.

Documentary photographs clearly show that this use of cut paper resulted in dramatic textural effects as the surfaces became layered with hundreds of small cuttings (figs. 30-31). The additive process created a sculptural feel and a visual animation subsequently muted in the finished murals.

Despite Matisse's apparent appreciation of the paper during the intermediary stages, the artist's overall intentions emphasized the division rather than the unity of the separate acts of drawing, painting, and cutting. He was not yet "drawing directly in color with scissors" (*Jazz* text).

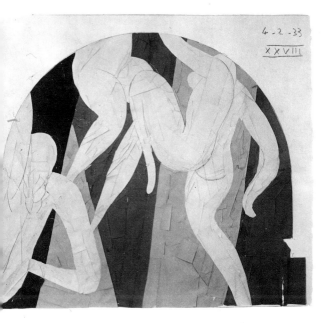

Fig. 30. *La Danse I*. Musée de la Ville de Paris. Early state, photograph April 16, 1932, showing painted cut papers applied as compositional and color aids.

Fig. 31. *La Danse II*. Barnes Foundation, Merion, Pa. Early state, photograph no. 28, February 4, 1933, showing painted cut papers applied as compositional and color aids.

Precursor C

Nu rose, 1935

From May to October 1935 Matisse worked on the painting *Nu rose* (Baltimore Museum of Art). During that time, 21 photographs were taken of the work in progress (see Russell 1969, pp. 134-135). From the sixth photograph (May 23) on, it can be seen that Matisse made use of cut paper as a compositional aid (fig. 32). By May 29 (photo no. 9), the use of cut paper not only modified but became a major element of the formal structure, playing an important role in the frontality and flattening of the composition. As Matisse became more sure of his direction, he gradually replaced the pinned paper elements with paint; by September 4 (photo no. 13), only the background and chairback are still indicated by cut paper shapes. Once again, cut paper was used as a means for experimenting with compositional changes and not as an end in itself.

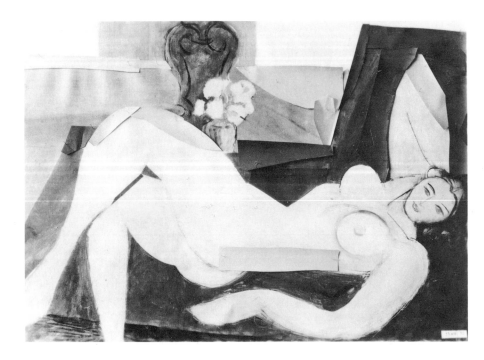

Fig. 32. *Nu rose,* 1935. Baltimore Museum of Art. Early state photograph, no. 6, May 23, 1935, showing painted and cut paper applied as compositional and color aids.

I

1 La Danse I

The Dance I (etching maquette)

c. 1936

Painted cut and pasted paper, pen and ink

31 x 77.6 cm.

12³⁄₁₆ x 30⁹⁄₁₆ in.

Signed: *Maquette Henri-Matisse* (lower right), *Reposez/le petit rose léger/devant* (upper left) *Bon/2eme/rose/un peu trop/faible-/on verra pour/la suite* (lower center)

Collections: Musée Matisse, Nice

This cut-out is the maquette for the color etching made after *La Danse I* by the engraver Lacourière, August 1936, in an edition of 50.

The inscriptions in the margins are evidently notations made by the artist to the master printer in the color-proofing stage.

2 Cahiers d'Art, 3-5, 1936 (cover maquette)

c. 1936

32.8 x 54 cm. (approx.)

12⅞ x 21¼ in. (approx.)

Signed: not known

Collections: present location unknown

Maquette used for the *exemplaires de tête* covers only; in colors of red, black, blue, white, and light green. With this 1936 cover design project Matisse began what would become an extensive production of large-run magazine and book dustcovers, exhibition catalogue covers, and posters based on painted, cut, and pasted paper maquettes.

The front cover is geometrical, with straight-edge forms, the back cover more organic and curvilinear. The composite effect of these contrasts and diagonals is not unlike the system later used in the *Rouge et Noir* ballet design, where dancers in flamelike costumes were juxtaposed against the static triangle and color planes of the background scenery lunettes (see no. 7).

Design precedents for this work include Simon Lissim's Ballets Russes 1933 curtain project (fig. 33), which also suggests comparison with the *Jazz* plate, *Le Cheval, l'écuyère et le clown,* no. 21.

Christian Zervos (co-founder and director of *Cahiers d'Art*) published an article hostile to Matisse's paper cut-outs: "I'm willing to admit that Matisse, having entered the game of the paper cut-outs as if by chance with the colored cover done for *Cahiers d'Art* in 1936, later converted it into an agreeable distraction which would ease his long hours of insomnia!" (Zervos 1949, p. 160).

Fig. 33. Simon M. Lissim (b. 1900). Proposed curtain design (not used) for *Choreartium*, a ballet choreographed by Léonide Massine for the Ballets Russes de Monte-Carlo, 1933. Watercolor and gold; 38.1 x 52.7 cm (15 x 20¾ in.). Mr. and Mrs. N. D. Lobanov Collection, New York.

2 □

3 Verve, I, 1, 1937 (cover maquette)

1937

Painted cut and pasted paper, brush and ink

36.5 x 55.5 cm. (approx.)
14⅜ x 22⅞ in. (approx.)

Signed: not known

Collections: Private Collection, Paris

The cover for the first issue of *Verve,* reproduced lithographically by Mourlot Frères, Paris, in colors of red, black, and blue on white stock. The back cover design appears to consist of the outline of a large arum lily at the center flanked by two tulips.

The chronology for the early paper cut-outs of Matisse has been confused by two erroneous sources: the first is the exhibition catalogue, *Henri Matisse, oeuvres récentes, 1947-1948,* Paris, Musée National d'Art Moderne, 1949, which publishes italicized texts written by Matisse (although they are not credited as such); one of these

texts (p. 12) is surely in error: "It was in 1937, for the curtain of *L'Etrange Farandole (Rouge et Noir)* at the Ballets Russes, that Matisse used cut paper for the first time; he subsequently used it for special covers of art reviews, *Verve* and *Cahiers d'Art";* the second is Tériade, who wrote: "In 1937 Matisse agreed to do the cover for the first number of *Verve* (December 1937). Thus was born his first collage work" (Matisse 1957, p. 45). In fact, the cover for *Cahiers d'Art* predates that for *Verve;* both preceded the final ballet designs.

Tériade (b. 1897, *né* Elstratios Eleftheriades) left his native Greece and came to France during World War I. He soon became active in the Parisian art and literary community. After working on *Cahiers d'Art* with Christian Zervos, he was art critic for *l'Intransigéant.* He then published *Minotaure* with Albert Skira, *La Bête Noire,* and finally *Verve.* He also originated and published a number of artists' books, notably Matisse's *Jazz.*

3 □

4

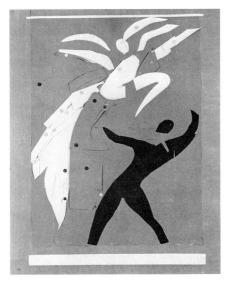

5

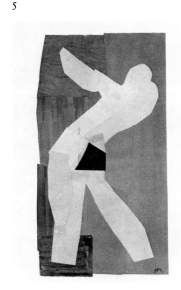

6 ☐

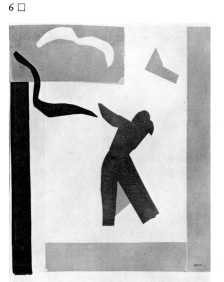

***4 Deux Danseurs, "Rouge et Noir"**

Two Dancers, "Rouge et Noir"

1937/38

Painted cut and pasted paper, notebook papers, pencil, thumbtacks

80.5 x 64.5 cm.
31¹¹⁄₁₆ x 25⅜ in.

Not signed or dated

Collections: Private Collection

Most probably an early version of the front curtain for the ballet *Rouge et Noir,* no. 7. The design is on thick cardboard, and some areas were not overlaid or cut out in advance but were apparently cut away with a mat knife directly upon the board, leaving a scored surface. This and the subsequent ballet studies may have been executed earlier than the date proposed here.

Color plate 1

***5 Petit Danseur sur fond rouge**

Small Dancer on Red Background

1937/38

37 x 19.5 cm.
14⁹⁄₁₆ x 7¹¹⁄₁₆ in.

Signed: *HM.* (lower right)

Exhibitions: Albi 1961, no. 168?, entitled *Danseur rouge*

Bibliography: Paris 1961 (color cover, ill. p. 45); Duthuit 1962 (ill. p. 99); Ferrier 1969 (ill.); Jacobus 1972 (ill. p. 51)

Collections: Private Collection, France

It is possible that this work may be a preliminary model for a dancer's costume in *Rouge et Noir.*

6 Le Danseur

The Dancer

1937/38

75 x 62 cm.
29½ x 24⅜ in.

Signed: *HM.* (lower right)

Exhibitions: Paris 1961, no. 2? (color poster); Albi 1961, no. 169?, entitled *Figure de ballet;* New York 1961, no. 1?

Collections: present location unknown

Probably a preliminary study for the front curtain of *Rouge et Noir.* The dancer is closely related to the smaller study *Petit Danseur sur fond rouge,* no. 5, in its pose and profile.

Fig. 34. Henri Matisse, Nice, 1937/38. At left: shadow box model of stage set for the ballet *Rouge et Noir*. The artist is holding three sketches of his costume designs for this ballet.

7 Danseur

Dancer

1937/38

61 x 61 cm. (approx.)

24 x 24 in. (approx.)

Signed: *à Léonide Massine/ Henri Matisse/Nice 1er Mai 38* (lower right)

Bibliography: *Vogue* 1938 (ill. p. 25, state); Ballets de Monte-Carlo 1939-2 (ill. color); Goode 1939 (ill. color); Barr 1951 (ill. p. 482); Guichard-Meili 1967, p. 116 (ill. color no. 109); Alpatov 1973, p. 118 (color pl. 57)

Collections: Léonide Massine; present location unknown

The final study for the front curtain of *Rouge et Noir*, a ballet "symphonically" choreographed by Massine to Shostakovich's First Symphony. It is not known whether the actual front curtain still exists.

The two figures in this curtain design evoke quite specifically part of the third movement of the actual ballet, in which the Woman, separated from the Man, is "tormented in her solitude by an evil spirit" (see Massine 1939, reel 3). The black form is that of the evil spirit, the yellow and white that of the woman. This theme of threatened lovers seems to anticipate some of the imagery of *Jazz,* especially *Le Destin,* no. 32.

The June 1939 Théâtre National du Palais du Chaillot program reproduced the front curtain design in color and included a Matisse pen and ink drawing showing two figures engaged in either a ballet lift or a struggling embrace. This drawing combines a major theme from *Rouge et Noir* with the artist's personal concern for rendering confrontations of dual psychological and physical forces. An earlier drawing dated May 16, 1935 (see Besson 1942, ill. no. 28, inscribed "d'après Pollajolo") suggests a relationship to the theme of Hercules and Antaeus. A subsequent variation of the theme is found in the upper left corner of *Le Jardin d'hiver,* 1938 (St. Louis, Pulitzer Collection). A 1938 watercolor of the theme (published Paris 1962, no. 24) is entitled *Etude pour le quatrième mouvement du ballet "Etrange farandole."* All of these images relate closely to the design of the *Rouge et Noir* front curtain and its paper cut-out maquette.

The ballet's décor, following Matisse's suggestion, was restricted to five colors: red, black, white, yellow, and blue. The two figures in white were the hero and heroine; the black leader and figures represented evil destiny; the red dancers were allied with the black; yellow symbolized material activities; and blue represented spiritual attributes (Barr 1951, p. 254). The front curtain design incorporates four of these colors. The central dancing figure is black, with white, yellow, and blue forms behind the figure set upon a yellow surrounding margin.

The program of the ballet is as follows. First movement ("Aggression"): Man, symbolizing the poetic spirit, is pursued and overtaken by brutal forces. The principal dancing groups are white, black, and yellow. Second movement ("City and Country"): the men of the city confront the men of the country and carry them away. Dancers in red, blue, yellow, and white. Third movement ("Solitude"): Woman is tormented in her solitude by an evil spirit. Dancers in black, white, and blue. Fourth movement ("Fate"): Man escapes his pursuers, finds Woman again, but his joy is short-lived because, in spite of his efforts toward freeing himself, he is overcome by his destiny. Dancers in white, black, red, and blue (Ballets de Monte-Carlo 1939-2).

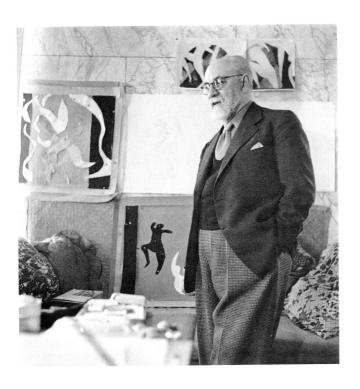

Fig. 35. Henri Matisse, Nice, 1937/38.
On wall: left, *Danseur*, no. 7; lower center, *Figure de ballet avec deux danseurs*, no. 8; center, two drawings relating to maquettes for *Rouge et Noir*; above, photograph of an early state of *La Danse I* (Precursor B).

The background scenery for *Rouge et Noir* derives from the Barnes Foundation *La Danse* mural projects. Massine, who had seen *La Danse I* in Matisse's studio, possibly as early as 1934 (see Porte 1939-2; Matisse 1972, p. 143, n. 7), felt that the theme of the mural was suitable for his ballet and urged Matisse to use it as the fundamental design. The scenery thus evolved with a central lunette and two partial side lunettes. From this Barnes mural format, Matisse removed the figures and simplified the central lunette composition into three overlapping planes of red, blue, and black. The flat archivolts of the Barnes mural arrangement were projected architecturally onto the stage as white pillars supporting bright yellow vaults. The removed figural elements were, in effect, replaced by live dancing groups in the ballet, which were often staged in semi-stationary tableaux in front of the scenery (see figs. 36-37). (See Massine 1939; also *Yale Literary Magazine* 1955, p. 124, and Massine writings in Documents Appendix, 18.) This backdrop is now in the collection of Butler University, Jordan College of Music, Indianapolis.

7 □

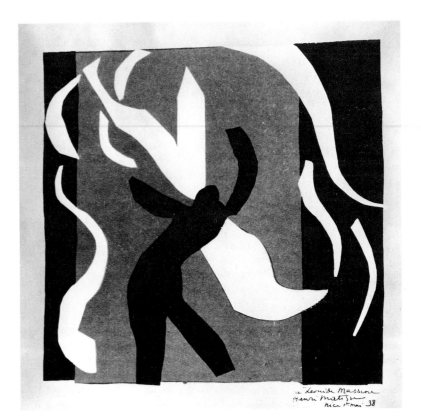

Fig. 36. *Rouge et Noir*, 1939. Scenery and costumes designed by Matisse. See remarks no. 7.

Fig. 37. Scenery for the ballet *Rouge et Noir*, from a cut-out design by Matisse, 1939. Scenery now property of Butler University, Jordan College of Music, Indianapolis. See remarks no. 7.

***8 Figure de ballet avec deux danseurs**

Ballet Figure with two Dancers

1937/38

61 x 62 cm.
24 x 24⁷⁄₁₆ in.

Not signed or dated

Exhibitions: Aix-en-Provence 1960, no. 66,
entitled *Etude pour un ballet;* Albi 1961,
no. 161, entitled *Etude pour un ballet*

Collections: Private Collection, France

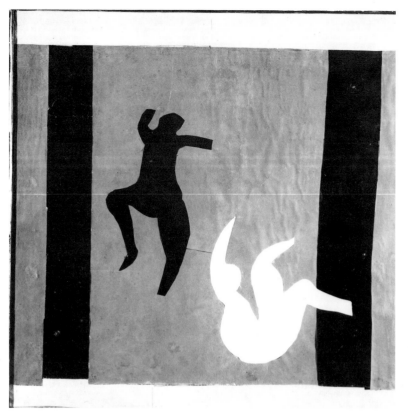

8

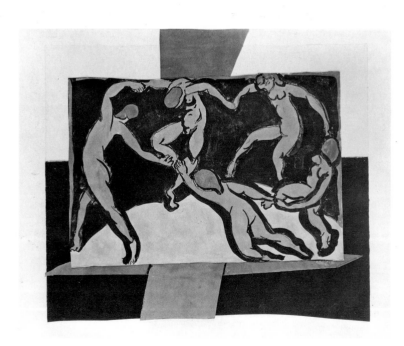

9

***9 La Danse**

The Dance

1938

Painted cut and pasted paper, brush and
ink

48.5 x 61.5 cm.
19⅛ x 24¼ in.

Signed: *H Matisse* (lower right)

Exhibitions: Boston 1939, no. 55 (ill. p. 64)

Bibliography: *Verve* 1938 (ill. color pp.
52-53)

Collections: Richard S. Davis; Richard,
Margery, and John Davis, New York

Matisse produced this work, whose central
image is a replica of his painting *La Danse,*
1910 (Leningrad, State Hermitage
Museum) as the maquette for a litho-
graphic reproduction in *Verve,* 1938. The
painted and cut margin papers were prob-
ably added to adjust the image to the
Verve format.

10 **Verve**, II, 8, 1940 (cover maquette, "Symphonie chromatique")

1939

37 x 55 cm. (approx.)
14⁹⁄₁₆ x 22¹¹⁄₁₆ in. (approx.)

Signed: *Henri Matisse 31/8 39*

Bibliography: *Verve* 1940, p. 7 (French ed.), p. 9 (American ed.)

Collections: Private Collection

In the French edition of this number of *Verve*, p. 7, there is an unsigned explanatory text which reads:

On the eve of the war, Henri Matisse finished the cover for Verve. The 26 printings necessitated by the 26 different colors of the leaves demanded arduous labor. We printed this symphonie chromatique, as

Matisse called it, quite slowly. In February, he wrote to us: "I am very happy to see that your perseverence has been rewarded by this war number which seemed almost unforeseeable when I went to see you at the rue Férou. It is true that I made the cover for it there and then; I showed my own mettle, too."

In the American edition of the same number of *Verve*, p. 9, there is an unsigned explanatory text longer than that in the French edition, which reads:

These leaf studies led the artist to extend his researches in arboreal details to those of the persons in his paintings. His drawing, Hands [this drawing of hands, dated December 13, 1939 is not included in the French edition] *is a part of this work and Matisse himself emphasizes its value:* "I

attach importance to these hands because, for me, they represent increased interest in my work. Hands, like the leaves on trees, have assumed a reality which they didn't have up to now. I devoted myself entirely to the representation of my personage by the head, the body and the arms and legs, as in the case of trees I did by the trunk and branches: as for the hands and leaves, I considered them merely as terminations which did not appear to me necessary—and hence were boring. I now begin painting a person by the hands."

Tériade has written (Matisse 1957): "This time he asked me to supply him with some samples of printer's colors. He wanted to work with these colors in order to permit accurate reproduction when they were printed."

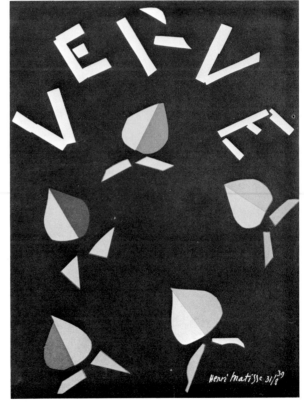

10 □

11

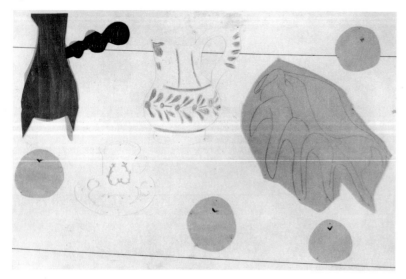

*11 **Nature morte au coquillage**

Still Life with Shell

1941

Painted cut and pasted paper, string, tracing paper, colored pencil and charcoal, pinned on canvas

60 x 81.3 cm.
23⅝ x 32 in.

Not signed or dated

Exhibitions: Los Angeles 1966, no. 335 (color pl. p. 170)

Collections: Private Collection

A cut-paper interpretation of Matisse's November 1940 painting *Nature morte au coquillage* (fig. 23). The implied plane of the table is established by two black strings. The shell in the cut-out, while drawn on tracing paper, is not, however, a tracing from the Pushkin Museum painting. This shell was brought back from Tahiti in 1930 by Matisse, who used it frequently in his work.

*12 Verve, IV, 13, 1945 (preliminary cover maquette)

pre-June 1943

36.5 x 55.5 cm.
14⅜ x 21⅞ in.

Not signed or dated

Bibliography: Matisse 1957, p. 45; Aragon 1971, II, p. 37

Collections: Marguerite Lang; (Palais Galliera, Paris, *Succession de Madame Lang Tableaux Modernes,* March 4, 1972, lot no. 39, ill.); Berggruen et Cie; Private Collection; Stephen Hahn, New York

The cover of *Verve,* IV, 13, as printed is not the same as this maquette design. Several of the compositional elements were shifted, and the actual cover was printed in green and white only. This preliminary maquette, on the other hand, has black, yellow, red, purple, and yellow/ orange, as well as green and white, elements. It has been said that in the process of the cover publication, Matisse was favorably struck by the appearance of the green and white first printing sequence proof and decided to use it directly as the final cover. Yet, owing to the number of changes between the preliminary maquette and the final cover, it seems likely that a green and white maquette was also made.

Concerning the general history of Matisse's early paper cut-out projects, Tériade has written:

In 1943, Matisse offered to design the cover for a new issue of Verve. *He summoned Angèle Lamotte and myself to Cimiez and there showed us not only the cover for* Verve *(vol. IV, no. 13) but also two large bright colored plates—*The Clown *and* The Toboggan*—which were to be the first and last pages of* Jazz. *The* Jazz *cycle was born. The other pages for the book were executed in Vence in the villa "Le Rêve" where he had established himself.* (Matisse 1957, p. 45)

See no. 8 for cut figures stylistically close to the figures in this maquette.

13 Verve, IV, 13, 1945 (cover maquette)

c. 1945

37 x 55 cm. (approx.)

14⁹⁄₁₆ x 22⅝ in. (approx.)

Signed: not known

Collections: present location unknown

See remarks no. 12.

In comparison to the preliminary maquette, no. 12, the final *Verve* cover has different lettering, the star or shell bursts are more numerous, additional triangular shapes have been placed throughout the composition, and the figures (most notably that on the back cover) have been cut in a variant design. The extent of these variations argues for the existence of the maquette which we list here.

The figure of the woman tumbling on her back is exactly the same as the tumbling figure in *Le Toboggan,* no. 17. These two figures have the following origins: a figure in the first version of the Barnes *La Danse I;* a reformulation, even closer to the *Verve* and *Jazz* figures, in the central panel of the Barnes *La Danse II* (see fig. 31); another reformulation, in the illustrations of "fighting women" which Matisse did for Joyce's *Ulysses* in 1934; finally, a reformulation, this time reproducing this figure almost line for line, in the 1938 gouache study for *Rouge et Noir.*

The ultimate source for this figure seems to be the right-hand bather in the Cézanne *Trois Baigneuses* (Paris, Petit Palais) that Matisse owned—a motif which is echoed in several of Matisse's early pastoral subjects (such as *Bonheur de vivre,* Merion, Pa., Barnes Foundation and *Le Luxe II,* Copenhagen, Statens Museum for Kunst) before its eventual incorporation into the Barnes *La Danse II.* This figure would also serve as the theme for the variations seen in the *Nu bleu I-IV,* nos. 167-170, and in *Femmes et singes,* no. 178.

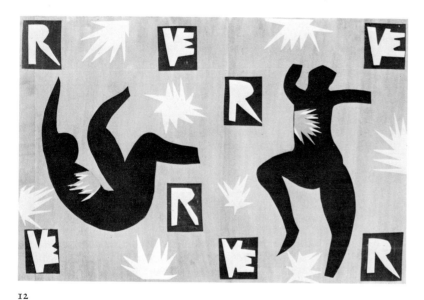

12

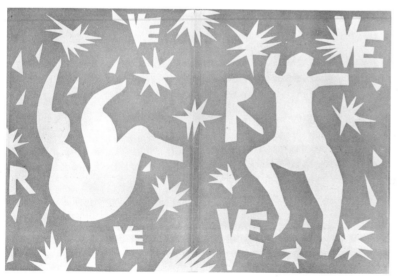

13 □

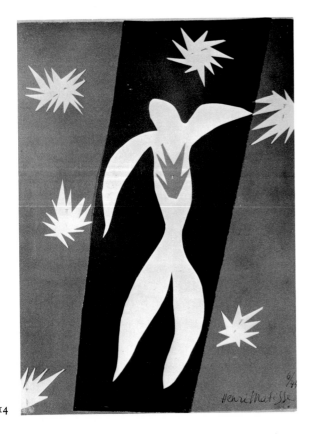

14

15 □

14 La Chute d'Icare

The Fall of Icarus

1943

Painted cut paper, pinned to support

35 x 26.5 cm. (approx.)
13¾ x 10½ in. (approx.)

Signed: *Henri Matisse/6/43* (lower right)

Bibliography: *Verve* 1945 (color pl. p. 7); Alpatov 1969 (color pl. p. 77); Diehl 1970 (ill. p. 61); Aragon 1971, II, p. 35 (color pl. IV)

Collections: Tériade, Paris

Some of the elements in this cut-out are still affixed with straight pins and are not fully pasted down. This is a prototype of the Icarus image later to be published in *Jazz*, no. 24. Aragon has written:

The Fall of Icarus . . . between two bands of deepest blue, contained a central bundle of black rays against which Icarus was set out in white like a corpse, and from Matisse's own confidential comments we gather that the yellow splashes, suns or stars according to mythological interpretation, stood for bursting shells in 1943 . . . (Aragon 1971, II, p. 35)

Color plate II

15 De la Couleur

About Color

Summer 1943?

35 x 26.5 cm. (approx.)
13¾ x 10½ in. (approx.)

Signed: *de / la/ couleur/ HM* (lower center)

Bibliography: *Verve* 1945 (ill. color p. 5)

Collections: present location unknown

The title head design for *Verve,* IV, 13, 1945.

The association here of color with the image of the black sun suggests Matisse's conception of *color as light.* (See Matisse 1972, p. 202 and Matisse, "Black is a Colour," in Flam 1973, p. 106).

Nos. 16-35 Maquettes for Jazz, 1943-44

In 1942, Tériade and Angèle Lamotte asked Matisse—whose previous book illustrations had been done largely in black and white—about the possibility of doing an illustrated album in color. Matisse, initially less than enthusiastic about the idea, nevertheless attempted a cut-paper version of his *Le Rêve de 1940* (Private Collection); he was dissatisfied with this and later destroyed it. The idea of a suite of book illustrations seems, however, to have struck a responsive chord, and later, while he was doing the cut-paper cover for *Verve,* IV, 13 (see nos. 12-13), he also worked on the two compositions that eventually were incorporated into *Jazz* as *Le Clown* and *Le Toboggan*—both of which were completed before the idea for the book became firm in his mind. (As late as January 1943, Matisse described his illustrations of Ronsard's love poems as "my most important work as an illustrator." See Bouvier 1943.)

Matisse moved to Vence in 1943 in order to avoid the expected bombardment of Nice. Physically weakened by his own illness and distressed by events around him, he was unable to paint, and took up in earnest the project for a book illustrated with pictures done in cut and pasted paper (L.D. 1976; Tériade 1976).

Although Matisse himself described the project as "ce joujou d'un sou" (this penny plaything) (see Documents Appendix, I), and a close associate has described it as a kind of "children's book," the suite of plates that became *Jazz* played a crucial part in the last phase of his career. It is also one of the few works on which, because of his physical condition, he worked directly with an assistant (Lydia Delectorskaya, who has so kindly contributed her comments, below, on the iconography of the images).

Documentary evidence suggests that the viability and general format of the book were probably not finally decided until the spring of 1944. At this time Matisse wrote at length to Tériade describing some of the pictures and agreed to an interview with Gaston Diehl (published April 29, 1944), in which he discussed a number of the completed images. Diehl reported that the album would consist of large plates "entitled either 'The Circus' or maybe 'Jazz' . . . for which Tériade will get together a text for the illustrations." Tériade (1976) recalled that Matisse chose *Jazz* for the title because "the découpages correspond to the spirit of jazz. Music was indispensible to Matisse. Cut paper was like jazz music." Later, Matisse decided to write the text himself, "because he couldn't think of an appropriate text that already existed" (Tériade 1976). It also seems possible that

Matisse's decision to have his text reproduced in his own handwriting was influenced by Pablo Picasso, who also had written poetry with the intention of publishing it in holograph, in order to exploit the visually expressive nature of handwriting (see Penrose 1958, pp. 250, 255, 267, 288). In any case, Matisse wrote the *Jazz* text in 1946, well after the pictures were finished. (Some of the maquettes are signed and dated in ink, "Henri Matisse juillet 1946"; they were probably signed around the same time that the text was written, just before they were sent to the publisher.) According to Lydia Delectorskaya (1976), the text was composed spontaneously, but written out four or five times, until the artist had found the manner of expression and size of handwriting which best suited him. Although most critics have accepted Matisse's claim that the text and the pictures are unrelated (see Barr 1951, pp. 274-275; Aragon 1971, II, p. 306; Goldin 1975, p. 53), it is evident that a subtle, but definite and largely conscious, relationship exists. (See Flam, "*Jazz*," above, and remarks nos. 17, 20, 23, 24, 25, below).

The care with which *Jazz* was printed has become legendary—yet the difference between the book and the original maquettes, which have only once been publicly exhibited (Paris 1973), is enormous. Although the printed book preserves much of the "cut-paper" quality of the originals, the maquettes are much fresher, have a much greater variation in texture and in color *application* as well as color, a much more sensitive line quality, and an unreproducible subtlety in the play between opaque and semi-opaque surfaces. Matisse himself was of course well aware of these differences, and was initially disappointed with the printed images (see Matisse's important letters to André Rouveyre in Matisse 1972, pp. 240-241).

Nevertheless, *Jazz,* because of its portable and replicable format, as well as its daring and seminal repertory of forms, has very likely been Matisse's most influential single cut-out work.

The book was published by Editions Verve on September 30, 1947 as a folio (42 x 32 cm.) containing one hundred forty-six pages and four leaves. The 20 stencil plates (15 double page) were printed by Edmond Vairel, using the same Linel colors that Matisse had used for the cut-outs. The cover and manuscript pages were printed by Draeger Frères. The edition consisted of 250 numbered copies (and 20 copies, numbered I-XX, *hors commerce)* on vellum; 100 albums of plates only were also printed.

Major Exhibitions of Jazz: Paris 1947; Rio de Janeiro 1947; New York 1948; Philadelphia 1948 (but not listed in cat.); Paris 1949; Lucerne 1949; Tokyo 1951; Cambridge 1955; St. Gall. Kunstverein, "Dichtende Maler, Malende Dichter," 1957; Geneva. Nicholas Rauch, "Les Peintres et le livre," 1957; Krefeld. Kaiser Wilhelm Museum, "Henri Matisse—Einzelblätter, Bucher, *Jazz,* Zirkusmotive," January-February 1959; Geneva 1959; New York. The Museum of Modern Art, "*Jazz* by Henri Matisse," June 17-September 15, 1960; Aix-en-Provence 1960; Bern 1960; Paris 1961; Boston. Museum of Fine Arts, "The Artist and the Book, 1860-1960," May 4-July 16, 1961; New York 1961; Helsinki 1965; Los Angeles 1966; Saint-Paul de Vence 1969; Paris 1970; Copenhagen 1970-1; Los Angeles. County Museum of Art, "The Apocalypse of Saint-Sever, ca. 1028-1072—Henri Matisse: *Jazz,* 1943-1944," April 11-May 28, 1972; Paris 1973; London. Royal Academy of Art, "Hommage à Tériade," August 9-October 12, 1975; New York. Issenbacher Gallery, "The Graphic work of Henri Matisse Featuring *Jazz,*" February 15-March 5, 1977

Selected Bibliography on Jazz: Diehl 1944; Barr 1951; Matisse 1957; L.D. 1964; Aragon 1971; Matisse 1972; Flam 1973; Paris 1973; Goldin 1975; Flam 1976; L.D. 1976; Tériade 1976

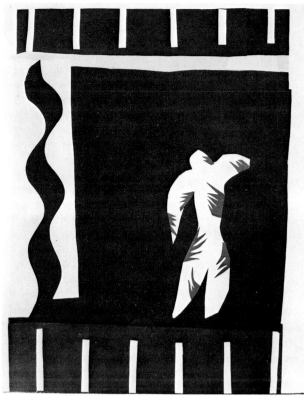

16 □

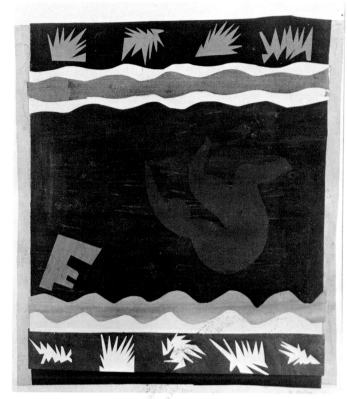

17

16 Le Clown

The Clown

early 1943

41 x 30.5 cm. (approx.)
16⅛ x 12 in. (approx.)

Signed: *H. Matisse/ Juin 43* (lower right)

Exhibitions: Paris 1973

Bibliography: *Jazz,* pl. I

Collections: Tériade, Paris

The clown stands before the circus, at the *parade.* The black and yellow curvilinear forms on the left denote the curtain; the blue horizontals, the architecture of the ramp (L.D. 1964, 1976).

Le Clown was begun in 1938, as one of the preliminary curtain design studies for the ballet *Rouge et Noir,* and was probably finished before Matisse moved to Vence in June 1943, before the idea for *Jazz* had taken shape (L.D. 1976).

The form of the figure is very similar to the *Verve* Icarus, no. 14, and also to the

Jazz Icarus, no. 24, which is basically the same figure reversed. The red flame-like shapes recall those of the *Rouge et Noir* male dancer costumes, and are distantly related to some of the costumes for *Le Chant du rossignol,* 1920. The image of the curtain is strikingly similar to that in *Le Rideau jaune,* 1914-15 (Brussels, M. Marcel Mabille Collection), one of Matisse's flattest and most abstract early paintings.

17 Le Toboggan

The Toboggan

early 1943

32.5 x 29 cm. (approx.)
12¾ x 11⅜ in. (approx.)

Signed: *H. Matisse / Juin 43* (lower right), *Bon* (lower center)

Exhibitions: Paris 1973

Bibliography: *Jazz,* pl. XX

Collections: Tériade, Paris

A female figure in a rolling fall, as in the descent of a toboggan (L.D. 1964).

The form of the figure (see nos. 12-13) and the central part of the composition were executed in 1938. The horizontal pink strip, in fact, is cut from the same paper as *Petit Danseur sur fond rouge,* 1937/38, no. 5, and the form to the left of the figure here is the same as the letter E from the *Verve* cover, no. 13—a telling instance of Matisse's use of repertorial forms. The red and yellow jagged forms on the top and bottom of the composition appear to express violent action and anticipate the similarly abstract suggestion of time and action in *Les Mille et Une Nuits,* no. 111. In the original maquette, the violet background is heavily brushed, giving a looser, freer effect than the printed version.

Cf. *Jazz* text: "He who loves, flies, runs, and rejoices; he is free and nothing holds him back."

Color plate III

18 Le Cirque

The Circus

1943

36.2 x 55 cm. (approx.)
14¼ x 21⅝ in. (approx.)

Signed: *H. Matisse/Juillet 46* (lower right)

Exhibitions: Paris 1973

Bibliography: *Jazz,* pl. II; Marchiori 1967
(pl. 105, p. 111)

Collections: Tériade, Paris

The circus, a banner, a red carpet, and a
high-wire walker (L.D. 1964). The banner
and related forms on the left suggest the
circus entrance, the yellow horizontal
band on the right suggests a trapeze (or
high wire), and the "red carpet" a safety
net (L.D. 1976).

The composition dates to 1943, at which
time Matisse thought of calling the book
Le Cirque (see Diehl 1944, Matisse 1957).

Clearly related to the cover study for
Verve, no. 12, this composition is organ-
ized as though it too might once have been
considered as a book or periodical cover.
The center break, corresponding to the
spine of a book, divides the format into
equal halves, each with its own title and
parallelogram trapeze, but with the
"front" cover on the right side emphasized
by the spotlit, silhouetted figure. The
alignment of "CIRQUE" along the right
vertical "spine" reinforces this hypothesis.

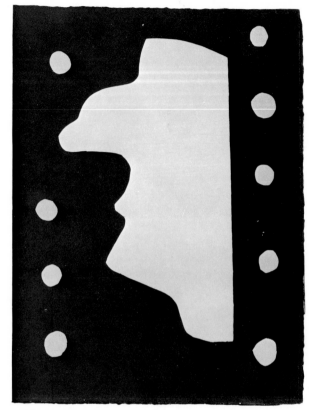

19 □

18 □

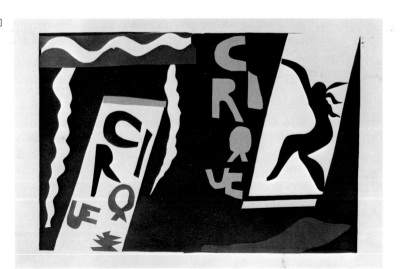

19 Monsieur Loyal

1943

42.2 x 32.3 cm. (approx.)
16⅝ x 12¾ in. (approx.)

Signed: *H. Matisse/Juillet 46* (lower right)

Exhibitions: Paris 1973

Bibliography: *Jazz*, pl. III

Collections: Tériade, Paris

Monsieur Loyal: Joseph-Léopold Loyal (1835-1889), ringmaster of the Cirque de l'Impératrice and Cirque Napoléon, descendant of a long line of circus riders. He is the classic ringmaster, who plays straight man to the clowns during the the equestriennes.

The profile of Monsieur Loyal stands out from the blue of his traditional gold-buttoned costume (L.D. 1964). It appears to suggest Charles de Gaulle. The form was originally cut for the sword-swallower, no. 29—which may be seen by turning the image upside down. The composition in its present form was seen by Diehl in the spring of 1944 and by Tériade, probably in 1943 (Diehl 1944, Tériade 1976).

A possible literary source for the image, further evidence of a Picassian influence on *Jazz*, is suggested in a story recounted by Fernande Olivier in *Picasso et ses amis*, Paris, 1933—a book which Matisse surely knew. Olivier relayed how a naval officer told Picasso of a visit to a sculpture-producing tribe in Africa:

He showed them a photograph of himself in uniform. One member of the tribe took it, looked at it, turned it upside down and sideways *and returned it without having made out or understood what it was. The explorer . . . explained that it was a picture of himself. The man laughed incredulously, and taking paper and pencil began making a portrait of the officer. He drew the head, the body, the legs and the arms, as he saw them, in the traditional style of tribal figures . . . [then] he took the drawing back in order to add the shiny buttons of the uniform . . . he saw no reason to put the buttons in their proper place. Instead, he surrounded the face with buttons!* (Emphases added) (Olivier 1964, p. 175)

20 Le Cauchemar de l'éléphant blanc

The Nightmare of the White Elephant

1943

42.5 x 65 cm. (approx.)
16¾ x 25⅝ in. (approx.)

Signed: *H. Matisse 43*

Exhibitions: Paris 1973

Bibliography: *Jazz*, pl. IV

Collections: Tériade, Paris

The white elephant (white, symbol of victims of captivity and training) performs his act standing on a ball, in the brilliant light of the circus; while the memories of his natal forest (black, primitive and forceful) strike him like tongues of flame, with the violence of arrows (L.D. 1964). The red forms that pierce the elephant may symbolize suffering, as does the red in the Vence chasubles (see nos. 149-151). The black form to the upper left represents a mosquito.

The composition was seen by Diehl (1944) in the spring of 1944.

The allusion here seems to be a parable concerning an artist's career. Cf. *Jazz* text:

Think that all those who have succeeded, as they look back to the difficulties of their start in life, exclaim with conviction, "Those were the good old days!" For most of them success = Prison, and the artist must never be a prisoner. Prisoner? An artist must never be a prisoner of himself, prisoner of a style, prisoner of a reputation, prisoner of success, etc. Didn't the Goncourt brothers write that Japanese artists of the great period changed their names several times during their lives? This pleases me: they wanted to protect their freedom.

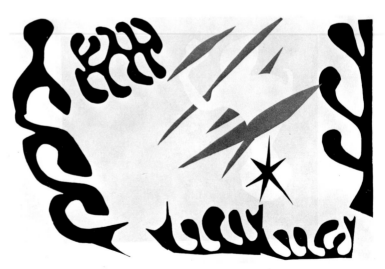

20 □

105

21 Le Cheval, l'écuyère et le clown

The Horse, the Rider, and the Clown

1943

41.9 x 65.4 cm. (approx.)
16½ x 25¾ in. (approx.)

Signed: not known

Exhibitions: Paris 1973

Bibliography: *Jazz,* pl. V

Collections: Tériade, Paris

The equestrienne is evoked by her black and white skirt which spreads over the back of the horse; the clown by his costume of green, black, and yellow; the yellow strip is the whip of Monsieur Loyal (L.D. 1964).

This composition was seen by Diehl (1944) in the spring of 1944.

The yellow color of the whip seems to relate it in fact to the clown, who in this scene takes the part of Monsieur Loyal— a doubling of role which is quite common in the modern circus (see *Grande Larousse* 1962, IV, p. 892).

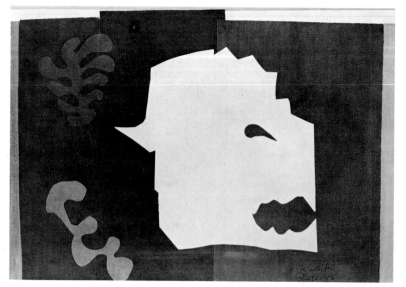

22

21 □

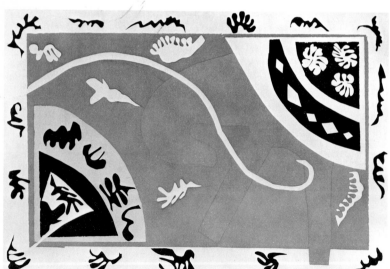

22 Le Loup

The Wolf

1944

42.2 x 65 cm. (approx.)

16⅝ x 25⅝ in. (approx.)

Signed: *H. Matisse/ Juill. 46* (lower right)

Exhibitions: Paris 1973

Bibliography: *Jazz,* pl. VI

Collections: Tériade, Paris

His eye is bloody, his mouth ready to bite (L.D. 1964).

At the beginning of a letter to Tériade written March 7, 1944, which contains a sketch of *Le Loup,* Matisse wrote: "The better to eat you with, my child—double page—white on a blue ground bordered with green, verso; and a cyclamen ground bordered with orange, recto" (see Documents Appendix, I). A notation below the sketch reads: "eye red." The allusion is of course to "Little Red Riding Hood."
In the original maquette, the semi-opaque white allows the warmth of the violet on the right side of the head to come through, heightening the intensity of the image.

Color plate IV

23 Le Coeur

The Heart

1943-early 1944

38.1 x 61 cm. (approx.)

15 x 24 in. (approx.)

Signed: *H. Matisse / Juill. 46* (lower right)

Exhibitions: Paris 1973

Bibliography: *Jazz,* pl. VII

Collections: Tériade, Paris

The tenderness of the human heart (L.D. 1964).

The first of several *Jazz* compositions (see nos. 30-31) which are based on a two-part "active/passive" compositional format.

The heart shape has a long and interesting history in Matisse's work. It is metaphorically alluded to as early as the *Portrait of Mlle. Yvonne Landsberg,* 1914 (The Philadelphia Museum of Art), a complex image where it suggests tenderness (see Barr 1951, pp. 184-185; Flam 1976); and in more overt form, in the leaves of *The Conservatory,* 1938 (St. Louis, Pulitzer Collection). Its literal use in *Le Coeur* clearly anticipates nos. 97 and 111.

The formal composition of *Le Coeur* is most closely related to *Le Destin,* no. 32, which also juxtaposes an image of human tenderness with one of impersonal fate. (The image of the artist is also suggested, not only by the color red—see Flam 1976 and remarks no. 20—but in the juxtaposition of the human heart with a window-like "blank-picture" image strongly reminiscent of *Porte-fenêtre à Collioure,* 1914; Paris, Private Collection).

The theme of love is central to the *Jazz* text: "Love alone makes light that which is heavy ... makes sweet and pleasant all that is bitter ... Nothing is more gentle than love, nothing stronger, nothing higher, nothing larger, nothing more pleasant, nothing more complete, nothing better. ..."

23 □

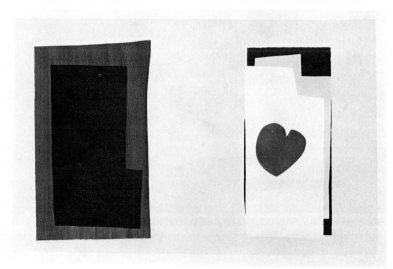

24 Icare

Icarus

1943

40.5 x 27 cm. (approx.)
16⅝ x 10⅝ in. (approx.)

Signed: *H Matisse Juill 46* (lower right)

Exhibitions: Saint-Paul de Vence 1969,
no. 28; Paris 1973

Bibliography: *Jazz,* pl. VIII

Collections: Tériade, Paris

Icarus, with a passionate heart, falls from
the starred sky (L.D. 1964).

This image is closely related to no. 14,
which Matisse dated "6/43," and was
probably done about the same time. Once
again, the color red denotes the heart—
"passionné" (passionate)—here of a
mythical figure whose quest is comparable
to the ambitions of the artist.

The broadly brushed sky of the original
maquette is much more airy than the
printed version.

The image of Icarus is wryly placed at the
end of the "Airplane" section of the *Jazz*
text, which speaks of a return from "an
enchanted world" to "our modest condi-
tion of walking."

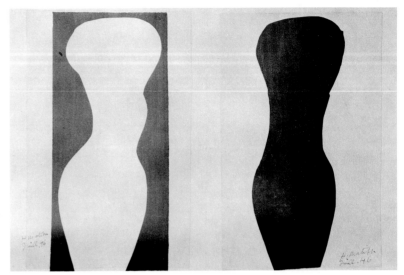

25

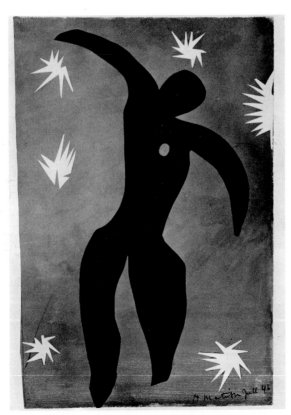

24

25 Formes

Forms

1943-early 1944

42.2 x 65.5 cm. (approx.)
16⅝ x 25¾ in. (approx.)

Signed: *H. Matisse/Juill. 46* (lower left),
H. Matisse/Juill. 46 (lower right)

Exhibitions: Paris 1973

Bibliography: *Jazz,* pl. IX; Aragon 1971,
II, pp. 307-308

Collections: Tériade, Paris

For a related work see no. 36.

To give the same visual weight to the
white and blue torsos—which originally
were identical—the upper part of the blue
torso had to be made heavier (L.D. 1964).

The composition is mentioned in Matisse's
March 7, 1944 letter to Tériade: "I've done
neither 'Nini casse-cou' nor 'Joseph casse-
tout'—but plastic Poses, 2 beautiful torsos;
on the verso: near-white gray on sky blue;
and on the recto: sky-blue torso on a
near-white pearl gray ground" (see Docu-
ments Appendix, I).

This positive and negative of a torso seen
at slightly different angles is related to
Matisse's sculpture *Petit Torse mince* of
1929 (Paris 1975, no. 224, p. 239). The
white and blue silhouettes may also refer
to the effect of seeing a marble statue in
both full sunlight and *contre-jour.* Both
extremes eliminate (depending on the
background) internal detail and stress the
overall shape. In the blue nudes of 1952
(nos. 167-181), Matisse dealt with similar
concerns.

The exquisite clarity of the draughtsman-
ship (not unlike that of the mid-1930s pen
drawings) is much more apparent in the
original maquette than in the book. The
white figure is clearly in the same pose as,
and shares some of the voluptuousness of,
the standing female figure to the far left of
Bonheur de vivre, 1905-06 (Merion, Pa.,
Barnes Foundation).

The problem of proportion and expression
set forth here is nicely stated in the *Jazz*
text: "the character of a face in a drawing
depends not upon its various proportions,
but upon a spiritual light which it reflects
. . . two drawings of the same face may
represent the same character though
drawn in different proportions."

26 L'Enterrement de Pierrot

Pierrot's Funeral

1943

42.5 x 65 cm. (approx.)
16¾ x 25½ in. (approx.)

Signed: *H Matisse 43*

Exhibitions: Paris 1973

Bibliography: *Jazz,* pl. X

Collections: Tériade, Paris

A funeral, with dead autumn leaves; but
since it is the funeral of a Pierrot, it is
nonetheless fresh and sprightly (L.D.
1964). The leaves in the upper violet band
are those of the Maritime Arrowhead, a
plant about which Matisse was passionate
at the time (L.D. 1976).

Tériade (1976) recalled seeing this com-
position in 1943. According to L.D., this
was done about half-way through the
sequence of *Jazz* compositions.

Matisse had been gravely ill two years
before, and it seems probable that the
mock funeral here refers to his own brush
with death. The red shape inside the car-
riage suggests, within the context of the
Jazz imagery, the passionate heart of
Pierrot—and perhaps of the artist.

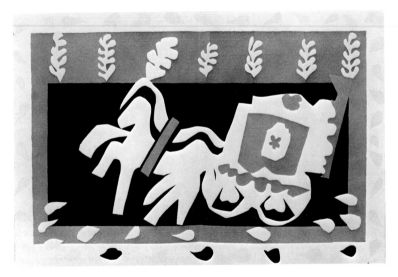

26 ☐

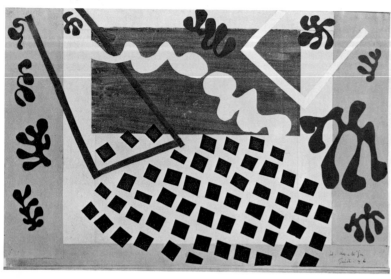

27

27 Les Codomas

The Codomas

early 1944

42.2 x 65 cm. (approx.)
16⅝ x 25⅝ in. (approx.)

Signed: *H. Matisse/ Juill.46* (lower right)

Exhibitions: Paris 1973

Bibliography: *Jazz,* pl. XI

Collections: Tériade, Paris

The Codomas brothers (celebrated trapeze artists at the beginning of the century), watched by a violet clown (at right), execute their perilous leap above an extended net (L.D. 1964).

This composition was seen by Diehl (1944) in the spring of 1944. The subject matter here anticipates the later acrobats, no. 175. Matisse had on several occasions compared himself to a juggler, an acrobat, and a tight-rope walker (see Escholier 1956, p. 145; Flam 1973, pp. 81, 107; see also the rubrics *Acrobate* and *Jongleur* in the index to Matisse 1972).

Color plate V

28

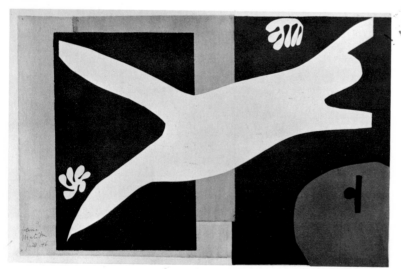

28 La Nageuse dans l'aquarium

The Swimmer in the Tank

1944?

42.2 x 65.5 cm. (approx.)
16⅝ x 25¾ in. (approx.)

Signed: *Henri/Matisse/ Juill. 46* (lower left)

Exhibitions: Paris 1973

Bibliography: *Jazz,* pl. XII

Collections: Tériade, Paris

The female swimmer is in an aquarium (a spectacle which Matisse had seen on the stage of one of the large Parisian "music halls") watched by the rubicund face of the fascinated spectator (L.D. 1964).

Matisse would return to a similarly "floating" figure for the cut-out on the back of the *Pierre à Feu* cover, no. 41.

The swimmer is related to Matisse's earlier paintings with goldfish, the red here being the color of the human observer rather than of the object observed. This composition, with its theme of "observer observed" is directly related to *Woman Before an*

Aquarium, 1921 (The Art Institute of Chicago). The "observer observed" theme goes back at least as far as *Woman Reading,* 1894 (Paris, MNAM) and *Carmelina,* 1903 (Boston, Museum of Fine Arts) in which the *red*-shirted artist is seen reflected in the mirror next to the model (see Flam 1976).

In the *Jazz* "Table des Images" the swimmer is drawn with a clearly female breast.

29 L'Avaleur de sabres

The Sword Swallower

1943-early 1944

36 x 27 cm. (approx.)
14⅛ x 10⅝ in. (approx.)

Signed: *Juill. 46/H Matisse* (lower right)

Exhibitions: Paris 1973

Bibliography: *Jazz,* pl. XIII

Collections: Tériade, Paris

See remarks no. 19.

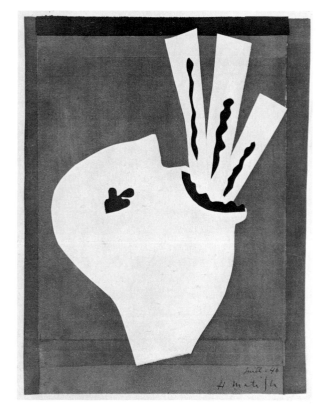

29

30 Le Cow-Boy

The Cowboy

1943-early 1944

42.2 x 65.2 cm. (approx.)
16⅝ x 25⅝ in. (approx.)

Signed: *H. Matisse/Juill 46*

Exhibitions: Paris 1973

Bibliography: *Jazz,* pl. XIV

Collections: Tériade, Paris

The cowboy on rearing horse lassos a woman (L.D. 1964). This image may refer to the cowboy routines once popular in Parisian revues such as the Folies Bergères.

Another active-passive, male-female composition, which alludes to the theme of artist and model. The fact that the centaur-like cowboy lassos a *woman* compounds the metaphorical allusion, giving the theme historical (and art historical) depth. The artist and model theme is a persistent one in Matisse's art (see Flam 1976). The color and vertical intervals of this composition recall *Le Peintre et son modèle,* 1917 (Paris, MNAM).

30 □

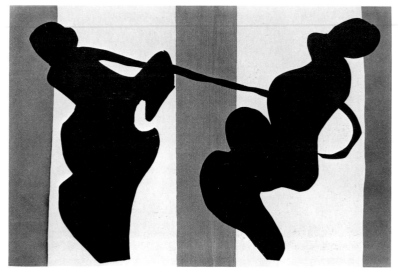

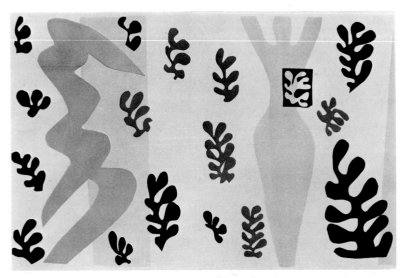

31 □

31 Le Lanceur de couteaux

The Knife Thrower

1943?-early 1944

42.2 x 65.2 cm. (approx.)
16⅝ x 25¾ in. (approx.)

Signed: *H. Matisse / Juill 46*

Exhibitions: Paris 1973

Bibliography: *Jazz,* pl. XV

Collections: Tériade, Paris

The knife thrower is translated into a mass of violent color (violet), delimited by a dynamic design. This is opposed by the soft (pale blue) color of the woman-target, her heart a flower, who is confident (L.D. 1964, 1976).

Another example of the male-female theme, *Le Lanceur de couteaux* suggests the artist and model, with the emphasis placed on the exacting demands of drawing as performance. Cf. *Jazz* text: *"If I have confidence in my hand* that draws, it is because as I was training it to serve me, I never allowed it to dominate my feeling." Cf. also Matisse, "Notes d'un peintre sur son dessin," Paris, 1939; Matisse 1972, pp. 159-163; Flam 1973, pp. 80-82. There is a fascinating visual pun here: the knife thrower himself is in the form of an African throwing knife.

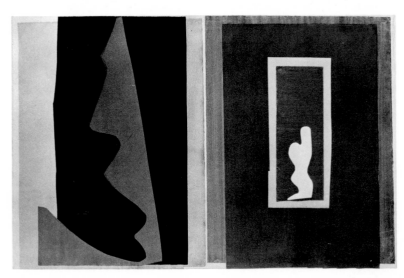

32

32 Le Destin

Destiny

1943-early 1944

42.2 x 65.5 cm. (approx.)
16⅝ x 25¾ in. (approx.)

Signed: *H. Matisse/ Juill. 46* (lower right)

Exhibitions: Paris 1973

Bibliography: *Jazz,* pl. XVI

Collections: Tériade, Paris

The small human couple (white) kneel, fearfully entwined, in the face of Destiny (black and violet), menacing and dangerous. Nearly the same violet (in slightly different values) is expressively quite different on the two sides of the same image —violent on the left, peaceful on the right. Destiny, composed of violet and black, defines a Negro mask—a reading which is confirmed in the schematic sketch in the "Table des Images" (L.D. 1964, 1976).

One of Matisse's most somber images, *Le Destin* was executed during the dark days of World War II and following an intense personal crisis. The double-profile image of Destiny owes a good deal to Pablo Picasso. The two white figures facing their destiny is a theme which goes back to the program of *Rouge et Noir* (see no. 7). The simple rendering of the embrace recalls the linoleum cut, *Etreinte,* 1940 (Paris, Bib. Nat., 1970, no. 150).

33 Le Lagon

The Lagoon

1944

42.2 x 65.5 cm. (approx.)
16⅝ x 25¾ in. (approx.)

Signed: *H. Matisse / Juill 46*

Exhibitions: Paris 1973

Bibliography: *Jazz,* pl. XVII

Collections: Tériade, Paris

Shimmering colors of the tropics, with animal or undulating forms which evoke calm waters (L.D. 1964).

The three *Lagon* compositions (see also nos. 34-35) appear to be the last three images Matisse executed for *Jazz,* and probably date to mid-1944. All three were made simultaneously, as indicated by the positive and negative shapes shared between them. Despite this mutual source, however, each *Lagon* achieves its own distinct sense of scale and focus, passing in sequence from the overall view in no. 33 to the close-up in no. 35. The *Lagons* anticipate not only the subject matter of many of the cut-outs that will follow *Jazz,* based on memories of Matisse's 1930 trip to the South Seas (see esp. no. 55, also nos. 56, 59, 60, 64, 114, etc.), but also the abstract, biomorphically-based reper-tory of forms and the all-over approach to composition which will become in-creasingly common in the later cut-outs.

The influence of Joan Miró is quite distinctly felt here.

Cf. *Jazz* text: "Lagoons: wouldn't you be one of the seven wonders of the Paradise of painters?"

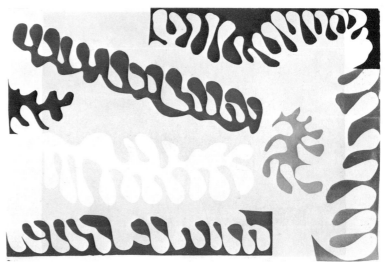

33 □

34 Le Lagon

The Lagoon

1944

40.5 x 60.5 cm. (approx.)
16 x 23¾ in. (approx.)

Signed: *H. Matisse/ Juill 46*

Exhibitions: Paris 1973

Bibliography: *Jazz,* pl. XVIII; *XXe
Siècle* 1970 (ill. p. 114)

Collections: Tériade, Paris

See remarks no. 33.

35 Le Lagon

The Lagoon

1944

42.2 x 65.5 cm. (approx.)
16⅝ x 25¾ in. (approx.)

Signed: *H. Matisse/ Juill 46*

Exhibitions: Paris 1973

Bibliography: *Jazz,* pl. XIX

Collections: Tériade, Paris

See remarks no. 33.

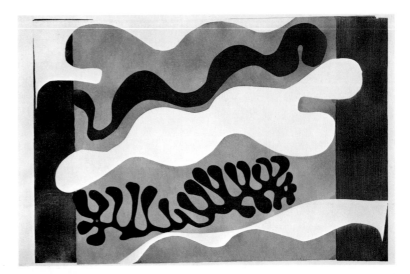

34 ☐

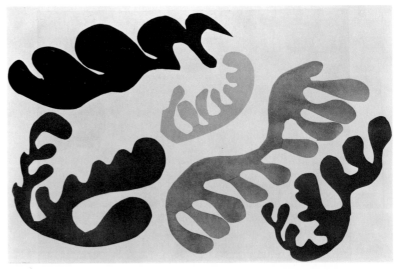

35 ☐

36 Composition

early 1944

42.2 x 65.5 cm. (approx.)
16⅝ x 25¾ in. (approx.)

Signed: not known

Collections: present location unknown

This work may no longer exist. In the
Cartier-Bresson documentary photograph
(fig. 18), the cut-out is hung above the
design for the *Jazz* composition, *Formes,*
no. 25, of which it was perhaps a variant.

***37 Le Dragon**

The Dragon

1943/44

42.5 x 65.5 cm.
16¾ x 25¾ in.

Signed: *H Matisse* (lower right)

Exhibitions: Aix-en-Provence 1960, no. 68;
Albi 1961, no. 163

Bibliography: Paris 1961 (ill. p. 45);
Duthuit 1962 (ill. p. 99); Aragon 1971, I
(ills. 142, 143 p. 258; ills. 144, 145 p. 259);
Jacobus 1972 (ill. p. 51)

Collections: Private Collection, France

It seems most likely that this work was
composed at the same time as the bulk of
the *Jazz* illustrations but not included in
that published suite. Documentary photo-
graphs in Aragon 1971, I, show *Le Dragon*
in Matisse's studio at Vence while he was
sketching the Haitian woman, c. autumn
1946.

Color plate VI

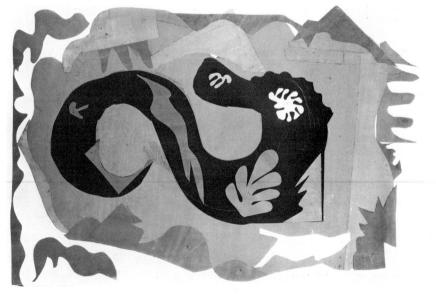

37

Nos. 38-54 The following entries, nos. 38-54, form a fairly consistent stylistic grouping and have been here dated late 1944 through early 1946. They show the artist composing with extremely simplified cut forms which were adjusted into clear visual balances usually devoid of narrative intention. A subsequent group of cut-outs, nos. 61-83, includes works that are less geometric and deal with an expanded range of subject matter.

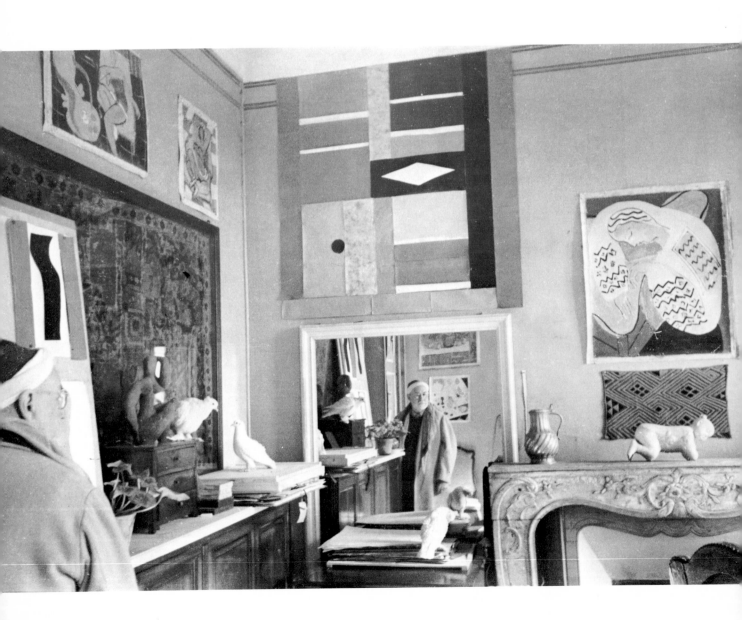

38 Composition

c. 1944

Signed: not known

Bibliography: Aragon 1971, I (ill. 132 p. 251)

Collections: present location unknown

This work, which may depict a harp or a lyre, is shown on the wall of Matisse's Vence studio in the Aragon photograph (see Bibliography above), along with two other forms. Since it is mounted on a backing sheet, it appears to have been a finished paper cut-out, whereas the other two forms are more likely random elements. The work is said to have been completed soon after *Jazz* and to have been kept on view by Matisse as an example of various qualities of cut-out techniques.

Not illustrated

39 Composition

1944

127 x 127 cm. (approx.)
50 x 50 in. (approx.)

Collections: present location unknown

This composition was probably dismantled, and some of its parts reused in subsequent works. Visible above a mirror in the photograph by Cartier-Bresson (fig. 38), *Composition* may very well have been Matisse's first large scale paper cut-out.

The strict hard-edge geometry of this work suggests the influence of earlier Constructivism and de Stijl, as well as other syntheses of utilitarian Art Deco designs. The first state of the Vence chapel apse window, *Jerusalem céleste*, no. 89, evolved in a similarly constructed and architecturally planar mode.

40 Oiseau

Bird

1945

Signed: *H Matisse* (lower right)

Bibliography: Paris 1961 (ill. p. 45); Duthuit 1962 (ill. p. 98); Jacobus 1972 (ill. p. 51); Editions Nouvelles Images color postcard G1

Collections: present location unknown

Thought to be a preliminary study for the 1945 *Pierre à Feu* cover, no. 41. Photographs in Aragon (1971, I, pp. 254-256) show four other cut-out designs which appear to be additional studies for this same cover.

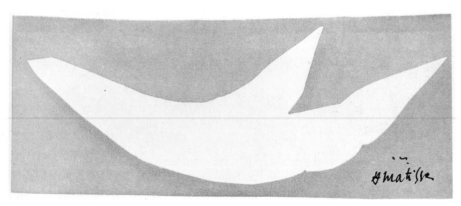

40 □

Fig. 38. Henri Matisse at his villa, Le Rêve, Vence, c. 1944. At left: *Composition*, no. 36, and, especially, above mirror, *Composition*, no. 39.

41 Pierre à Feu (cover maquette)

1945

Painted cut and pasted paper, ink

25 x 41 cm. (approx.)

9⅞ x 16⅛ in. (approx.)

Signed: *H.M.* (lower left front cover)

Exhibitions: Saint-Paul de Vence 1969, no. 27

Collections: Private Collection, Paris

Color cover for *Les Miroirs Profonds,* "Pierre à Feu," January 1947, ed. Maeght. The front cover consists of a green whale at the top and a red shark at the bottom revolving clockwise around a black and blue spiked "burst"; the letters of the title are scattered legibly on both sides. On the back cover Matisse placed a yellow fish above a black square against a cream background. Reproduced lithographically, 950 copies in the first run. Later, reprinted photographically in smaller dimensions, larger run.

The poems, essays, and interviews in this book constitute an hommage to Matisse. Many of the contributions allude to Matisse's contemporary thematic pre-occupations, indeed to specific plates in *Jazz,* while others find restatement in later works. This book is perhaps the first literary reaction to *Jazz* and other pre-1947 cut-outs.

A letter by Matisse exhibited at Saint-Paul de Vence 1969, addressed to Aimé Maeght and dated July 1, 1946, deals with this cover design—a subject also mentioned in other Matisse-Maeght letters. One of these, dated November 15, 1945, informs Maeght that the cover maquette was completed.

41 □

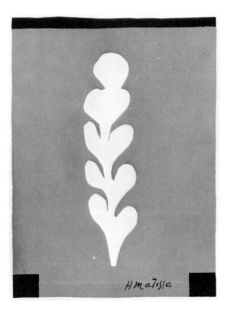

42 □

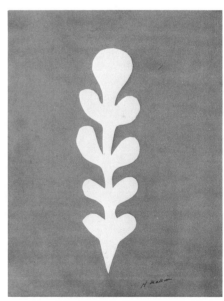

43

42 Palme blanche aux deux carrés noirs sur fond bleu

White Palm with Two Black Squares on Blue Background

late 1945 - early 1946

54.5 x 40.5 cm.
21½ x 15¹⁵⁄₁₆ in.

Signed: *H Matisse* (lower right)

Exhibitions: Aix-en-Provence 1960, no. 67; Albi 1961, no. 162

Bibliography: Paris 1961 (ill. p. 45); Duthuit 1962 (ill. p. 99); Jacobus 1972 (ill. p. 51); Editions Nouvelles Images color postcard CP52 entitled *Palme Blanche sur Fond Bleu*

Collections: Private Collection

It is presumed that the work referred to in the bibliography is the same as that exhibited in Aix-en-Provence and Albi, despite the fact that the measurements listed in the exhibition catalogues appear not to coincide precisely with this work.

43 Palme blanche sur rouge

White Palm on Red

late 1945 - early 1946

52.5 x 40.2 cm.
20¹¹⁄₁₆ x 15¹³⁄₁₆ in.

Signed: *H. Matisse* (lower right)

Bibliography: Paris 1961 (ill. p. 45); Duthuit 1962 (ill. p. 99); Jacobus 1972 (ill. p. 51); Editions Nouvelles Images color poster M34

Collections: Private Collection

44 Composition

late 1945 - early 1946

Signed: *H. Matisse* (lower right)

Bibliography: Paris 1961 (ill. p. 45); Duthuit 1962 (ill. p. 99); Jacobus 1972 (ill. p. 51); Editions Nouvelles Images color poster

Collections: Private Collection, Paris

Posthumously referred to as *Harmonie tahitienne (Tahitian Harmony)*.

45 Rouge et or

Red and Gold

late 1945 - early 1946

52.5 x 40.5 cm.
20¹¹⁄₁₆ x 15¹⁵⁄₁₆ in.

Signed: *H. Matisse* (lower right)

Exhibitions: Aix-en-Provence 1960, no. 70; Albi 1961, no. 165

Bibliography: Paris 1961 (ill. p. 45); Duthuit 1962 (ill. p. 99); Jacobus 1972 (ill. p. 51); Editions Nouvelles Images color postcard CP53 entitled *Carrés rouges sur fond jaune*

Collections: Private Collection

46 Composition

late 1945 - early 1946

60 x 38 cm. (approx.)
23⅝ x 15 in. (approx.)

Signed: not known

Exhibitions: Paris 1953-2

Collections: present location unknown

Visible at the far right edge of the documentary installation photograph by Hélène Adant of the 1953 Berggruen et Cie exhibition (fig. 39).

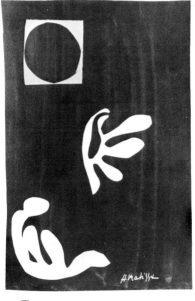

44 ☐

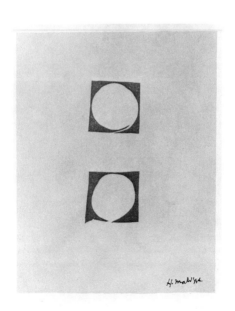

45 ☐

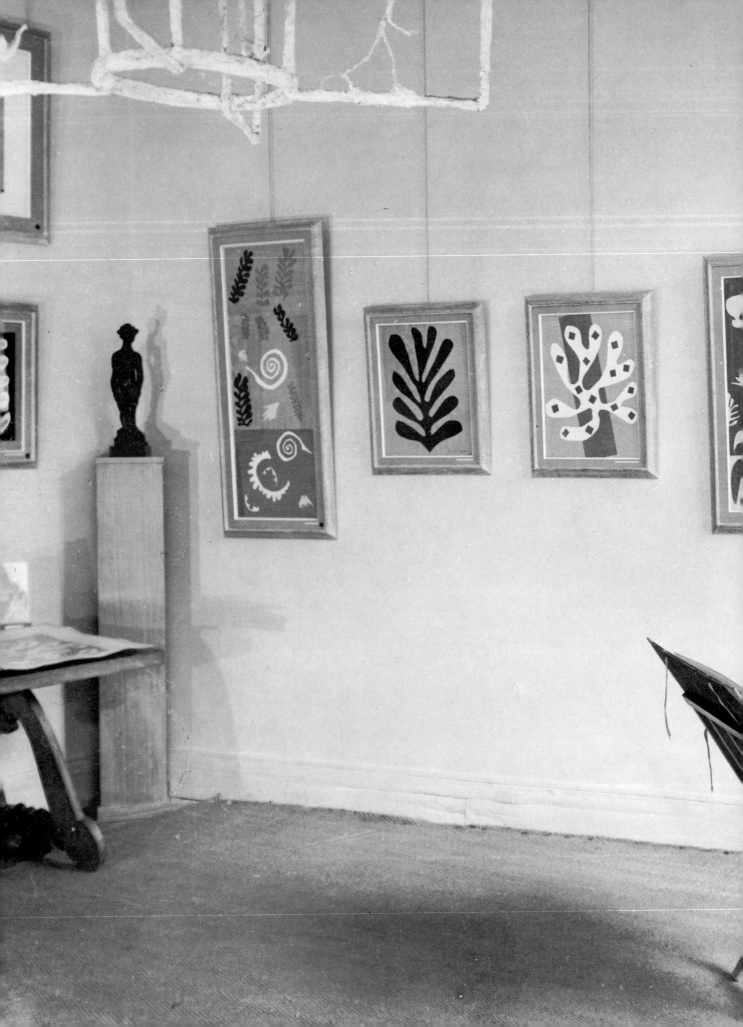

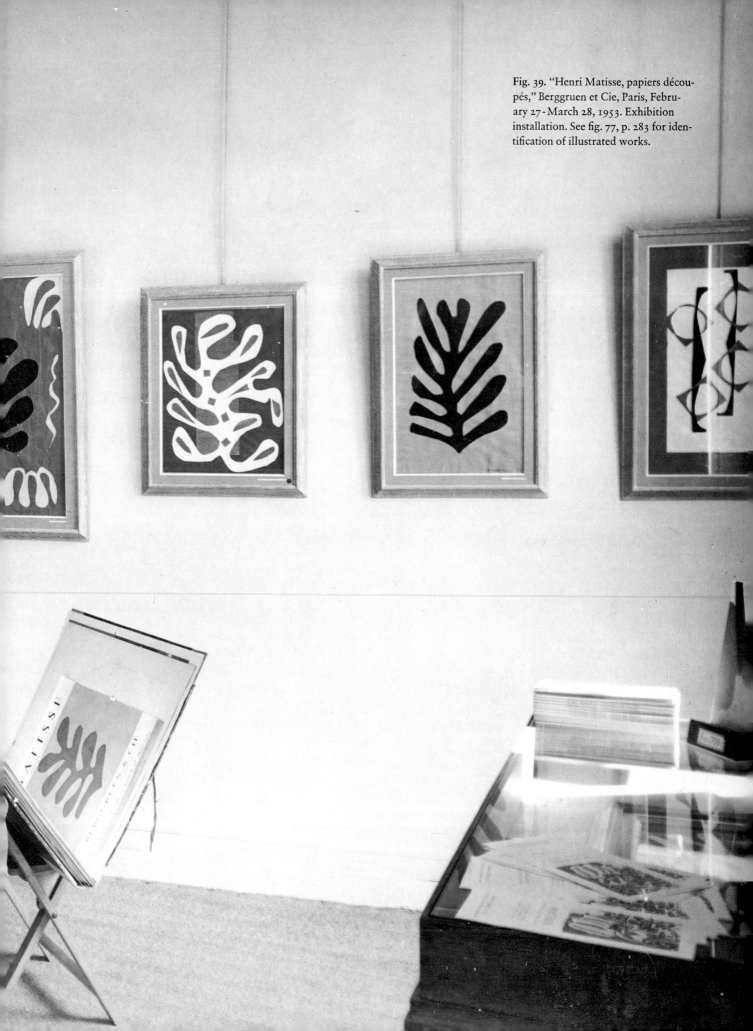

Fig. 39. "Henri Matisse, papiers décou-
pés," Berggruen et Cie, Paris, Febru-
ary 27 - March 28, 1953. Exhibition
installation. See fig. 77, p. 283 for iden-
tification of illustrated works.

47 Composition

late 1945 - early 1946

52 x 40 cm. (approx.)
20½ x 15¾ in. (approx.)

Signed: not known

Bibliography: Paris 1961 (ill. p. 45);
Duthuit 1962 (ill. p. 99); Jacobus 1972
(ill. p. 51)

Collections: present location unknown

Not illustrated

48 Composition (cercle rouge aux quatre triangles noirs sur fond vert)

Composition (Red Circle with Four Black Triangles on Green Background)

late 1945 - early 1946

52.5 x 40.5 cm.
20¹¹⁄₁₆ x 15¹⁵⁄₁₆ in.

Signed: *H. Matisse* (lower right)

Bibliography: Paris 1961 (ill. p. 45);
Duthuit 1962 (ill. p. 99); Jacobus 1972
(ill. p. 51)

Collections: Private Collection

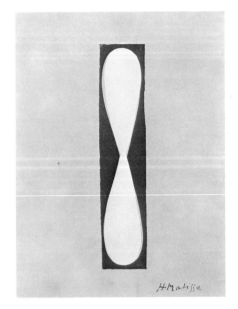

48 49

50

Fig. 40. Sonia Delaunay (b. 1885).
Tableau du bord, 1937. Archiv för Deko-
rativ Konst, Lund. Large-scale mural on
canvas for the Exposition Internationale
Pavillon de l'Air, Paris, 1937.

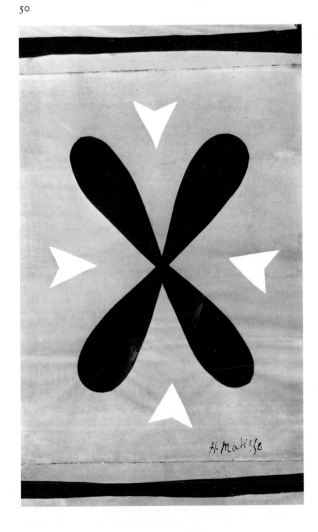

49 L'Hélice

The Propeller

late 1945 - early 1946

52.5 x 40.5 cm.
20¹¹⁄₁₆ x 15¹⁵⁄₁₆ in.

Signed: *H Matisse* (lower right)

Bibliography: Paris 1961 (ill. p. 45);
Duthuit 1962 (ill. p. 99); Jacobus 1972
(ill. p. 51)

Collections: Private Collection

See remarks no. 50.

50 Fleur à quatre pétales

Four-Petaled Flower

late 1945 - early 1946

62 x 40.2 cm. (irreg.)
24⁷⁄₁₆ x 15¹³⁄₁₆ in. (irreg.)

Signed: *H Matisse* (lower right)

Bibliography: Paris 1961 (ill. p. 45);
Duthuit 1962 (ill. p. 99); Jacobus 1972
(ill. p. 51); Editions Nouvelles Images
color poster M35

Collections: Private Collection

For the 1937 Exposition Internationale
Pavillon de l'Air in Paris, Sonia Delaunay
executed several large murals which
Matisse knew: *Tableau du bord* (fig. 40),
L'Hélice, and *Moteur d'avion.* Delaunay's
vocabulary of large discs, abstracted
propellers, spirals, and planar machine
parts can reasonably be proposed as pro-
viding Matisse with specific formal stimuli.
The results of these design influences may
be seen throughout this early period of
Matisse's work in cut paper.

51 La Marguerite

The Daisy

late 1945 - early 1946

52.5 x 40.5 cm. (approx.)
20¹¹⁄₁₆ x 15¹⁵⁄₁₆ in. (approx.)

Signed: *H Matisse* (lower right)

Bibliography: Paris 1961 (ill. p. 45);
Duthuit 1962 (ill. p. 99); Jacobus 1972
(ill. p. 51); Editions Nouvelles Images
color poster NP124

Collections: Private Collection

52 As de trèfle

Ace of Clubs

late 1945 - early 1946

52.5 x 40.5 cm. (approx.)
20¹¹⁄₁₆ x 15¹⁵⁄₁₆ in. (approx.)

Signed: *H Matisse* (lower right)

Bibliography: Paris 1961 (ill. p. 45);
Duthuit 1962 (ill. p. 99); Jacobus 1972
(ill. p. 51)

Collections: present location unknown

Sonia Delaunay produced a playing card
design for the King of Clubs in 1938 (now
Spielkartenmuseum, Bielefeld; Damase
1971, ill. p. 391). Matisse here used vir-
tually the same geometric forms and com-
position, with the sole exception that his
design is white on black and Delaunay's
was the reverse. It cannot be determined
at present whether Matisse was aware of
this particular Delaunay work, but his
early cut-outs are often surprisingly close
to other aspects of Delaunay's decorative
conceptions.

Not illustrated

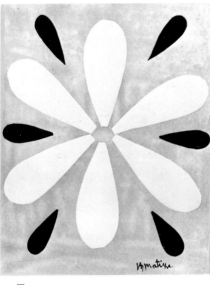

51 □

53 Les Voiles

The Sails

early 1945 - late 1946

52.7 x 40.4 cm.
20¾ x 15¹⁵⁄₁₆ in.

Signed: *H Matisse* (lower right)

Exhibitions: Geneva 1959, no. 35; Bern
1960, no. 55

Bibliography: Paris 1961 (ill. p. 45);
Duthuit 1962 (ill. p. 99); Jacobus 1972
(ill. p. 51)

Collections: Gérald Cramer; present
location unknown

Not illustrated

54 Les Voiles

The Sails

early 1945 - late 1946

Signed: not known

Bibliography: Paris 1961 (ill. p. 44);
Duthuit 1962 (ill. p. 98); Jacobus 1972
(ill. p. 51)

Collections: present location unknown

Not illustrated

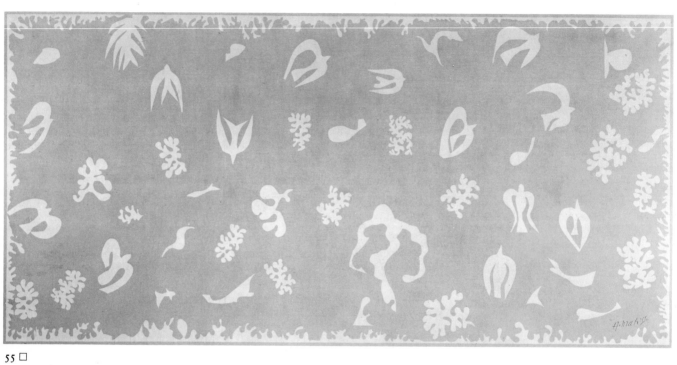

55 □

55 Océanie, le ciel

Océania, the Sky (silkscreen maquette)

Summer 1946

165 x 380 cm. (approx.)
64¹⁵⁄₁₆ x 149⅝ in. (approx.)

Not signed or dated

Bibliography: Matisse 1946-2 (ill. p. 3, *La Mer*); Diehl 1947 (ill. pp. 6-7, *Le Ciel*; p. 7, *La Mer*); Goldfinger 1948; Reed 1949, p. 9; Paris 1949, p. 12; Barr 1951, p. 279; Brassaï 1964, pp. 305-306; Alpatov 1973, p. 129; Flam 1973, p. 109, pl. 42; Fourcade 1976, p. 106

Collections: present location unknown

Zika Ascher recalls that he first approached Matisse in 1946 concerning the possibility of a decorative commission for A. Ascher, Inc., London. Matisse did not immediately refuse but rather asked that Ascher visit again the next time he was in Paris. Several months later, when Ascher returned to the artist's Boulevard Montparnasse apartment, Matisse showed him the finished *Océanie* designs pinned directly onto the walls and asked if they could be reproduced for the project (fig. 25). See no. 56.

At this early stage of Matisse's cut-out work, an effective method had not yet been devised for transferring and preserving the compositions. Matisse and Ascher thought first of attempting photographic enlargements for the silkscreen printing, as referred to in the artist's letters of October 13 and 24, 1946 (see Documents Appendix, 2-4). This experimental process was not satisfactory, and Ascher suggested instead tracing the full compositional layouts and sending the subsequently unpinned maquette elements to London to verify the detailing in the silkscreens. Eventually, this was the procedure followed. The working pattern for *Océanie, le ciel* is still in London; that for *Océanie, la mer* was destroyed in a fire. The cut-out elements were returned to the artist and apparently never remounted.

Another area of concern was the artist's wish to duplicate for the silkscreen background the exact color and texture of his apartment wall-covering. After extensive searching, Matisse found the fabric supplier Planeix, in the Brittany town of Uzel, whose linen provided the closest match (see Documents Appendix, 2).

The designs were issued in 30 examples each, signed and numbered by Matisse. These panels are the artist's first large scale cut-out expression of his remembrances of his 1930 voyage to Tahiti and the South Pacific. Matisse explained aspects of the trip and the works:

The memories of my voyage to Tahiti have only now returned to me, fifteen years later, in the form of obsessive images: madrepores, corals, birds, jellyfish, sponges . . . It's curious, isn't it, that all these enchantments of the sky and sea hardly inspired me right off . . . I returned from the islands completely empty-handed . . . I didn't even bring back photos . . . Even though I bought a very expensive camera . . . But once there, I hesitated: "If I take photos," I said to myself, "of everything I see in Oceania, hereafter I'll never see anything but these poor images. And the photos will perhaps keep my impression from becoming more profound . . ." It seems to me that I was right. It is more important to drink things in than to catch them on the run. I cut and put all of these elements up on the walls provisionally. The little lines represent the line of the horizon . . . I no longer know what that will bring forth . . . Maybe some panels, wall hangings (Brassaï 1964, pp. 305-306, see Documents Appendix, 19)

(Despite his remark to the contrary, Matisse did take photographs in Tahiti; see Aragon 1971, I, pp. 103, 204.)

Other references to this trip and the island environment, an acknowledged major influence upon the artist, are found in Escholier 1937; Matisse 1972, pp. 101-112, ns. 58-61, 63; p. 125, n. 87; pp. 231-232, 290; Flam 1973, pp. 57-64. Concerning the synthesis of these influences in their temporal relationship, see Lebensztejn 1974. *Océanie, le ciel* and *Océanie, la mer* and the thematically related *Polynésie* tapestries (see nos. 59-60) represent an important development in Matisse's vocabulary of forms. These projects contain decisions about the uses of cut-outs which will find restatement in later works, including nos. 57-58, 83, 114.

56 Océanie, la mer

Oceania, the Sea (silkscreen maquette)

Summer 1946

165 x 380 cm. (approx.)
65 x 149⅝ in. (approx.)

Not signed or dated

Bibliography: see listing no. 55

Collections: present location unknown

See remarks no. 55.

Matisse has written of this panel:

This panel, printed on linen—white for the motifs and beige for the background—forms, together with a second panel, a wall tapestry composed during reveries which came fifteen years after a voyage to Oceania.

From the first, the enchantments of the sky there, the sea, the fish, and the coral in the lagoons, plunged me into the inaction of total ecstasy. The local tones of things hadn't changed, but their effect in the light of the Pacific gave me the same feeling as I had when I looked into a large golden chalice.

With my eyes wide open I absorbed everything as a sponge absorbs liquid. It is only now that these wonders have returned to me, with tenderness and clarity, and have permitted me, with protracted pleasure, to execute these two panels.
(Matisse 1946-2; Flam 1973, p. 110)
See fig. 25.

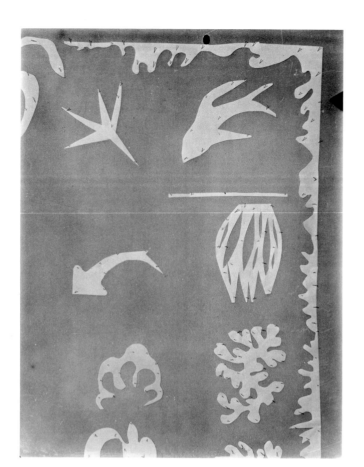

Fig. 41. Detail of the maquette, *Océanie, la mer,* no. 56, mounted on wall of Matisse studio, Boulevard Montparnasse, Paris, c. 1946.

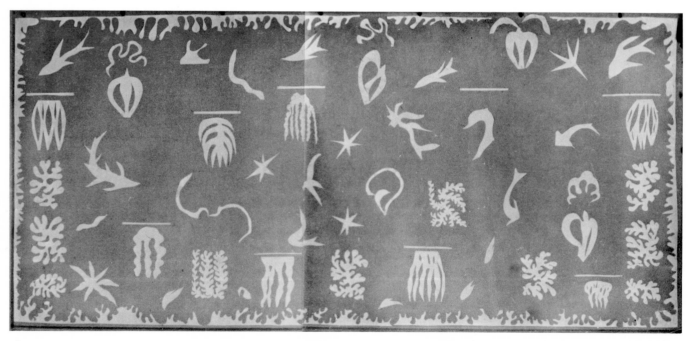

56

57 Ascher Square (scarf maquette "A")

1946

87.5 x 89.5 cm.
34 7/16 x 35 1/4 in.

Not signed or dated, but each white alga is numbered (1 through 4) and has *HAUT* and *BAS* inscriptions in black pencil, most probably by Matisse

Exhibitions: London 1968, no. 121 (ill. p. 142, bottom panel)

Collections: Zika Ascher; Leslie Waddington Gallery; Alistair McAlpine; Leslie Waddington Gallery; Marie Cuttoli; (Galerie Beyeler, Basel, Cuttoli sale, 1970, lot no. 67, ill.); Hubert de Givenchy, Paris

Commissioned by Ascher while Matisse was working on the *Océanie* panels, nos. 55-56, the scarves were produced in an edition of 275. See also no. 58.

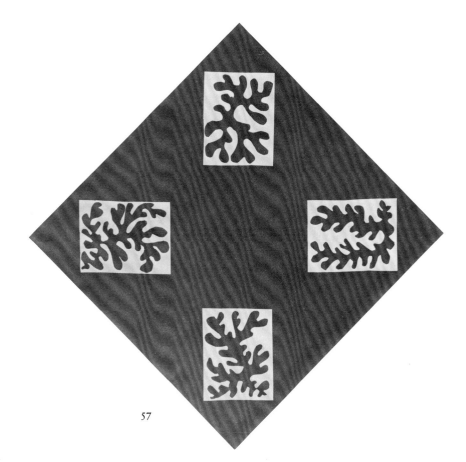

57

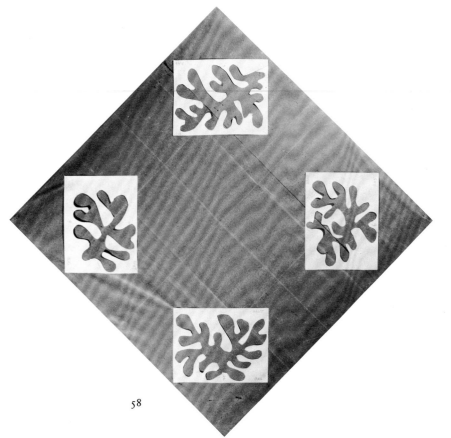

58

58 Ascher Square (scarf maquette "B")

1946

89 x 89 cm.
35 x 35 in.

Not signed or dated, but each white alga is numbered (5 through 8) and has HAUT and BAS inscriptions in red pencil, most probably by Matisse

Exhibitions: London 1968, no. 121 (ill. p. 142, top panel)

Collections: Zika Ascher; Leslie Waddington Gallery; Alistair McAlpine; (Sotheby, London, April 16, 1970, lot no. 108, p. 147, ill. p. 146); Tarica Gallery Ltd., Paris

See remarks no. 57.

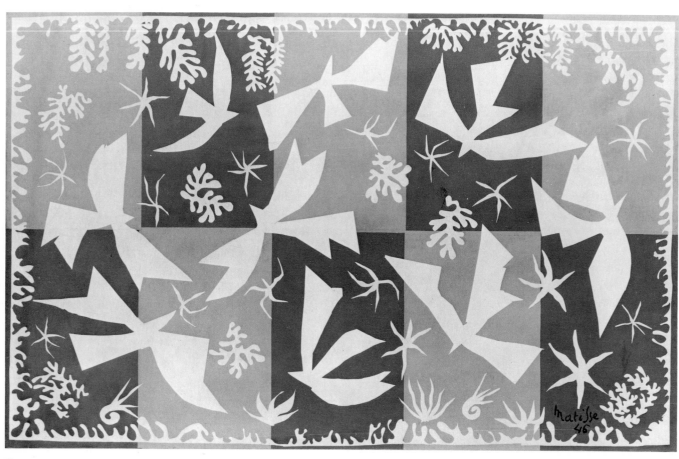

59

Figs. 42-43. *Polynésie, le ciel*, no. 59, proposed variants, paper pinned on tapestry, c. 1946.

*59 Polynésie, le ciel

Polynesia, the Sky (tapestry maquette)

1946

200 x 314 cm.
78¾ x 123⅝ in.

Signed: *Matisse/46* (lower right)

Exhibitions: Paris 1975 (not in cat.); Brussels 1975 (listed without no.)

Bibliography: Barr 1951, pp. 278-279

Collections: Mobilier National, Paris, on loan to Centre National d'Art et de Culture Georges Pompidou, Musée National d'Art Moderne, Paris

The earlier *Océanie* commission (see nos. 55-56) resulted in works with silkscreened images of unified texture and whiteness. In the *Polynésie* tapestries, Matisse exploited weaving and materials to achieve a fuller, more painterly range of color and texture. He also used the tapestry medium to portray the actual composite, additive nature of his paper cut-out processes. Some of the tonal "flaws" in the cut-outs, which resulted from paper quality and overlay technique, were translated into varied whites in the birds and edging of the *Polynésie, le ciel* tapestry. Equivalent variations are also evident in the *Polynésie, la mer* tapestry. Color illustrations of the tapestries are found in Aragon 1971, II (pls. XLIII-XLIV).

When Matisse received the first weavings in 1947, he decided to make several variations which would give the Manufacture de Beauvais the option of offering variants of the basic *Polynésie* designs. The three photographs (figs. 42-44) show Matisse's variants, achieved by pinning new groups of cut-outs directly onto a finished tapestry: there were two variations of *Polynésie, le ciel* and one of *Polynésie, la mer*. Tracings and photographs were made and sent to the weavers, along with the new paper elements. The variant tapestries were not produced, and we do not know the present location of the variant elements.

*60 Polynésie, la mer

Polynesia, the Sea (tapestry maquette)

1946

196 x 314 cm.
77³⁄₁₆ x 123⁵⁄₈ in.

Signed: *Matisse 46* (lower right)

Exhibitions: Paris 1975 (not in cat.);
Brussels 1975 (listed without no.)

Bibliography: see listing no. 59

Collections: Mobilier National, Paris, on
loan to Centre National d'Art et de
Culture Georges Pompidou, Musée
National d'Art Moderne, Paris

See remarks no. 59.

Color plate VII

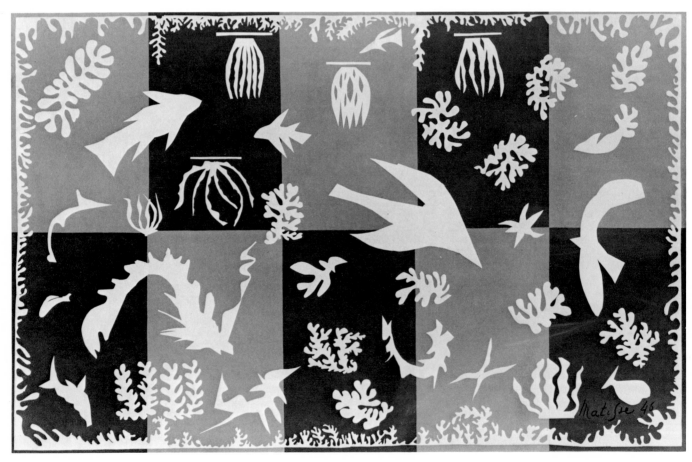

60

Nos. 61-83 Numbers 61-83 do not necessarily give the precise chronological sequence of production. These works most likely were completed in 1947, although some might have been begun in 1946. Their common characteristic is that they are primarily studies in cut color. In the catalogue of his 1949 Paris exhibition (p. 12), Matisse explained that after the *Polynésie* compositions he covered his studio walls with paper cut-outs, "without any goal other than study" ("sans autre but que l'étude") (see fig. 45). The following works demonstrate this direction in a more elaborate fashion than the preceding grouping of cut-outs, nos. 38-54, which tend to be more schematic and geometrical.

Fig. 44. *Polynésie, la mer,* no. 60, proposed variant, paper pinned on tapestry, c. 1946. See no. 59.

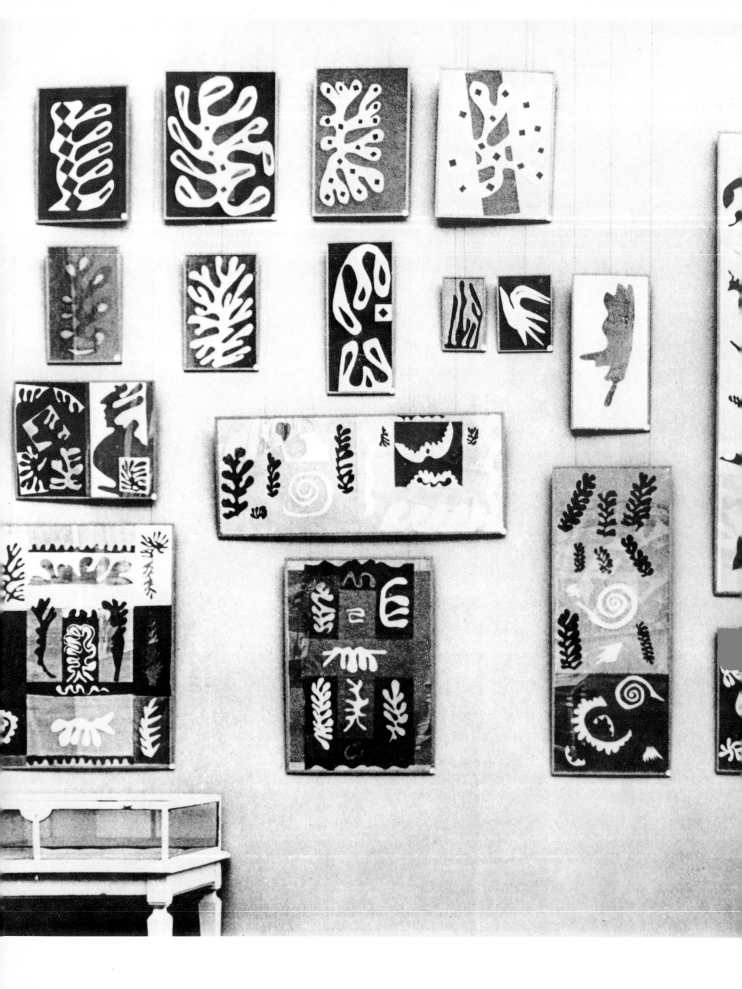

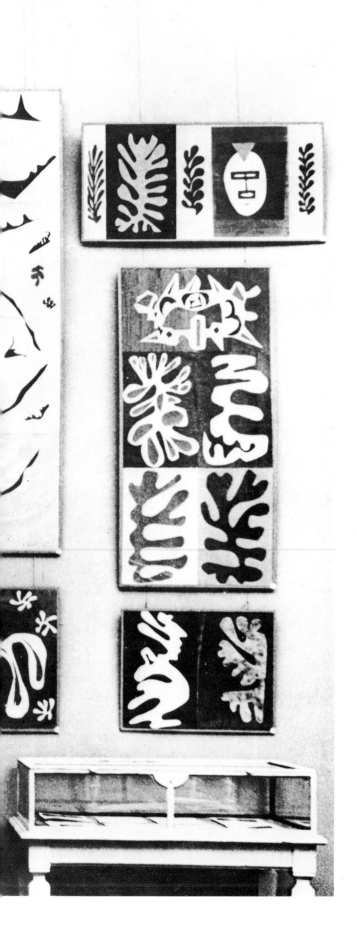

Fig. 45a. Paper cut-outs shown in fig. 45, identified by present catalogue numbers.

***61 Amphitrite**

1947

85.5 x 70 cm.
33⅝ x 27⅝ in.

Not signed or dated

Exhibitions: New York 1949; Paris 1949, no. 13; Aix-en-Provence 1960, no. 65 entitled *Composition décorative*; Albi 1961, no. 160 entitled *Composition décorative*

Collections: Private Collection, France

Amphitrite appears to be a particularly narrative work, for it contains various elements which seem to be directly drawn from the several stories of Amphitrite, the Greek Queen of the Sea. According to Grimal (1963, p. 33):

"Amphitrite"—She belongs to the group of the daughters of Nereus and Doris, called the Neriades. It is she who conducts the choir of her sisters. One day when she was dancing with them near the island of Naxos, Poseidon saw her and abducted her. It is said that Poseidon loved her for some time but that out of modesty she refused him and hid in the ocean depths beyond the Columns of Hercules. She was found by dolphins and brought back in a grand procession to Poseidon, who then married her . . . She is often represented surrounded by a large retinue of ocean-world divinities.

According to Fox (1916, p. 214):
Amphitrite—On a larger level she seems to have been regarded as the sea itself and as the divine being who sent the monsters of the sea and drove waves against the rocks.

The account in *Larousse* (1959, pp. 154, 170) reads:

"Amphitrite"—Poseidon was far from faithful to Amphitrite but only once did she show jealousy. Enraged by the love Poseidon showed toward Scylla, a nymph of rare beauty, Amphitrite threw magic herbs in a pool where Scylla bathed, and the nymph was changed into a monster. Six heads on long necks sprang from her shoulders, and each mouth had a triple row of teeth.

The Matisse cut-out seems to allude to the myth in the following ways: the densely-articulated surface may be the cortege, with sea floor animals and plants in the lower two-thirds of the composition, and with floating forms near the top; the upper center panel may represent waves; the black and white spiked form in the center might represent the metamorphosed Scylla in her underwater cavern; and the blue form to the right may be the royal Amphitrite.

Color plate VIII and cover

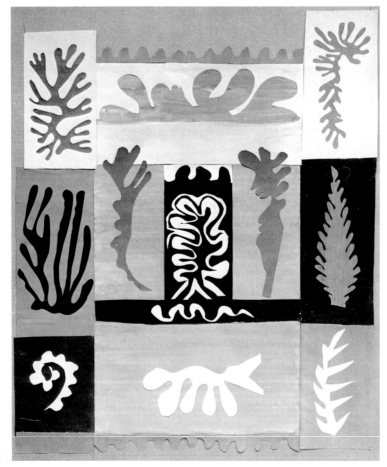

61

***62 Composition à la croix rouge**

Composition with Red Cross

1947

74.1 x 52.4 cm.
29⅛ x 20⅝ in.

Signed: *H. Matisse* (lower right)

Exhibitions: New York 1949; Paris 1949

Bibliography: Greenberg 1953 (pl. 36);
Huyghe 1953 (pl. 36); Lübecker 1955
(pl. 36)

Collections: Niveau Gallery; Baldwin M.
Baldwin; Mrs. Maruja Baldwin Hodges,
Newport Beach

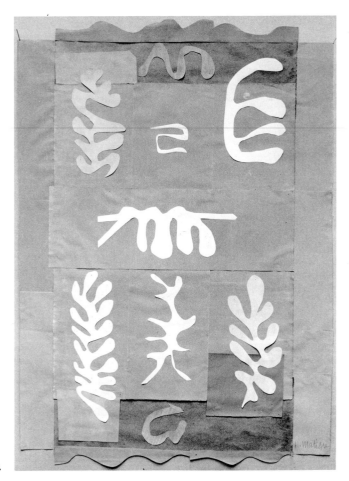

62

***63 L'Oiseau et le requin**

The Bird and The Shark

1947

40.6 x 105.4 cm.

16 x 41½ in.

Signed: *H Matisse* (lower left)

Exhibitions: Paris 1949, no. 14; Paris 1953-2 (ill. color)

Bibliography: Courthion 1956 (ill. p. 46)

Collections: Berggruen et Cie; Mr. and Mrs. Morton Neumann, Chicago

See remarks no. 64.

A thematic relationship is to be found in the frontispiece drawing for *Les Miroirs profonds*, "Pierre à Feu," January 1947, which Matisse described to René Char: "... a drawing in which the shark surfaces and the seagull dives down to it to create a ballet figure, above the waves" (Matisse 1972, p. 231).

Coincidentally, Matisse had executed the drawing by May 1946, before he knew about Char's poem, "Le Requin et la mouette" ("The Shark and the Seagull"):

Je vois enfin la mer dans sa triple harmonie, la mer qui tranche de son croissant la dynastie des couleurs absurdes, la grande volière sauvage, la mer crédule comme un liseron.

Quand je dis: j'ai levé la loi, j'ai franchi la morale, j'ai maillé le coeur, ce n'est pas pour me donner raison devant ce pèse-néant dont la rumeur étend sa palme au delà de ma persuasion. Mais rien de ce qui m'a vu vivre et agir jusqu'ici n'est témoin alentour. Mon épaule peut bien sommeiller, ma jeunesse accourir. C'est de cela seul qu'il faut tirer richesse immédiate et opérante. Ainsi, il y a un jour de pur dans l'année, un jour qui creuse sa galerie merveilleuse dans l'écume de la mer, un jour qui monte aux yeux pour couronner midi. Hier la noblesse était déserte, le rameau était distant de ses bourgeons. Le requin et la mouette ne communiquaient pas.

O Vous, arc-en-ciel de ce rivage polisseur, approchez le navire de son espérance. Faites que toute fin supposée soit une neuve innocence, un fiévreux en avant pour ceux qui trébuchent dans la matinale lourdeur.

Matisse then undertook a drawing more specifically relating to the Char poem. The drawing and poem were subsequently published in *Cahiers d'Art* 1945-46, p. 77 (Char 1945-46).

The title given by Matisse to this cut-out has always been *L'Oiseau et le requin*. If read with the above information in mind, however, the primary composition group on the right could be more precisely a balletic encounter between a *seagull* and a shark, thus relating to the acknowledged Matisse-Char affinities. The white bird and shark were cut from the same piece of paper. At the left, the red heart perched precariously on the tip of the white spike may depict the bird in the open mouth of the shark (seen in profile).

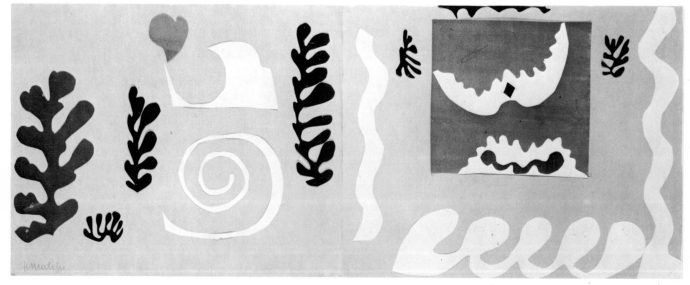

63

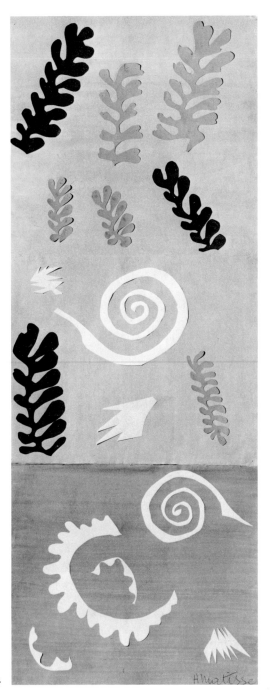

64

*64 Composition fond vert

Composition Green Background

1947

105.4 x 40.7 cm.
41½ x 16 in.

Signed: *H Matisse* (lower right)

Exhibitions: Paris 1949, no. 21; Paris
1953-2 (ill. color); London 1968, no. 128
(ill. p. 147)

Collections: Berggruen et Cie; Private
Collection, USA

The same size (except here in vertical
format) with some elements similar to no.
63; yet, *Composition fond vert,* with the
watery texture of its green paper back-
grounds and the suspended dispersion of
marine elements, suggests aquatic imagery
more strongly. Compositional relation-
ships also exist with the Ascher project
Océanie, la mer, no. 56.

***65 Composition (Les Velours)**

Composition (The Velvets)

1947

51.5 x 217.5 cm.
20¼ x 85⅝ in.

Signed: *Matisse/47* (lower right)

Exhibitions: Paris 1953-2 (not in cat.);
Basel 1958

Bibliography: Bernier 1949 (ill. color, early
state); *Du* 1955 (ill. color, detail, title
page); Guichard-Meili 1967 (ill. pp. 140-
141, entitled *Decorative Composition*);
Basel 1970 (ill. p. 256); Alpatov 1973 (ill.
color, details, endpapers)

Collections: Berggruen et Cie; Gravures
Modernes; Kunstmuseum, Basel

The Kunstmuseum, Basel entitles this
work: *Composition: papiers gouachés,
découpés.* Matisse in his studio usually
referred to this work as *Les Velours.*

Les Velours not only contains an unprec-
edented sequencing of algae forms but also
another rare technical procedure wherein
Matisse painted rather than pasted two
abutting colors (orange and yellow)
directly upon the same sheet with a white
margin between them.

The rhythm and counterpoint of this color
frieze, embellished by the multicolored
leaves, create the impression both of a
musical score and of the sound of music
itself. This format and its metaphor
anticipate *Les Mille et Une Nuits* of 1950,
no. 111.

66 Le Panneau au masque

The Panel with Mask

1947

110 x 53 cm.
43⅝₁₆ x 20⅞ in.

Signed: *H. Matisse* (bottom center)

Exhibitions: New York 1949; Paris 1949,
no. 1; Copenhagen 1953, no. 52; Copen-
hagen 1970-1, no. 103 (ill.)

Collections: Det Danske Kunstindustri-
museum, Copenhagen

An extract from Matisse's February 15,
1950 letter to the director of Det Danske
Kunstindustrimuseum reads:

Dear Sir,
*I am very happy to learn from your letter
that the Decorative Arts Museum of
Copenhagen has found it possible to
obtain for its collection my three "paper
cut-outs." Thank you for this good news.
I am writing above all in response to your
question concerning the place of my
"paper cut-outs" within the context of my
oeuvre. As you have assumed, they are
each unique works. Each "paper cut-out"
is a work complete in itself. With scissors
I have drawn directly in color, as has been
described in one of the texts in the cata-
logue of my exhibition last year at the
museum in Paris. These works cannot be
reproduced in multiple copies because, as
with a tracing, they would lose the sensi-
bility that my hand brought to them. (See
Documents Appendix, 6)*

65

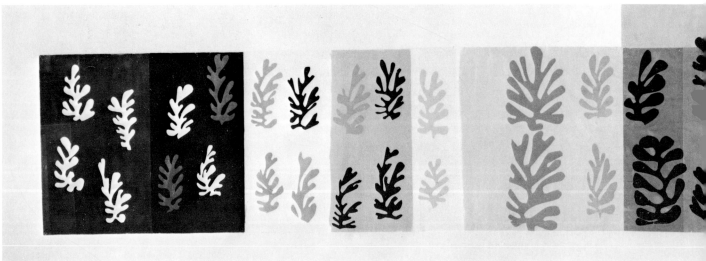

The composition may be "read" as follows: top panel, a frontal view of a multicolored mask, perhaps based on a New Ireland *Uli* figure Matisse kept in his studio; left center panel, a reindeer or caribou (maybe one of Matisse's Russian toys), with its rack of antlers at the top; right center panel, the profile of a beast (or a skull) facing left, its lower jaw extending beyond its nose; bottom panels, plant forms.

A source for the reindeer may have been the photographs in the Poncins book (see remarks no. 67). The general composition and mask imagery arrangement here is similar to Northern New Caledonian door jamb carvings.

This composition combines many typical Matisse cut-out techniques of the period: the alternation of opaque and streaked papers; the juxtaposed panels, with intense colors and complex shapes, played off against images of simple outlines and high tonal contrast; edge-to-edge zoning with one profiled motif each; and a potpourri of objects unified by their arrangement rather than by a specific narrative theme.

Color plate IX

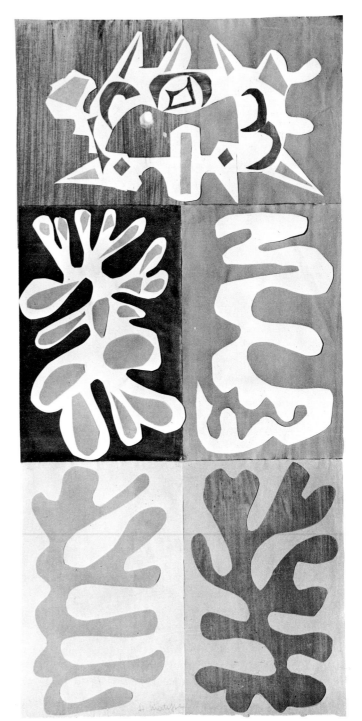

66

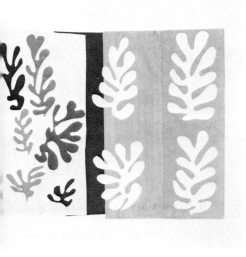

67 L'Esquimau

The Eskimo

1947

40.5 x 86 cm.

15$\frac{15}{16}$ x 33$\frac{7}{8}$ in.

Signed: *l'esquimau*/*H. Matisse* (lower right)

Exhibitions: New York 1949; Paris 1949, no. 11; Copenhagen 1953, no. 53; Copenhagen 1970-1, no. 104 (ill.)

Collections: Det Danske Kunstindustrimuseum, Copenhagen

A photograph of the work in progress (Bowness 1968, p. 7) shows this composition with a white profile head in place of the final Eskimo head.

The likely source for the Eskimo wearing wooden snow goggles is the book by Gontran de Poncins, *Esquimaux, voyage d'exploration au pôle magnétique nord (1938-1939)*, Paris, 1946. This book rests on Matisse's lap in the color cover illustration of *La Biennale di Venezia* (December 1955). Matisse's son-in-law, Georges Duthuit, owned a collection of Eskimo masks.

The Poncins photos of Eskimo daily life include portraits of men wearing snow goggles as well as modern sunglasses (pp. 52, 57, 63, 77, 79). Although covering only the eyes, the anti-glare goggles transform the face into a full mask. These photographs—as well as the Duthuit collection of masks—inspired Matisse's lithographs for Duthuit's *Une Fête en Cimmérie*, Paris, 1963, a novel with the theme of an imaginary voyage to the Arctic.

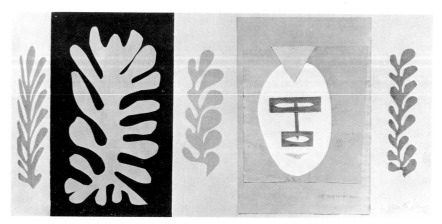

67

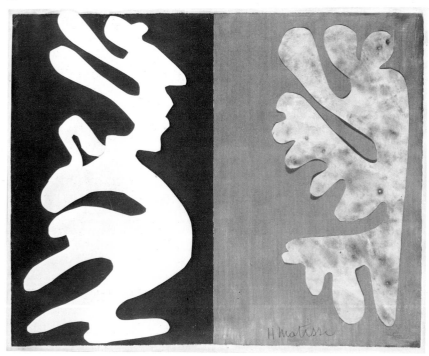

68

68 Composition, violet et bleu

Composition, Violet and Blue

1947

40.5 x 52 cm.
15¹⁵⁄₁₆ x 20½ in.

Signed: *H. Matisse* (bottom center)

Exhibitions: Paris 1949, no. 12; Copenhagen 1953, no. 54; Copenhagen 1970- I, no. 102 (ill.)

Collections: Det Danske Kunstindustrimuseum, Copenhagen

Erik Zahle, director of Det Danske Kunstindustrimuseum, had seen the Paris 1949 exhibition of Matisse's recent cut-outs, and in a November 9, 1949 letter to the artist said that the three cut-outs eventually purchased by his museum "appear to me to be perfect proofs, which in an original and splendid manner express the sense of our times, both in terms of color and of fantasy."

This work and no. 66 are some of the very few which have not been mounted or pasted flat. The result is that the paper elements here are extraordinarily tactile and "alive" and communicate a strong sense of their actual material. Matisse is known to have been especially aware of the particular physical characteristics of his *unpasted* paper cut-outs, but his desire to protect and preserve the works eventually led him to recognize the necessity of pasting them down.

The white profile element here is the remaining cutting, reversed and only slightly remodeled, from *Composition noir et rouge*, no. 69. The mottled green shape on the right was cut from a vertical band in the dismantled *Composition*, no. 39. The two-part composition here is related to the "call and response" format of some of the *Jazz* images (see Flam, *"Jazz,"* above).

The sphinx-like form on the left, with its plumed human head, large-nosed profile, and bird-like body strongly suggests similar Mayan hybrid creatures; this Mayan origin has been confirmed by Matisse's assistant. See Max Ernst's 1937 *Cahiers d'Art* cover for its sphinx-like imagery.

***69** Composition, noir et rouge

Composition, Black and Red

1947

40.5 x 53 cm.
15¹⁵⁄₁₆ x 20⅞ in.

Signed: *H Matisse* (bottom center)

Exhibitions: Paris 1949, no. 10; Paris 1953-2 (ill. color); Chicago 1974

Bibliography: Cassou 1953 (ill.); Marchiori 1955 (ill. p. 30); *Art d'Aujourd'hui* 1954 (ill. p. 41); *Life* 1957 (filmstrip); *Wellesley* 1964 (ill. p. 78)

Collections: Berggruen et Cie; Mrs. John McAndrew; Wellesley College, Wellesley

A good example of Matisse's use of positive and negative cut-out shapes. The right-hand side of this work employs the same sheet of white paper from which the sphinx-like form in no. 68 was cut; the green shapes on the left-hand side were also cut from a single sheet.

A commercial print was issued of this work.

69

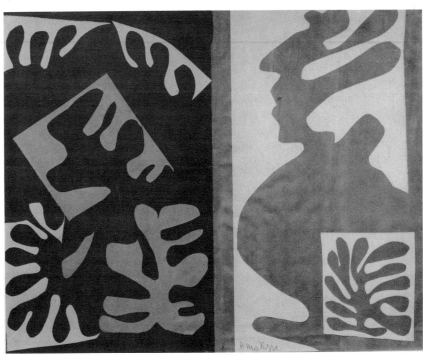

***70 Silhouette, fond jaune**

Silhouette, Yellow Background

1947

53.5 x 26 cm.
21 1/16 x 10 1/4 in.

Signed: *H Matisse* (lower right)

Exhibitions: Paris 1949, no. 17

Collections: Private Collection

The silhouette suggests an African face mask, curiously similar in spirit and form to certain BaYaka or Ogowe River style masks (see no. 108). Perhaps in reference to the tradition of silhouette portraiture, this may be a caricature of an actual person.

***71 Deux Masques (La Tomate)**

Two Mummers (The Tomato)

1947

47.7 x 52 cm.
18 3/4 x 20 1/2 in.

Signed: *H Matisse* (lower left)

Exhibitions: New York 1949; Paris 1949, no. 6

Collections: Private Collection

The studio nickname for this work was *La Tomate*; the design of the mummer's interlocked arms and legs resemble a halved tomato.

70

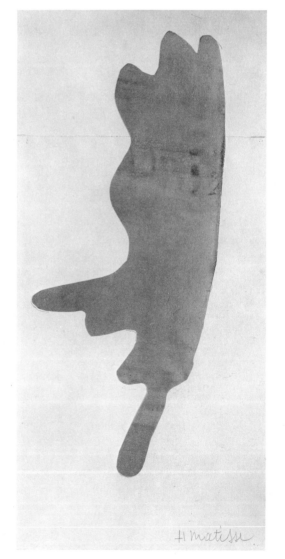

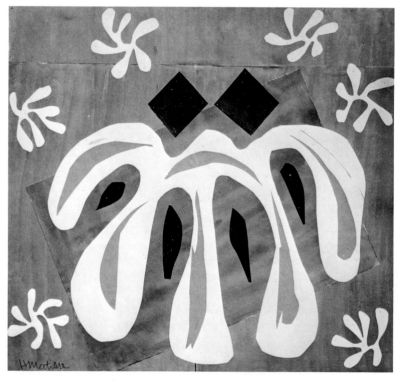

71

72 Azor

1947

52.5 x 23.5 cm.

20¹¹⁄₁₆ x 9¼ in.

Signed: (lower left)

Exhibitions: New York 1949; Paris 1949, no. 5

Collections: present location unknown

Azor is a common name for a dog in France.

This cut-out is visible in fig. 45.

73 Boxeur nègre

Negro Boxer

1947

32 x 25.5 cm.

12⅝ x 10 in.

Signed: *H Matisse* (lower right)

Exhibitions: New York 1949?; Paris 1949, no. 19 (ill. color cover); Paris 1953-2 (ill. color)

Bibliography: Barr 1951 (ill. p. 513); Stockholm 1951 (ill. color cover, not in exh.); Man 1954 (ill. color); *Art d'Aujour-d'hui* 1954 (ill. p. 41); Wescher 1955 (ill. p. 55); Muller 1956 (ill. color p. 39); Guichard-Meili 1967 (ill. color pl. 136 p. 148); Marchiori 1967 (ill. pl. 106 p. 112); Luzi 1971 (ill. p. 111)

Collections: Berggruen et Cie; Private Collection, Paris

There is a playful, almost Surrealist irony in this metamorphic image. Cf. a collage by Jean Arp (Janis 1962, ill. 47 p. 47).

74 Algue bleue sur fond rouge

Blue Alga on Red Background

1947

40.5 x 26 cm.

15¹⁵⁄₁₆ x 10¼ in.

Signed: *H Matisse* (lower right)

Exhibitions: Paris 1949, no. 9; Paris 1953-2 (ill. color)

Bibliography: Courthion 1956 (ill. color opp. p. 46)

Collections: Berggruen et Cie; Private Collection, Milan

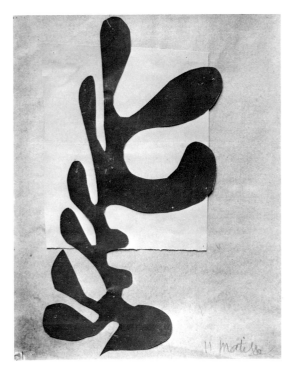

73

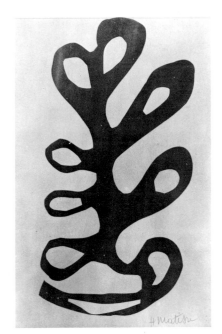

74

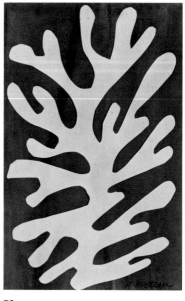

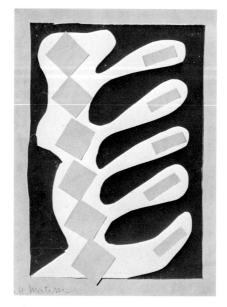

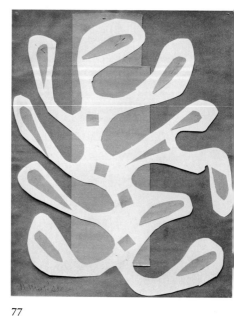

75

76

77

75 Arbre de neige

Snow Tree

1947

40.5 x 26 cm.
15¹⁵⁄₁₆ x 10¼ in.

Signed: *H Matisse* (lower right)

Exhibitions: Paris 1949, no. 7; Paris 1953-2 (ill. color); Stockholm 1954, no. 53; Helsinki 1957?; Liège 1958, no. 3; Zurich 1959, no. 74; Göteborg 1960, no. 3; Copenhagen 1961?

Bibliography: Cassou 1953 (ill.)

Collections: Berggruen et Cie; Theodor Ahrenberg; (Sotheby, London, July 3, 1968, lot no. 89, ill.); O. Adler

76 Composition, jaune, bleu, et noir

Composition, Yellow, Blue, and Black

1947

47 x 34 cm.
18½ x 13⅜ in.

Signed: *H Matisse* (lower left)

Exhibitions: Paris 1949, no. 8; Paris 1953-2 (ill. color); Stockholm 1954, no. 54; Helsinki 1957?; Liège 1958, no. 4; Zurich 1959, no. 75; Göteborg 1960, no. 4; Copenhagen 1961?

Bibliography: Cassou 1953 (ill.); San Lazzaro 1954 (ill. color opp. p. 34)

Collections: Berggruen et Cie; Theodor Ahrenberg; present location unknown

*77 Algue blanche sur fond rouge et vert

White Alga on Red and Green Background

1947

52.7 x 40.5 cm.
20¾ x 15¹⁵⁄₁₆ in.

Signed: *H Matisse* (lower left)

Exhibitions: Paris 1949, no. 3; Paris 1953-2 (ill. color); Stockholm 1954, no. 55 (ill. p. 19); Helsinki 1957?; Liège 1958, no. 5; Zurich 1959, no. 76; Göteborg 1960, no. 5; Copenhagen 1961?

Collections: Berggruen et Cie; Mr. and Mrs. Theodor Ahrenberg, Chexbres

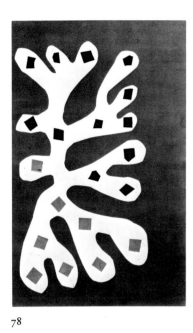

78

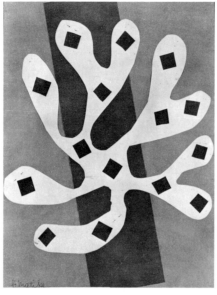

79

8 Algue blanche sur fond rouge

White Alga on Red Background

1947

52.5 x 34 cm.
20¹¹⁄₁₆ x 13⅜ in.

Signed: *H Matisse* (lower right)

Exhibitions: Paris 1949, no. 2; Paris 1953-2 (ill. color); Basel 1958, no. 19; London 1968, no. 129 (ill. p. 169); Basel 1976, no. 48

Collections: Berggruen et Cie; Philippe Dotremont; Private Collection, Basel

***79 Algue blanche sur fond orange et rouge**

White Alga on Orange and Red Background

1947

52.5 x 40.5 cm.
20¹¹⁄₁₆ x 15¹⁵⁄₁₆ in.

Signed: *H Matisse* (lower left)

Exhibitions: New York 1949; Paris 1949, no. 5; Paris 1953-2 (ill. color)

Bibliography: Cassou 1953 (ill.); *Art News* 1956 (ill. color cover)

Collections: Berggruen et Cie; G. David Thompson; (Sotheby Parke Bernet, New York, sale 2420, March 23-24, 1966, lot no. 88, ill.); Acquavella Gallery; Mr. and Mrs. Edwin Singer, Corpus Christi

80 Algue sur fond vert

Alga on Green Background

1947

25 x 15 cm.
9⅞ x 5⅞ in.

Signed: (upper right)

Exhibitions: Paris 1949, no. 18

Collections: present location unknown

Close in design to the alga element found in no. 61, center left edge, but the form is reversed.

This cut-out is visible in fig. 45.

81 Oiseau

Bird

1947

26 x 18.5 cm.

10¼ x 7¼ in.

Signed: (lower left)

Exhibitions: New York 1949; Paris 1949, no. 15

Collections: present location unknown

This cut-out is visible in fig. 45.

82 Arabesques noires et violettes sur un fond orange

Black and Violet Arabesques on an Orange Background

1947

39.5 x 26.5 cm.

15⁹⁄₁₆ x 10⁷⁄₁₆ in.

Signed: *H Matisse* (lower right)

Exhibitions: Aix-en-Provence 1960, no. 71; Albi 1961, no. 166

Bibliography: Paris 1961 (ill. p. 45); Duthuit 1962 (ill. p. 99); Jacobus 1972 (ill. p. 51)

Collections: Private Collection, France

83 Feuille de paravent, fond beige

Screen Panel, Beige Background

1947

162 x 53.5 cm.

63¾ x 21¹⁄₁₆ in.

Signed: (lower right)

Exhibitions: Paris 1949, no. 20

Collections: Private Collection

This cut-out is visible in fig. 45.

*84 Untitled

1947

26.5 x 20 cm.

10⁷⁄₁₆ x 7⅞ in.

Not signed or dated

Collections: Régine Pernoud, Paris

This form, reminiscent of the elements in the 1946 *Ascher Square* maquettes, nos. 57-58, was cut by Matisse as a memento for Régine Pernoud on September 16, 1947, during one of her visits to his studio. The white sheet from which the form was cut has also been preserved (27 x 21 cm., fig. 46). This is a good example of the artist's unbroken cutting technique.

84

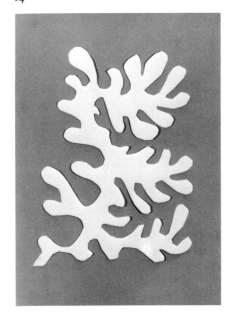

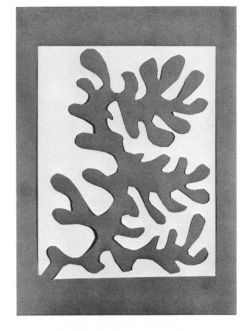

Fig. 46. *Untitled,* 1947. Cut and pasted paper, 27 x 21 cm. (10⅝ x 8¼ in.). Collection Régine Pernoud, Paris. See no. 84.

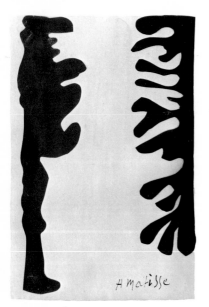

82

85 Art et Décoration, 1947, no. 6 (cover maquette)

1947

Painted cut and pasted paper; pen and ink

30.5 x 23.8 cm. (approx.)
12 x 9⅜ in. (approx.)

Signed: *H. Matisse / 1947* (lower left)

Collections: present location unknown

Not illustrated

86 Repli (cover maquette)

c. 1947

Collections: present location unknown

The color cover for André Rouveyre's *Repli*, Paris, Editions du Bélier, 1947. Printed in silkscreen by Nervet, 370 copies; yellow and white.

87 Jazz (exhibition poster maquette)

1947

20 x 43.8 cm. (approx.)
7⅞ x 17¼ in. (approx.)

Signed: *H.M.* (lower left)

Bibliography: Mourlot 1959 (ill. p. 39); Copenhagen 1970-2, p. 3

Collections: Pierre Berès; Private Collection

This maquette, white birds on blue ground, served as the poster design for the Pierre Berès exhibition of *Jazz* in Paris and Rio de Janeiro, 1947.

The printer Mourlot wrote:

For the execution of the Jazz *poster, the date having been moved forward, only a few days of preparation remained. I could not therefore submit the texts to the artist, and Berès asked me to choose the characters that I thought best; which was done and came out quite well. A few days later I received a long letter, affectionate but quite severe, from Monsieur Matisse, who criticized my choice, evidently with good reason.* (Copenhagen 1970-2, p. 3)

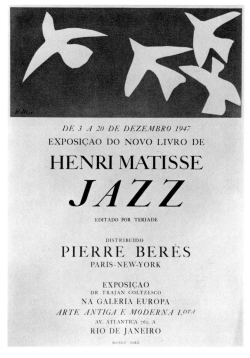

87 □

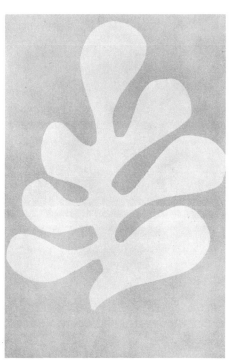

86 □

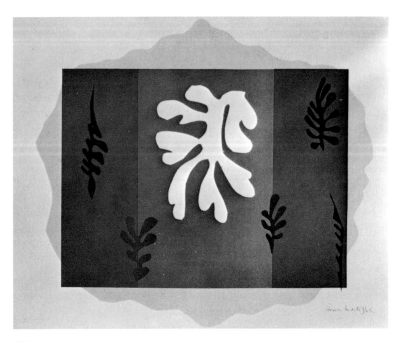

88 □

88 **La Danseuse**

The Dancer

1948

49.5 x 76.2 cm. (approx.?)
19½ x 30 in. (approx.?)

Signed: not known

Bibliography: UNESCO 1953 (ill. p. 135
of lithograph no. 301)

Collections: School Prints, Ltd.; reported
stolen, present location unknown

This work is known to us only through the
lithograph (49.5 x 76.2 cm.) illustrated in
UNESCO which was based on a paper
cut-out. The lithograph was published by
School Prints, Ltd., London, and printed
by W. S. Coswell Ltd., London.

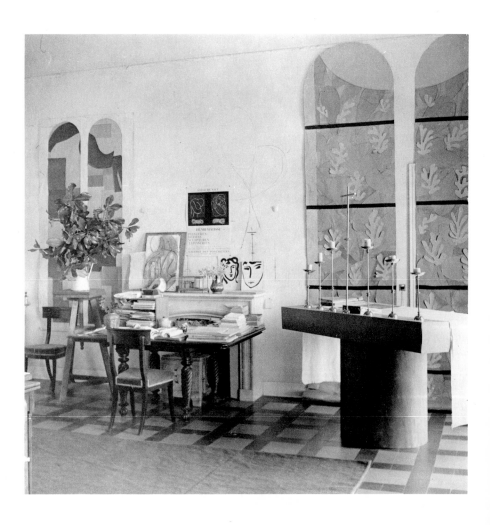

Fig. 47. Matisse studio, Hôtel Régina,
Nice, c. 1951. On wall: left, *Jerusalem
Céleste*, no. 89; right, *L'Arbre de vie*,
no. 95, apse.

89 Jerusalem Céleste

Celestial Jerusalem (preliminary window maquette)

early 1948

270 x 130 cm.
106⁵⁄₁₆ x 51³⁄₁₆ in.

Not signed or dated

Exhibitions: Tokyo 1951, no. 36; Paris 1961, no. 46 (ill. p. 60); Brussels 1966, no. 69 (color pl. no. 23); Paris 1970, no. 246A (ill. p. 297)

Bibliography: Aragon 1971, II, p. 184 (color pl. XXXII)

Collections: Private Collection

The first project maquette for the apse window, Chapel of the Rosary, Vence.

Writing in the third person (Paris 1949, p. 12), Matisse stated: "When Matisse had the opportunity to decorate the interior of a chapel, he decided to apply these studies [nos. 61-83], to the decoration of the chapel, particularly the stained-glass windows." He continued (p. 21): "That is why in the chapel there will be one side based on my studies in cut paper, that of the luminous and colored stained-glass windows, opposed to the other side decorated in black and white."

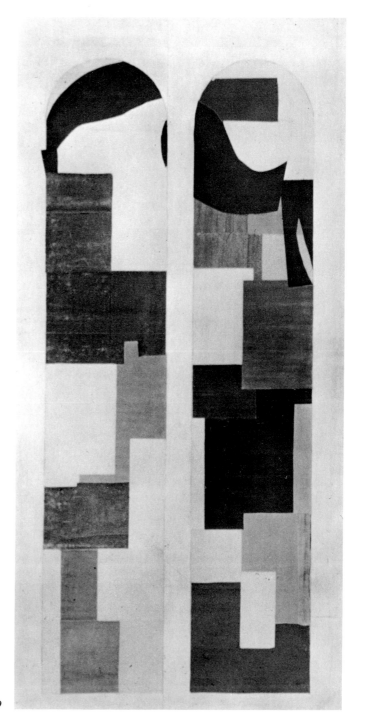

89

90

90 Les Abeilles

The Bees (preliminary window maquette)

Summer 1948

101 x 241 cm. (approx.)
39¾ x 94⅞ in. (approx.)

Not signed or dated

Exhibitions: Paris 1961, no. 4

Bibliography: Bernier 1949 (ill. color, reversed); Bertin 1949 (ill. p. 211); Barr 1951 (ill. p. 514); Aragon 1971, II (ill. p. 187)

Collections: Musée Matisse, Nice

The first maquette for the flank windows, Chapel of the Rosary, Vence. This design was subsequently executed in glass and installed in the Groupe Scolaire at Le Cateau, France, Matisse's birthplace.

This motif is said to have been inspired by the headdresses of the Dominican nuns at Vence. The metaphor of the image is extraordinarily kinesthetic, suggesting both the sight and sound of a swarm of bees.

Bees also have a long tradition of religious symbolism, the beehive being a symbol of "a pious and unified community," and honey signifying the virginity of Mary (Ferguson 1954, p. 2).

91 Mural Scroll (mural maquette)

1948

26.5 x 33 cm. (approx.)
10⁷⁄₁₆ x 13 in. (approx.)

Not signed or dated

Bibliography: *Arts & Architecture* 1949, pp. 26-28 (ill. p. 26, finished project); Barr 1951, p. 279

Collections: Katzenbach and Warren, Inc.; present location unknown

The *Mural Scroll* project was sponsored by Katzenbach and Warren, Inc., New York City. Calder, Matta, Mirò, and Matisse submitted designs which were then issued as large-scale silkscreen murals in editions of 200. To date, no more than 30 of the Matisse *Mural Scrolls* have been printed.

The size of the production silkscreen was 152.4 x 190.5 cm.

The procedural agreement was reached between Matisse and Katzenbach and Warren on May 21, 1948, indicating that Matisse would soon thereafter begin the design. The maquette was probably finished by January 1949, when Matisse signed the royalty contract with the firm.

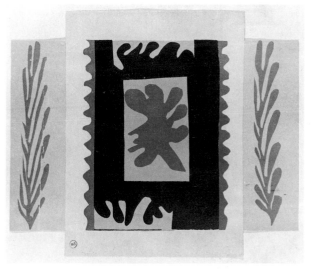

91 ☐

92 Verve, VI, 21/22, 1948 (cover maquette)

1948

36 x 54 cm.
14³⁄₁₆ x 21¼ in.

Signed: *H. Matisse* (lower right)

Exhibitions: Saint-Paul de Vence 1969,
no. 29 (front only)

Collections: Tériade, Paris

Cover design for *Verve,* VI, 21/22 (Octo-
ber 1948).

The vegetal V.E.R.V.E. letters on the front
cover contrast with the geometric char-
acter of the back cover. The sun and moon
imagery of this cover would find further
elaboration in Matisse's chasuble designs
(see nos. 128, 137, 139-142, 145, 148).

93

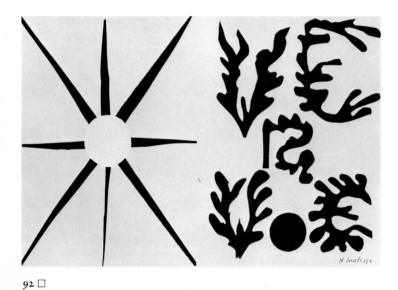

92 □

93 Vence 1944-48 (title page maquette)

1948

Painted cut and pasted paper, black crayon

36 x 27 cm.
14¼ x 10⅝ in.

Not signed or dated, but inscribed
Vence/1944-48 by Matisse

Collections: Tériade, Paris

Published as the color title page of *Verve,*
VI, 21/22 (October 1948).

This and no. 92 suggest a symbolic pro-
gression in their sequence of front cover,
title page, back cover, seemingly a transi-
tion from an eclipsed sun to a partial
eclipse to a radiant burst of solar light.

94 Vitrail bleu pâle

Pale Blue Window (preliminary window
maquettes)

1949

515 x 252; 515 x 600; 515 x 515 cm.
(three panel groups)
202¾ x 99¼; 202¾ x 236¼;
202¾ x 202¾ in. (three panel groups)

Not signed or dated

Exhibitions: Tokyo 1951, no. 35?; Paris
1961, no. 46 (ill. pp. 60-61, detail);
Brussels 1966, nos. 70-72; Paris 1970, no.
246B (ill. pp. 298-299)

Bibliography: *Le Journal Yomiuri* 1951
(ill. color p. 39, detail of apse); *XXᵉ Siècle*
1952 (ill. color opp. p. 44, detail); Gui-
chard-Meili 1967 (pl. 129, detail)

Collections: Private Collection

Second group of maquettes for the Vence
chapel windows. After he executed the
designs, Matisse found that he had not
made allowances for the windows' lead
braces. He then produced the third and
final maquette, *L'Arbre de vie,* no. 95.

Nave and Choir not illustrated

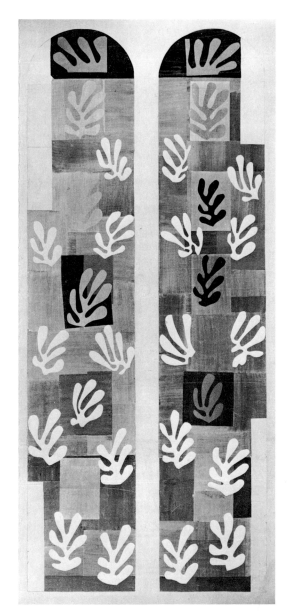

94 Apse

*95 **L'Arbre de vie**

The Tree of Life (final window maquettes)

1949

515 x 252; 515 x 600; 515 x 515 cm.
(three panel groups)
20¾ x 99¼; 20¾ x 236¼;
20¾ x 20¾ in. (three panel groups)

Not signed or dated

Exhibitions: Tokyo 1951, no. 37 (apse only); New York 1951, no. 134 (ill. detail); Paris 1961, no. 46 (ill. detail); Brussels 1966, no. 73 (ill. no. 24, detail); Paris 1970, no. 246C (ill. p. 299, detail)

Bibliography: *Le Journal Yomiuri* 1951 (ill. color p. 41, detail of apse); Guichard-Meili 1967 (ill. no. 130 p. 143); Aragon 1971, II (ill. color p. 191)

Collections: Private Collection; The Vatican Museums, Collection of Modern Religious Art

The definitive group of maquettes for the Vence chapel windows. The actual windows were executed by Paul Bony.

Concerning the Vence windows, Matisse said:

Originally, the stained-glass window provided only colored light, as evidenced by the beautiful·old windows at Chartres and in the East. Then the windows were made to tell stories, the history of the church, the lives of the saints. This was for lack of inspiration. The window became more richly embellished, but the light was lost. One cannot return to the position of one's father, but it is necessary to return to principles. The stained-glass window is an orchestra of light. (Cassonari 1950, p. 56)

The windows' background motif is a hanging drapery design iconographically related to the prevalent Gothic/Renaissance convention of the *hortus conclusis* and the Cloth of Honor.

Color plate X

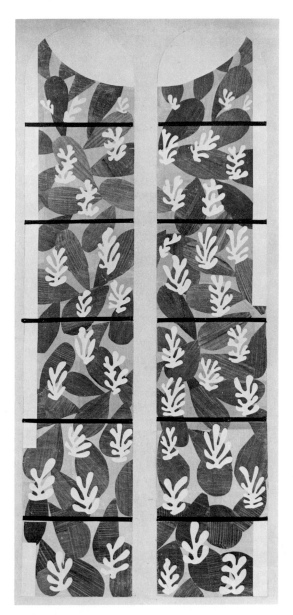

95 Apse

Fig. 48. Matisse studio, Hôtel Régina, Nice, c. 1951. On wall: left, *L'Arbre de vie,* no. 95, choir; right, preliminary design drawing for Vence chapel nave tile wall, *Ave.*

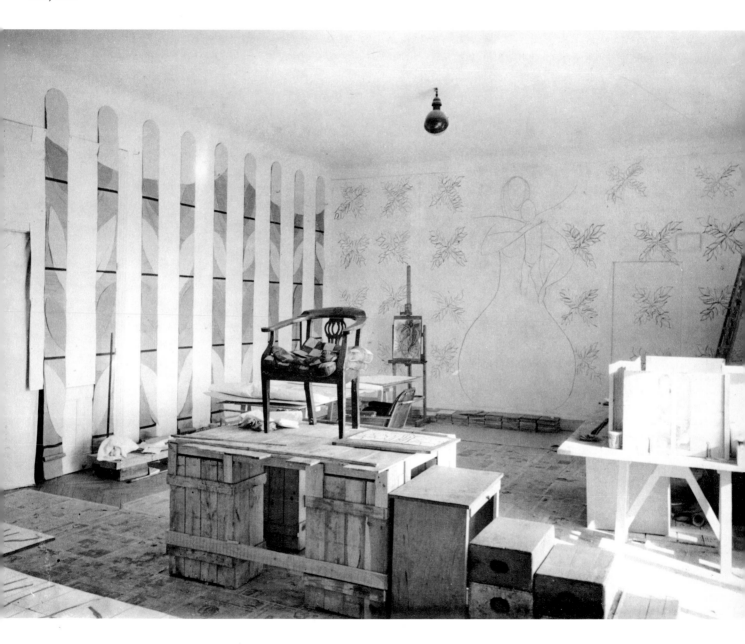

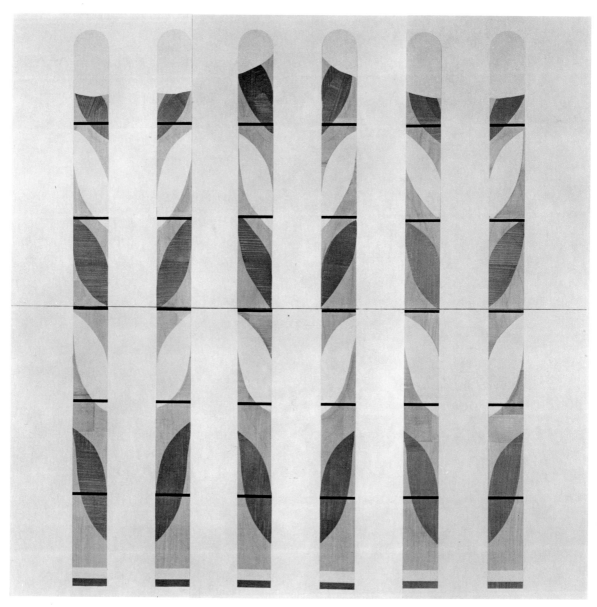

95 Nave

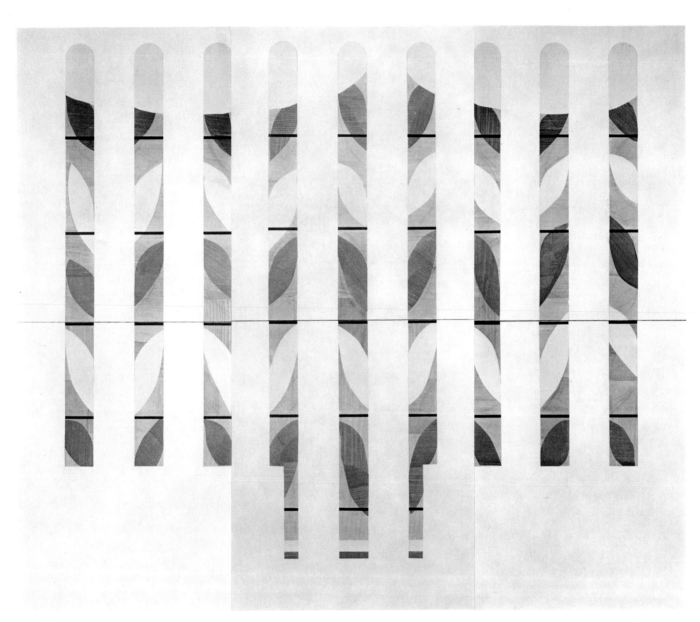

95 Choir

96 La Vierge et l'Enfant avec Saint Dominique

Virgin and Child with Saint Dominique
(tabernacle door maquette)

c. 1949

Not signed or dated

Bibliography: Barr 1951 (ill. p. 284); Holm
1951 (ill. p. 49); New York 1961 (ill. p. 16)

Collections: present location unknown

The maquette for the tabernacle door on
the main altar of the Chapel of the Rosary,
Vence.

Through the courtesy of Sister Jacques-
Marie, we also reproduce here (fig. 49)
a tiny cut-out composition of the Virgin
and Child with Saint Dominique (h. 5.2
cm.). This work was executed at the same
time as the tabernacle door maquette and
relates to the project. Matisse mounted the
cut-out, and inscribed the underside of its
base: *à Soeur Jacques initiatrice de la
chapelle.*

97 □

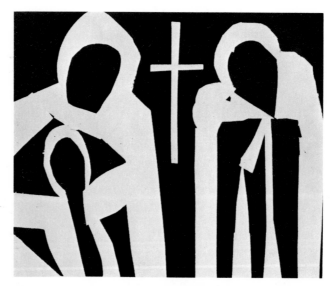

96 □

Fig. 49. *La Vierge et L'Enfant avec S.
Dominique,* 1949. Cut paper; h. 5.2 cm.
(2 in.). See no. 96.

97 Coeur d'Amour Epris (front cover maquette)

1949

Painted cut and pasted paper, crayon

36 x 27 cm.
14 3/16 x 10 5/8 in.

Not signed or dated, but inscribed *coeur d'amour épris/verve* by Matisse

Collections: present location unknown

The front cover maquette for *Verve,* VI, 23 (April 1949). This issue reproduces the illustrations of René d'Anjou's *Livre du Coeur d'Amour Epris,* a late 15th-century poem concerned with the quest for perfect love of a courtly-lover hero, Coeur d'Amour Epris ("Heart Taken with Love"), and his squire, Vif Desir ("Ardent Desire"). For Matisse's use of the heart shape, see no. 23.

98 Henri Matisse (cover maquette)

1949

21 x 14.7 cm. (approx.)
8 1/4 x 5 3/4 in. (approx.)

Signed: *H. Matisse* (lower right)

Collections: present location unknown

Maquette for the catalogue cover of the exhibition "Henri Matisse," Lucerne, Musée des Beaux-Arts, July 9-October 2, 1949. According to Matisse's assistant, the silhouette refers to the headdress of an American Indian.

*99 La Danseuse

The Dancer

c. 1949

35.7 x 25.4 cm.
14 1/16 x 10 in.

Signed: *H. Matisse* (center left)

Bibliography: Paris 1961 (ill. p. 45); Duthuit 1962 (ill. p. 99); Jacobus 1972 (ill. p. 51)

Collections: Pierre Matisse Gallery; Robert Motherwell, Greenwich

The left edge of this white shape describes a negative blue profile head.

Another variation on the theme of "observer observed" (see no. 28)—the head watching the dancer dance.

98 □

99

*100 Les Fauves

The Fauves (cover maquette)

1949

32.3 x 50.8 cm.
12¾ x 20 in.

Signed: *H. M.* (lower right), *un/seul/bleu celui-ci/sans/variantes/si elles ne/sont pas/réussies* (upper left), *si possible* (lower right)

Exhibitions: Zurich 1966

Collections: François Lachenal, Ingelheim Am Rhein

Color cover maquette for Georges Duthuit, *Les Fauves,* Geneva, 1949.

To the special *exemplaires de tête* Matisse added five small blue and red flowers (fig. 50). This part of the edition was then signed by both Matisse and Duthuit. On the original maquette there are pencil outlinings where the flower designs were to be placed.

A promotional color poster—with two illustrations of the cover, comments by Matisse from the book, and signed by the artist—was issued at the time of the book's publication.

This cover may be compared to Sonia Delaunay's early collage book covers. Her experiments were well known in the pre-World War I Parisian art community. Collaged jackets were also made by Natalia Gontcharova (*Mirskontsa,* August-September 1912); Olga Rosanova (*Zaumanaya-gniga,* c. 1915); and Nach-mann Granovsky (Iliazd's *Le Dentu le Phare*).

Color plate XI

100

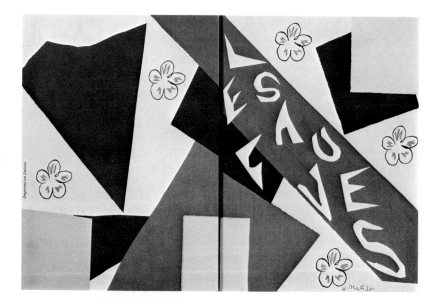

Fig. 50. Georges Duthuit, *Les Fauves,* cover by Matisse for the "exemplaires de tête," 1949. See no. 100.

101 Danseuse acrobatique

Acrobatic Dancer

1949/50?

52.3 x 40.3 cm.
20⅝ x 15⅞ in.

Signed: *H. Matisse* (lower right)

Bibliography: Paris 1961 (ill. p. 45);
Duthuit 1962 (ill. p. 99); Jacobus 1972
(ill. p. 51); Editions Nouvelles Images
color card CP90

Collections: Private Collection

The pin-wheeling composition disperses
the calligraphic cuttings, and the two
black forms at the top extend beyond the
orange background.

Cf. the serrations and arabesques in the
futurist collages of Giacomo Balla, such
as *Collage for Marinetti* and *Patriotic
Demonstration* (Wescher 1968, pl. 52 p.
62; color pl. 12 p. 71).

102 Algue

Alga

1949/50?

Signed: not known

Bibliography: Paris 1961 (ill. p. 45);
Duthuit 1962 (ill. p. 99); Jacobus 1972
(ill. p. 51)

Collections: present location unknown

Not illustrated

103 Les Quatre Rosaces aux motifs bleus

The Four Rosettes with Blue Motifs

1949/50?

38 x 54 cm.
14¹⁵⁄₁₆ x 21¼ in.

Signed: *H. Matisse* (lower right)

Exhibitions: Aix-en-Provence 1960, no. 72;
Albi 1961, no. 167

Bibliography: Paris 1961 (ill. p. 45);
Duthuit 1962 (ill. p. 99); Jacobus 1972
(ill. p. 51)

Collections: Private Collection, France

This work is said to have been designed
for a book cover, not used, but then re-
tained by the artist as an independent
composition.

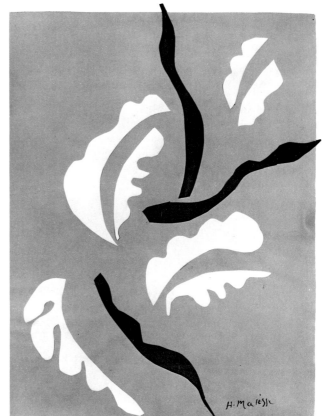

101

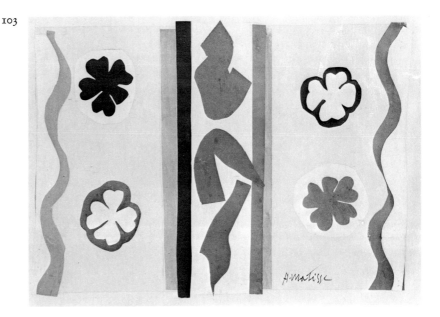

103

104 Composition

1950

32 x 24.5 cm. (approx.)
12¾₁₆ x 9⁹⁄₁₆ in. (approx.)

Signed: *Nice le 14 Avril 1950 / Henri Matisse / Pour la Revue Domus* (lower right)

Bibliography: Cassonari 1950 (ill. color p. 55); *Domus* 1971 (ill. color p. 55)

Collections: *Domus;* present location unknown

Not illustrated

***105 Composition, fond bleu**

Composition, Blue Background

early 1950

80 x 50 cm.
31½ x 19¹¹⁄₁₆ in.

Signed: *Matisse 51* (lower right)

Exhibitions: Paris 1953-2 (ill. color); Basel 1958, no. 5; Zurich 1967 (ill. p. 201)

Bibliography: Lacaze 1950 (ill. color p. 17, detail); Lacotte 1953 (ill.); *Le Rassemblement* 1953 (ill.); Degand 1953 (ill. p. 28); San Lazzaro 1954 (ill. color opp. p. 34); Matisse, P. 1955 (ill. p. 8, reversed); *Du* 1976 (ill. color p. 35)

Collections: Berggruen et Cie; Max Bill, Zurich

Contrary to the signed date of 1951, this finished composition is illustrated in a photograph taken by Walter Carone on April 15, 1950, for publication in *Paris Match,* May 6, 1950.

The form in the upper right corner and that in the lower left corner are reverse images cut from the same sheet, a feature which strongly influences the composition.

106 Composition

early 1950

Bibliography: *La Biennale di Venezia* subscription card (ill., detail)

Collections: present location unknown

This work is partially illustrated in a subscription card for *La Biennale di Venezia.* The card photograph also reproduces *Masque nègre,* no. 108, one of the lamps from *Les Mille et Une Nuits,* no. 111, and a not-yet-completed element later to be found in *Les Bêtes de la mer . . .,* no. 114. Thus, the date for the photograph must be before June 1950, which is the signed date of *Les Mille et Une Nuits.*

Not illustrated

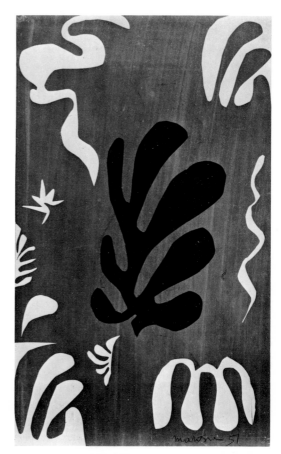

105

107 Composition

early 1950

Collections: present location unknown

See remarks no. 106.

Not illustrated

108 Masque nègre

Negro Mask

early 1950

55 x 43 cm. (approx.)
21⅝ x 16¹⁵⁄₁₆ in. (approx.)

Signed: *H. Matisse* (lower right)

Bibliography: Lacaze 1950 (ill. color p. 18); Pernoud 1952 (ill. p. 12); Matisse, P. 1955 (ill. p. 8, reversed); *La Biennale di Venezia* subscription card (ill.); Paris 1961 (ill. p. 45); Duthuit 1962 (ill. p. 99); Jacobus 1972 (ill. p. 51)

Collections: Private Collection

Matisse's concern with actual mask images reflects a life-long fascination with "masking" in his painted imagery: identities reflected in and partially concealed by mirrors, pictures-within-pictures, and surrogate portraits (see Flam 1975-1).

This image seems to be based on two kinds of Congolese masks: the Ba Songe *Kifwebe* and Ba Kuba *Mboom*. The irregular form around the lower part of the jaw area suggests a fragment of raffia costume, such as is often seen in collected examples of such masks. Although based on fairly specific prototypes, Matisse's mask, like so much of the imagery in the cut-outs, goes far beyond description of actual simple entities.

This cut-out is illustrated in figs. 52-53.

109 Zulma

early 1950

Painted cut and pasted paper, crayon

238 x 133 cm.
93¾ x 52⅜ in.

Signed: *H. Matisse/50* (lower left)

Exhibitions: Paris 1950-1, no. 123; Paris 1950-2, p. 10, no. 60; Copenhagen 1970-1, no. 105 (ill.)

Bibliography: Dorival 1950 (ill. p. 20, state); Barr 1951, pp. 263, 278, 281 (ill. p. 513); *Paletten* 1952 (ill. p. 135); Diehl 1954, pp. 81, 94, 147, 156 (pl. 134); Matisse, P. 1955 (ill. color cover, state); Escholier 1956 (ill. p. 246); Muller 1956 (ill. p. 234); *Verve* 1958 (ill. color p. 15); Lassaigne 1959-2, pp. 121-122 (ill. color p. 121); Copenhagen 1964, no. R189; Brill 1967 (color pl. 46); Guichard-Meili 1967 (ill. p. 144, pl. 131); Bowness 1968 (color pl. 30); Moulin 1968, p. 195 (color pl. II p. 33); Diehl 1970 (color pl. 48); *Lettres françaises* 1970 (ill. p. 9, underdrawing); *XXe Siècle* 1970 (ill. p. 82); Grand Collections of World Art (ill. no. 68); Aragon 1971, II (color pl. 30 p. 169); Flam 1971 (fig. 18); Luzi 1971 (ill. p. 111)

Collections: Statens Museum for Kunst, Copenhagen

The director of the Statens Museum for Kunst, Leo Swane, saw this finished work during a visit to Matisse's studio on May 2, 1950. *Zulma* was purchased by the museum from the artist by June 1950.

See the letter from Matisse to Jean Cassou, April 9, 1952, Documents Appendix, 9, concerning Matisse's personal evaluation of *Zulma* compared to *Tristesse du roi*, no. 166. See also the letter from Matisse to J. Rubow, June 6, 1954, Documents Appendix, 14, concerning the artist's attention to the presentation and preservation of *Zulma*. This was one of Matisse's favorite works (*Tristesse du roi* notwithstanding), and he was immodestly opinionated about its publicity.

Documentary photographs taken during the restoration of *Zulma* reveal that Matisse began this cut-out by first indicating the elements of the composition with simple charcoal lines (see fig. 51). Next he added the central orange strip of cut paper upon which he drew the missing details. Finally, after working up the background and still-life elements, he com-

pleted the figure with bright blue and
again reinforced the drawing, this time
around the breasts. In this cut-out—one
of the earliest large independent works—
he dealt with the composition as a whole
by first resolving its constituent parts.
Matisse also adapted what was most
familiar to him, so that *Zulma* was in
effect an oil painting translated into
gouache découpée. Matisse here re-
sponded to the colored shapes and
modified their effect in much the same
way he had used "drawn" lines in paint-
ing: to reinforce the "weight" of a fig-
ure insufficiently defined by color alone.

Zulma appears not to be a reference to a
specific person, but an evocation of a
"femme orientale."

109

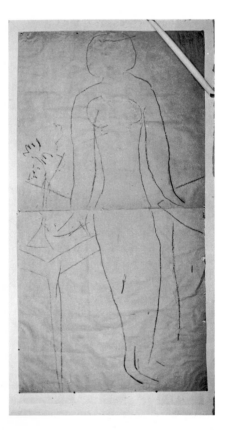

Fig. 51. Preliminary drawing for *Zulma*,
no. 109.

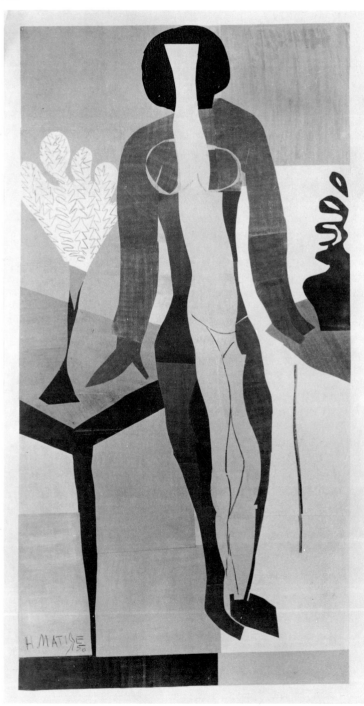

164

110 Danseuse créole

Creole Dancer

June 1950

205 x 120 cm.
80¾ x 47¼ in.

Signed: *Matisse Juin 50* (lower right)

Exhibitions: Paris 1950-2, no. 62; Paris 1961, no. 5; New York 1961, no. 2 (color pl. A)

Bibliography: Verdet 1952; *Verve* 1958 (ill. color p. 10); Moulin 1968 (color pl. IX); Murphy 1970 (ill. color p. 36); *Jardin des Arts* 1970 (ill. color p. 19); Aragon 1971, II, p. 305 (color pl. LXXII p. 343); Luzi 1971 (ill. p. 111); Commissariat Général du Tourisme—Musée Matisse color poster

Collections: Musée Matisse, Nice

According to Aragon, the subject is the well-known dancer Katherine Dunham, whom Matisse had seen perform (Aragon 1971, II, p. 305).

Close examination of the paper used in this composition reveals numerous indentations, like those made by a dressmaker's roulette. These tracks seem to establish the contours upon the painted paper for subsequent cutting. To our knowledge, there are no other works which contain such stippling.

110

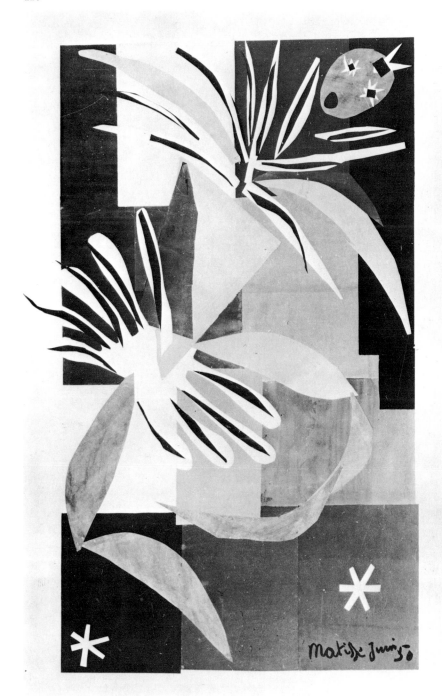

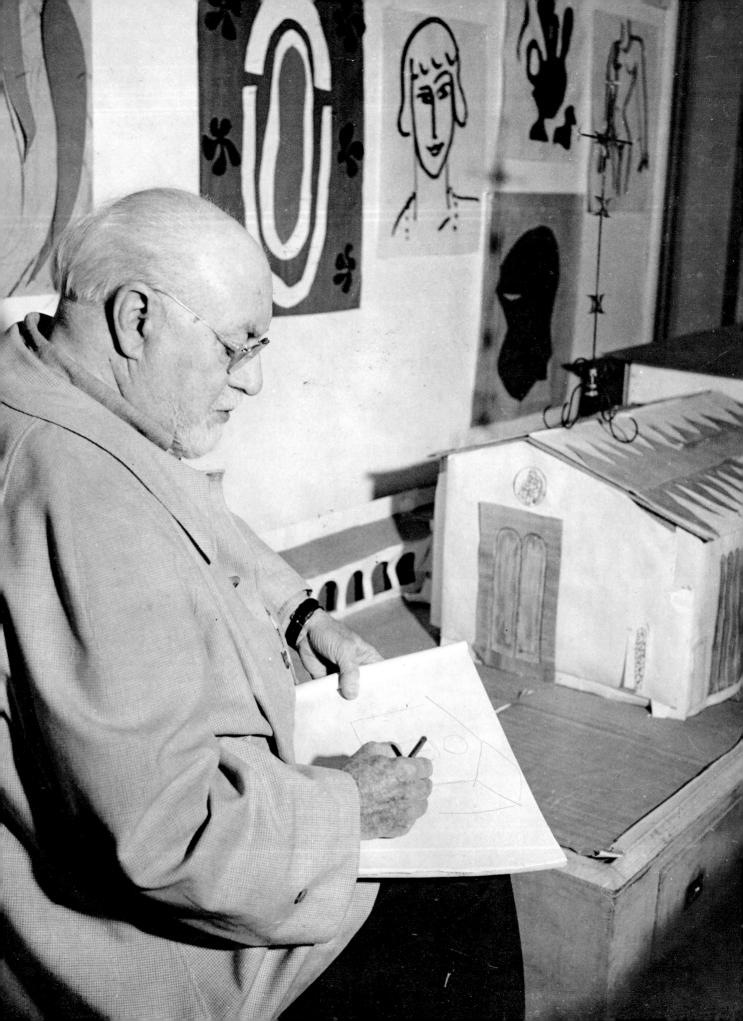

Fig. 52. Henri Matisse, Hôtel Régina, Nice, 1950. On wall: several brush and ink drawings and what will become *Les Mille et Une Nuits,* no. 111; lower right, *Masque nègre,* no. 108. Front right: model for the Chapelle du Rosaire, Vence.

Fig. 53. Matisse studio, Hôtel Régina, Nice, 1950. On wall: portions of what will become *Les Bêtes de la mer . . . ,* no. 114, and *Les Mille et Une Nuits,* no. 111; top center, *Composition, fond bleu,* no. 105; lower right, *Masque nègre,* no. 108. Foreground: model of the Chapelle du Rosaire, Vence.

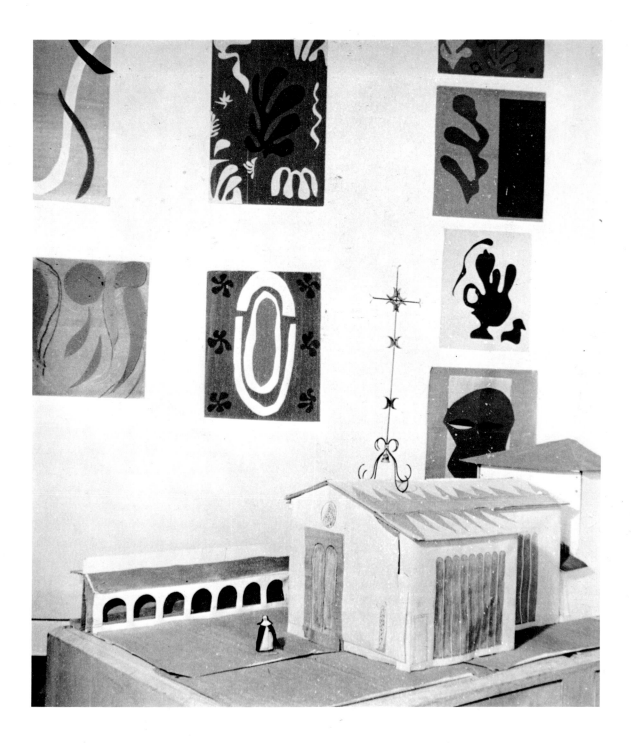

Fig. 54. Henri Matisse, Hôtel Régina,
Nice, April 15, 1950. On wall: portions of
what will become *Les Bêtes de la mer . . .* ,
no. 114, and *Les Mille et Une Nuits,* no.
111; lower left, *Le Masque japonais,* no.
112, early state.

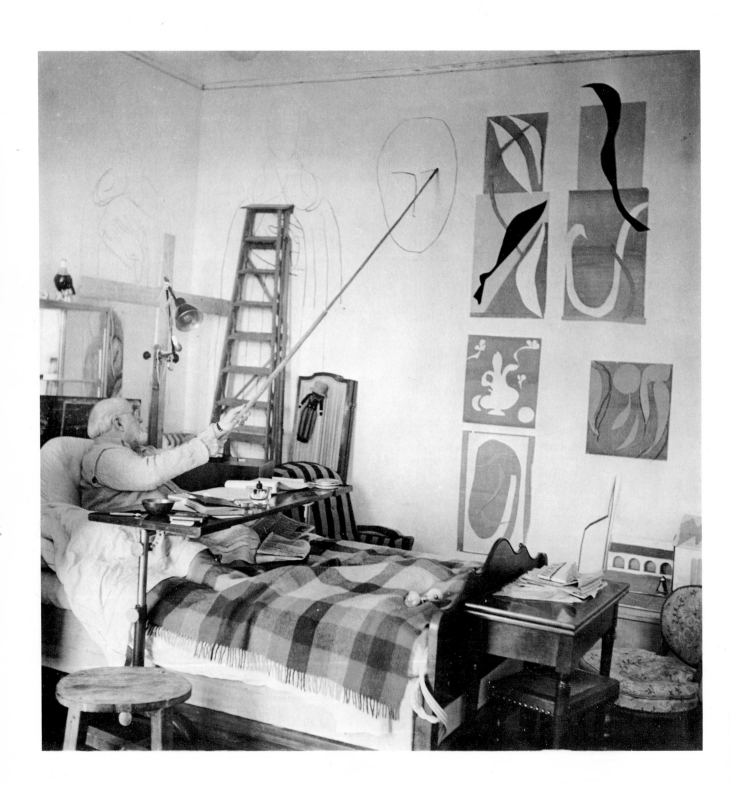

11 Les Mille et Une Nuits

The Thousand and One Nights

June 1950

140 x 374 cm.
54¾ x 147¼ in.

Signed: *H. Matisse Juin 50* (lower right)

Exhibitions: Paris 1950-2, no. 61; Paris 1951, no. 23; New York 1951, no. 74 (ill. p. 8); Paris 1961, no. 6; New York 1961, no. 3; Saint-Paul de Vence 1969, no. 30 (ill. color); Copenhagen 1970-1, no. 106 (ill.); New York 1973-2

Bibliography: Barr 1951, p. 278 (ill. p. 512); *Derrière le miroir* 1951; *Cahiers d'art,* 1951, p. 209; Besson 1954 (pl. 60); Diehl 1954, p. 147 (ill. p. 156); *Life* 1954 (ill. p. 44, detail state); *Paris Match* 1954 (ill. p. 31, color detail state); Murcia 1955 (ill. p. 94, detail); *Apollo* 1972 (ill. p. 158); Teilman 1972, pp. 186-188 (ill. pp. 186-187 and color cover); Pittsburgh 1973, p. 113 (ill. color cover)

Collections: Contemporary Art Establishment; Pierre Matisse Gallery; Museum of Art, Carnegie Institute, Pittsburgh

The text in cut-out lettering translates: ". . . She saw the light of day/She fell discreetly silent."

Documentary photographs (figs. 52-54) show that some of the constituent elements for this composition were fixed at random on Matisse's studio wall. (Much the same happened with those cut-outs which eventually coalesced into *Les Bêtes de la mer . . .*, no. 114.)

Diaghilev staged the ballet *Scheherazade* in 1910 with décor and costumes by Léon Bakst and music by Rimsky-Korsakov. The ballet was restaged in 1924 and was again performed in Monte Carlo in 1943. Elsa Triolet later wrote about *Scheherazade* in *Le Cheval roux.*

Les Mille et Une Nuits is structured in terms of the passage of time on several levels. First there is the actual physical time it takes for the viewer's eyes to read the horizontal 12-foot expanse of the panel from left to right—a movement reinforced by Matisse's use of the written phrase.

Secondly, there is the composite and diurnal nature of the Arabian nights theme itself—the passage of a single night. This narrative sequence might thus begin on the left with the Persian lamp burning in the night, a wisp of smoke, a blue figure perhaps dancing, then the central panel recording a condensed passage of the phases of the night, maroon and black, into the early morning, gray and orange, the curved black line across them indicating the uncertain division between night and day, and the now extinguished Persian lamp silhouetted against the light. The last panel within this context might suggest the rising sun.

Thirdly, the panels allude to recurrent motifs within the repetitive thematic structure of the tales themselves, adding to narrative time another kind of happening: fictional time. Reading from the left, the panels suggest: a magical lamp, such as Aladdin's; a genie, such as recurs throughout the tales; a storm at sea, as in the Sinbad tales and that of the Lady with the Beautiful Tresses; another lamp, suggestive perhaps of the tale of the Princess Parizade (the Talking Bird, the Singing Lamp, and the Yellow Water); a sexual form which also suggests the entrance to a magical cave (cf. the passageway in Matisse's *Morocains,* 1916, MOMA) such as the cavern of Solomon and the cave of Ali Baba (in which the magical use of words parallels Scheherazade's own magical use of language). The large red shape to the far right, distinct from the framed panels on colored grounds, might indicate the dawn, the moment when the action and high color of the tales fades and Scheherazade "falls discreetly silent."

The embellishments of plant and fruit forms also suggest the richly sensuous imagery of the tales, as do the heart shapes, which reflect the overriding theme of love. "Love," as Ilzaide says in the story of the Lady with the Beautiful Tresses, "can make every place agreeable; even the elements are subject to its empire." Words that find a parallel in Matisse's own *Jazz* text (see no. 23).

The structural and narrative relationship between this cut-out and Rimsky-Korsakov's *Scheherazade* should not be overlooked.

Galerie Maeght has issued a print made from this cut-out image, reduced format.

Color plate XII (detail)

III

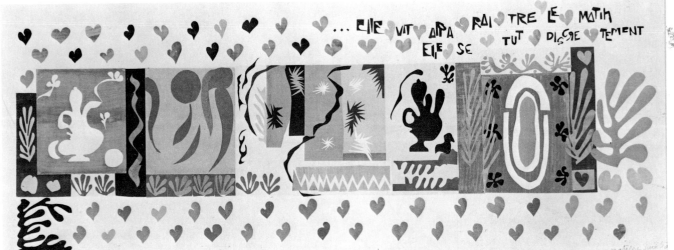

***112 Le Masque japonais**

The Japanese Mask

early 1950?

79.5 x 49.5 cm.
31⁵/₁₆ x 19½ in.

Signed: *H. Matisse* (lower left)

Bibliography: Pernoud 1952 (ill. p. 21, state); *Paris Match* 1954 (ill. color p. 31); *Life* 1954 (ill. p. 44, detail state); Paris 1961 (ill. p. 45); Duthuit 1962 (ill. p. 99); Jacobus 1972 (ill. p. 51)

Collections: Private Collection

Japanese theater masks, with their fantastic designs, could easily have provided Matisse with material from which to extrapolate ideas.

113 Henri Matisse, Maison de la Pensée Française (poster maquette)

1950

76 x 53 cm. (approx.)
29¹⁵/₁₆ x 20⅞ in. (approx.)

Not signed or dated

Bibliography: Alpatov 1973, p. 128

Collections: present location unknown

The poster for the exhibition at the Maison de la Pensée Française, Paris, July 5 - September 24, 1950, was printed by Mourlot Frères, Paris, in 700 copies, four-color, 76 x 53 cm. format.

The slightly skewed construction of the head suggests a relationship to Matisse's 1949 lithographic illustrations of eskimos for Georges Duthuit's *Une Fête en Cimmérie*, Paris, 1963 (see also no. 67).

Cf. Sonia Delaunay's cut-out lettering in her *Dubonnet* and *Zenith* posters (Damase 1971, ill. pp. 373, 387).

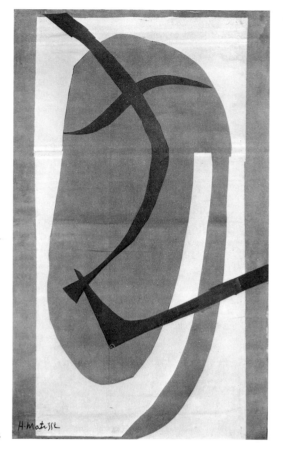

112

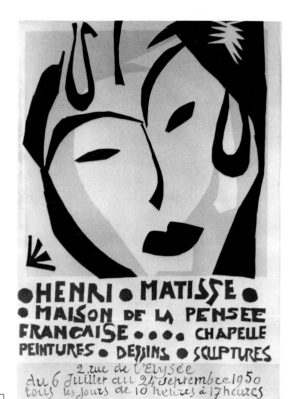

113 □

114 Les Bêtes de la mer . . .

The Beasts of the Sea . . .

1950

295.5 x 154 cm.
116⅜ x 60⅝ in.

Signed: *les bêtes de la mer . . ./H. Matisse
50* (lower right)

Exhibitions: Tokyo 1951, no. 1; New
York 1951, no. 74a; Bern 1959, no. 1 (ill.);
Amsterdam 1960, no. 2; Paris 1961, no. 7;
New York 1961, no. 4 (ill. p. 17)

Bibliography: *Le Journal Yomiuri* 1951
(ill. color p. 9); *Paris Match* 1954 (ill. color
p. 31, detail state); *Life* 1954 (ill. color p.
44, detail state); Lassaigne 1959-2, p. 122;
Cowart 1975, pp. 53-55 (ill. color p. 53);
National Gallery of Art, Washington,
D.C. color poster

Collections: Private Collection; National
Gallery of Art, Washington, D.C.

This work combines a number of dynamic,
though balanced, chromatic shapes into
screen-like panels or columns. Dense
forms and color zones are generally at the
bottom; less dense forms are near the top.

The composition suggests a tropical ocean
floor, water view. See Cowart 1975 for
further discussion of the colors, themes,
and potential symbolism of this work. The
title and its ellipsis are curiously poetic,
almost Baudelarian.

Color plate XIII

114

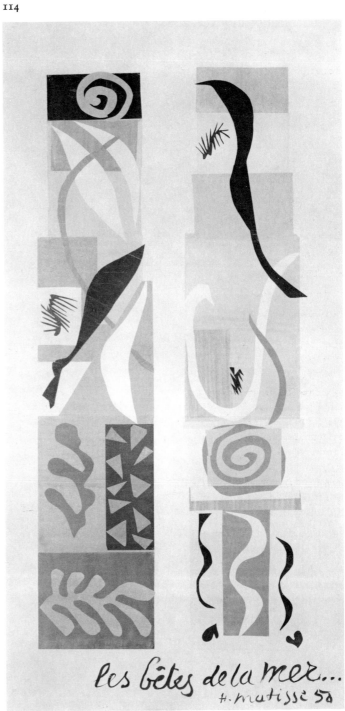

115 **Henri Matisse: chapelle, peintures, dessins, sculptures, Maison de la Pensée Française** (cover maquette)

1950

Painted cut and pasted paper, ink and brush

21 x 16 cm. (approx.)
8¼ x 6⁹⁄₁₆ in. (approx.)

Signed: *H. Matisse 50* (lower left)

Bibliography: Aragon 1971, II (color pl. XXVIII p. 168)

Collections: present location unknown

The maquette for the front cover of the exhibition catalogue *Henri Matisse: chapelle, peintures, dessins, sculptures, Maison de la Pensée Française,* Paris, July 5-September 24, 1950. Cf. Matisse's sculpture *Le Tiaré,* 1930, which was most likely the source for the female figure in this paper cut-out.

116 **Roman** (cover maquette)

1950

Painted cut and pasted paper and ink

25.3 x 34.4 cm. (approx.)
10 x 13⁹⁄₁₆ in. (approx.)

Not signed or dated

Collections: present location unknown

Cover maquette for *Roman,* a bimonthly revue edited by Pierre de Lescure and Célia Bertin in Saint-Paul de Vence. The first printing was January 1951; the Matisse design was the standard cover.

116 ☐

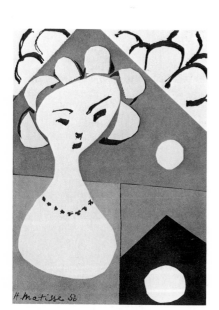

115 ☐

17 Fleurs de neige

Snow Flowers

1951

173.1 x 81 cm.
68 3/16 x 31 7/8 in.

Signed: *Fleurs de Neige Henri Matisse/
1951* (lower right)

Exhibitions: Warsaw 1954 (not in cat.);
Bern 1959, no. 3 (ill.); Amsterdam 1960,
no. 4; Paris 1961, no. 9; New York 1961,
no. 5 (ill. p. 21); Los Angeles 1966, no.
338; Baltimore 1968, no. 127 (ill. p. 151);
Buffalo 1970, no. 34 p. 12 (ill. p. 42); New
York 1973-1 (ill. color)

Bibliography: *Verve* 1958 (ill. color p. 21);
Lassaigne 1959-1 (ill.); Lassaigne 1959-2,
p. 122; Marmer 1966 (ill. p. 33)

Collections: Private Collection; Vicci
Sperry; Mr. and Mrs. Jacques Gelman

Color plate XIV

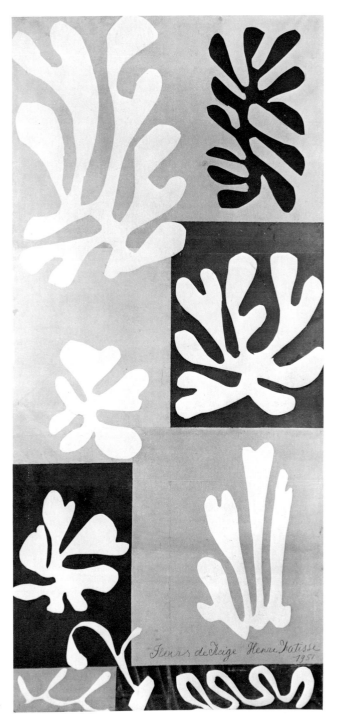

117

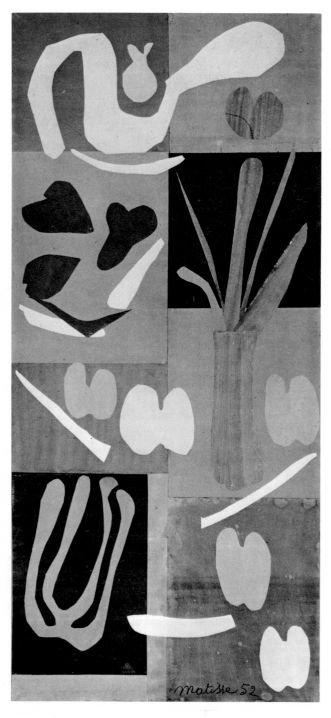

118 **Végétaux**

Vegetables

1951

175 x 81 cm.
68 15/16 x 31 7/8 in.

Signed: *Matisse 52* (lower right)

Exhibitions: Bern 1959, no. 2 (ill.);
Amsterdam 1960, no. 3; Paris 1961, no. 8;
New York 1961, no. 7 (ill. p. 20); Los
Angeles 1966, no. 339; Paris 1970, no.
225ter (ill.)

Bibliography: *Verve* 1958 (ill. color p. 20);
Moulin 1968 (color pl. X); Luzi 1971 (ill.
p. 111)

Collections: Private Collection, France

Probably signed and dated by Matisse
after the work had been completed for
some time. Matisse's nickname for this
cut-out was *Le Poireau (The Leek).*

119 **Madame de Pompadour . . . (poster
maquette)**

1951

Painted cut and pasted paper, brush
and ink

88.9 x 73.7 cm.
35 x 29 in.

Signed: *H. Matisse 51* (lower left)

Bibliography: London 1968, no. 127A
(ill. but not exhibited)

Collections: Ecole des Arts Décoratifs;
Mr. and Mrs. Sidney F. Brody; Los
Angeles County Museum of Art

The actual poster for the artists' gala ball
at the Ecole des Arts Décoratifs, Paris, was
printed with the holograph insert:
"Madame de Pompadour reçoit le mardi
20 Novembre 1951 au Pavillon de Marsan
à 22 heures." The poster run was 1,500
copies, 10-color lithography, 80 x 60 cm.
format. The maquette was donated by
Matisse for the benefit of the alumni of
the Ecole. Matisse had studied at the Ecole
des Arts Décoratifs from 1892 to 1894 (for
further details, see Cowart 1972).

The brush and ink drawing is on tracing
paper, which integrates the line drawing
with the color.

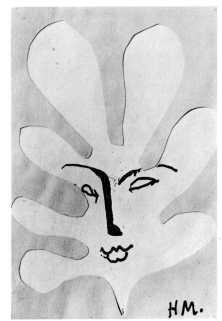

120

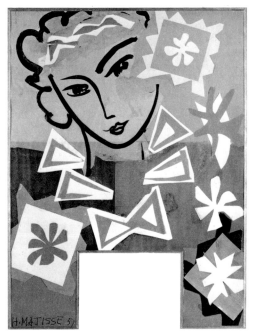

119

Head

1951

Painted cut and pasted paper, brush and ink

14.5 x 10 cm.
5¾ x 3¹⁵⁄₁₆ in.

Signed: *HM.* (lower right)

Bibliography: San Francisco 1975

Collections: Heinz Berggruen, Paris

The element reproduced on the invitation card to the opening of the important exhibition of Matisse's paper cut-outs at Berggruen et Cie (Paris 1953-2).

According to Berggruen:
I was received by Matisse who was propped up in bed looking at me sternly or, rather, scrutinizing me through strong scintillating glasses. I asked him to let me do a show of his paper cut-outs . . . and to my great joy he agreed. When I saw him again a few days later, he handed me, generously and without saying a word, the covers of the catalogue [no. 197] and of the invitation which he had drawn or, rather, cut out for me. (San Francisco 1975)

The stylistic derivations of this cut-out, however, tend to suggest a date of 1951, when Matisse was more interested in the combination of drawn faces and cut-outs. It seems likely, therefore, that Matisse, as he had on other occasions, used an existing design for the invitation.

121 **Henri Matisse** (cover maquette)

1951

Painted cut and pasted paper, brush, pen and ink

21 x 15.3 cm. (approx.)
8¼ x 6 in. (approx.)

Collections: present location unknown

Maquette for the front cover of the catalogue of the exhibition "Henri Matisse," National Museum, Tokyo, 1951. This exhibition also traveled to Kyoto and Osaka, sponsored by *Le Journal Yomiuri.*

Not illustrated

***122 Matisse His Art and His Public** (cover maquette)

1951

Painted cut and pasted paper, brush and ink

27 x 42.8 cm.
10⅝ x 16⅞ in.

Signed: *HM.* (lower left)

Exhibitions: Cambridge 1955, no. 45; New York 1961, no. 41

Collections: Museum of Modern Art, New York

The design for the dust jacket of Alfred Barr, *Matisse His Art and His Public,* New York, 1951.

The Alexander Liberman photograph (fig. 55) shows Matisse working on a cover maquette said to be an early state of this Barr dust jacket. A letter dated September 1, 1951 from the artist to Monroe Wheeler at the Museum of Modern Art mentions the completion of this maquette. Matisse's letter of September 18, 1951, again to Wheeler, indicates that he thought this design was to serve as the book's actual binding rather than the jacket. This would relate the design conception more closely to the craft and formal considerations of contemporary French art bookbinding.

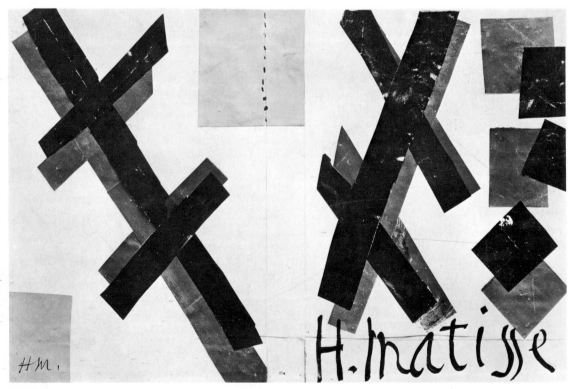

122

Fig. 55. Matisse studio, Boulevard Montparnasse, Paris, 1951. In foreground, *Matisse His Art and His Public* cover maquette, no. 122, early state.

***123 Henri Matisse** (cover maquette)

1951

Painted cut and pasted paper, brush and ink

27 x 40 cm.
10⅝ x 15¾ in.

Signed: *HM* (lower right)

Exhibitions: Cambridge 1955, no. 46; New York 1961, no. 40

Collections: Museum of Modern Art, New York

Maquette for the cover of the Matisse exhibition catalogue, Museum of Modern Art, New York, 1951. This exhibition also traveled to Cleveland and Los Angeles. A September 18, 1951 letter from the artist to Monroe Wheeler at the Museum of Modern Art mentions that this maquette was completed. Wheeler had offered the commission for the cover only a short time before, in his letter to Matisse of September 12, 1951. See Documents Appendix, 7, for extract of Matisse's letter.

124 Chapelle du Rosaire des Dominicaines de Vence par Henri Matisse (cover maquette)

1951

25.5 x 37.2 cm. (approx.)
10¹⁄₁₆ x 14¹¹⁄₁₆ in. (approx.)

Signed: not known

Collections: present location unknown

Maquette for cover of the book *Chapelle du Rosaire des Dominicaines de Vence par Henri Matisse,* Vence, 1951.

123

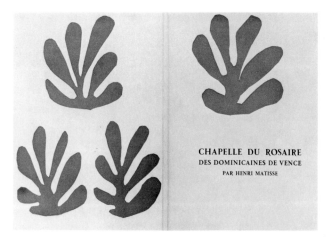

124 ☐

125 **Chapelle du Rosaire des Dominicaines de Vence par Henri Matisse** (cover maquette)

1951

35.5 x 52.7 cm. (approx.)
14 x 20¾ in. (approx.)

Signed: not known

Collections: present location unknown

Maquette for the cover of a ten-page insert published in *France-Illustration,* December 1951, as well as of an offprint of 1,500 additional copies printed by S.N.E.P. Imprimerie, Bobigny.

126 **Petite Arabesque bleue sur fond vert**

Small Blue Arabesque on Green Background

1951

24 x 19.5 cm.
9 7/16 x 7 11/16 in.

Signed: *Matisse 51* (lower right)

Exhibitions: Aix-en-Provence 1960, no. 69; Albi 1961, no. 164

Collections: Private Collection, France

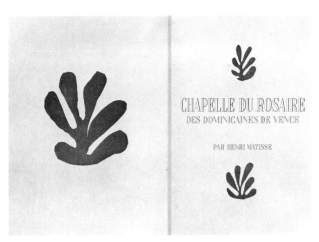

125 □

126

***127 Poissons chinois**

Chinese Fish

1951

192.2 x 91 cm.
75$\frac{11}{16}$ x 35$\frac{7}{8}$ in.

Signed: *H. Matisse 51* (lower right)

Exhibitions: New York 1951, no. 133;
Bern 1959, no. 4 (ill.); Amsterdam 1960,
no. 5; Paris 1961, no. 11; New York 1961,
no. 6 (color pl. K); Cleveland 1966

Bibliography: Luz 1952; *Verve* 1958 (ill.
color p. 31); Lassaigne 1959-2, pp. 120,
122; Reff 1976

Collections: Private Collection; Vicci
Sperry, Los Angeles

The maquette for the stained-glass win-
dow which was executed by Paul Bony
for Tériade's villa in Saint-Jean-Cap-
Ferrat.

Cf. *Les Poissons rouges,* 1911 (Moscow,
State Pushkin Museum), the floral ele-
ments, tank, and table of which are re-
lated to the lower half of this composition.

Matisse described the work to Maria Luz
in 1951: "Look at this stained-glass win-
dow again; here is a dugong—an easily
recognizable fish, it is in the Larousse—
and, above, a sea animal in the form of
algae. Around are begonias" (Matisse
1972, p. 247; Flam 1973, p. 137).

The quatrefoils are not unlike the quatre-
foil pattern of the cover maquette for
Verdet's *Prestiges de Matisse,* no. 195. The
vibrant "X" forms relate to the slashed
diagonals of the dust jacket of Barr's 1951
monograph on Matisse (see no. 122).

Color plate XV

127

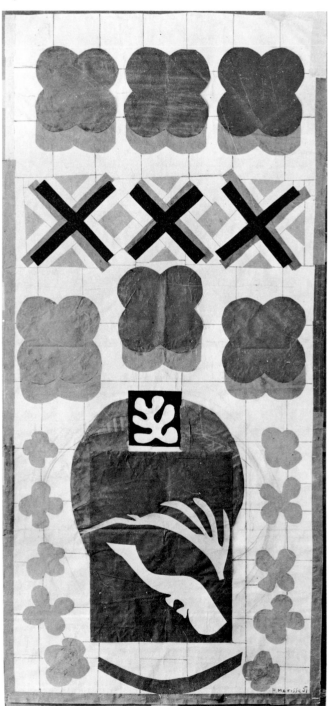

Nos. 128-155 Chasubles and Accouterments for the
Chapelle du Rosaire (Chapel of the Rosary), Vence

From 1948 to 1952 Matisse devoted much of his creative energy to a single project, the Chapel of the Rosary of the Dominicans at Vence. During this period he produced a number of cut-out maquettes (three design groups for the stained-glass windows, one for the tabernacle door, perhaps twenty-two large cut-outs for six sets of vestments, and six smaller cut-out groups for their accouterments). In addition, he designed three major interior, and two minor exterior, ceramic murals, various liturgical accouterments (including crucifix, candlesticks, tabernacle, sanctuary lamp, altar cloths), the exterior spire, and a pattern for the ceramic roof.

The chasubles, in concept, design, and execution occupy a singular position within this overall scheme. They add a further element of color, form, and texture to Matisse's balance of "a surface of light and color against a solid white wall covered with black drawings": their concentrated color provides a resonant link between the translucent color of the windows and the austere black and white walls. (The black and white nuns' habits perform a similar function, thus creating four "voices" in the orchestration of the chapel: two in color, two in black and white.)

Indeed, the total effect of Matisse's design cannot be fully experienced unless the chasubles are present and in use. They bridge the gap between the chapel as a structure and the chapel as a setting for the performance of cultic rites. They are the only objects in the chapel which are not static, mobility being an integral part of their function.

Matisse did not turn his attention to the task of designing the chasubles until late in 1950, after he had completed work on the ceramic murals and stained-glass windows. The vestments were a difficult challenge, for while he had created costumes for the Ballets Russes, he had never faced the problems of composing a design for garments whose shape and style had been determined by centuries of liturgical convention or iconography. The problem was further complicated by the fact that Matisse, although a baptized Roman Catholic, was a functional Deist.

It seems most likely that Brother L. B. Rayssiguier, O.P., the architect of the chapel, perceived these problems and enlisted the foremost French authority on liturgical art, Fr. Marc Alain Couturier, to serve as a consultant and to assist Matisse with the chasubles.

Fr. Couturier's participation has been a matter of record, but the precise extent of his contribution has not. Fr. Couturier, co-editor of the journal *L'Art Sacré*, also designed vestments in his spare time. He was the first to introduce the ample semicircular shape for chasubles as an alternative to the two corrupted forms, the so-called Roman and Gothic then in use. Of equal importance was the fact that he fostered the use of symbolic elements rather than representational images for decoration. Couturier transmitted these ideas, as well as basic information on the meaning and use of liturgical colors, to Matisse.

There is no evidence that Couturier dictated to Matisse the composition of his designs. The recurrent inclusion of a cross and its prominent placement clearly seems to reflect, however, Couturier's belief that this principal instrument of the Passion was the most appropriate symbol for chasuble decoration.

Following Couturier's advice, Matisse utilized only prescribed liturgical colors: white, green, violet, red, rose, and black, as the principal colors for both the maquettes and the chasubles. Since there is no specific hue required for each color, however, Matisse was able to exercise his own judgment in determining, in each case, what tone of the given color would be most compatible with the rest of the chapel.

Matisse's interest in the chasubles extended to every phase of their execution. He personally selected the fabrics, employed a local artisan to dye materials, and supervised the work of the Dominican Sisters of Les Ateliers des Arts Appliqués in Cannes as they transferred his designs into cloth.

Documentary photographs show a total of twenty-two individual maquettes by Matisse for the six chasuble groups, ten more than needed.

The following liturgical accouterments were also designed by Matisse for each chasuble: chalice veil (a covering for the chalice during the Liturgy of the Word), and burse (a square receptacle for the corporal, or napkin, spread on the altar during the Liturgy of the Eucharist); two minor vestments, stole (the symbol of priestly authority draped from the neck), and maniple (a sign of service formerly worn on the left forearm, but now abolished).

The size and shape of the four accouterments, like that of the chasubles, reflect Couturier's understanding of modern liturgical design. Of particular interest is the square-shaped chalice veil, which necessitates the use of small chalices of modern design rather than of large chalices usually of Gothic design.

Since the accouterments are not visible throughout the liturgy, Matisse simply decorated them with small elements based on the design of their respective chasuble.

The arrangement of the chasuble maquettes in this catalogue is based on a perceived stylistic development in the designs, and on a consideration of the liturgical requirements for the use of a particular vestment for a specific occasion or season during the church year.

A stylistic development in the designs can be traced from white and green, through the rose and violet, to the red and black chasuble. This shows a progression from a centrally oriented design with little integration of the lateral areas, in the white and green, through a less centralized and more fragmented design in the rose and violet, to a more expansive "overall" design in the red and black.

The liturgical rubric governing the use of certain vestments for specific occasions and seasons required: white for the dedication of the chapel, June 25, 1951; green for the observance of the time after Pentecost; violet and rose for the season of Advent. The red could be legitimately replaced by the white on other occasions, and the black was necessary only for funerals. Thus, Matisse did not have to complete the red and black chasubles by any given date.

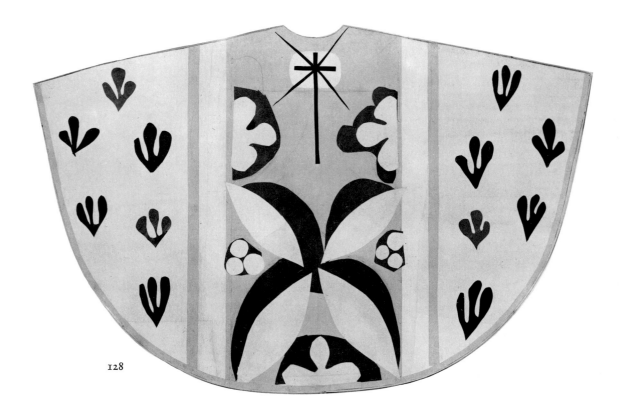

128

128 Chasuble blanche

White Chasuble (front maquette)

late 1950/52

130 x 200 cm. (approx.)
51 3/16 x 78 3/4 in. (approx.)

Not signed or dated

Collections: Musée Matisse, Nice

Nos. 128-129 are the front and back designs for the white chasuble eventually produced by Les Ateliers des Arts Appliqués for the chapel.

White, the principal and most inclusive liturgical color, can be substituted for any of the liturgical colors because its Christological and Eucharistic symbolism reflects the central focus of the liturgy. Is is used on the feasts of Christ, the Blessed Virgin, and all nonmartyr saints, and on festive occasions.

The concentration of decorative elements in the center is traditional, but the boldness of the forms and the inclusion of leaves in the lateral areas is unique.

The large plant-like form in conjunction with the leaves is a modernistic reprise of John XV, 1: "I am the vine and you are the branches." The six white disks connoting bread expand the Eucharistic inference, and the three cruciform-shaped clouds, a Trinitarian motif, complete the design.

See nos. 129-130.

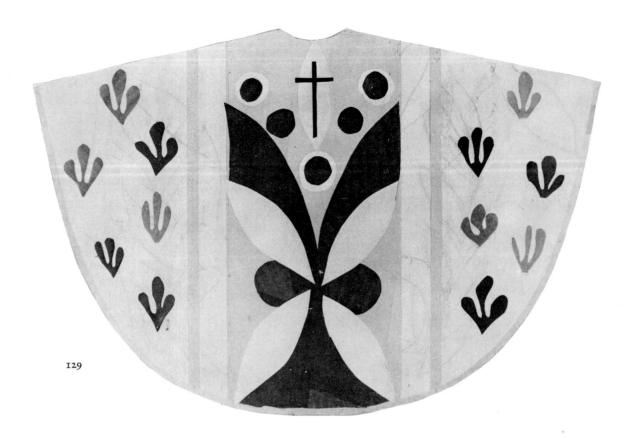

129

129 Chasuble blanche

White Chasuble (back maquette)

late 1950/52

130 x 200 cm. (approx.)
51³⁄₁₆ x 78¾ in. (approx.)

Not signed or dated

Exhibitions: New York 1961, nos. 37-39,
with accouterments (ill. p. 13)

Collections: Musée Matisse, Nice
See remarks no. 128.

The large tree-like form may be an addi-
tional reference to Christ as the Tree of
Life.

130

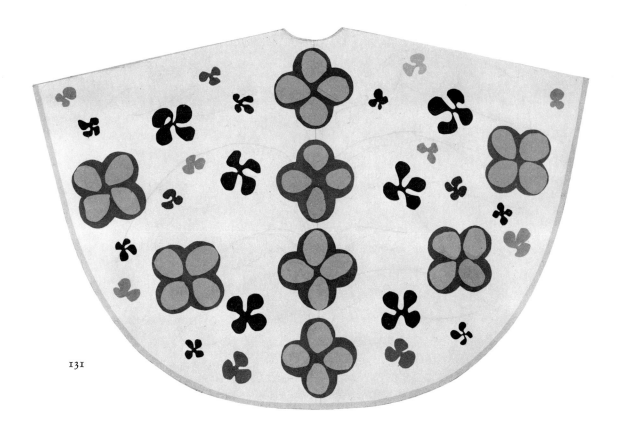

131

130 **White Accouterments** (maquettes)

late 1950/52

Not signed or dated

Collections: Musée Matisse, Nice

Designs for the stole, maniple, chalice veil, and burse for the *Chasuble blanche* group, nos. 128-129. The approximate dimensions for these elements and the equivalent elements in nos. 135, 140, 144, 147, 150 are as follows:

stole:	247.65 x 9.2 cm.
	97½ x 3⅝ in.
maniple:	87.3 x 10.2 cm.
	34⅜ x 4 in.
chalice veil:	51.5 cm. sq.
	20¼ in. sq.
burse:	25.4 x 22.2 cm.
	10 x 8¾ in.

131 **Chasuble blanche**

White Chasuble (maquette)

late 1950/52

130 x 200 cm. (approx.)
51³⁄₁₆ x 78¾ in. (approx.)

Not signed or dated

Collections: Musée Matisse, Nice

This design was not made into a chasuble. It was probably considered inappropriate because it lacks any identifiable religious symbolism.

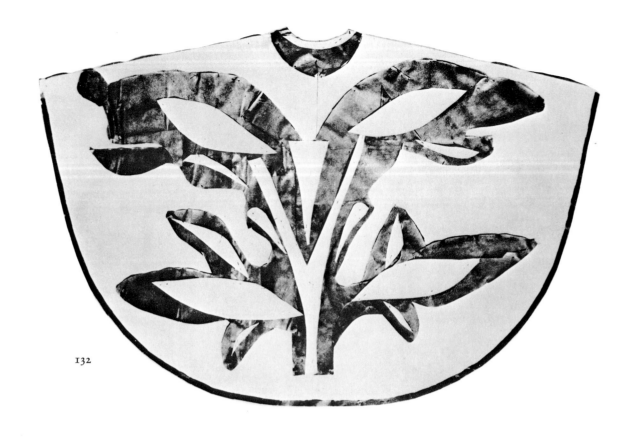

132

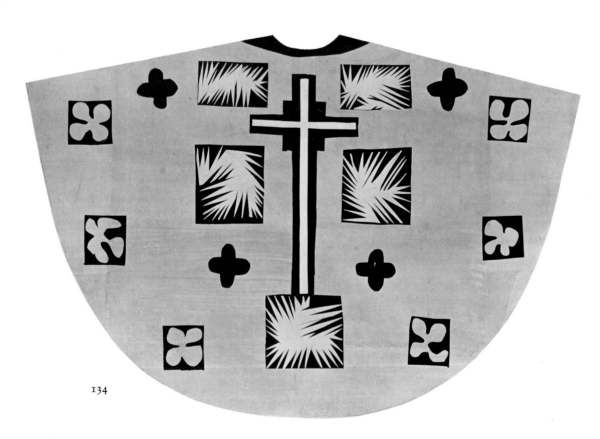

134

2 Chasuble blanche

White Chasuble (maquette)

late 1950/52

130 x 200 cm. (approx.)
51³⁄₁₆ x 78¾ in. (approx.)

Not signed or dated

Bibliography: *Time* 1952 (ill. color p. 75);
Man 1954 (ill. color); Vence-Ronchamp
1955 (pl. 44)

Collections: present location unknown

This design was not made into a chasuble.
Matisse's inscription for the Vence-
Ronchamp illustration: "Ch Blanche &
jaune citron" (white and lemon yellow
ch[asuble]).

This maquette is a relatively "advanced"
design corresponding in concept to the
back of the finished black chasubles. It
lacks any overt religious symbolism,
except for what may be an oblique refer-
ence to Christ as the Vine and source of
regenerative life (see remarks no. 128).

33 Chasuble verte

Green Chasuble (front maquette)

late 1950/52

128 x 200 cm.
50⅜ x 78¾ in.

Not signed or dated

Exhibitions: Paris 1970, no. 249B
(ill. p. 296)

Collections: Musée Matisse, Nice

Nos. 133-134 are the front and back
designs for the green chasuble eventually
produced by Les Ateliers des Arts
Appliqués for the chapel.

Green carries the vernal meaning of life's
victory over the apparent death of nature
in winter and the transferred liturgical
significance of hope and expectation
heightened by the spiritual renewal expe-
rienced at Christmas and Easter. It is in
the time after these feasts and until the
seasons of Advent and Lent respectively
that the color is used.

The symbolism contained in the *Chasuble
verte* group is the least complicated of the
six sets. Here, in all four maquettes (two
definitive and two preliminary), the main
component element is a large cross. This

symbol conveys the meaning of Christ as
the *Redemptor Mundi* and model for
Christians. The small leaf forms in lateral
areas on all four maquettes may stand for
Christians who receive new life in Christ.
The three stylized palms/flames bordered
with black at the bottom of no. 133 con-
note, in addition to the Trinity, the three
theological virtues of Faith, Hope, and
Charity.

134 Chasuble verte

Green Chasuble (back maquette)

late 1950/52

130 x 200 cm. (approx.)
51³⁄₁₆ x 78¾ in. (approx.)

Not signed or dated

Bibliography: *Time* 1952 (ill. color p. 75)

Collections: Musée Matisse, Nice

See remarks no. 133.

The disposition of the five stylized palm/
flames around the large cross emphasizes
references to the five wounds of Christ.

Color plate XVI

135 Green Accouterments (maquettes)

late 1950/52

Not signed or dated

Collections: Musée Matisse, Nice

Designs for the stole and chalice veil for
the *Chasuble verte* group, nos. 133-134.
See no. 130 for the approximate dimen-
sions of the individual elements.

135

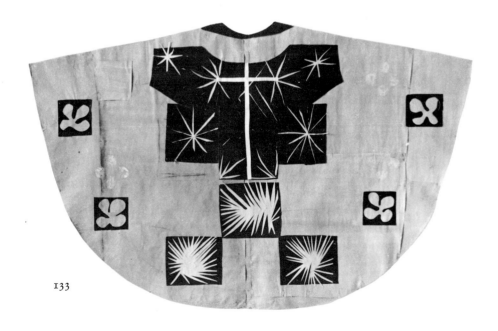

133

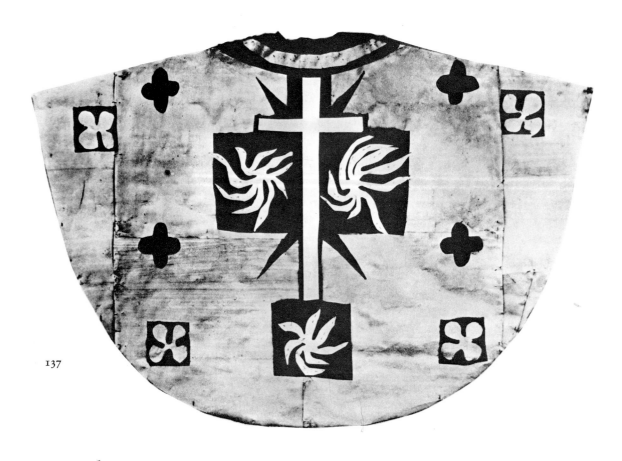

137

136 Chasuble verte

Green Chasuble (preliminary maquette)

late 1950/52

130 x 200 cm. (approx.)
51³⁄₁₆ x 78¾ in. (approx.)

Not signed or dated

Bibliography: Holm 1951 (ill. p. 50)

Collections: present location unknown

This design was not made into a chasuble.
An earlier version of no. 133, this differs
from the definitive maquette only in the
arrangement of the three palm/flames at
the bottom, and in the size and shape of
the central field surrounding the cross.

Not illustrated

137 Chasuble verte

Green Chasuble (preliminary maquette)

late 1950/52

130 x 200 cm. (approx.)
51³⁄₁₆ x 78¾ in. (approx.)

Not signed or dated

Bibliography: Man 1954 (ill. color);
Vence-Ronchamp 1955 (pl. 42)

Collections: present location unknown

This design was not made into a chasuble.
Matisse's inscription for the Vence-Ron-
champ 1955 illustration: "Tout est vert
sauf croix blanche—flamme jaune citron—
et le reste noir—(vert)" (all is green
excepting the white cross—lemon yellow
flame—and the rest black—[green]).

This is the initial design for the back,
which was further stylized and amplified
in no. 134.

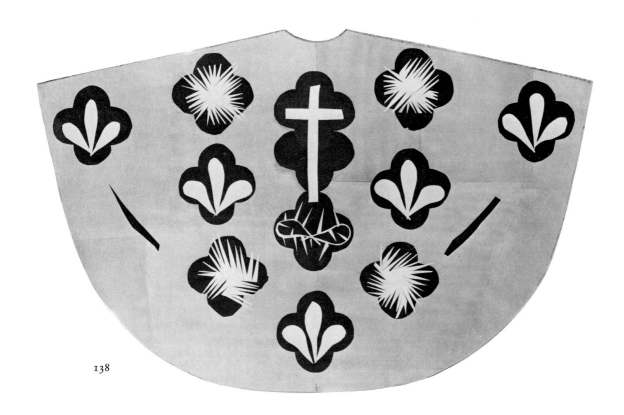

138

38 **Chasuble rose**

Rose Chasuble (front maquette)

late 1950/52

130 x 200 cm. (approx.)
51 3/16 x 78 3/4 in. (approx.)

Not signed or dated

Bibliography: *Time* 1952 (ill. color p. 75)

Collections: Musée Matisse, Nice

Nos. 138-139 are the front and back designs for the rose chasuble eventually produced by Les Ateliers des Arts Appliqués for the chapel.

Rose, used only on Gaudete Sunday in Advent, and Laetare Sunday in Lent, symbolizes the restrained joy of the Church at the midpoint of these two seasons in the realization that the feasts of Christmas and Easter, respectively, are near. Reflecting the two occasions when it is used, the chasuble is symbolically divided into two, the front for Lent and the back for Advent.

The Lenten side is dominated by two instruments of the Passion: the cross and the crown of thorns. The two stylized palm branches and the five leaf forms reinforce the Passion theme with the palm branches signifying the badge of martyrdom, and the leaf forms, the five wounds of Christ.

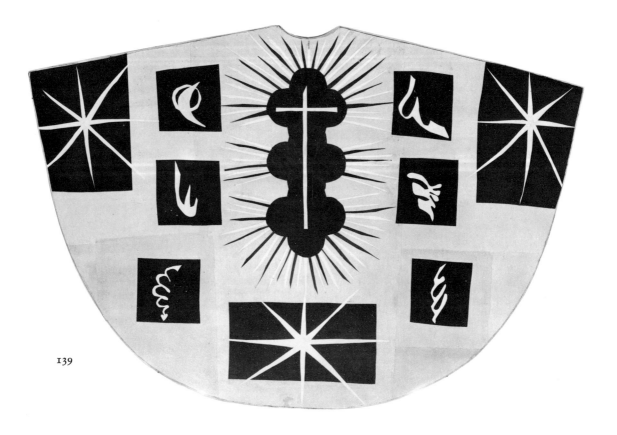

139

139 Chasuble rose

Rose Chasuble (back maquette)

late 1950/52

130 x 200 cm. (approx.)
51 3/16 x 78 3/4 in. (approx.)

Not signed or dated

Collections: Musée Matisse, Nice

See remarks no. 138.

The Advent side is as cheerful as its obverse is somber. The three stars at the periphery symbolize the Magi and the star which led them to the Messiah, who is represented by one triple quatrefoil with emanating rays, an abstract reference to the manger.

140 Rose Accouterments (maquettes)

late 1950/52

Not signed or dated

Collections: Musée Matisse, Nice

Design for the stole, maniple, chalice veil, and burse for the *Chasuble rose* group, nos. 138-139. See no. 130 for the approximate dimensions of the individual elements.

140

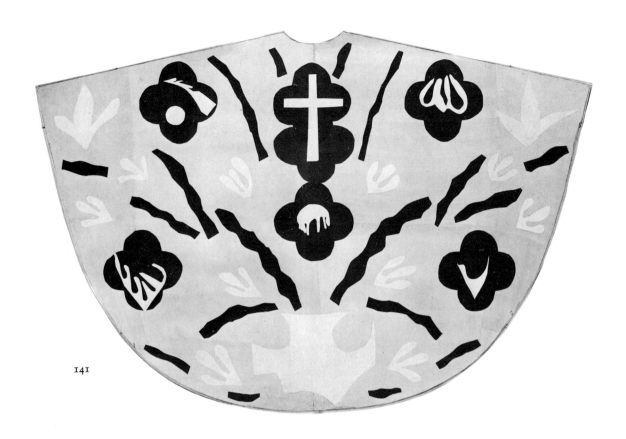

141

141 **Chasuble rose**

Rose Chasuble (preliminary maquette)

late 1950/52

130 x 200 cm. (approx.)
51 3/16 x 78 3/4 in. (approx.)

Not signed or dated

Collections: Musée Matisse, Nice

This design was made into cloth, now in
the collection of the Museum of Modern
Art, New York. It may have been Matisse's
first attempt at an overall design. The
stylized palm branches, however, seem to
clutter the composition and may have con-
vinced Matisse of the necessity of making
a subsequent design.

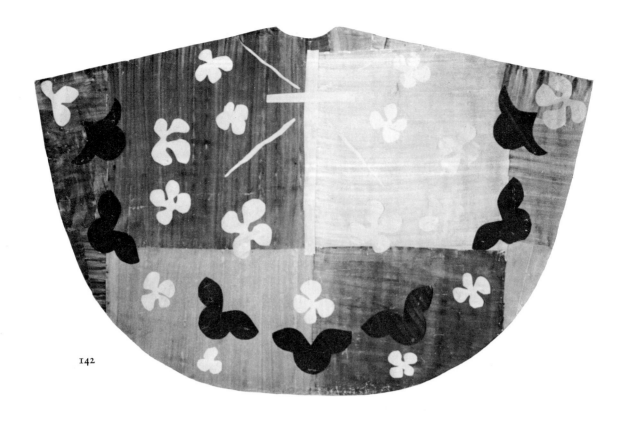

142

142 Chasuble violette

Violet Chasuble (front maquette)

late 1950/52

129 x 200 cm.
50¹³⁄₁₆ x 78¾ in.

Not signed or dated

Exhibitions: Paris 1970, no. 249C (ill. p. 296)

Bibliography: *Time* 1952 (ill. color p. 75); Calmels 1975 (ill. p. 183)

Collections: Musée Matisse, Nice

Nos. 142-143 are the front and back designs for the violet chasuble eventually produced by Les Ateliers des Arts Appliqués for the chapel.

Violet, used daily during the seasons of Advent and Lent, and periodically for Ember Days, is the Church's penitential color. The overall design of the leaf forms and schematic butterflies oriented toward

the central image of the cross is noticeably similar in both the front and back.

The symbolic nature of the vestment is enhanced by the fractured underlying field. This unusual device provides an important liturgical distinction. The lighter areas represent the season of Advent, a quiet time for reflection and renewal, while the darker areas signify the season of Lent, an austere time for ascetical practices and penitence. These considerations are overlaid by the leaf forms and butterflies symbolizing new life in Christ, and the resurrection of spirit at Christmas and Easter: in short, a reminder of things to come.

143 Chasuble violette

Violet Chasuble (back maquette)

late 1950/52

130 x 200 cm. (approx.)
51³⁄₁₆ x 78¾ in. (approx.)

Not signed or dated

Bibliography: Vence-Ronchamp 1955 (pl. 41)

Collections: Musée Matisse, Nice

See remarks no. 142.

Matisse's inscription for the Vence-Ronchamp illustration: "ch. violette 4 compartiments violets—la photo accentue des nuances de la gouache-papillons volants (bleu outremer)—*tout* la reste vert d'une valeur moins accentuée que celle indiquée" (violet ch[asuble] 4 violet sections—the photo accentuates the nuances of the flying gouache butterflies—[ultramarine blue]—*all* the rest a green of less intensity than what is indicated).

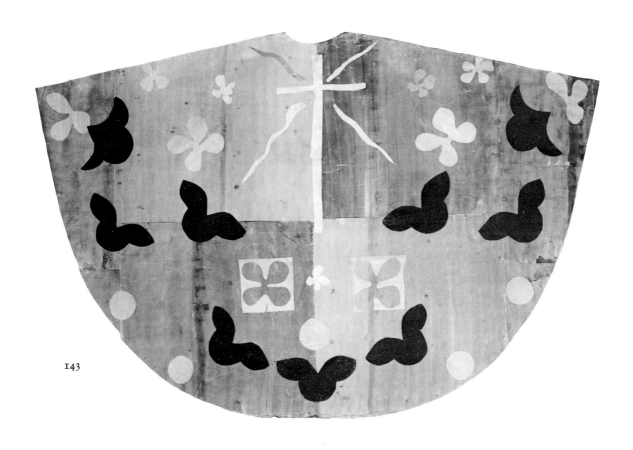

143

144

144 **Violet Accouterments** (maquettes)

late 1950/52

Not signed or dated

Collections: Musée Matisse, Nice

Designs for the stole, maniple, chalice veil, and burse for the *Chasuble violette* group, nos. 142-143. See no. 130 for the approximate dimensions of the individual elements.

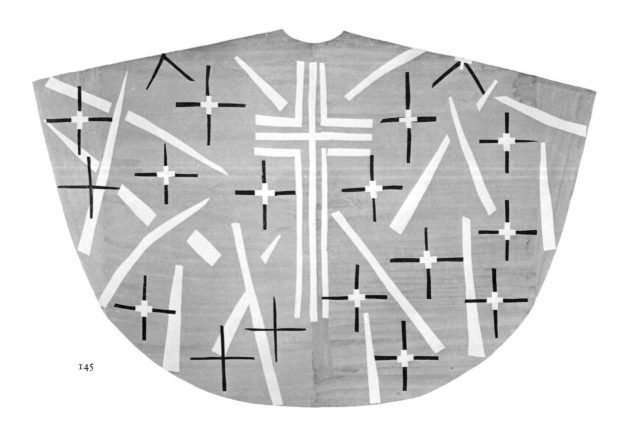

145

***145 Chasuble rouge**

Red Chasuble (front maquette)

late 1950/52

128.2 x 199.4 cm.
50½ x 78½ in.

Not signed or dated

Exhibitions: Chicago 1975, no. 172 (ill. p. 331); New York 1976

Bibliography: Janis 1962, p. 215 (ill. no. 306 p. 218)

Collections: Museum of Modern Art, New York

Nos. 145-146 are the front and back designs for the red chasuble eventually produced by Les Ateliers des Arts Appliqués for the chapel.

Alfred Barr acquired the red chasuble maquette set from the chapel with the assistance of Matisse. He also purchased five of the actual chasubles. This red

chasuble maquette set was sent to New York in early December 1952.

Red is reserved for the feasts of Pentecost and Martyrs.

This is the only chasuble whose design is co-extensive with the surface. In both nos. 145 and 146 the central motif of the composition overlaps and is overlapped by subordinate elements, thereby uniting the central and lateral areas in an overall design. This symbolically connects the sacrifice of the martyrs to the sacrifice of Christ. In no. 145 the Latin cross representing Christ is surrounded by numerous small Greek crosses for the martyrs, interspersed with stylized palms of martyrdom.

***146 Chasuble rouge**

Red Chasuble (back maquette)

late 1950/52

133.3 x 198.5 cm.
52½ x 78³⁄₁₆ in.

Not signed or dated

Exhibitions: New York 1966, no. 63 (ill.); New York 1976

Bibliography: *Time* 1952 (ill. color p. 75); Man 1954 (ill. color); Vence-Ronchamp 1955 (ill. p. 43); Janis 1962, p. 215 (ill. no. 306 p. 218); Chicago 1975 (ill. p. 331)

Collections: Museum of Modern Art, New York

See remarks no. 145.

Matisse's inscription for the Vence-Ronchamp 1955 illustration: "fond rouge coquelicots—les claires sont jaune citron—les grandes croix sont noires et les petites croix sont jaune citron—chasuble

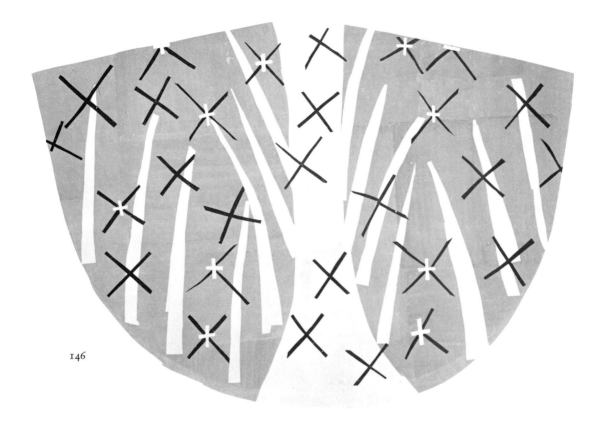

146

rouge" (red poppy background—the light areas are lemon yellow—the big crosses are black and the little crosses are lemon yellow—red chasuble).

The large trunk of a tree is surrounded by schematized branches, and the whole is overlaid with a combination of Greek and St. Andrew crosses. The meaning is similar to that of no. 145: the tree is Christ (author of the New Dispensation and its first martyr); the branches and crosses are his progeny of martyrs.

Color plate XVII

*147 **Red Accouterments** (maquettes)

late 1950/52

Not signed or dated

Exhibitions: New York 1976

Bibliography: Janis 1962, p. 215 (ill. no. 306 p. 218); Chicago 1975 (ill. p. 331)

Collections: Museum of Modern Art, New York

Designs for the stole, maniple, chalice veil, and burse for the *Chasuble rouge* group, nos. 145-146. See no. 130 for the approximate dimensions of the individual elements.

147

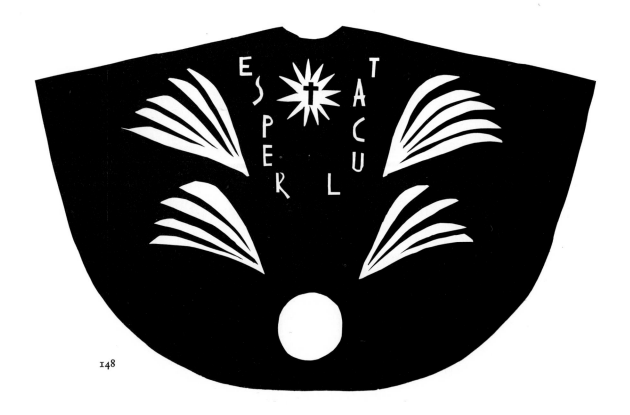

148

148 Chasuble noire "Esperlucat"

Black Chasuble (front maquette)

late 1950/52

129 x 197 cm.
50¹³⁄₁₆ x 77⁹⁄₁₆ in.

Not signed or dated

Exhibitions: Paris 1970, no. 249A (ill. p. 296)

Collections: Musée Matisse, Nice

Nos. 148-149 are the front and back designs for the black chasuble eventually produced by Les Ateliers des Arts Appliqués for the chapel.

Black, until recently the Church's color of mourning, was used for all Masses of the Dead, All-Souls Day, and Good Friday. Matisse apparently devoted much time to this chasuble, making five preliminary maquettes, including one early design and two complete pairs, before finding the right mode of expression.

These chasubles represent the culmination of Matisse's progression toward a unified design. The various elements of no. 148, the white sphere, four wing-like forms, the cross within a sunburst, and the word "esperlucat," constitute a succinct visual rendering of the opening line of the final antiphon of the funeral service: "In paradisum deducant te angeli" (may the angels lead you into Paradise). "Esperlucat," the only word found on any of the maquettes, is a colloquial term from the Provençal dialect meaning "to open one's eyes." The interpretation of death as a passage to a new state of being is an eloquent synopsis of the preface of the Mass of the Dead, which states: "vita mutator non tollebatur" (life is not taken away, it is merely changed). This sophisticated design clearly reflects Couturier's schooling of Matisse in liturgical matters, as well as the artist's own desire to convey a specific and personal attitude toward death and the afterlife. For Matisse's own explanation of the iconography of this black chasuble, see remarks no. 155.

149 Chasuble noire

Black Chasuble (back maquette)

late 1950/52

129 x 197 cm.
50¹³⁄₁₆ x 77⁹⁄₁₆ in.

Not signed or dated

Exhibitions: New York 1961, nos. 37-39 (ill. p. 12); Paris 1970, no. 249A (ill. p. 296)

Collections: Musée Matisse, Nice

See remarks no. 148.

Perhaps the boldest chasuble design produced by Matisse, this black chasuble features a large abstracted bird which may represent a phoenix, symbol of the promised resurrection.

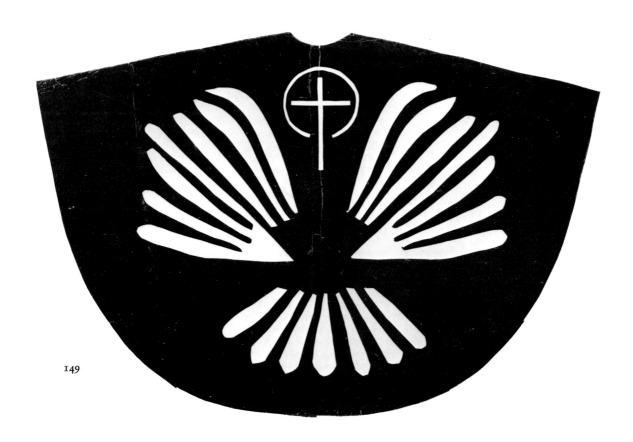

149

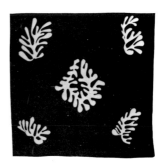

150 Black Accouterments (maquettes)

late 1950/52

Not signed or dated

Collections: Musée Matisse, Nice

Designs for the stole, maniple, chalice veil, and burse for the *Chasuble noire* group, nos. 148-149. See no. 130 for approximate dimensions of the individual elements.

150

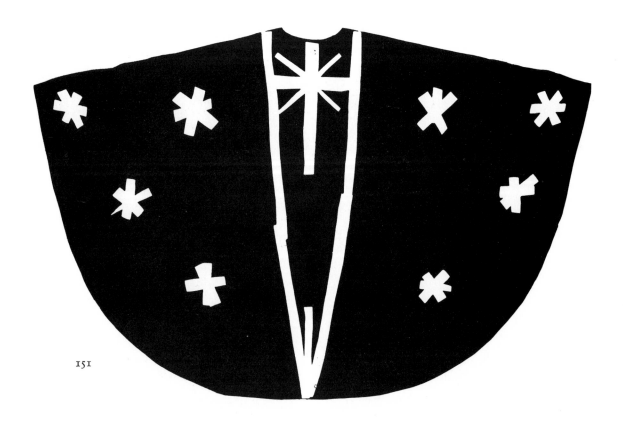

151

151 **Chasuble noire**

Black Chasuble (preliminary maquette)

late 1950/52

130 x 200 cm. (approx.)
51³⁄₁₆ x 78¾ in. (approx.)

Not signed or dated

Bibliography: Vence-Ronchamp 1955
(pl. 45)

Collections: present location unknown

This design was not made into a chasuble.

Matisse's inscription for the Vence-Ron-
champ 1955 illustration: "Noir" (black).

152 **Chasuble noire**

Black Chasuble (preliminary maquette)

late 1950/52

130 x 200 cm. (approx.)
51³⁄₁₆ x 78¾ in. (approx.)

Not signed or dated

Bibliography: Matisse 1970 (ill.)

Collections: present location unknown

This design was not made into a chasuble.

Not illustrated

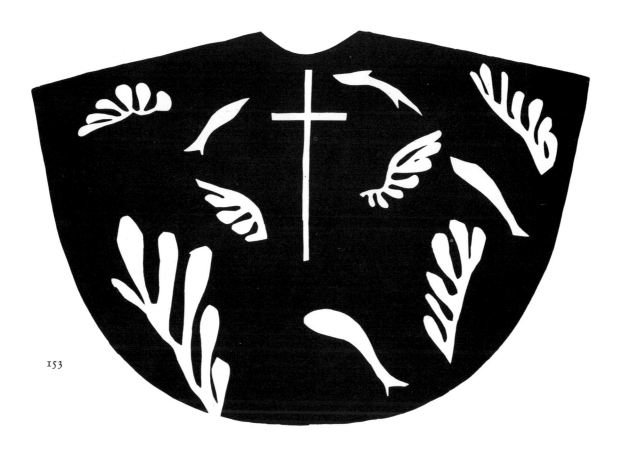

153

153 **Chasuble noire**

Black Chasuble (preliminary maquette)

late 1950/52

130 x 200 cm. (approx.)
51 3/16 x 78 3/4 in. (approx.)

Not signed or dated

Bibliography: Vence-Ronchamp 1955
(pl. 46)

Collections: present location unknown

This design was not made into a chasuble.

Matisse's inscription for the Vence-Ron-champ illustration: "Noir & blanc—des ailes des palmes, accompagnant la croix et les poissons" (black and white—wings of palms accompanying the cross and the fish).

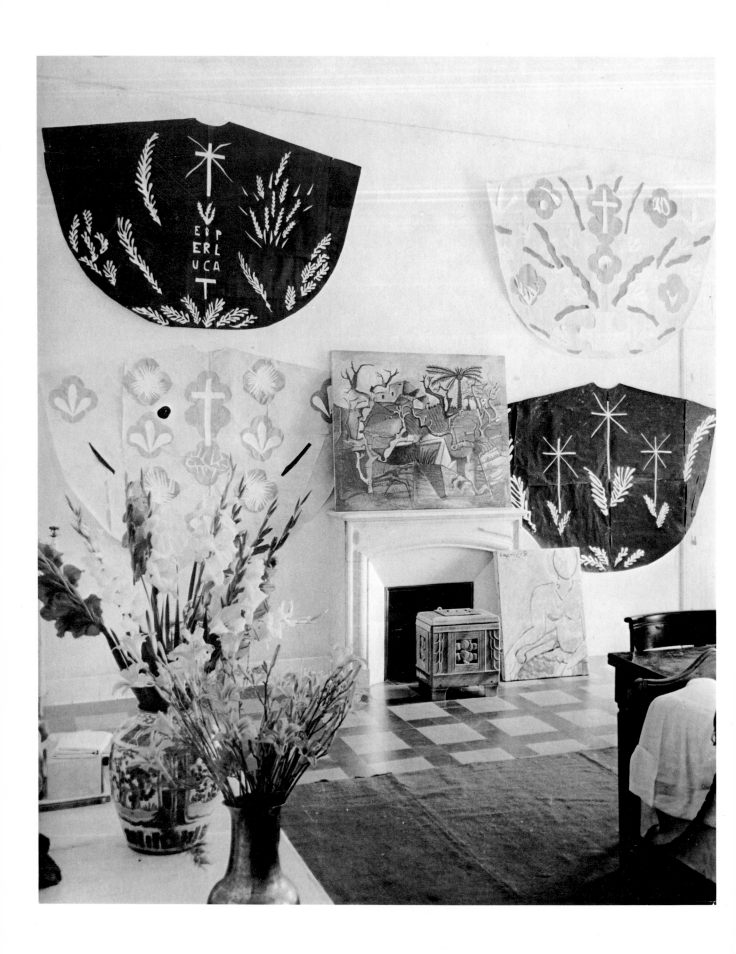

154 Chasuble noire

Black Chasuble (preliminary maquette)

late 1950/52

130 x 200 cm. (approx.)
51 3/16 x 78 3/4 in. (approx.)

Not signed or dated

Bibliography: *Time* 1952 (ill. color p. 75)

Collections: present location unknown

This design was not made into a chasuble. See fig. 56. The design recalls Christ's death on Calvary and also reminds the Christian of Christ's triumph over death.

155 Chasuble noire "Esperlucat"

Black Chasuble (preliminary maquette)

late 1950/52

130 x 200 cm. (approx.)
51 3/16 x 78 3/4 in. (approx.)

Not signed or dated

Bibliography: Man 1954 (ill. color); Vence-Ronchamp 1955 (pl. 47)

Collections: present location unknown

This design was not made into a chasuble. Matisse's inscription for the Vence-Ronchamp 1955 illustration:

Composition born of the desire to create wheat, and of my encounter with a Provençal word which means to open your eyes—to see or perceive—in reflecting before a death chasuble one can understand that the most reassuring attitude to assume in the face of death is to be accompanied by good actions (wheat). esperlucat—(from the Larousse dictionary of synonyms). (See Documents Appendix, 23)

For more on "esperlucat" and Matisse's attitude toward death as expressed in this *Chasuble noire* concept, see remarks no. 148. See fig. 56.

Fig. 56. Matisse studio, Hôtel Régina, Nice, c. 1951. On wall, clockwise from upper left: *Chasuble noire,* no. 155; *Chasuble rose,* no. 141; *Chasuble noire,* no. 154; *Chasuble rose,* no. 138. On floor: Matisse, *Katia,* 1951, oil on canvas, 81 x 60 cm. (31 7/8 x 23 5/8 in.), Private Collection, Paris. On mantle: Picasso, *Winter Landscape,* 1950, oil on wood, 102.9 x 125.8 cm. (40 1/2 x 49 1/2 in.), Mr. and Mrs. Victor W. Ganz Collection, New York.

156 La Cloche

The Bell

1951

121 x 48 cm.
47⅝ x 18⅞ in.

Signed: *Matisse 51* (lower right)

Exhibitions: Paris 1953-2 (ill. color)

Collections: Berggruen et Cie; present location unknown

This composition evokes simultaneously a bell and its clapper, the mold for a bell casting, a bell within a bell tower, a bell surrounded by its own sound.

156

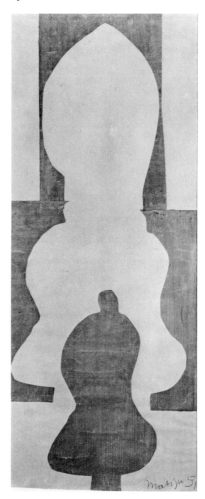

157 La Vis

The Wine Press

c. 1951

175 x 82 cm.
68⅞ x 32¼ in.

Not signed or dated

Collections: Maurice Lefebvre-Foinet, Paris

This work is here published for the first time.

The cut-out depicts a wine press in cross-section. The screw shaft runs from the top to the bottom of the composition, where the purple diamonds and triangles allude to the geared cog drive, as well as to grapes. The two blue butterflies at the center left and right are shapes previously developed in the Vence chapel violet chasubles, nos. 142-143.

Color plate XVIII

157

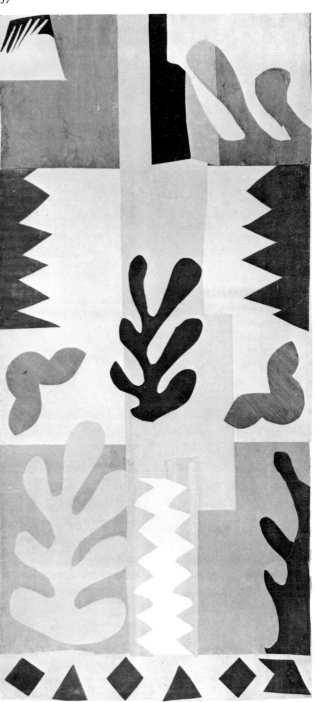

*158 **Mimosa** (rug maquette)

1949/51

148 x 96.5 cm.

58¼ x 38 in.

Signed: *HM* (lower left)

Exhibitions: New York 1951 (not in cat.)

Bibliography: Barr 1951, p. 279; Hess 1951 (ill. color p. 41)

Collections: Alexander Smith Carpets and Mohasco Industries Inc.; Ikeda Museum of 20th Century Art, Itoh City

Maquette for a rug issued by Alexander Smith and Sons, New York, 1951, in 500 examples.

The theme for this rug maquette may have come from the Festival of Flowers in Nice, with its floats, parades, and the symbolic emphasis on the mimosa in the so-called "Bataille de Fleurs" (floral competition). The mimosa is a popular flowering tree along the Côte d'Azur, with the unusual feature of being extremely sensitive to external factors. In response to stimulus, its petals visibly open and close.

Color plate XIX

158

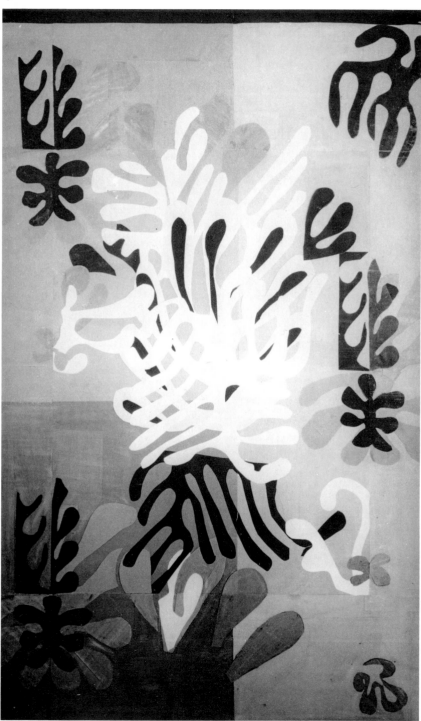

159 Feuille noire sur fond vert

Black Leaf on Green Background

1952

60 x 39.1 cm.
23 ⅝ x 15 ⅜ in.

Signed: *Matisse 52* (lower right)

Exhibitions: Paris 1953-2 (ill. color);
Houston 1958

Bibliography: Matisse 1955-1 (ill. as red
on black for front dust jacket, black on
red for back dust jacket)

Collections: Berggruen et Cie; Private
Collection, USA

Documentary photographs (figs. 57-58)
show that this leaf, and the following, no.
160, both began as elements in the pre-
liminary stages of *Nuit de Noël*, no. 162.
The photographs were taken on January
17 and 30, 1952, and were used by Matisse
to evaluate his progress.

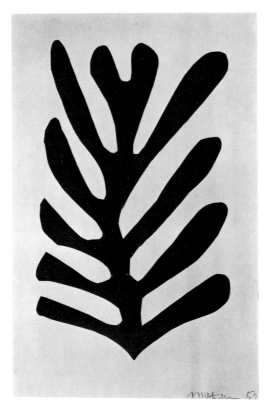

159

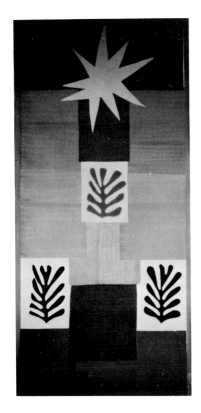

Fig. 57. *Nuit de Noël*, no. 162, early state,
January 17, 1952, Hôtel Régina, Nice.

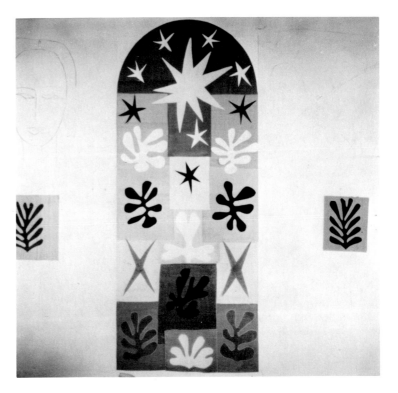

Fig. 58. *Nuit de Noël*, no. 162, early state,
January 30, 1952. Left, *Feuille noire sur
fond vert*, no. 159; right, *Feuille noire sur
fond rouge*, no. 160, Hôtel Régina, Nice.

***160 Feuille noire sur fond rouge**

Black Leaf on Red Background

1952

50 x 40 cm.

19¹¹⁄₁₆ x 15¾ in.

Signed: *Matisse/52* (lower right)

Exhibitions: Paris 1953-2 (ill. color); Houston 1958 (ill.)

Bibliography: Cassou 1953 (ill.)

Collections: Berggruen et Cie; de Menil Collection; Lois and George de Menil, Princeton

See remarks no. 159.

161 Algue

Alga

1952

Signed: *Matisse/51* (lower right)

Bibliography: Editions Nouvelles Images color postcard G2

Collections: present location unknown

The February 1952 photograph (fig. 59) of an early state of *Nuit de Noël*, no. 162, shows this *Algue* in the lower right corner. The signature was evidently added later.

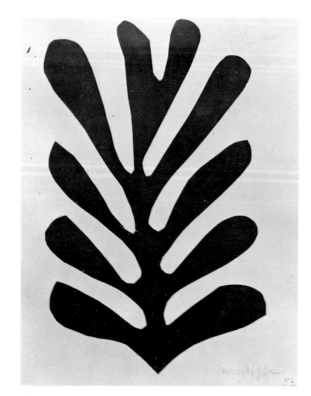

160

161 □

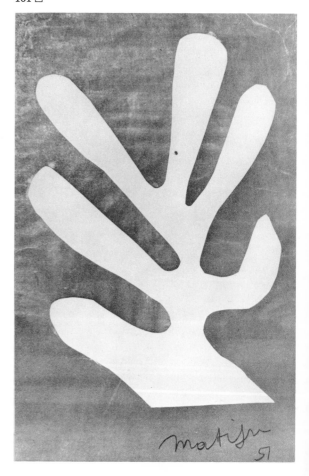

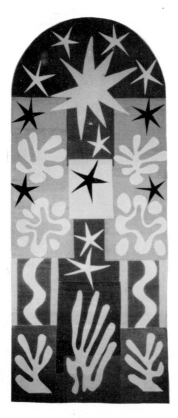

Fig. 59. *Nuit de Noël*, no. 162, early state, February 1952, Hôtel Régina, Nice.

162 Nuit de Noël

Christmas Eve (window maquette)

1952

335 x 135 cm.
123⅛ x 53½ in.

Signed: *Matisse 52* (lower right)

Exhibitions: Paris 1961, no. 10; New York 1961; Buffalo 1964 (on loan)

Bibliography: Verdet 1952, p. 13; *Quadrum* 1957 (ill. color p. 9); *Verve* 1958 (ill. color p. 26); Janis 1962 (ill. no. 307 p. 219); Guichard-Meili 1967 (ill. no. 128 p. 142); Luzi 1971 (ill. p. 111); Cowart 1975 (ill. p. 55); Fourcade 1976, p. 114

Collections: *Life*; Museum of Modern Art, New York

Maquette for a stained-glass window commissioned by *Life* magazine on January 15, 1952. Matisse finished the maquette on February 27, 1952. Paul Bony executed the window during the next four months. By December 8, 1952 the window had arrived in New York and was put on display in the reception center of the Time-Life Building at Rockefeller Center; the window design was used for a Christmas card that year.

On December 4, 1952 Matisse wrote to Alfred Barr:

The stained-glass window for Life, *of which I showed you the maquette, has finally left for New York. I had it at home for two days, which allows me to assure you that it is a success. It will be exhibited during the Christmas holiday at Rockefeller Center. If you have a chance to see it, you will agree with me that a maquette for a stained-glass window and the window itself are like a musical score and its performance by an orchestra. (See Documents Appendix, 10)*

In June 1953 the window and maquette were given to the Museum of Modern Art by *Life* magazine.

In his letters to Barr of March 12 and August 24, 1954 (see Documents Appendix, 11-12) Matisse asked that the window and the maquette not be displayed side by side. Again, he insisted that the maquette

is like a musical score, while the glass is like the symphonic performance of that score; this notion was expressed earlier (Cassonari 1950; see remarks no. 95), when Matisse used the image of "un orchestre lumineux" (an orchestra of light) regarding the stained-glass window projects for the Vence chapel.

See remarks no. 159.

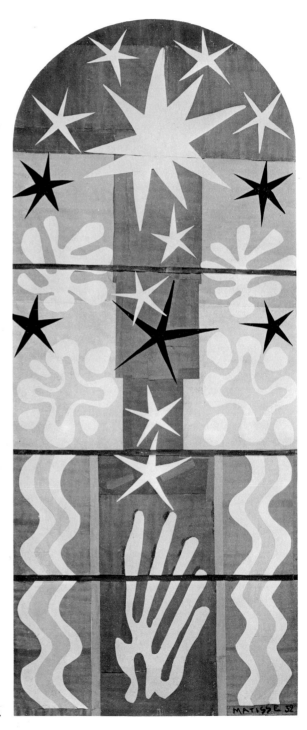

162

163 La Vague

The Wave

c. 1952

51.1 x 158.5 cm.
20⅛ x 62⅜ in.

Not signed or dated

Collections: Musée Matisse, Nice

Cut from one piece of blue-painted paper,
then spread and offset, this is an excellent
demonstration of Matisse's simplicity of
means and of his masterly use of positive
and negative shapes.

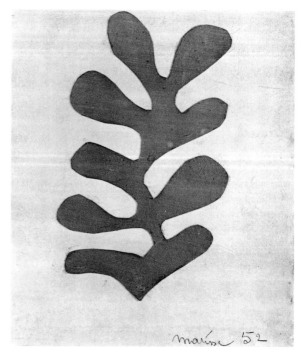

164

163

64 Algue

Alga

1952

44 x 39 cm.
17⁵⁄₁₆ x 15³⁄₈ in.

Signed: *Matisse 52* (lower right)

Exhibitions: Paris 1953-2?; Zurich 1960,
no. 132? entitled *Komposition*

Collections: Berggruen et Cie; G. David
Thompson?; present location unknown

Algue was the exhibition poster image for
"Henri Matisse, papiers découpés," Berg-
gruen et Cie, Paris, February 27-March
28, 1953. It was most probably included
in the exhibition itself. It is neither listed
in the catalogue nor visible in any of the
known installation photographs. It is
possible that this cut-out is the work from
the G. David Thompson Collection listed
as *Komposition*, no. 132, Zurich 1960.

165 La Fillette

The Little Girl

c. 1952

Not signed or dated

Bibliography: Paris 1961 (ill. p. 45);
Duthuit 1962 (ill. p. 99); Jacobus 1972
(ill. p. 51)

Collections: Private Collection

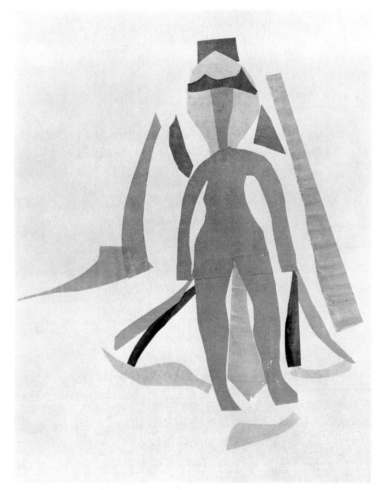

165

166 Tristesse du roi

Sorrow of the King

1952

292 x 396 cm.

115 x 155 ⅞ in.

Signed: *Henri Matisse / 1952* (lower right)

Exhibitions: Paris 1952-1, no. 124 (ill.); Paris 1956, no. 100 (ill. no. 1); Kassel 1959 (ill. p. 259); Paris 1961, no. 13; New York 1961, no. 9 (color pl. F-G)

Bibliography: Verdet 1952, p. 31; *Verve* 1952 (ill. color pp. 18-19); Diehl 1954, pp. 147, 156 (pl. 135); Humbert 1954 (ill. p. 15); *Paris Match* 1954 (ill. p. 77); *Réalités* 1954 (ill. color); *Ver y Estimar* 1955 (ill. p. 7); Escholier 1956, p. 247; Martin 1956 (ill. p. 16); *Verve* 1958 (ill. color pp. 50-51); Lassaigne 1959-2, p. 122; Brill 1967, pp. 22, 39 (color pl. 47); Guichard-Meili 1967 (color pl. 135 p. 148); Leymarie 1967 (ill. color p. 70); Marchiori 1967, pp. 102-119 (color pl. 98 p. 102); Alpatov 1969 (ill. color pp. 84-85); Diehl 1970 (ill. p. 28, inverted); *Jardin des Arts* 1970 (ill. p. 20); Murphy 1970 (ill. color pp. 34-35); *XXe Siècle* 1970, pp. 93, 114 (ill. color p. 77); Aragon 1971, II, pp. 235, 307, 308; Luzi 1971 (ill. p. 111); Dorival 1972 (ill. p. 47); Jacobus 1972, pp. 50, 51, 178, 180 (color pl. 47 p. 179); Ooka 1972 (color pl. VIII); Alpatov 1973, pp. 122-125 (color pl. 59); Flam 1975-1, p. 52

Collections: Centre National d'Art et Culture Georges Pompidou, Musée National d'Art Moderne, Paris

It has been suggested that Matisse began illustrating the Song of Songs and that this composition was inspired by the Biblical theme of King David (Paris 1961, p. 48). The scene portrayed, however, could well be Salome dancing for Herod Antipas, instead of David playing for King Saul.

Matisse wrote to Jean Cassou on April 9, 1952:

Your letter about Tristesse du roi *touches me greatly because it confirms my own opinion about this panel, which I consider equal to all my best paintings. . . . [Zulma,] although of very fine quality, has neither the quality nor the breadth nor the profoundly expressive pathos of* Tristesse du roi. (See Documents Appendix, 9)

166

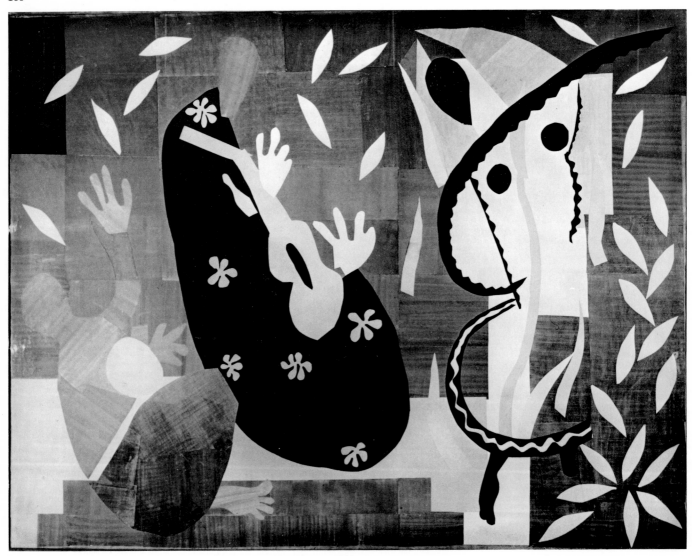

Nos. 167-183 **The Blue Nudes**

Matisse was extremely productive in 1952. He completed a wide variety of cut-outs, ranging from single-figure images of medium size to multifigured compositions occupying entire walls. The dominant theme in these works was the female nude, long a favorite source of inspiration for Matisse. He began slowly, with the series of *Nu bleu I-IV,* nos. 167-170, studying the human figure anew in terms of his cut-paper technique; he then evolved a number of distinct blue nude variations, nos. 171-183, which culminated in the mural *La Piscine,* no. 177, perhaps the last time Matisse used the nude in a major work. At the same time, Matisse was involved with *La Perruche et la sirène,* no. 183, in which the emphasis on an overall repetitive pattern was to be repeated in the more geometric murals of 1953, nos. 203-204. *La Perruche et la sirène* was also an important factor in the evolution of the various blue nudes, because so many of them were either tried out or specifically made to fit in the problematic upper right-hand corner of that composition.

The very ambiance of Matisse's large, sunny studio (see figs. 62-63, 67), its white walls covered with cut-outs in various stages of completion, encouraged mutual interaction between the various compositions. The larger cut-outs were worked out by Matisse directly on the wall, the smaller images usually on an easel. When considered finished, however, these smaller cut-outs were transferred to the wall—often adjacent to the murals, thus reinforcing the give-and-take among the images. Because they often evolved over a long period of time, the murals were the natural focus of the exchange and compelled Matisse to invent specific kinds of figures and shapes. Sometimes he appears to have elaborated these ideas further in smaller "independent" works, completing the cycle by trying some of the latter in still other murals. (See, for example, the energetic figure of *La Chevelure,* no. 176, whose type reappears as the siren of *La Perruche et la sirène,* and again as the swimmers of *La Piscine.*) This process, ongoing and apparently never quite the same, greatly appealed to Matisse, who, in effect, was cultivating numerous images in the "garden" of his studio (see remarks no. 183).

The cut-outs themselves, together with documentary photographs, a related sketchbook, and the recollections of Matisse's assistants, suggest that the large series of blue nude variations evolved in several states. The first group, *Nu bleu I-IV,* are the most closely related to Matisse's work in sculpture. Like his bronzes, these cut-

out images involve complex crossings of arms and legs, with emphasis on the joints. Rendered in cut paper, these poses entail intense foreshortening. The four nudes and their most direct variants, nos. 171 and 178, are seated and passive; two other versions, nos. 173-174, share the general pose but introduce action. This latter theme is developed in a second group of blue nudes, directly related to *Acrobates,* no. 175, in which energetic, active figures are evoked with gestural, unbroken silhouettes (see nos. 176, 183). Apparently cut quickly and with great gusto, these figures resemble the swimmers on the early right side of *La Piscine.* As that work developed, Matisse began gradually to shift from blue figures on white and brown ground at the right to white figures defined by blue at the far left. This latter phase relates *La Piscine* to a third group of blue nudes, all in highly simplified, frontal poses and constructed with a strong emphasis on positive and negative reversals and interpenetration of parts (see nos. 179-181, 201-202).

167 Nu bleu I

Blue Nude I

1952

116 x 78 cm.
45¹¹⁄₁₆ x 30¾ in.

Signed: *H Matisse / 52* (lower left)

Exhibitions: Paris 1953-3 (not in cat. but exhibited according to various later sources); Bern 1959, no. 17 (ill.); Amsterdam 1960, no. 14; Zurich 1960, no. 135; Paris 1961, no. 20; New York 1961, no. 16 (color pl. M); Paris 1970, no. 219A (ill. p. 262); Basel 1972-2, no. 63 (ill. color p. 37); Basel 1976, no. 49; New York 1976-2, p. 76 (ill. p. 77)

Bibliography: Verdet 1952, p. 24; *Verve* 1958 (ill. color p. 104); Lassaigne 1959-1 (ill.); Lassaigne 1959-2 (ill. color p. 3); Morris 1970 (ill. color p. 43); Luzi 1971 (ill. p. 111); Elsen 1972 (ill. p. 203); Editions Nouvelles Images color postcard CP26

Collections: G. David Thompson; Ernst Beyeler, Basel

The four works in this series of blue nudes were originally entitled *Baigneuses (Bathers)* and were developed for possible inclusion in the cut-out in progress, *La Perruche et la sirène*, no. 183.

Matisse described this *Nu bleu* group to Verdet:

In order to arrive at the simplicity of these bathers that you see at the far end of the garden [La Perruche et la sirène], *a great deal of analysis is necessary, a great deal of invention and love. You must be worthy of them, merit them. As I have already said, "When the synthesis is immediate, it is schematic, without density, and the expression is impoverished."* (Verdet 1952, p. 24; see Documents Appendix, 21)

The *Nu bleu* group was apparently not given roman numerals or a specific sequence during Matisse's lifetime. The numbering I-IV was employed for the first time in the New York 1961 exhibition and catalogue.

Study of Matisse's sketchbook and documentary photographs (fig. 64), together with recollections of his assistants, indicate that *Nu bleu IV*, no. 170, was in fact begun first (see remarks no. 170).

167

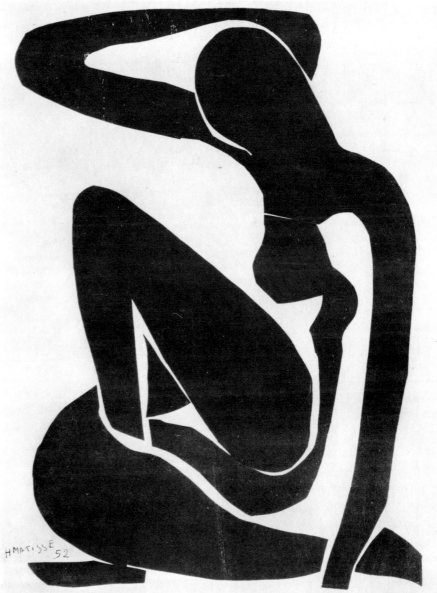

168 Nu bleu II

Blue Nude II

1952

116.2 x 88.9 cm.
45¾ x 35 in.

Signed: *H. Matisse 52* (lower left)

Exhibitions: Paris 1953-3 (not in cat. but exhibited according to contemporary press and various later sources); Paris 1956, no. 97; Bern 1959, no. 14; Amsterdam 1960, no. 15 (ill.); Paris 1961, no. 21 (ill.); New York 1961, no. 17 (ill. p. 22); Los Angeles 1966, no. 341 (ill. p. 171); Paris 1970, no. 219B (ill. p. 262)

Bibliography: *Art et Décoration* 1953 (ill. p. 40); *Verve* 1958 (ill. color p. 106); *République française* postage stamp 0,65 fr.; Marmer 1966 (ill. p. 28); Guichard-Meili 1967 (ill. no. 133 p. 147); Diehl 1970 (pl. 48); Murphy 1970 (ill. color p. 40); *XXᵉ Siècle* 1970 (ill. color p. 80 and dust jacket as blue on yellow); Aragon 1971, II (color pl. I)

Collections: Private Collection

See remarks nos. 167 and 170.

168

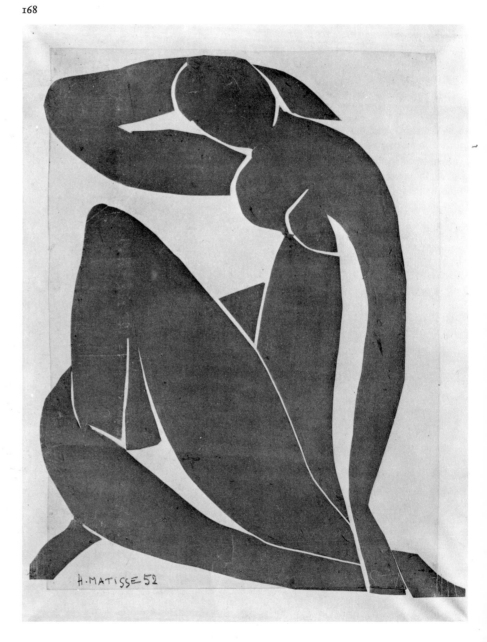

169 Nu bleu III

Blue Nude III

1952

116.2 x 81.9 cm.

45¾ x 32¼ in.

Signed: *H Matisse 52* (lower center)

Exhibitions: Paris 1953-3 (not in cat. but exhibited according to contemporary press and various later sources); Paris 1956, no. 96; Bern 1959, no. 15 (color cover); Amsterdam 1960, no. 16 (ill.); Paris 1961, no. 22; New York 1961, no. 18 (ill. p. 22); Los Angeles 1966, no. 342 (ill. p. 171); London 1968, no. 134 (ill. p. 153); Paris 1970, no. 219C (ill. p. 263); Copenhagen 1970-1, no. 107 (ill.)

Bibliography: *Art et Décoration* 1953 (ill. p. 40); *Verve* 1958 (ill. color p. 107); République française postage stamp 0,65 fr.; Guichard-Meili 1967 (ill. no. 134 p. 147); Neve 1968 (ill. p. 72); *The Illustrated London News* 1968 (ill. p. 27); Moulin 1968 (color pl. IV); Diehl 1970 (pl. 48); Flam 1973 (pl. 47 and dust jacket as white on red)

Collections: Private Collection, France

See remarks nos. 167 and 170.

169

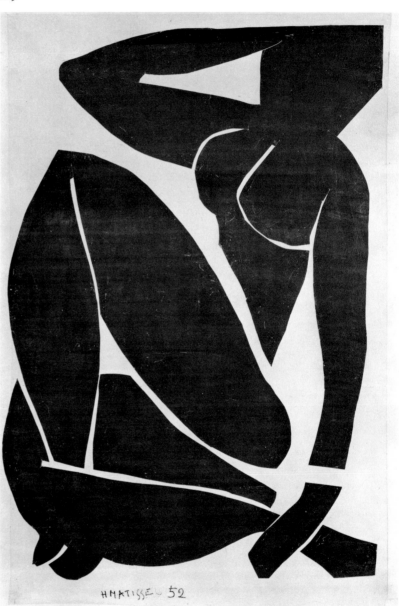

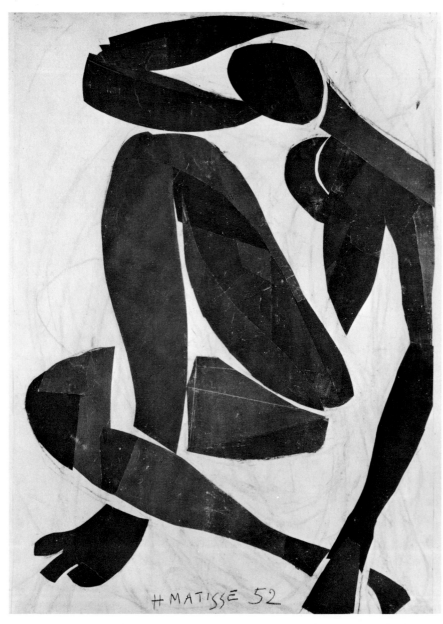

170 Nu bleu IV

Blue Nude IV

1952

Painted cut and pasted paper, charcoal

102.9 x 76.8 cm.

40½ x 30½ in.

Signed: *H Matisse 52* (lower center)

Exhibitions: Paris 1953-3 (not in cat. but exhibited according to various later sources); Bern 1959, no. 16; Amsterdam 1960, no. 17; Paris 1961, no. 23; New York 1961, no. 19 (ill. p. 23); Los Angeles 1966, no. 343 (ill. p. 171); Paris 1970, no. 219D (ill. p. 263); Copenhagen 1970-1, no. 108 (ill.)

Bibliography: *Verve* 1958 (ill. color p. 109); Jacobus 1972 (ill. no. 55 p. 46)

Collections: Private Collection, France

Matisse began this *Nu bleu,* traditionally designated as no. IV, as a study for the other three (nos. 167-169), but finished it only after they were complete.

Nu bleu IV is Matisse's most elaborate figure study in *gouache découpée,* with the exception of the Barnes mural studies, Precursor B, which were not intended as independent works. Following his liturgical designs for the Vence chapel, Matisse returned to the human figure in this traditional and familiar pose, stressing both the decorative alignment of limbs and the compact sculptural mass.

Although he had used this pose throughout his career in numerous paintings, and particularly in sculpture, Matisse apparently felt compelled to renew his understanding of the nude figure before attempting to render it in terms of cut and pasted paper. To this end he made numerous drawings in pen, pencil, and colored pencil of the seated nude—relating the parts of the figure to one another and to the proportions of the sheet of paper.

Matisse kept a *carnet d'études* or a sketchbook of drawings which were the preliminary sketches for the blue nude types. The drawings from this important *carnet* are now dispersed, but a facsimile edition was issued by Galerie Huguette Berès and Berggruen et Cie, Paris in 1955. The order of Matisse's drawings in this sketchbook appears to be chronological and allows one to follow his first thoughts and elaborations of the blue nude theme. For ex-

ample, the first drawing shows a seated female nude with her right arm extended, a pose unique in the sketchbook but the very one with which Matisse apparently began *Nu bleu IV.* (See fig. 64, in which this early state is reflected, reversed, in the studio mirrors.) The second sketchbook drawing, however, poses the nude with the bent right arm, which Matisse retained not only for the rest of the blue nude drawings in the *carnet* but for the four cut-outs, themselves. The photograph of the early state indicates the many changes Matisse made in this cut-out, changes made with both charcoal and cut paper which remain visible in the final work and give it a labored appearance found only in a few other cut-outs (see *Acrobates,* no. 175). Matisse's assistant has recalled that *Nu bleu IV* demanded so many adjustments that it occupied Matisse for some two weeks.

The same documentary photograph records that *Nu bleu IV* evolved not on the studio wall but on an easel. This suggests that Matisse worked on it at close range, directly, adding and deleting bits of paper to refine the curve of a contour just as he had previously modeled with clay. Having patiently worked out the pose here, he then proceeded to the three variants, which he completed with relative ease.

The unusual preparations for *Nu bleu IV* underscore its intimate relation to Matisse's work in sculpture. Direct ties to the living model are most clear in this cut-out, particularly the articulation of weight and the prominent biomorphic toes, a detail Matisse eliminated in the more schematic blue nudes that followed. That Matisse retained these toes in the final state of *Nu bleu IV* suggests that the cut-out was well-advanced when he temporarily put it aside and that it was probably not extensively reworked when he took it up again.

Color plate XX

171 □

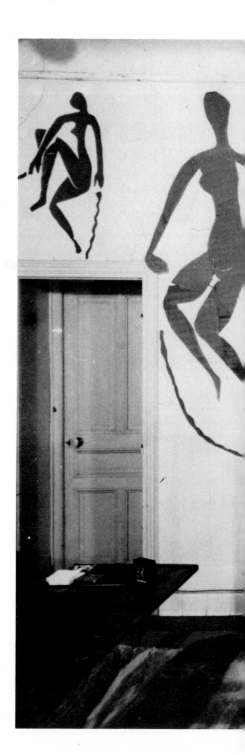

Fig. 60. Matisse studio, Hôtel Régina, Nice, c. 1952. Left to right: *Nu bleu, sauteuse de corde,* no. 174; *Nu bleu aux bas verts,* no. 173, state; *Femmes et singes,* no. 178, state; and *La Perruche et la sirène,* no. 183, state. The Chinese calligraphic panel in the center hangs above two cases holding various objects from the artist's collection.

171 **Baigneuse dans les roseaux**

Bather among the Reeds

1952

118 x 171 cm.
46⁷⁄₁₆ x 67⁵⁄₁₆ in.

Not signed or dated

Exhibitions: Bern 1959, no. 23; Amsterdam 1960, no. 24; Paris 1961, no. 24; New York 1961, no. 21 (ill. p. 30); Paris 1970, no. 224 bis. (ill. p. 315); Copenhagen 1970-1, no. 114 (ill.)

Bibliography: *Verve* 1958 (ill. color pp. 170-171); Editions Nouvelles Images color postcard CP50; Poster Originals Ltd., New York, color poster

Collections: Private Collection

172 **La Voile**

The Sail

1952

143 x 112 cm.
56⁵⁄₁₆ x 44¹⁄₁₆ in.

Not signed or dated

Exhibitions: Bern 1959, no. 22 (ill.); Amsterdam 1960, no. 23; Paris 1961, no. 26 (ill. color p. 65); New York 1961 (ill. p. 31); Copenhagen 1970-1, no. 113 (ill.)

Bibliography: *Verve* 1958 (ill. color p. 168)

Collections: Private Collection

Not illustrated

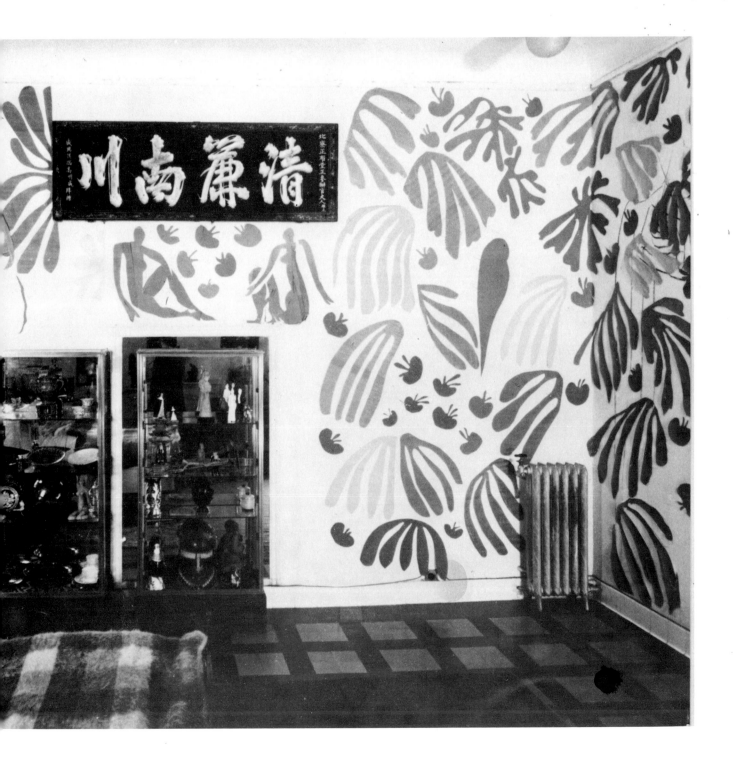

173 Nu bleu aux bas verts

Blue Nude with Green Stockings

1952

260 x 168 cm.
102⅜ x 66⅛ in.

Not signed or dated

Exhibitions: Bern 1959, no. 9; Amsterdam 1960, no. 9; Paris 1961, no. 16; New York 1961, no. 12

Bibliography: *Verve* 1958 (ill. color p. 67); Lassaigne 1959-2, p. 123; Leymarie 1959, p. 112; Duthuit 1962; Moulin 1968 (color pl. VIII); Luzi 1971 (ill. p. 111)

Collections: Private Collection

A photograph (fig. 60) suggests that the compositional arrangement of this work and that of *Nu bleu, sauteuse de corde,* no. 174, were affected by the architecture and setting of Matisse's studio. Matisse made a drawing in his *carnet* (see Matisse 1955-2, p. 11) of a nude with red head, arms, and bust, with the lower torso and legs in blue.

Color plate XXI

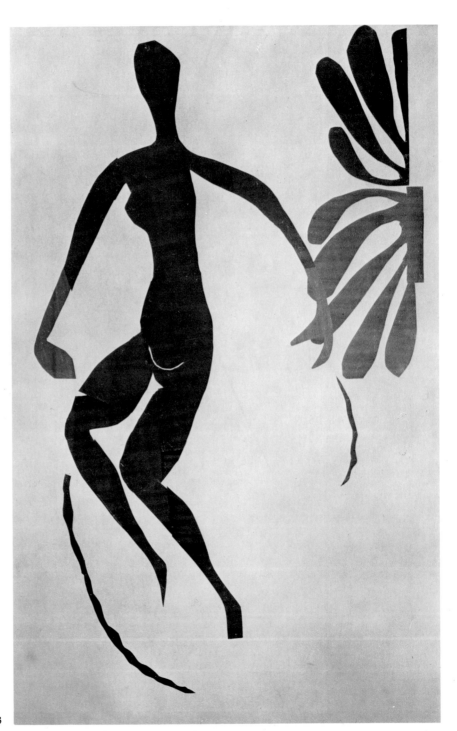

173

174 Nu bleu, sauteuse de corde

Blue Nude, Jumping Rope

1952

145 x 98 cm.

57 1/16 x 38 1/2 in.

Not signed or dated

Exhibitions: Bern 1959, no. 8 (ill.); Amsterdam 1960, no. 8; Paris 1961, no. 15 (ill. p. 67); New York 1961, no. 11 (ill. p. 24); Paris 1970, no. 224ter (ill. p. 315)

Bibliography: Verdet 1952, p. 29; *Verve* 1958 (ill. color p. 66); Lassaigne 1959-2, p. 123; *XXe Siècle* 1970 (ill. p. 84); Luzi 1971 (ill. p. 111)

Collections: Private Collection

See remarks no. 167. Matisse titled this work, as recounted in Verdet 1952, *Jeune Fille dansant à la corde*.

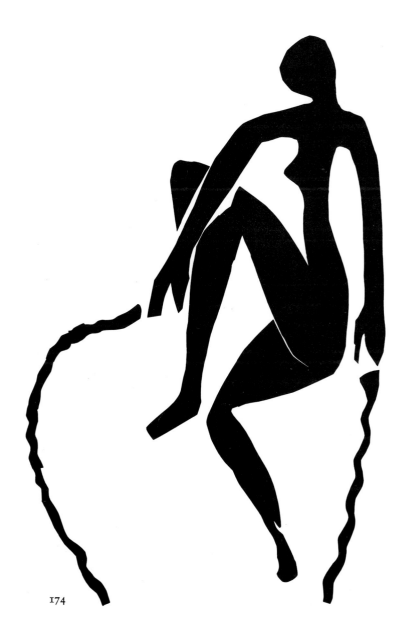

174

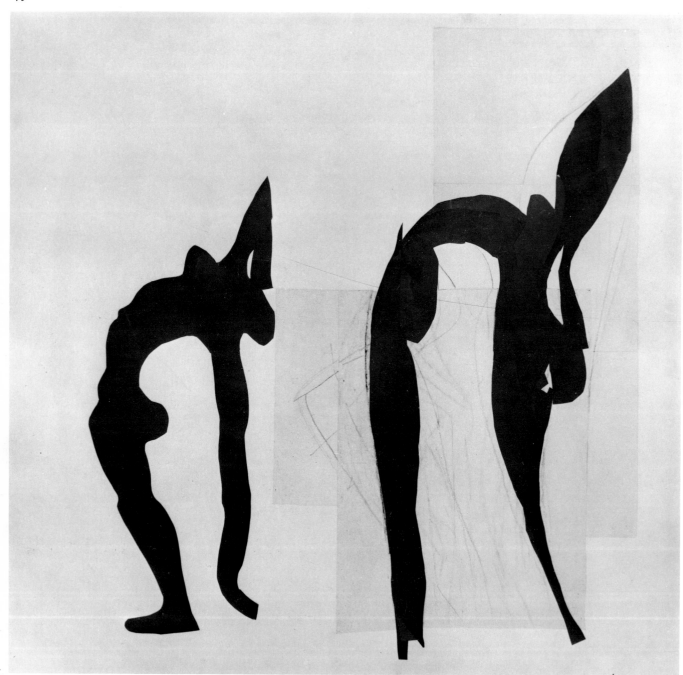

***175 Acrobates**

Acrobats

1952

Painted cut and pasted paper, charcoal

213 x 209.5 cm.
83¹³⁄₁₆ x 82½ in.

Not signed or dated

Exhibitions: Paris 1956, no. 99; Bern 1959, no. 20; Amsterdam 1960, no. 18; Paris 1961, no. 24; New York 1961, no. 20 (ill. p. 28); Paris 1970, no. 224 (ill. p. 269); Copenhagen 1970-1, no. 112 (ill. color); Baltimore 1971, no. 81, p. 182 (ill. p. 183)

Bibliography: *Verve* 1958 (ill. color p. 111); Lassaigne 1959-2, p. 124; Moulin 1968, pp. 34, 196 (color pl. VII); Aragon 1971, II (ill. color p. 347); Luzi 1971 (ill. p. 111); Jacobus 1972 (ill. p. 47); Toca 1974 (ill. no. 16)

Collections: Private Collection; Sheldon H. Solow, New York

Evolving at around the same time as six brush and ink acrobat drawings (see *Verve* 1958, ill. pp. 71, 82, 110 and Paris 1975, ill. pp. 182-183), which took as their primary source the artist's charcoal drawing in *Derrière le miroir*, 1952. The figure at the left is a sculpturesque stylistic throwback, perhaps closest to Matisse's 1906 bronze *Nu campé, bras sur la tête*. In contrast, the right-hand figure is an abstract composite of numerous flattened planes visually activated by charcoal sketch lines. Constructed like a jigsaw puzzle, it differs significantly from the left-hand figure, with its volumetric allusions.

Color frontispiece

176 La Chevelure

The Flowing Hair

1952

108 x 80 cm.
42½ x 31½ in.

Signed: *H. Matisse 52* (lower right)

Exhibitions: Bern 1959, no. 13 (ill.); Amsterdam 1960, no. 13 (ill. color); Paris 1961, no. 19 (ill. color); New York 1961, no. 15 (color pl. I); London 1968, no. 133 (ill. p. 152); Paris 1970, no. 220 (ill. p. 265 and color poster); Copenhagen 1970-1, no. 109 (ill.); Baltimore 1971, no. 83, p. 186 (ill. p. 187)

Bibliography: *Verve* 1958 (ill. color p. 81); Lassaigne 1959-1 (ill.); Levêque 1968 (ill. color p. 53); Moulin 1968 (color pl. III); Alpatov 1969 (ill. color p. 87); Murphy 1970 (color cover); Luzi 1971 (ill. p. 111); Flam 1973 (pl. 46); Radulescu 1974 (pl. 65); Editions Nouvelles Images color postcard CP48

Collections: Private Collection

This work has been described as a blue dancer, which emphasizes its relationship with Matisse's contemporary acrobat drawings (see remarks no. 175). Flowing hair was a subject often treated by Matisse, notably in an illustration for *Poésies de Stéphane Mallarmé*, Paris, 1932, p. 128, although its literary ancestry may be traced to Baudelaire's poem "La Chevelure." This cut-out appears to have been the source for the more streamlined siren figure in *La Perruche et la sirène*, no. 183.

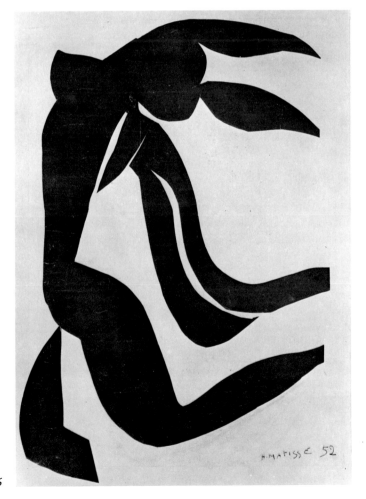

176

*177 La Piscine

The Swimming Pool

1952

230 x 1,645 cm.
90½ x 647⅝ in.

Not signed or dated

Exhibitions: Paris 1956, no. 98; Bern 1959,
nos. 18-19 (ill.); Amsterdam 1960, no. 27;
Paris 1961, no. 30 (ill.); New York 1961,
no. 25 (color pls. B-C pp. 32-33); London
1968, no. 130 (ill. pp. 148-149); Paris 1970,
no. 225 (ill. pp. 270-271)

Bibliography: Verdet 1952, pp. 97-98
(ill. color detail, reversed, entitled *La
Plongeuse*); *Verve* 1958 (ill. color pp. 85-
88, 97-100); Lassaigne 1959-2, p. 123;
Jacobus 1972 (ill. detail pp. 48-49);
Alpatov 1973, pp. 127-128; Glueck 1976
(ill.)

Collections: Private Collection; Museum
of Modern Art, New York

Matisse began *La Piscine* for himself, not
in response to any specific ceramic com-
mission, as has often been proposed. The
composition apparently evolved slowly
over some time from the right side around
to the left. It is known that the corner
bather (to the immediate right of the door
in fig. 61) took Matisse a very long time
to do, while the other figures on the panel
were quickly cut from single sheets of
blue paper.

Punctuated at the beginning and the end
by starfish (and by a small dolphin on the
right side), the composition consists of
female swimmers who frolic in the water:
falling, diving, swimming. This occurs
above, on, and below the water surface,
as indicated by the individual gestures and
the full or partial silhouettes. Some figures
are seen from a vantage point above the
pool, others from the water itself, but
there is no obvious break between the
views.

The panoramic effect of the cut-out is the
result of the organic composition, which
grew internally with one shape generating
the next. This process is most clear on the
left panel, where the final swimmer—
white defined by blue— completes the
gradual reversal of blue figure on white
ground begun in the earlier swimmers
across the room. Indeed, there are three
basic blue nude styles in *La Piscine*, which
suggests its interaction with other cut-outs.

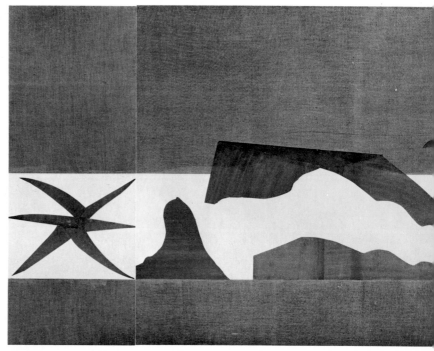

177

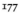

177

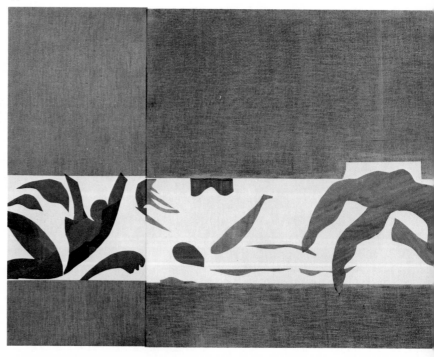

224

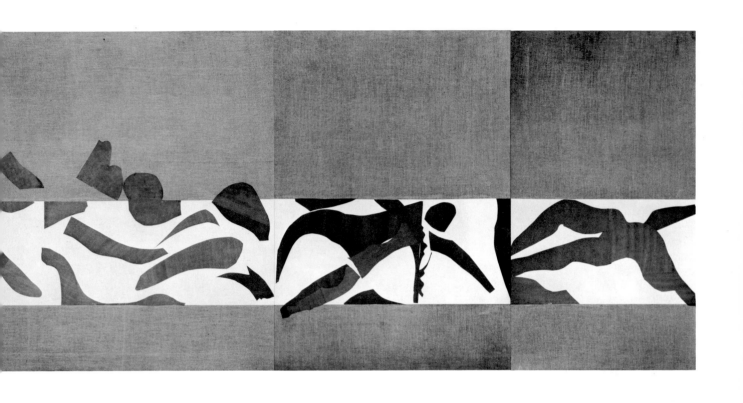

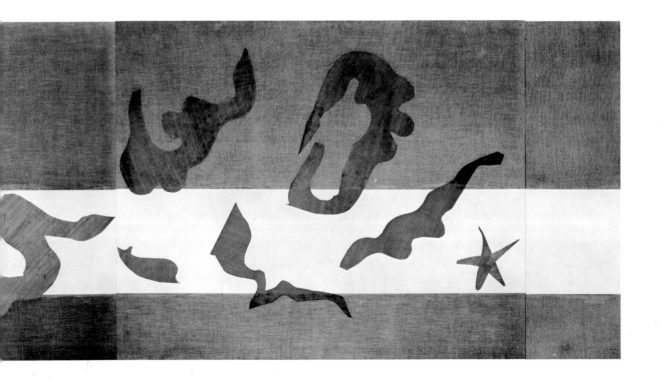

The vigorous gestural silhouettes at the beginning of *La Piscine* are clearly related to *Acrobates,* no. 175 (and ultimately to *Le Cow-Boy* in *Jazz,* no. 30), although the precise chronology is uncertain (see also *La Chevelure,* no. 176, and particularly *La Perruche et la sirène,* no. 183). The backstroking swimmer on the left side of the first panel, suggested by a separate head and arm (the rest obscured by the "water"), is analogous to the similar construction of *Nu bleu debout,* no. 179, and *La Grenouille,* no. 180. Matisse developed this direction further in the center of the second panel, which culminates in the "white" nude at the far left, perhaps contemporary with *Vénus,* no. 181.

An interesting comparison can be made with Amadée Ozenfant's *La Belle Vie* of 1929 (see Ozenfant 1952, p. 336), a large swimming scene juxtaposing highly simplified silhouettes of partial and complete figures in a multiplicity of views. Ozenfant's style in this work reflects his interest in prehistoric cave paintings as illustrated in his book (p. VI). The probable relationship between *La Belle Vie* and Fernand Léger's *Les Plongeurs* of 1940/42 is made explicit by Ozenfant's juxtaposition of the two works, with detail enlargements (pp. 336-337). It is not known whether Matisse was aware of either work.

The cut forms were attached to the white background paper and directly to the beige wall fabric. The present jute mounting material is an approximation of the original wall covering.

According to documents at the Museum of Modern Art, Barr visited Matisse early in September 1952, when he saw *La Piscine,* as well as *Souvenir d'Océanie,* no. 199 (then entitled *Rêve en Océanie*).

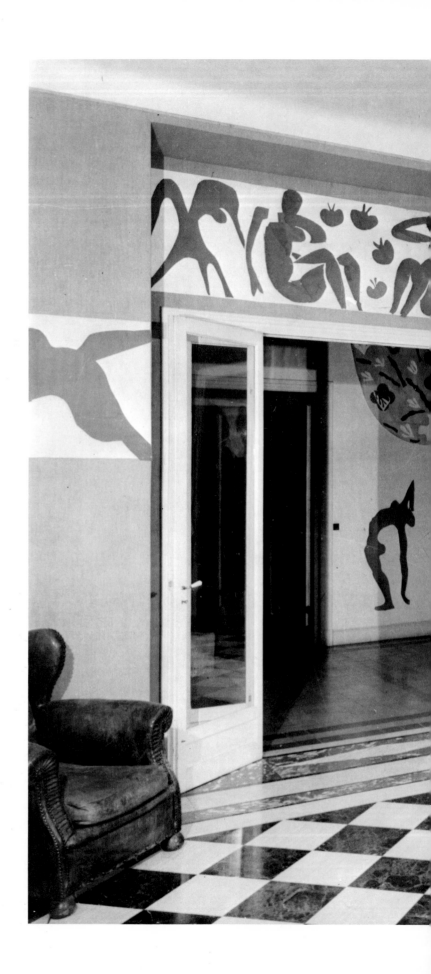

Fig. 61. Matisse studio, Hôtel Régina, Nice, 1953. On wall: *La Piscine,* no. 177; over door, *Femmes et singes,* no. 178. In background: *Acrobates,* no. 175, *Chasuble rose,* no. 141.

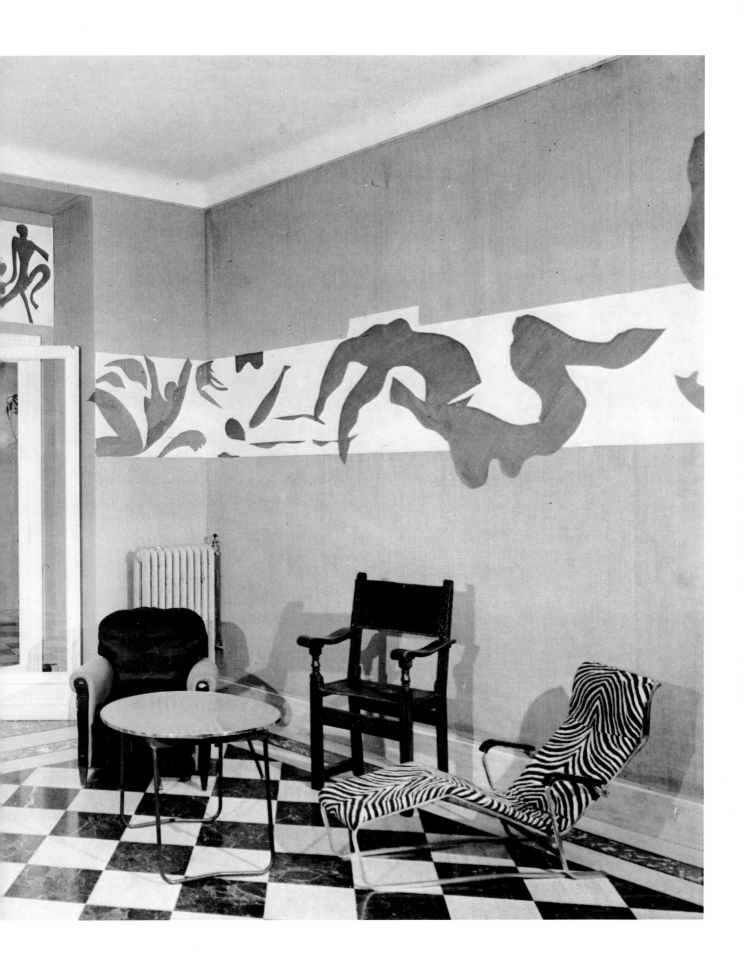

*178 Femmes et singes

Women and Monkeys

1952

71.7 x 286.2 cm.
28¼ x 112¹¹⁄₁₆ in.

Not signed or dated

Exhibitions: Bern 1959, no. 21; Amsterdam 1960, no. 19; Paris 1961, no. 31; New York 1961, no. 26 (ill. pp. 26-27); London 1968, no. 132 (ill. p. 151); Basel 1976, no. 50 (color cover and color pl.)

Bibliography: *Verve* 1958 (ill. color pp. 92-93); Moulin 1968 (ill. p. 7); Alpatov 1969 (ill. color pp. 80-81); Alpatov 1973 (color pl. 60); Museum of Modern Art color poster

Collections: Private Collection; Museum of Modern Art, New York; Galerie Beyeler, Basel

A 1952 photograph (fig. 60) records an early state of this work, which consisted of only two seated nudes and a wedge of six pomegranates; these nudes, more open variants of *Nu bleu I-IV*, were made about the same time as *Nu bleu, sauteuse de corde,* no. 174, and *Nu bleu aux bas verts,* no. 173, with which they shared the wall; to their left is the incomplete *La Perruche et la sirène,* no. 183.

The final frieze-like proportions of *Femmes et singes* seem determined by the space above the doorway (fig. 61). The monkeys were apparently added to fit this new location. At the very least, the similar heights of the white backgrounds of this work and of *La Piscine,* no. 177, suggest that *Femmes et singes* was reworked within the ambiance of the mural *La Piscine.*

178

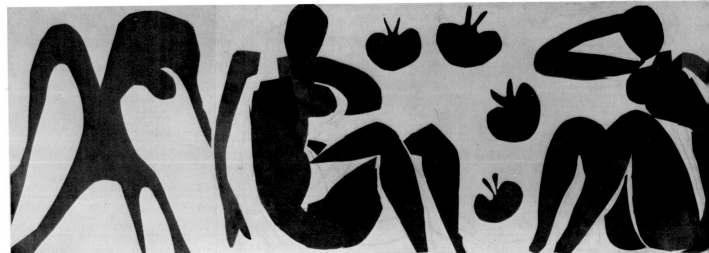

***179 Nu bleu debout**

Standing Blue Nude

1952

113 x 74 cm.
44½ x 29⅛ in.

Signed: *HM* (lower right)

Exhibitions: Bern 1959, no. 7 (ill.); Amsterdam 1960, no. 7; Paris 1961, no. 14 (ill. p. 6); New York 1961, no. 10 (color pl. H); Los Angeles 1966, no. 340

Bibliography: *Verve* 1958 (ill. color p. 64); Flam 1971 (fig. 18)

Collections: Private Collection

The upper torso of this work is the closest reversed equivalent of the frontal torso in *Vénus,* no. 181. *Nu bleu debout* also finds a sculptural relation in Matisse's bronze *Nu debout, Katia,* 1950.

Nu bleu debout and *Zulma,* no. 109, seem to follow a progression related to that of the sculpture *Nu de dos III,* 1916-17, and *Nu de dos IV,* 1930: *Zulma,* like *Nu de dos III,* is heavily "modeled" within its outlines; *Nu bleu debout,* like *Nu de dos IV,* is an image in which form and outline are inseparable.

Color plate XXII

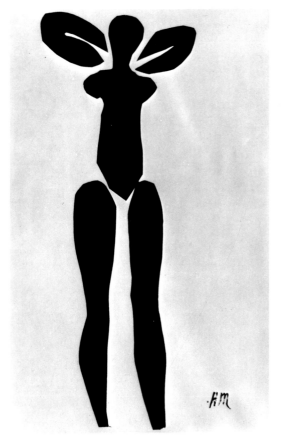

179

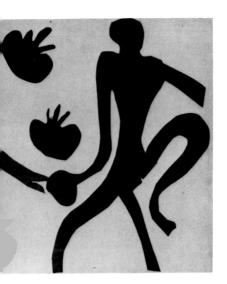

180 La Grenouille

The Frog

1952

141 x 134 cm.
55½ x 52¾ in.

Signed: *HM* (lower right)

Exhibitions: Bern 1959, no. 10; Amsterdam 1960, no. 10; Paris 1961, no. 17 (ill. p. 30); New York 1961, no. 13 (color pl. E); Paris 1970, no. 223 (ill. p. 267)

Bibliography: *Verve* 1958 (ill. color p. 69); Moulin 1968 (color pl. VI); Diehl 1970 (ill. p. 61); *Time* 1970 (ill. color p. 38); Luzi 1971 (ill. p. 111)

Collections: Private Collection; Otto Preminger, New York

An unusual blue nude work, in that the figure is placed on a strong yellow background.

180

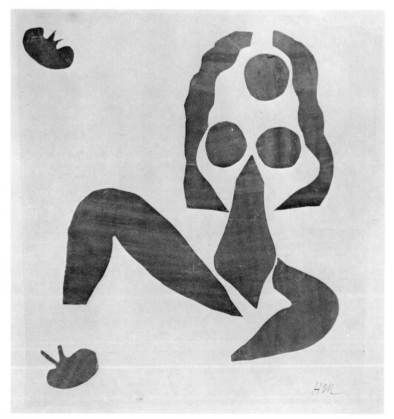

*181 Vénus

Venus

1952

101.2 x 76.5 cm.
39⅞ x 30⅛ in.

Signed: *HM* (lower right)

Exhibitions: Bern 1959, no. 11; Amsterdam 1960, no. 11 (ill. color); Paris 1961, no. 18 (ill. color p. 54); New York 1961, no. 14 (color pl. L); Paris 1970, no. 222 (ill. p. 266); Copenhagen 1970-1, no. 110 (ill.); Baltimore 1971, no. 82, p. 184 (ill. p. 185)

Bibliography: *Verve* 1958 (ill. color p. 72); Moulin 1968 (ill. p. 35); Aragon 1971, II (color pl. XLI p. 280); Cowart 1974 (ill. p. 54); Washington, D.C., 1975, no. 265 ill. p. 231; Carmean 1976 (ill. color p. 124); National Gallery of Art, Washington, D.C. color poster

Collections: Private Collection; National Gallery of Art, Washington, D.C.

Vénus is a cut-out demanding compositional, thematic, and biographical interpretation. Its complexity results from issues and potentials seen during Matisse's work on the pivotal blue and white cut-out, *La Piscine,* no. 177. It is a cogent expression of Matisse's instinctive balances and reversals of materialized color and space. The white of this "positive" torso bleeds out at the lower left, thus reverting into a "negative" background. The ultramarine blue, which suggests a deep envelope of Aegean sky, then becomes a flat plane with specific boundaries and edges. *Vénus* has an especially sculptural effect and calls to mind certain Praxitelian sources (or perhaps Matisse's own Roman copy after a Greek torso, now in the Musée Matisse, Nice).

The March 1947 charcoal drawing (*XXe Siècle* 1970, ill. p. 105) of a simplified nude torso is one of the closest graphic renderings of this Venus-like torso image, but it has none of the other implications discussed above. Matisse's line drawing of a nude torso with its right breast in profile in his *carnet* (Matisse 1955-2, p. 59), while done earlier in the year, relates to *Vénus.*

182 L'Escargot

The Snail

1952

69 x 89 cm.

27³⁄₁₆ x 35 in.

Signed: *Matisse 52* (lower left)

Exhibitions: Paris 1953-2?

Bibliography: Verdet 1952, p. 64 (ill. color p. 65 entitled *Composition en couleurs);* Editions Nouvelles Images color poster

Collections: Private Collection

Green snail on a blue background.

Matisse discussed this cut-out with Verdet: *. . . the decision of the line comes from the artist's profound conviction. That paper cut-out, the kind of volute acanthus that you can see on the wall up there, is a stylized snail. First of all I drew the snail from nature, holding it between two fingers; drew and redrew. I became aware of an unfolding, I formed in my mind a purified sign for a shell. Then I took the scissors. It was necessary that the end be alive right in the beginning. Further, I had to establish the connection between the object observed and its observer. . .*

I had placed that snail in the large composition Le Jardin [La Perruche et la sirène, *no. 183]. But the musical movement of the whole ensemble was broken. So I removed the snail; I have put it aside while awaiting another place for it.* (Verdet 1952, pp. 64-65; see Documents Appendix, 20).

Although this work is neither listed in the catalogue of the Paris 1953-2 exhibition nor visible in the known installation photographs, it is mentioned in a review of the exhibition and therefore may have been shown. See also no. 198.

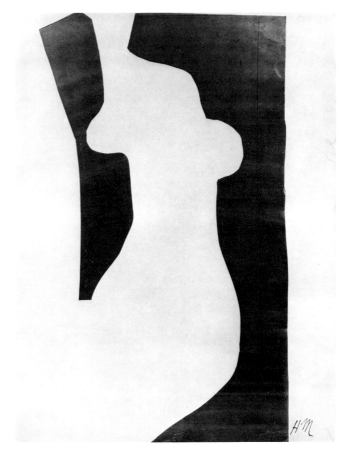

181

182

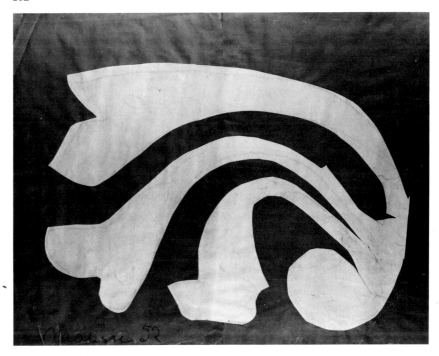

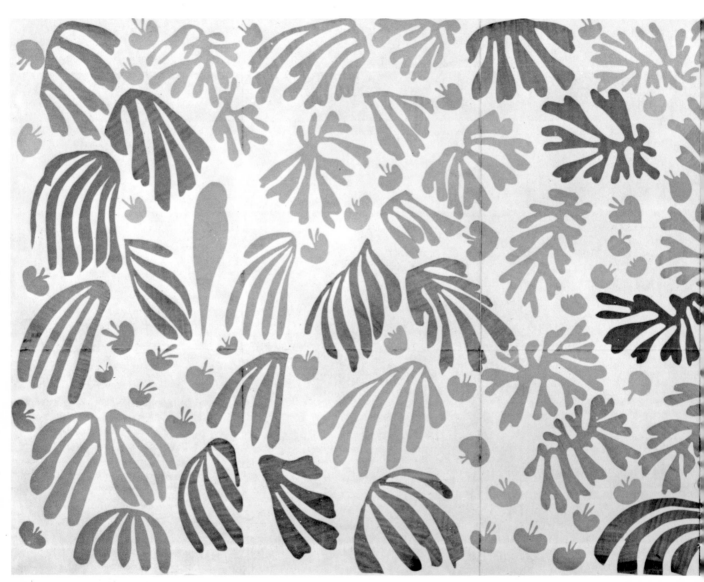

183

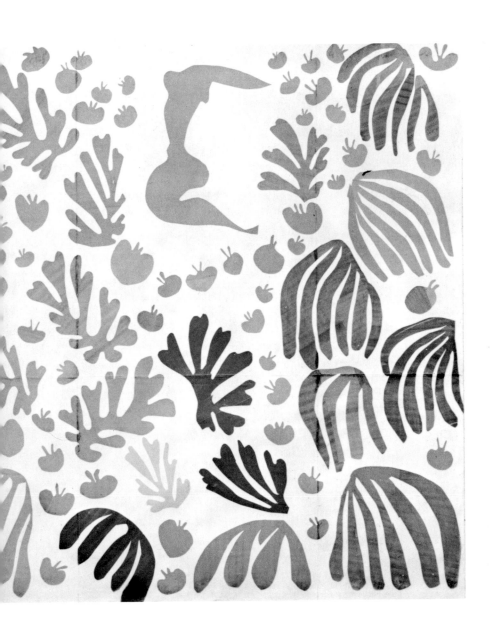

183 La Perruche et la sirène

The Parakeet and the Mermaid

1952

337 x 773 cm.
132¹¹⁄₁₆ x 304⅜ in.

Not signed or dated

Exhibitions: Paris 1956, no. 103; Paris 1957, no. 130; Paris 1961, no. 27 (ill. p. 38); Marseille 1962, no. 88; Kassel 1964, no. 4 (ill. color pp. 80-81)

Bibliography: Verdet 1952, pp. 20-23, 64 entitled *Le Jardin;* Cassou 1953; *Verve* 1958 (ill. color pp. 58-60); *Burlington Magazine* 1966 (ill. pp. XIV-XV); Fleet 1966 (ill. p. 73); Guichard-Meili 1967, p. 143; Alpatov 1969 (ill. color pp. 82-83); Moulin 1969, p. 36; Aragon 1971, II (color pl. XXXIX pp. 260-261); Matisse 1972, pp. 253-254; Alpatov 1973, p. 128; Fourcade 1976, p. 114

Collections: Pierre Berès; (Sotheby, London, June 22, 1966, lot no. 78, pp. 80-81, ill. color); (Robert Elkon—Kasmin Ltd.—Larry Rubin, on loan to The Tate Gallery, June 1966-January 1967); Stedelijk Museum, Amsterdam

Matisse said of this work:

You see, as I am obliged to remain often in bed because of the state of my health, I have made a little garden all around me where I can walk. . . . There are leaves, fruits, a bird. Restrained movement, calming. I took out the motif that you see there, isolated, at the right: I took it out because it had a violent movement. This movement struck a wrong note in the score. An andante and a scherzo that clashed [note this musical analogy and compare it to Matisse's remarks concerning *Nuit de Noël, no. 162]. . . . In entering into the object one enters one's own skin. I had to make . . . this parakeet with colored paper. Well, I became a parakeet. And I found myself in the work. The Chinese say that one must grow with the tree. I know nothing truer.* (Verdet 1952, pp. 20, 21, 28-29; see Documents Appendix, 22)

This seminal work eloquently demonstrates Matisse's realization of large-scale environmental decoration. Originally set up in his main studio room, the work grew from left to right. Matisse seems to have lived with it longer and more happily than he did with some of his other cut-outs.

The placement of the siren figure in the upper right corner of this mural composition was, like the title, apparently an afterthought. Before finally deciding to place the siren here, Matisse tried out all four blue nudes, nos. 167-170; *La Chevelure,* no. 176; *Vénus,* no. 181; and *L'Escargot,* no. 182 (see Verdet 1952, pp. 64-65). The figure of the siren consists of three pieces of paper cut from a single large sheet—an instance of remarkable virtuosity which probably required an assistant standing next to Matisse to feed the large supple sheet of paper into the scissors. (This procedure, Matisse continually turning and guiding the paper as he cut, is documented in a film [Maeght 1952] of Matisse working on a large leaf shape. In the film Matisse is seen cutting without stopping to check his progress, pushing the large heavy shears through the paper in long sweeps, working the blades only to cut tight corners. He maintains an even rhythm which allows him to grasp a sense of the entire shape even as it rotates in his hand, the paper bent, obscuring the whole from view.) According to an assistant, Matisse almost never reworked the contours once his cutting (and rhythm) had stopped.

Documentary photographs (figs. 62-63), together with the proportions of the final work, suggest that Matisse originally conceived of this work as a central panel with two wings. The composition seems to have developed steadily until Matisse reached the right wing, at which point he experimented with various solutions, finally deciding on the addition of the siren. The visual relationship between this figure and the early swimmer on the right side of *La Piscine,* no. 177, further suggests that *La Perruche et la sirène* was finished in late 1952. Moreover, a letter from Matisse to Pierre Berès of January 20, 1953 (see Documents Appendix, 13) implies that the work was then finished.

Fig. 62. Matisse studio, Hôtel Régina, Nice, 1952. On wall: left, *Femmes et singes,* no. 178, early state; center and right, *La Perruche et la sirène,* no. 183.

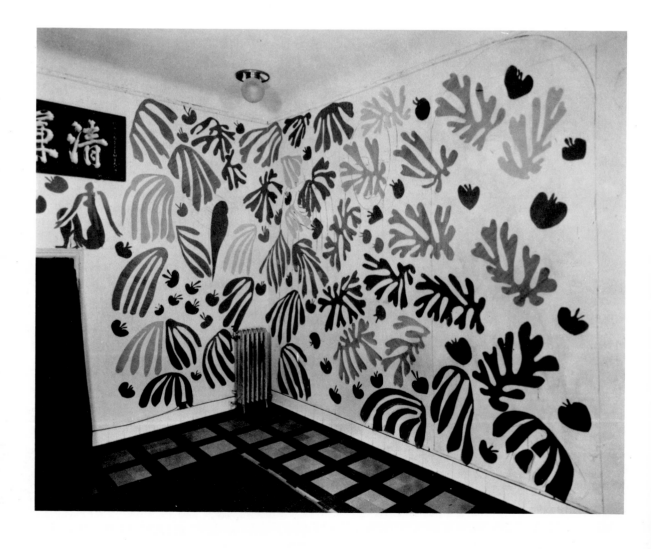

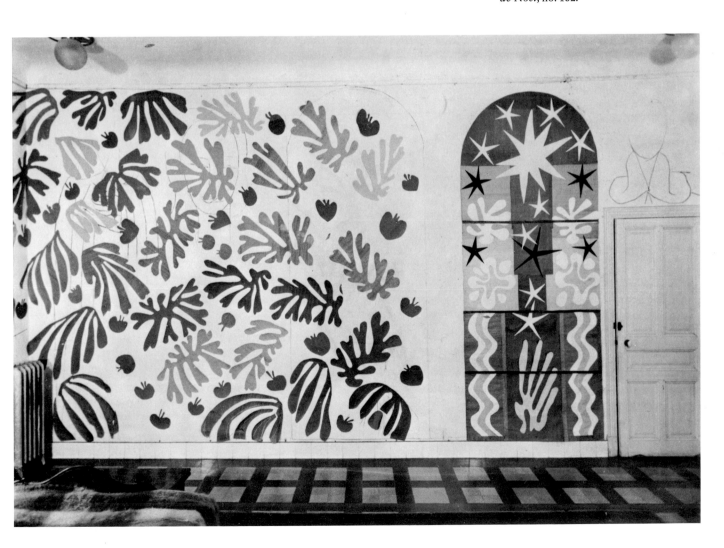

***184 Henri Matisse Gravures Récentes**
(cover maquette)

1952

22 x 11 cm.
8¹¹⁄₁₆ x 4⁵⁄₁₆ in.

Signed: *Henri Matisse* (center)

Exhibitions: Saint-Paul de Vence 1969, no. 32

Collections: Heinz Berggruen, Paris

Maquette for the cover of the catalogue for the exhibition "Henri Matisse Gravures Récentes," Berggruen et Cie, Paris, June 19-July 12, 1952. The top shape is green, the bottom, blue, on a white background.

For this exhibition Matisse also designed an invitation for the opening which may have been based on a cut paper design: a black ink drawing of a woman's head on a yellow ground, green border.

185 Festival International d'Art Dramatique
(cover maquette)

1952

Painted cut and pasted paper, pen and ink

27 x 21 cm. (approx.)
10⅝ x 8¼ in. (approx.)

Signed: *H. Matisse* (lower right)

Collections: present location unknown

Maquette for the cover of the program for the Festival International d'Art Dramatique, Nice, May 31-June 2, 1952. The colors of the faces are: upper left, orange; upper right, green; lower, yellow. The background is white.

186 Henri Matisse (cover maquette)

1952

Painted cut and pasted paper, pen and ink

24.5 x 18.6 cm. (approx.)
9⅝ x 7⁵⁄₁₆ in. (approx.)

Signed: *Henri Matisse* (bottom)

Collections: present location unknown

Maquette for the cover of the catalogue for the exhibition "Henri Matisse," Knokke-le-Zoute, Grande Salle des Expositions de la Réserve, July 12-August 31, 1952. The background is orange and the face image is drawn on cut yellow paper. Cf. no. 185.

184

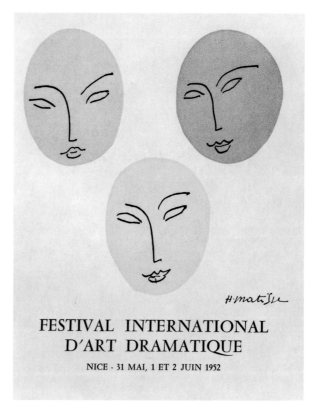

FESTIVAL INTERNATIONAL
D'ART DRAMATIQUE

NICE · 31 MAI, 1 ET 2 JUIN 1952

185 □

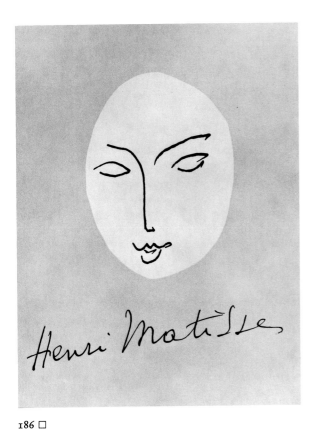

186 □

187 **Images à la Sauvette** (cover maquette)

1952

37 x 57.5 cm. (approx.)
14⅝ x 22⅝ in. (approx.)

Signed: *Matisse* (lower left), *Images à la Sauvette* (center-spine), *Images à la Sauvette/Photographies par Henri Cartier Bresson* (lower right)

Collections: present location unknown

Maquette for the cover of a book of Cartier-Bresson photographs published by *Verve,* July 22, 1952. The American edition, New York, 1952, has the translated title, *The Decisive Moment,* and description, *Photographs by Henri Cartier Bresson,* written in script by Matisse.

187 □

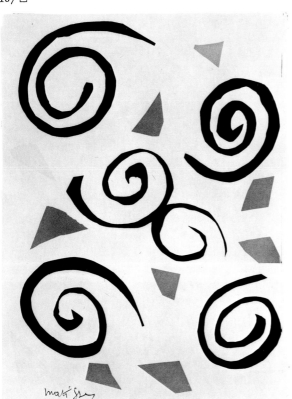

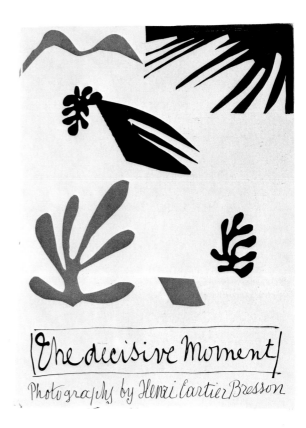

188 □

189 □

188 Apollinaire (cover maquette)

1952

Painted cut and pasted paper, crayon

Collections: present location unknown

Maquette for the front and back covers of André Rouveyre's *Apollinaire,* Paris, 1952. The contours of the flower petals are in black crayon with yellow cut-outs inside the petals. See also no. 189.

The French poet Guillaume Apollinaire (1880-1918) was an early supporter of Matisse and did the first published interview with the artist in 1907.

189 Apollinaire (slipcase maquette)

1952

Collections: present location unknown

Maquette for the slipcase of André Rouveyre's *Apollinaire,* Paris, 1952. Front, white letters *Apo/lli/naire/HM* on blue ground; back, blue and white alga shape on white ground. See also no. 188.

190 Echos (cover maquette)

1952

Signed: *Echos/24 Juin 1952*

Collections: present location unknown

Maquette for the cover of *Echos,* a book of poems by Prévert, Verdet, Hikmet, etc., privately printed, 1952, in 15 copies. Front cover, green profile on yellow ground, all on white paper; back cover, yellow profile on green ground, all on white paper. The cut-out elements may date from several years before (see no. 98).

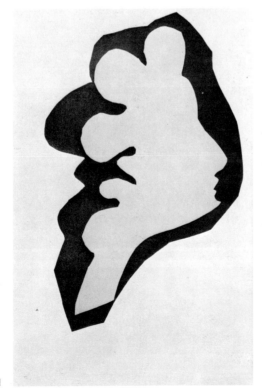

190 □

191 Livrés Illustrés Estampes Sculptures
(cover maquette)

1952

20.7 x 14.5 cm. (approx.)
8⅛ x 5¹¹⁄₁₆ in. (approx.)

Signed: *HM* (lower right)

Exhibitions: Copenhagen 1953, no. 56? as
udkast til kataloganslag

Collections: Private Collection

Maquette for the cover of the catalogue
for the Gérald Cramer exhibition "Livrés
Illustrés . . . ," Geneva, November 1952.
The Copenhagen 1953 catalogue lists a
work under no. 56 whose dimensions
appear close to those of no. 191. The
shapes on the right suggest a green para-
keet on a blue perch. At the top is a red
circle on a white background; the lower
half consists of a black shape on yellow.

**192 Les Peintres Témoins de leur Temps Le
Dimanche** (poster maquette)

1952

51.5 x 37.5 cm. (approx.)
20¼ x 14¾ in. (approx.)

Signed: *H. Matisse 52* (lower left)

Exhibitions: Paris 1953-1 (ill. p. 138)

Bibliography: Mourlot 1959 (ill. no. 44)

Collections: present location unknown

Maquette for the poster and catalogue
cover for the exhibition "Les Peintres
Témoins de leur Temps," Musée d'Art
Moderne de la Ville de Paris, January 30-
March 1, 1953, and Musée de Bourges,
Hôtel Cujas, March 21-May 31, 1953.
Separate printings of the type inserts for
each exhibition. Four-color lithography by
Mourlot Frères, Paris.

191 □

192 □

193 Affiches d'Expositions Réalisées Depuis 25 Ans par l'Imprimerie Mourlot . . . (poster maquette)

1952

54.2 x 49.6 cm. (approx.)
21⅚ x 19½ in. (approx.)

Signed: *Matisse 52* (lower left)

Bibliography: Mourlot 1959, p. 243 (ill. no. 45 and dust jacket)

Collections: present location unknown

Maquette for the exhibition poster for "Affiches d'Expositions Réalisées Depuis 25 Ans par L'Imprimerie Mourlot et Présentées à l'Occasion de son Centenaire à la Galerie Kléber, Paris, December 5, 1952-January 1953," in six-color lithography. There was also a printing with a Dutch text.

194 The Sculpture of Matisse . . . (poster maquette)

1952

Painted cut and pasted paper, brush and ink

82 x 57.5 cm.
32¼ x 22⅝ in.

Signed: *H. Matisse.* (lower right)

Exhibitions: Copenhagen 1953, no. 55

Collections: present location unknown

Maquette for the poster of the exhibition "The Sculpture of Matisse and three paintings with studies," The Tate Gallery, London, January 9-February 22, 1953. Five-color lithography by Mourlot Frères, Paris.

This poster image was used again for at least one other exhibition at the Ny Carlsberg Glyptotek, Copenhagen, 1953.

193 □

194 □

195 Prestiges de Matisse (cover maquette)

1952

19.5 x 29.5 cm. (approx.)
7¹¹⁄₁₆ x 11⅝ in. (approx.)

Signed: not known

Collections: present location unknown

Maquette for the cover of André Verdet's *Prestiges de Matisse,* published in Paris, 1952, in an edition of 1,800. Front and back, rows of blue quatrefoils on white. "In April and May 1952, André Verdet interviewed Matisse at Cimiez. This extended interview, ranging over many subjects, is one of the most important interviews with Matisse. Verdet's questions are well chosen, and Matisse's answers clarify and extend many of his previous ideas with great eloquence..." (Flam 1973, p. 142). This interview was included in *Prestiges de Matisse* (pp. 37-76).

196 Acanthe

Acanthus

1952

Signed: not known

Bibliography: Paris 1961 (ill. p. 45); Duthuit 1962 (ill. p. 99); Jacobus 1972 (ill. p. 51)

Collections: present location unknown

This palmate form, though undated, seems closely related to the style of leaf cut-outs Matisse was using for areas of *La Perruche et la sirène,* no. 183.

Not illustrated

*197 Henri Matisse Papiers Découpés (cover maquette)

1952

22 x 24 cm.
8¹¹⁄₁₆ x 9⁷⁄₁₆ in.

Signed: *H Matisse* (center left panel), *Matisse* (lower right panel)

Bibliography: Aragon 1971, II, p. 308; San Francisco 1975

Collections: Heinz Berggruen; (Parke-Bernet, New York, April 27, 1960, lot no. 2, ill.); Mr. and Mrs. Armand Bartos, New York

Maquette for the catalogue cover of the exhibition "Henri Matisse Papiers Découpés," Berggruen et Cie, Paris, February 27-March 28, 1953. Background colors, front cover: orange, yellow, green, beige; back cover: orange, green. The blue forms suggest positive and negative profile faces whose calm, detailed features, joined nose-forehead, and general placement seem prefigured in the profile in the mirror of Pablo Picasso's painting *Woman with a Book,* 1932 (Norton Simon Museum of Art, Pasadena).

Color plate XXIII (front cover)

195 □

197

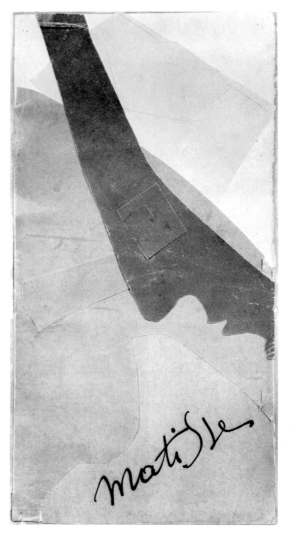

The Snail

1952

286 x 287 cm.

112⅝ x 113 in.

Signed: *H. Matisse/53* (lower right)

Exhibitions: Bern 1959, no. 26 (ill.); Paris 1961, no. 35; New York 1961, no. 29 (ill. p. 38); London 1968, no. 136 (ill. color p. 54)

Bibliography: Verdet 1952, pp. 32-35; *Verve* 1958 (ill. color p. 154); Lassaigne 1959-1 (ill.); Lassaigne 1959-2, p. 124; Brill 1967 (pl. 48); Guichard-Meili 1967 (ill. color no. 137 p. 149); Moulin 1967 (color pl. XII); *XXᵉ Siècle* 1970 (ill. color p. 78); Paris 1970 (ill. p. 48); Aragon 1971, II (color pl. XLV p. 315); Luzi 1971 (ill. p. 111); Jacobus 1972, p. 180 (color pl. 48); Flam 1973, p. 48; London 1977 (at press)

Collections: Private Collection; The Tate Gallery, London

This work was published by Verdet (1952), with Matisse's title given as *Panneau abstrait sur racine de réalité (Abstract Panel Rooted in Reality)*. Matisse himself is known to have called the work *La Composition chromatique (The Chromatic Composition)* as well as *L'Escargot*.

The snail image is based on the implied motion of the colored shapes, which spiral out like the shell of a snail (cf. also no. 182). For Matisse this volution was a metaphor which embodied universal movement. See remarks no. 199 and fig. 72.

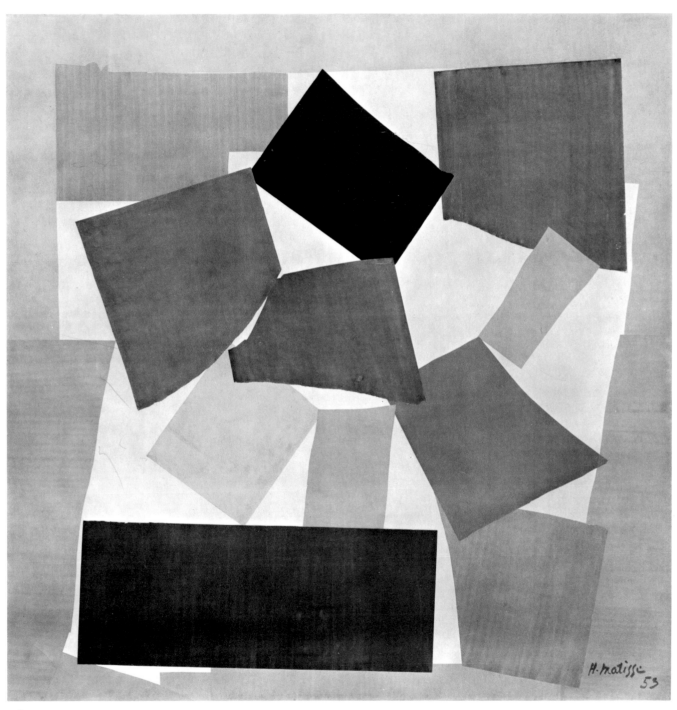

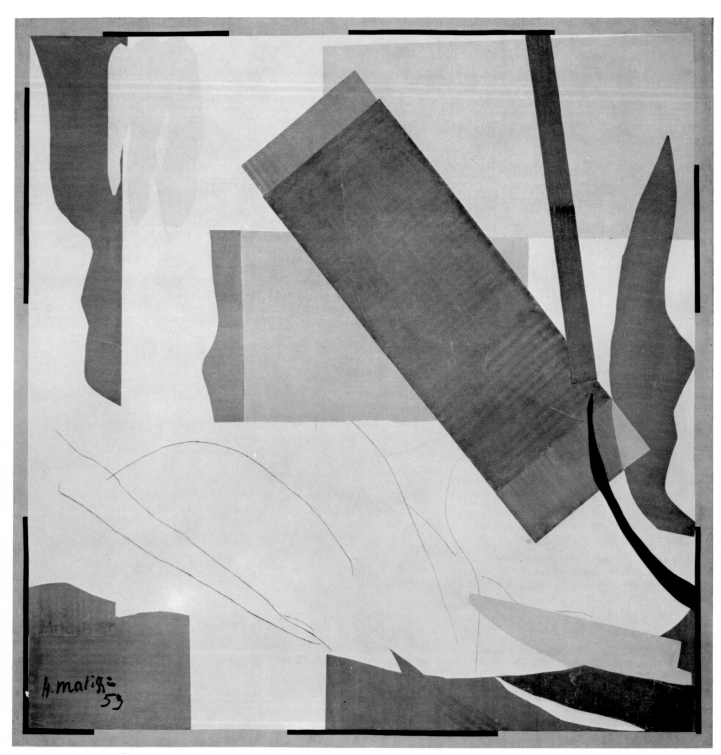

199

199 Souvenir d'Océanie

Memory of Oceania

1952-53

Painted cut and pasted paper, crayon

286.4 x 286.4 cm.

112 x 112 in.

Signed: *H. Matisse/53* (lower left)

Exhibitions: Paris 1956, no. 102; Bern 1959, no. 27 (ill.); Amsterdam 1960, no. 21; Paris 1961, no. 36 (ill. color p. 27); New York 1961, no. 30 (color pl. D); Venice 1962, no. 18 (ill. X); Kassel 1964, no. 6; New York 1966; London 1968, no. 137 (color cover); Paris 1970, no. 227 (ill. p. 273)

Bibliography: *Verve* 1958 (ill. color p. 155); Leymarie 1967 (ill. color p. 69); Moulin 1968, p. 37 (color pl. V); *L'Arte Moderna* (ill. color p. 69); Murphy 1970 (ill. color p. 37); Luzi 1971 (ill. p. 111); Radulescu 1974 (color pl. 64, inverted); Clay 1975 (ill. pp. 228-229); Cowart 1975 (ill. p. 55)

Collections: Private Collection; Galerie d'Art Moderne; Museum of Modern Art, New York

Matisse's 1930 trip to Tahiti had been the inspiration for a tapestry design in 1935, *Fenêtre à Tahiti* (Escholier 1937, p. 139), which was executed the next year as a Beauvais tapestry (Barr 1951, p. 475). This view through the trees to the harbor with the sailing ship *Papeete* moored to the dock below was Matisse's first large scale work on a Tahitian theme, although Aragon has noted (1971, I, p. 205) that the source of the balustrade in the composition was not Tahiti, but Nice. Matisse had made an etching of the same subject in 1932 (*ibid.*); both the etching and the tapestry are similar to Matisse's own snapshot of the scene (*ibid.*, p. 204).

Souvenir d'Océanie appears to have developed from these earlier works. The view is once again out over the beach; the yellow shape at upper left apparently refers to a banana tree and the yellow shape at lower right to the native pirogue Matisse had sketched over 20 years before (*Cahiers d'Art* 1936, ill. p. 15). The large green diagonal rectangle suggests the *Papeete,* and the thin, straight fuschia shape superimposed over the "ship" suggests a mast.

(Matisse had reduced the details of this ship to a similar geometric scheme as early as 1936 in his painting *La Chemise verte* (Copenhagen, Statens Museum for Kunst), in which *Fenêtre à Tahiti* is represented in the background. The direction of the "ship" in the cut-out—from lower right to upper left—corresponds to the placement of the ship in Matisse's original photograph, the etching, and the tapestry. The distant horizon is implied by the deep yellow and orange rectangles at the center and upper right, evoking the sky and sea, respectively. The orange border, like the roseate border in the tapestry cartoon, suggests a window.

The specifics of the identification are less important, however, than the overall quality of light implied by the relations established between the colored paper and the white background: the feeling of a clear, golden sky and an infinite expanse. "The light of the Pacific, of the Islands [is] a deep golden goblet into which you look" was one of Matisse's persistent *souvenirs* of Oceania (Verdet 1952, p. 60).

A color photograph by one of Matisse's assistants records that *Souvenir d'Océanie* was placed temporarily on the studio wall as the right wing of a triptych consisting of *L'Escargot,* no. 198, on the left, with the blue and white center panel for *Grande Décoration aux masques,* no. 203, between them.

****200 La Négresse**

The Negress

1952/53

453.9 x 623.6 cm.
178¾ x 245½ in.

Not signed or dated

Exhibitions: Paris 1956, no. 101; Bern 1959, no. 6 (ill.); Amsterdam 1960, no. 6; Zurich 1960, no. 133 (ill.); Paris 1961, no. 12 (ill. pp. 52-53); Basel 1964, no. 19; London 1968, no. 131 (ill. p. 150); Saint-Paul de Vence 1969, no. 31 (ill. color); Copenhagen 1970-1, no. 115 (ill.); Basel 1972-1 (ill. color)

Bibliography: Verdet 1952, pp. 31-32 (ill. color p. 33, state, entitled *La Danseuse nègre*); Mizue 1953 (ill. p. 46, state);

Escholier 1956, pp. 245-246; *Verve* 1958 (ill. color pp. 42-43); Leymarie 1959 (ill. p. 111); Lassaigne 1959-2, p. 122; Guichard-Meili 1967 (ill. p. 139 no. 125); Moulin 1968 (ill. p. 36); Aragon 1971, II (ill. color pl. XLII p. 285); Flam 1971; Luzi 1971 (ill. p. 111); Editions Nouvelles Images color poster

Collections: Private Collection; G. David Thompson; Galerie Beyeler; National Gallery of Art, Washington, D.C.

This work was inspired by the American entertainer Josephine Baker.

A documentary photograph (fig. 64) shows that *La Négresse* was underway at about the same time as the blue nudes, nos. 167-170. Some of the four-leafed patterns in *La Négresse* are similar to those

200

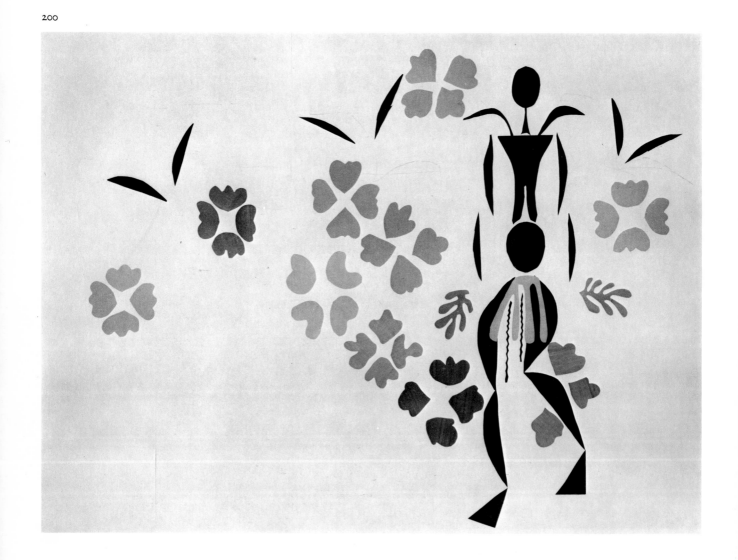

used in the *Grand Décoration aux masques* and *Décoration fruits* (nos. 203-204). It appears, however, that *La Négresse* was completed before these two works were finished.

As installed in Matisse's studio, the triangular feet of *La Négresse* actually rested upon the floor (figs. 64, 79). Matisse used similar shapes for the calves, thighs, and arms and was eager to note that, because of their relative placement, these shapes, along with the "birds" on the wall, assumed specific identities and object readings. This same play occurs in the circles which denote both the head and the stomach.

**National Gallery of Art, Washington, D.C. only

Fig. 64. Matisse studio, Hôtel Régina, Nice, 1952. On wall: *La Négresse,* no. 200, early state. In mirror: *Nu bleu IV,* no. 170. Lower right: Matisse, *Nu allongé bras levé,* 1907, plaster.

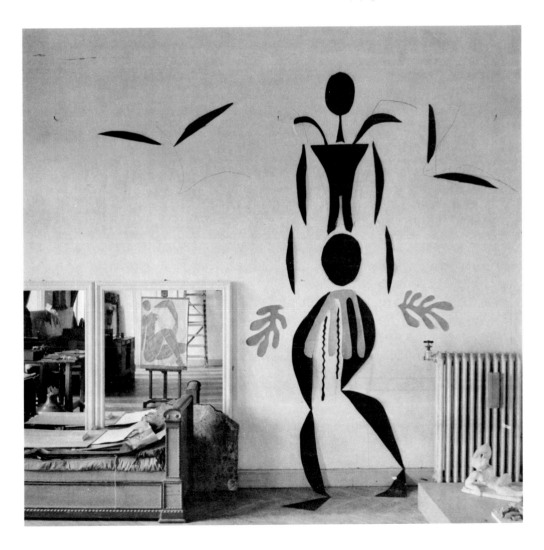

Fig. 65. Matisse studio, Hôtel Régina, Nice, c. 1952. On wall, left to right: *Grande Décoration aux masques*, no. 203, early state; *Femme à l'amphore et grenades*, no. 201, early state; *La Cloche*, no. 156; *Vénus*, no. 181; *Nymphe endormie et faune jouant de la flûte* (see caption fig. 66).

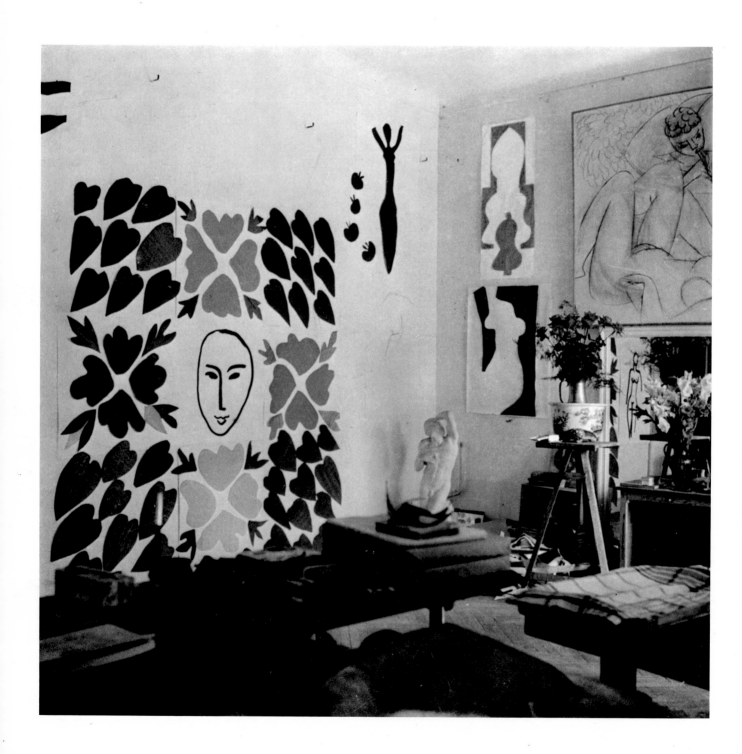

201 Femme à l'amphore et grenades

Woman with Amphora and Pomegranates

1953

243.8 x 96.2 cm.
96 x 37⅞ in.

Not signed or dated

Exhibitions: Bern 1959, no. 12; Amsterdam 1960, no. 12; Paris 1961, no. 28; New York 1961, no. 23 (color pl. P, p. 29); Paris 1970, no. 221 (ill. p. 266); Copenhagen 1970-1, no. 111 (ill.)

Bibliography: *Verve* 1958 (ill. color p. 74); Aragon 1971, II (ill. color p. 347); Luzi 1971 (ill. p. 111); Editions Nouvelles Images color postcard CP25; Washington 1975, no. 2652 (ill. p. 231); National Gallery of Art, Washington, D.C. color poster

Collections: Private Collection; National Gallery of Art, Washington, D.C.

Documentary photographs (fig. 65) show this work in progress, while Matisse was composing what would become *Grande Décoration aux masques,* no. 203. The latter work was begun in January 1953. See also no. 202.

**National Gallery of Art, Washington, D.C. only

202 Femme à l'amphore

Woman with Amphora

1953

164 x 48 cm.
64⁹⁄₁₆ x 18⅞ in.

Not signed or dated

Exhibitions: Paris 1961, no. 29 (ill. p. 70)

Bibliography: *Verve* 1958 (ill. color p. 79); Moulin 1968 (color pl. XI); Elsen 1972 (ill. p. 214)

Collections: Private Collection

Closely related to *Femme à l'amphore et grenades,* no. 201, this work should be dated to the same period.

201

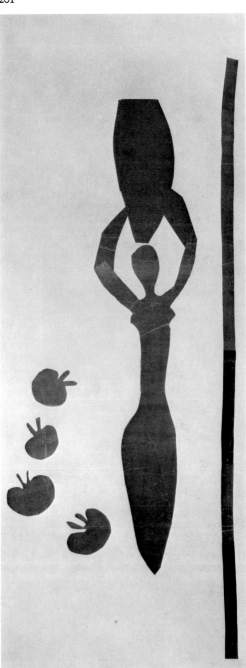

202

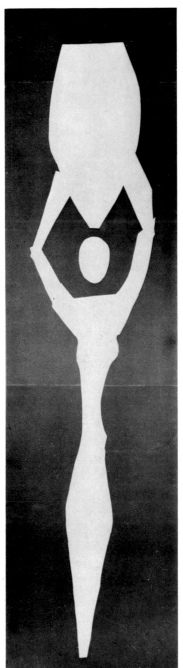

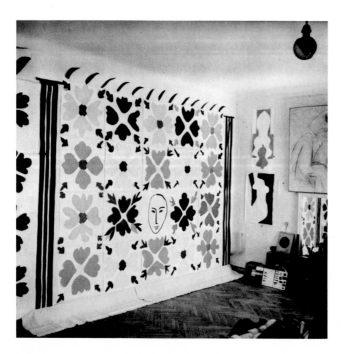

Fig. 66. Matisse studio, Hôtel Régina, Nice, c. 1952. On wall: left, *Grande Décoration aux masques,* no. 203, early state; right, *La Cloche,* no. 156, *Vénus,* no. 181; extreme right, *Nymphe endormie et faune jouant de la flûte,* late state, begun 1935, charcoal on canvas, 153 x 167 cm. (60¼ x 65¾ in.). Private Collection, Paris.

203

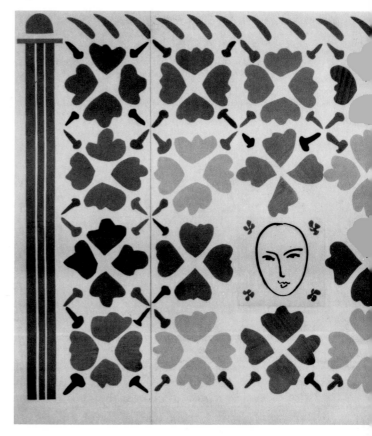

03 Grande Décoration aux masques

Large Decoration with Masks

1953

Painted cut and pasted paper, brush and ink

353.7 x 997 cm.
139¼ x 392½ in.

Signed: *HM 53/53* (lower right)

Exhibitions: Bern 1959, no. 25 (ill.); Amsterdam 1960, no. 28; Paris 1961, no. 33; Paris 1970, no. 228 (ill. p. 271)

Bibliography: Mizue 1953 (ill. p. 46, state); *Verve* 1958 (ill. color pp. 122-126 entitled *Décoration-Masques*); Lassaigne 1959-2, p. 124; Aragon 1971, II, p. 353 (ill. color pp. 348-350); Luzi 1971 (ill. p. 111); Carmean 1976, p. 126 (ill. p. 125)

Collections: Private Collection; National Gallery of Art, Washington, D.C.

This work and the following three cut-outs, nos. 204-206, are a result of the artist's activities relating to the Brody ceramic commission (see remarks no. 206).

Grande Décoration aux masques was Matisse's first speculative response to suggestions of a possible commission. At the end of January 1953 he began work enthusiastically, without benefit of specific measurements, formal contract, or consultation with either the Brodys or his liaison in America.

Available documentary photographs (figs. 66-67) show that this first project evolved from a densely packed, multi-colored work, whose elements were primarily heart-shaped, into a more orderly setting of quatrefoils, and finally into a further simplified grid. See also no. 195 and Neff, "Matisse, His Cut-Outs and the Ultimate Method," above.

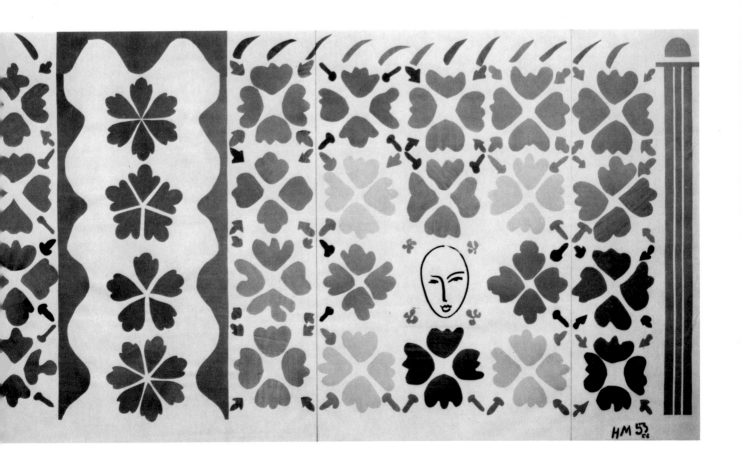

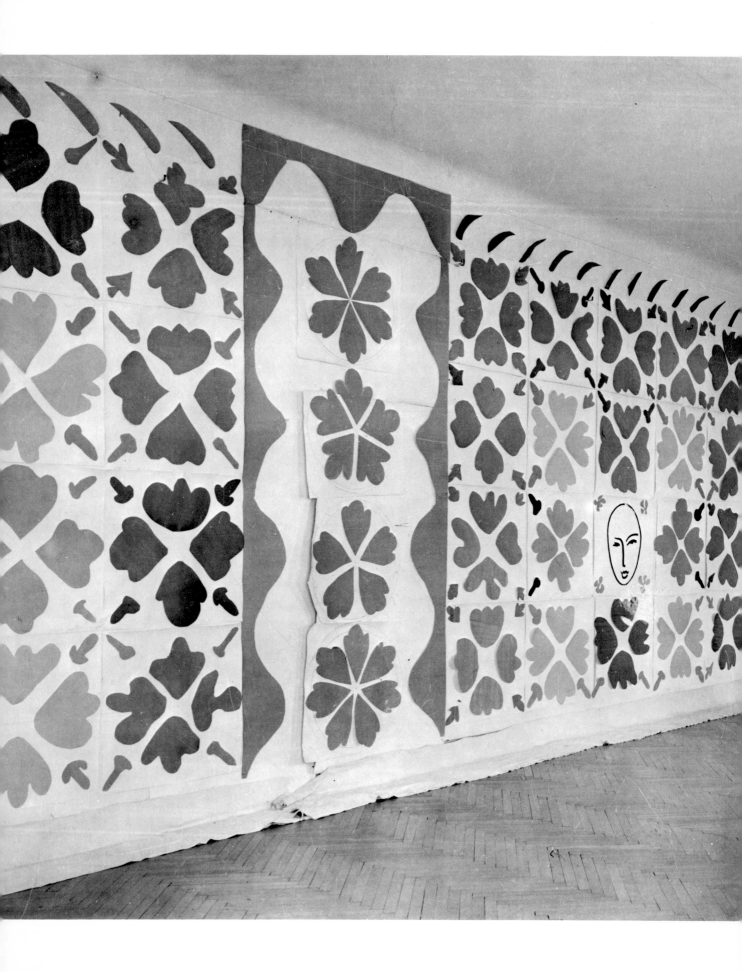

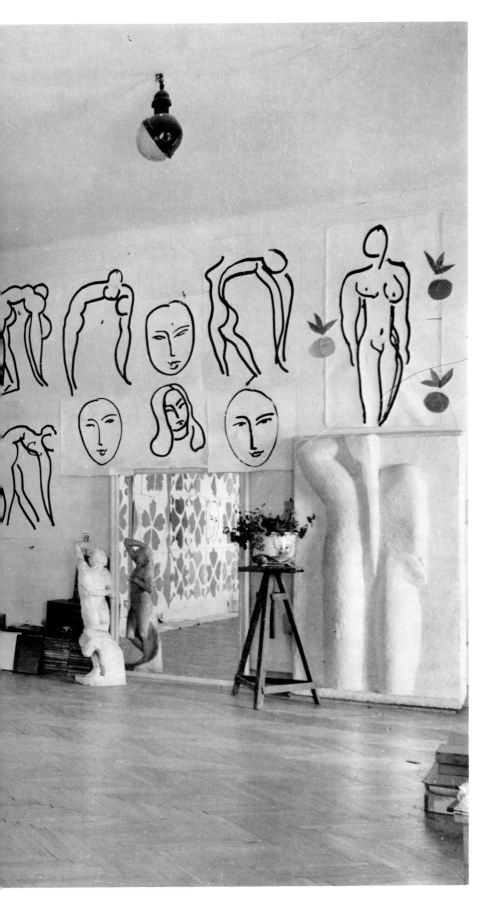

Fig. 67. Matisse studio, Hôtel Régina, Nice, c. 1953. On wall: left, *Grande Décoration aux masques,* no. 203; right, *Acrobate* and portrait head, brush and ink drawings, *Nu aux oranges,* no. 207. Sculptures on floor: left, plaster reproduction of Michelangelo's *Bound Slave;* right, Matisse, *Nu de dos IV,* 1930, plaster.

204 Décoration fruits

Decoration Fruits

1953

410 x 870 cm.
161 7/16 x 342 1/2 in.

Not signed or dated

Exhibitions: Paris 1961, no. 42 entitled
Décoration: Fleurs et fruits

Bibliography: *Life* 1954 (ill. color p. 42,
detail); *Verve* 1958 (ill. pp. 134-136);
Musée Matisse, Donation Matisse invita-
tion 5 Jan. 63 (ill., detail)

Collections: Musée Matisse, Nice

This was Matisse's second response to the
potential commission for the Brody cer-
amic mural (see remarks no. 206).

204

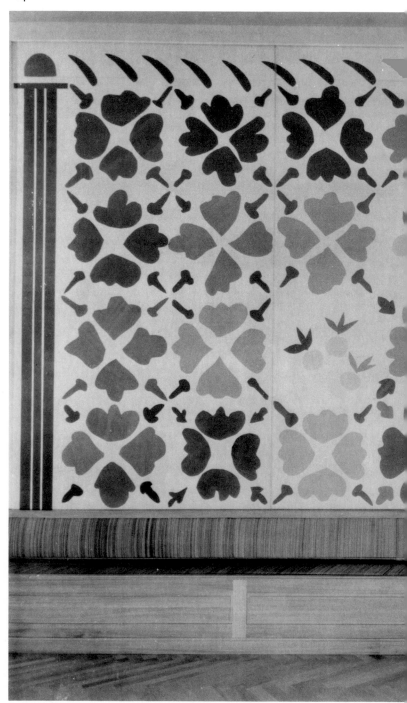

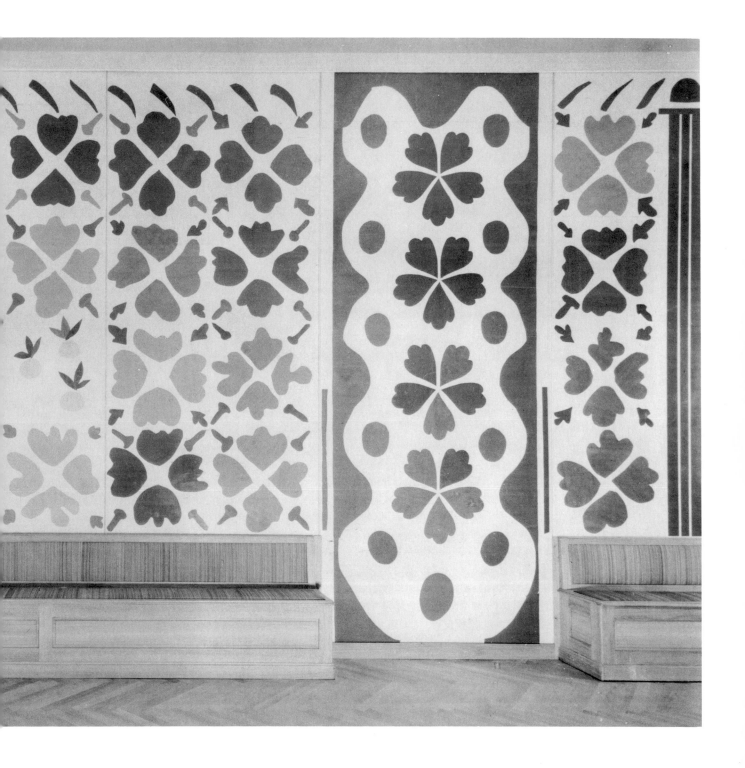

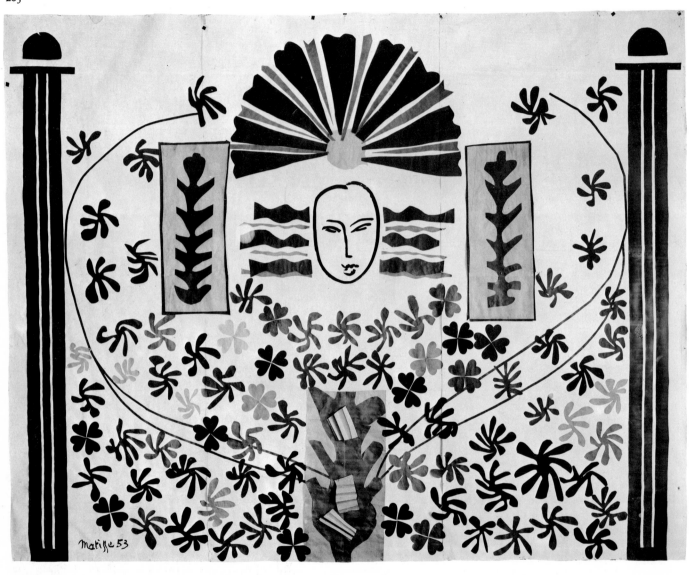

205 Apollon

Apollo

1953

Painted cut and pasted paper, brush
and ink

327 x 423 cm.
128¼ x 166½ in.

Signed: *Matisse 53* (lower left)

Exhibitions: Stockholm 1957, no. 45;
Helsinki 1957; Liège 1958; Zurich 1959,
no. 70; Göteborg 1960, no. 1; Copenhagen
1961?; Stockholm 1968 (ill.)

Bibliography: *Art News* 1956, p. 67; Linde
1957; Stockholm 1957; *Verve* 1958 (ill.
color pp. 142-143); Aragon 1971, II (color
pl. XL pp. 265-266)

Collections: Galerie Samlaren; Theodor
Ahrenberg; (Svensk-Franska Konst-
galleriet, Stockholm, January 31, 1968);
Moderna Museet, Stockholm

Apollon evolved from the same inspira-
tion that had already produced *Grande
Décoration aux masques* and *Décoration
fruits*, nos. 203-204: the Brody commission
(see remarks no. 206). When the Brodys
visited Matisse in May 1953, he let them
see the finished *Apollon.* The composition
did not meet their requirements. At this
point Matisse readily undertook a fourth
composition, responding to the specifics of
the commission.

The theme of this composition appears to
be the cultivation of wine, suggesting that
the ceramic work was intended to decorate
a wall in a winery. Apollo, God of Agri-
culture and of the Sun, oversees the ripen-
ing of the grapes. The vertical blue form,
lower center, suggests a pruned stalk *(cep
de vigne)* with spreading tendrils. This
stalk bears three bunches of grapes (the
folded pieces of yellow paper) and, under
the beneficent effects of the sun, it gener-
ates new shoots (the two vertical blue-on-
yellow shapes on either side of the drawn
face). The leaf forms suggest the expanse
of the vineyard; the undulant forms flank-
ing the face suggest the water so necessary
to grapes.

The work has been also interpreted in re-
lation to the myth of Apollo and Daphne
as found in Ovid's *Metamorphoses* (see
Linde 1957).

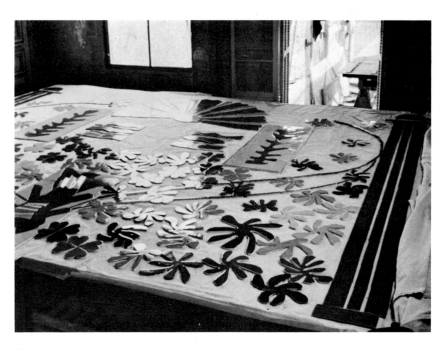

Fig. 68. Tiles for the ceramic project,
Apollon, before final mounting, at the
Charles Cox studio, Juan-les-Pins, c. 1953.
See no. 205.

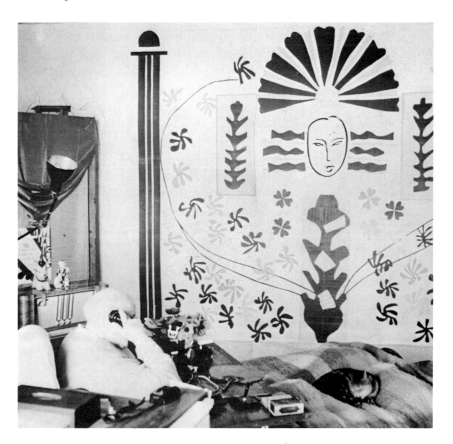

Fig. 69. Henri Matisse, Hôtel Régina,
Nice, c. 1953. On wall: *Apollon,* no. 205.

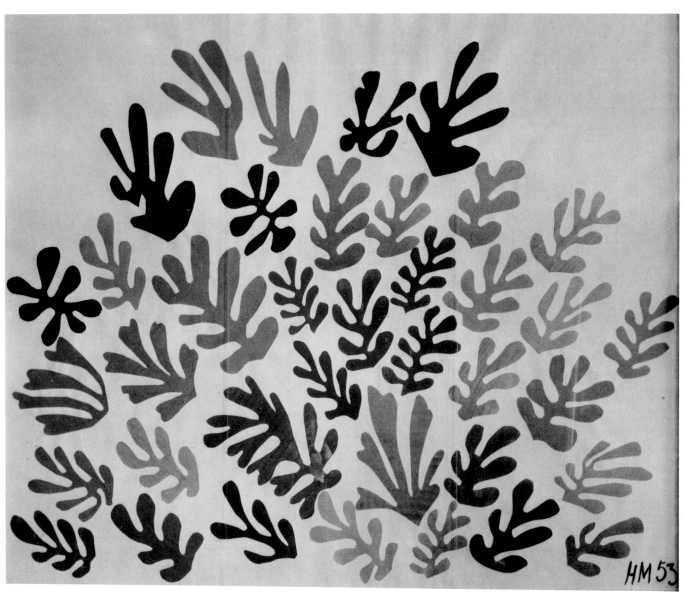

206

206 La Gerbe

The Sheaf

1953

294 x 350 cm.
115¾ x 137¾ in.

Signed: *HM 53* (lower right)

Exhibitions: Paris 1954-2, no. 137 (ill. cover); Paris 1961, no. 34; Los Angeles 1966, no. 345 (ill. color p. 172 and color poster)

Bibliography: *Art & Décoration* 1954 (ill. p. 40); Marchiori 1955 (ill. p. 30); Courthion 1956 (ill. p. 45); *Art News* 1956, pp. 30-31, 67 (ill. p. 31); *Verve* 1958 (ill. color pp. 148-149); Aragon 1971, II, p. 353 (ill. color pp. 351-352)

Collections: Mr. & Mrs. Sidney F. Brody; UCLA Art Galleries, Los Angeles

La Gerbe is the maquette for a ceramic mural installed in the central open patio of the home of Mr. and Mrs. Sidney F. Brody, West Los Angeles. Matisse had worked previously with ceramic: in small tiles on occasion from as early as c. 1907 (see Neff 1972-1, Neff 1974-2), and on a larger scale, notably in the Vence chapel, 1949-50. The Brody commission and its challenges provided a timely positive stimulus for the artist. For additional remarks on this commission, see remarks nos. 203-205. The ceramist Partigas produced the tiles from the cut-out maquette.

Much of the imagery of the cut-outs (no. 201 is another excellent example) seems to reflect Matisse's interest in Bergsonian ideas (see Flam 1976). The subject here appears to be clearly related to the second chapter of Bergson's *Evolution Créatrice*, 1907: "For life is tendency, and the essence of the tendency is to develop in the form of a sheaf, creating, by its very growth, divergent directions among which the impetus is divided."

207 Nu aux oranges

Nude with Oranges

1953

Painted cut and pasted paper, brush and ink

154.2 x 107.1 cm.
60¹¹⁄₁₆ x 42³⁄₁₆ in.

Signed: HM (lower right)

Exhibitions: Bern 1959, no. 24 (ill.); Amsterdam 1960, no. 1; Paris 1961, no. 32; New York 1961, no. 27 (ill. p. 34); Los Angeles 1966, no. 344; London 1968, no. 135 (ill. p. 169); Paris 1970, no. 226 (ill. p. 259); Copenhagen 1970-1, no. 116 (ill.)

Bibliography: *Verve* 1958 (ill. color p. 4); Moulin 1968 (color frontispiece); Alpatov 1969 (ill. color p. 88); Aragon 1971, II, p. 306 (ill. color p. 346); Luzi 1971 (ill. p. 111)

Collections: Private Collection

This work began as a brush and ink drawing to which were added the three fruit cut-outs, probably during the execution of *Décoration fruits*, no. 204 (see fig. 67).

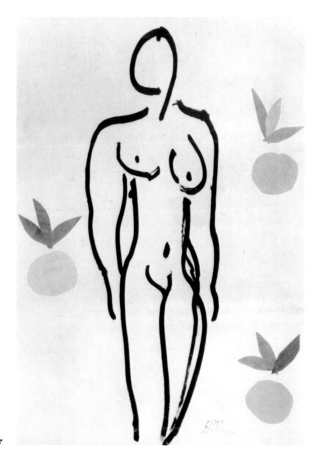

207

208 La Vigne

The Vine

1953

265 x 94 cm.
104⅝₁₆ x 37 in.

Signed: *HM 53* (lower right)

Exhibitions: Bern 1959, no. 28 (ill.);
Amsterdam 1960, no. 25; Paris 1961, no. 39

Bibliography: *Verve* 1958 (ill. color p.
173); Lassaigne 1959-2, p. 124; Paris 1961
(ill. p. 44); Duthuit 1962 (ill. p. 99); *XXᵉ
Siècle* 1970 (ill. p. 76); Jacobus 1972
(ill. p. 51)

Collections: Private Collection

Maquette for a stained-glass window for a
villa at Saint-Jean-Cap-Ferrat. Two pre-
liminary drawings for this design are
known to exist (figs. 70-71). The gen-
eral scroll-like volute forms for this win-
dow derive from the villa's interior
decorative iron work. Matisse worked
with similar forms in his 1946 preliminary
sketches for the title page of Baudelaire's
Les Fleurs du Mal.

208

Figs. 70-71. Preliminary drawings for *La
Vigne,* no. 208, c. 1953.

*209 Les Coquelicots

The Wild Poppies

1953

80 x 342 cm.

31½ x 134⅝ in.

Not signed or dated

Exhibitions: Bern 1959, no. 29 (ill.);
Amsterdam 1960, no. 26; Zurich 1960;
Paris 1961, no. 40 (ill. p. 44); Basel 1976,
no. 52 (ill. color)

Bibliography: *Verve* 1958 (ill. pp. 178-
179); Lassaigne 1959-1 (ill.); Lassaigne
1959-2, p. 124; Duthuit 1962 (ill. p. 99);
Jacobus 1972 (ill. p. 51); New York
Graphic Society color poster 9085

Collections: Private Collection; Pierre
Matisse Gallery Corp., New York

Maquette for a stained-glass window said
to be originally intended for a Dominican
convent in Lyons. The window glass was
eventually produced by Paul Bony in 1969.

An alternate title for this work is *Fleurs de
grenadier (Pomegranate Blossoms)*.

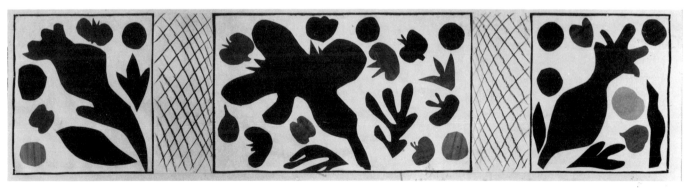

209

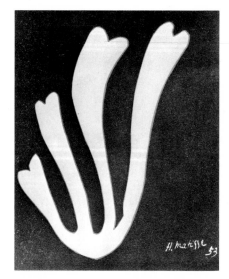

210 ☐ 211 ☐

210 Untitled

c. 1953

Signed: *HM.* (lower right)

Collections: present location unknown

Cut-out used as the cover of the catalogue for the exhibition "Rétrospective Henri Matisse," Paris, Musée National d'Art Moderne, July 28-November 18, 1956.

211 Algue verte sur fond noir

Green Alga on Black Background

1953

81 x 65 cm.
31 7/8 x 25 9/16 in.

Signed: *H. Matisse 53* (lower right)

Exhibitions: Saint-Etienne 1964, no. 1 (pl. 81 and color poster)

Bibliography: Paris 1961 (ill. p. 44); Duthuit 1962 (ill. p. 99); Jacobus 1972 (ill. p. 51); Editions Nouvelles Images color postcard CP49

Collections: Private Collection

This work has also been called *Le Cygne (The Swan).* For a related work, see no. 182.

*212 Lierre en fleur

Ivy in Flower

1953

284.2 x 286.1 cm.
111 7/8 x 112 5/8 in.

Signed: *Matisse/53* (lower right)

Exhibitions: Buffalo 1970, no. 35, p. 12 (ill. p. 42)

Bibliography: *Verve* 1958 (ill. color p. 157, earlier state ill. color p. 152, entitled *Lierre*; Lassaigne 1959-2, p. 124

Collections: Mr. and Mrs. Albert D. Lasker; Dallas Museum of Fine Arts

Maquette for a stained-glass window for the proposed mausoleum of Albert Lasker. The window was fabricated by Paul Bony. In addition, a brush and ink drawing by Matisse for an ironwork grill doorway to the mausoleum is known (fig. 72). The entire project, however, was not assembled.

Matisse's painting, *Lierre en fleur,* 1941, belonged to Lasker. Ivy is a traditional symbol of everlasting life.

Color plate XXIV

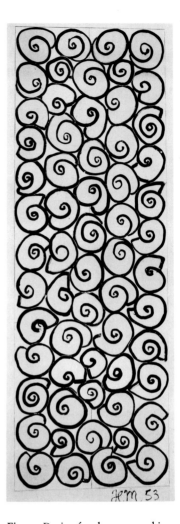

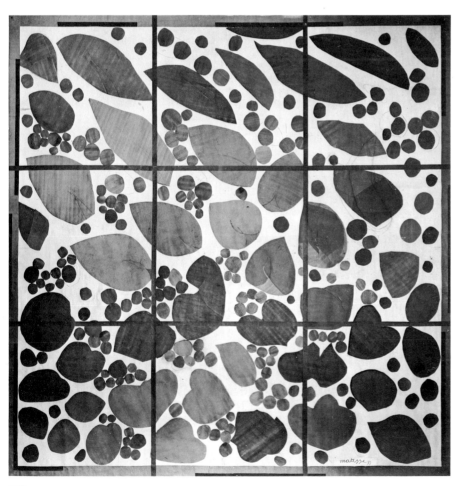

Fig. 72. Design for the proposed iron-work grille door (never executed) for the Albert D. Lasker mausoleum, 1953. Brush and ink, 273.1 x 109.2 cm. (107½ x 43 in.). Private Collection.

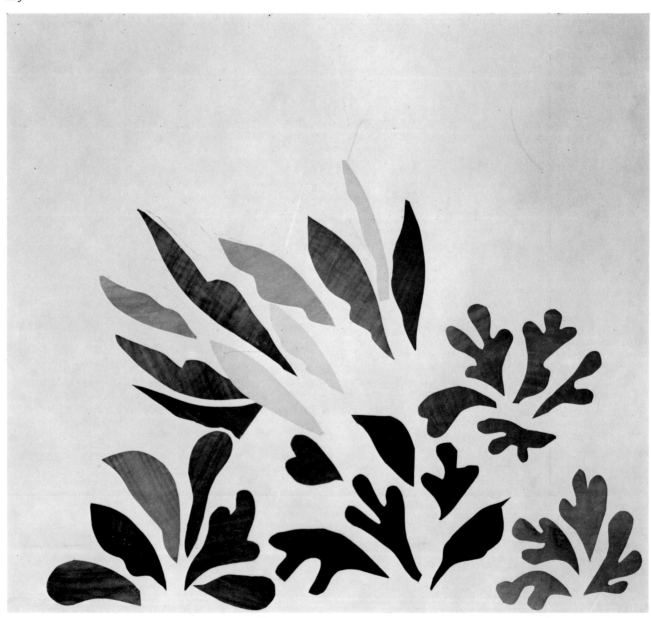

213 Les Acanthes

The Acanthuses

1953

Painted cut and pasted paper, charcoal

311 x 350.5 cm.
122 7/16 x 138 in.

Not signed or dated

Exhibitions: Bern 1959, no. 30 (ill.);
Amsterdam 1960, no. 22; Zurich 1960,
no. 137; Paris 1961, no. 38; New York
1961, no. 32 (ill. p. 39); Copenhagen
1970-1, no. 117 (ill. color); Basel 1976,
no. 51 (ill. color)

Bibliography: *Verve* 1958 (ill. color pp.
162-163); Lassaigne 1959-2, pp. 84, 123-
124 (ill. color p. 123); Paris 1970 (ill. p.
301, not in exh., tiles only); Clay 1975
(ill. color p. 228)

Collections: Private Collection; G. David
Thompson; Ernst Beyeler, Basel, on long
term loan to Basel Kunstmuseum

Maquette for a ceramic project executed
by Charles Cox, Juan-les-Pins. The tiles
are now in a Paris private collection.

214 Lithographies Rares (cover maquette)

c. 1954

22 x 24 cm. (approx.)
8 11/16 x 9 7/16 in. (approx.)

Signed: *Matisse* (lower left), *HM* (upper
right)

Collections: Heinz Berggruen; present
location unknown

Maquette for the cover of the catalogue
for the exhibition, "Henri Matisse Litho-
graphies Rares," Berggruen et Cie, Paris,
1954. Front cover, a large orange and a
small black leaf on white ground; back
cover, black leaf on white ground.

214 □

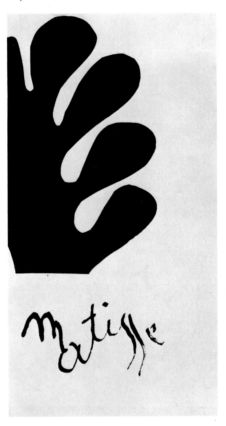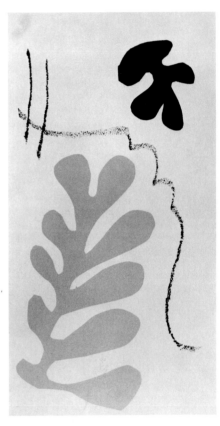

215 Verve, IX, 35-36, 1958 (cover maquette)

c. 1954

36.4 x 55.5 cm. (approx.)
14⅝₁₆ x 21⅞ in. (approx.)

Signed: *H Matisse* (lower left)

Collections: present location unknown

Maquette for the cover of the *Verve* special edition, published spring 1958, *Dernières Oeuvres de Matisse.* The issue had been planned during Matisse's lifetime, but the actual production was postponed by his death. Dark orange letters and pale orange forms on an orange ground.

216 The Torch of Hope

1954

Signed: *HM.* (lower right)

Bibliography: Rotzler 1954 (ill. p. 287)

Collections: present location unknown

Christmas card design for the United Nations International Children's Emergency Fund.

Not illustrated

215 □

17 Portraits (cover maquette)

c. 1954

31.5 x 52 cm. (approx.)
12⅜ x 20½ in. (approx.)

Cut and pasted paper, brush and ink

Not signed or dated

Collections: present location unknown

Maquette for the cover of Henri Matisse's
Portraits, Monte Carlo, published December 1954. Front cover, black ink brush
drawing on yellow ground, blue border;
back cover, blue leaf shape on white
ground.

217 □

Rose

1954

194 cm. diam.

76⅜ in. diam.

Not signed or dated

Exhibitions: Paris 1956, no. 104; Paris 1961, no. 41 (ill. p. 72); New York 1961, no. 35 (ill. p. 43); London 1964, no. 1 (ill.)

Bibliography: *The Yale Literary Magazine* 1955, p. 38; *Verve* 1958 (ill. color p. 183); Rockefeller 1956 (ill.); Rockefeller [1965] (ill.); New York 1969, p. 21; Jacobus 1972, p. 180

Collections: Mr. & Mrs. Nelson A. Rockefeller; Private Collection, New York

Maquette for the rose window commissioned by Nelson A. Rockefeller for the Union Church of Pocantico Hills, New York, in memory of Abby Aldrich Rockefeller. The window glass was executed by Paul Bony.

A rosette surrounded by a border containing eight green pomegranates. The pomegranate is a traditional symbol of everlasting life (see also nos. 209, 212).

Alfred Barr wrote to Matisse on March 31, 1954 to commission the window on behalf of Nelson Rockefeller. Matisse answered on May 3, saying that he was interested in the commission but could not yet give a definite answer. On May 11, Matisse regretfully declined the commission, pleading his inability to visit the site and his fragile health (see Documents Appendix, 15). Barr, undaunted, sent Matisse photographs of the site and a full-size drawing of the window space. On August 23, Matisse wrote Barr to acknowledge receipt of the photographs and drawing, and said that it might, after all, be possible for him to execute the work (see Documents Appendix, 16). The material conditions were set by Matisse in a letter of October 28, which Barr received on the day of Matisse's death (November 3). The day after Matisse's death, Barr received a final letter, dated November 1, saying that the window design had been completed (see Documents Appendix, 17).

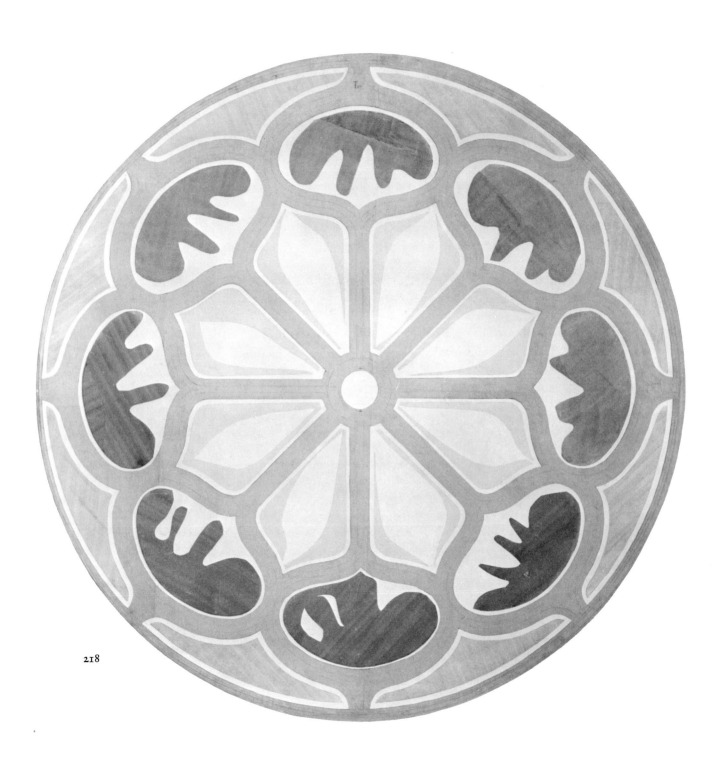

218

Technical Appendix

BY ANTOINETTE KING

A number of paper cut-outs made by Matisse between 1947 and 1953, including two which are now being conserved, have been examined to determine the types of paper used, the range of colors and their stability, and the methods of construction and mounting.

In order to do his paper cut-outs, Matisse had assistants paint sheets of paper with gouaches; then he had a piece of unpainted white paper pinned to the wall of his studio (in the case of some large cut-outs, just the wall was used); then he cut the painted papers into the shapes he wanted and pinned them, or, usually, directed an assistant to pin them, into the desired composition. The gouached, cut, pieces were unpinned and moved about until he was satisfied with the placement and expression.

Papers

The papers which Matisse used for these cut-outs fall into a few groups, distinguished by the watermarks found on many of them.

ARCHES

This particular Arches watermark distinguishes a rather delicate wove paper in a creamy color. The felt side of the paper is textured with a slight horizontal ribbed effect; the mould side has a distinct delicate, wove texture. Matisse often used this paper for his drawings. It also appears frequently in the smaller cut-outs of the late 1940s and, occasionally, in large cut-outs of the 1950s. Some examples include: all but one of the painted papers in *Composition (Les Velours),* 1947, no. 65; many of the papers of *Le Panneau au masque, L'Esquimau,* and *Composition, violet et bleu,* 1947, nos. 66-68; most of the brown, blue, and yellow painted papers on *Zulma,* 1950, no. 109, and the two yellow papers at the bottom of the maquette for *Nuit de Noël,* 1952, no. 162.

The Arches paper of the Copenhagen cut-outs, nos. 66-68, have somewhat denser, more opaque surfaces than those of *Zulma.* This may be due to differences in manufacture between 1947/48 and 1950, and to some changes in the paper's surface when it is pasted flat (as it is in *Zulma*).

CANSON & MONTGOLFIER·VIDALON-LES-ANNONAY·LAVIS.B·ANC^HES^ MANUF^RES^

This "pressmark" is found on a wove paper, somewhat smooth, ivory-white, with small horizontal surface indentations. Around 1950 Canson papers were lightly tinted ivory; from about 1950 to 1955, the papers began to contain traces of optical brighteners which made them almost luminous.[1] Different weights of these papers are sold in large rolls, as well as sheets, and they were often used as the background for the cut-outs, as well as for the painted pieces.

A sample of this paper, which was taken from *La Piscine*, 1952, no. 177, was analyzed by The Institute of Paper Chemistry, Appleton, Wisconsin. The fiber furnish (composition) is 57% bleached cotton, 22% softwood bleached Kraft, 21% bleached monocotyledon (principally cereal straw), and a possible trace of esparto. The fibers show much cutting and fibrillation. The paper also contains rosin, protein (animal glue), over 10% talc, and 5 to 10% chlorite. "These are typical of fillers found in French papers even today."[2]

Papeteries T. Barjon Moirans Isère

This wove, ivory-white paper is somewhat smooth; close up, the surface (felt side) is seen to have very small, horizontal indentations. The underside (wireside) is rougher, with a slightly "nubbly" surface effect. It was used for the central white background paper in *Femmes et singes*, 1952, no. 178; for many blue-painted papers in *La Piscine, Femmes et singes*, and for a number of painted papers in *Nuit de Noël*.

John Krill, formerly of the National Gallery of Art, Washington, D.C., took a sample of this paper from *Vénus*, 1952, no. 181, and had it analyzed by The Institute of Paper Chemistry. The fiber furnish is 44% softwood bleached sulfite, 42% softwood bleached Kraft, 7% bleached cotton, 5% monocotyledon bleached esparto, 2% hardwood bleached Kraft, 2% hardwood bleached sulfite. The fibers show moderate cutting and fibrillation. The paper contains rosin, protein (animal glue), and starch, approximately 4% talc and 4% chlorite. There is probably an optical brightener in the paper.

S.A.V·VELIN.

This mark was noted on *Femmes et singes* (it is the proper left background paper and, judging from its appearance, also the proper right), and *Grande Décoration aux masques*, 1953, no. 203. This is a wove paper, the texture of which is opaque and smoother than that of the Barjon paper. The *Femmes et singes* S.A.V. VELIN papers have a distinct yellowish tonality, which may be the reason for their somewhat infrequent use by Matisse.

Krill also took a sample of this paper from *Grande Décoration aux masques* and had it analyzed. The fiber furnish is 49% softwood bleached sulfite, 28% softwood bleached Kraft, 14% hardwood bleached Kraft, 6% cotton, 3% monocotyledon bleached esparto. The fibers show considerable cutting and fibrillation. The paper also contains rosin, protein (animal glue and casein-type surface adhesive), and starch, an optical brightener, over 10% talc, and 5-10% chlorite.

A few other papers were also used for the cut-outs; marks were not found on them. These have the somewhat bland surfaces of papers made partly of rag and partly of chemically purified wood pulp fibers. They appear to be different Canson papers, or variations in type of manufacture or weight of Canson Lavis B paper. "In Nice one couldn't buy things, and materials were bought through intermediaries so one bought what was common and easy to come by. Canson was a very common paper in France at that time. All the shops stocked it."[3]

In *Composition (Les Velours)* there is one laid paper, probably Ingres. This paper was sometimes used for his drawing and so probably came readily to hand. A ribbed Kraft paper forms the shape of a table leg in *Zulma*.

The components of these papers analyzed at The Institute of Paper Chemistry are not absolutely permanent. Glue, rosin (and alum used to set rosin size), chemical pulped fibers, and residual chemicals make papers which are undoubtedly already acid, sen-

sitive to future exposure to environmental acidity and to light.[4] Therefore, it is particularly important to filter the air in galleries and storerooms where Matisse's paper cut-outs are exhibited or stored to remove air pollutants, some of which can convert to strong acids. The works should be framed with ultraviolet filtering plexiglas; the frames, including backings of nonacidic materials, should be carefully sealed to prevent the passage of air as much as possible.

Various paper surfaces take gouache differently. Even if the same color and the same type of brushwork are used, a change in the surface of the paper will create different densities and tonal areas. A good example is *Zulma:* there are several pieces of Arches paper painted green on the lower left area, and the different sides are used randomly. The light is refracted differently from the two sides of the painted papers, creating a shifting surface movement across the picture.

Matisse did not deliberate over the choice of the painted papers for these minute textural effects. The color, the tone, the cutting, and the direction of the brushstrokes, were what was important.[5] But the surfaces are rich in varied textures and visual effects (see color plate XIII).

Gouaches

Many sheets of paper, gouached with the colors Matisse habitually used, were kept in reserve for his work. Each color was used pure, without mixing; differing tonalities were achieved by more or less diluting the gouache with water, and brushing heavily or lightly on the paper.

The direction of the brushstrokes or the washes often dictated the way a gouached piece was cut.[6] Beautiful examples of this are found in *Les Acanthes,* 1953, no. 213: on the light green and orange plant forms, the lateral or downward directions of the somewhat thinly-washed brushstrokes emphasizes their lateral or downward growth pattern in the composition.

A casual glance at the uneven way some of these cut pieces are painted may give the impression that thinner, paler, strokes have faded badly; but careful examination reveals that these variations follow brushstrokes exactly and are the natural result of unevenly loading brushes with paint, or using the same loaded brush several times.

Matisse used Linel gouaches exclusively. Tubes, manufactured today, of those colors Matisse liked to use were obtained from Maurice Lefebvre-Foinet, Paris, who originally supplied Matisse with his paints. They were analyzed under the direction of Dr. Robert L. Feller at the Carnegie-Mellon Institute of Research, Pittsburgh, by polarizing microscope, x-ray diffraction, and emission spectrography. The results of his analysis give the following compositions:

Deep and Light Japanese Green: phthalocyanine green, chalk, and perhaps blanc fixe.

Vert Emeraude (Imitation Viridian): phthalocyanine green, chalk, and ochre.

Deep Cadmium Yellow: yellow ochre, cadmium yellow, blanc fixe.

Deep Cadmium Red: cadmium red, yellow ochre, chalk, and blanc fixe.

Deep Persian Orange: mixture of a yellow and an organic orange.

Deep Persian Red: an organic-based colorant.

Persian Violet: an organic pigment with chalk.

Yellow Ochre: yellow ochre.

Samples of these gouaches were exposed under an RS-type sunlamp in a standard method for lightfastness. They all exhibit excellent lightfastness, with the possible exception of the Persian Violet which showed a slight tendency to fade after the equivalent of approximately 20 museum years of light exposure. Of course, this is not necessarily the same paint Matisse used. Matisse did use a "violet mineral" which faded during his lifetime; therefore he discontinued its use. He also used a pink ("rose à l'analine"), thinned with water, in certain precise circumstances (for example, a particular chasuble for the Vence chapel); this pink also faded.[7]

Pigment samples were taken from all the colors on *Nuit de Noël* and analyzed with a polarizing microsope and an electron microprobe by Walter McCrone, Walter C. McCrone Associates, Inc., Chicago. A sample of the white paint on the background papers of *La Piscine* was also analyzed.

The white paint on both pictures is zinc oxide. The black is carbon black. The light and medium greens, the light and medium yellows, and the magenta are all organic dyes co-precipitated on an inorganic matrix. The different shades of yellow and green are apparently different ratios of organic dye to inorganic matrix. According to Walter McCrone, this is a series of fine pigments, probably generally fast to light, "... because of the uniformity of composition of the inorganic matrix for the three colors ... a recognized commercial material produced under controlled conditions ... a well considered formula well produced."[8]

There would seem to be a fairly good correlation between the pigment samples taken from the actual pictures and the Linel gouaches manufactured today. They seem to be a continuously good, generally lightfast, line of gouaches.

The Paper Conservation Laboratory at The Museum of Modern Art took samples of paint from several blue areas with differing tonalities on *La Piscine, Femmes et singes,* and *Nuit de Noël.* These were analyzed microchemically, and all were found to be artificial ultramarine blue.

Ultramarine is permanent to light but is sensitive to acidity. "Artificial ultramarine is ... decomposed, even by dilute acetic acid, with decoloration of the pigments...."[9] This is a rate process: the stronger the acid, the faster the pigment decolorizes.[10] Some acid decolorization of ultramarine can be seen on the cut-out pieces of *La Piscine* which are glued directly to the very acid burlap background.

Zinc oxide, which would seem, from the above analyses, to be the white gouache Matisse generally used, makes the paper particularly sensitive to light. "... zinc oxide [is] capable of absorbing light in the near-ultraviolet or visible part of the spectrum and utilizing this energy to induce the degradation of cellulose."[11]

The gouache is quite thinly painted on many of Matisse's cut-out pieces, and the white paper shows through. Any discoloration of the paper, from exposure to light or the action of acids, will change the relative appearance of the colors. The appearance of fading can often be produced by a layer of dust which accumulates when the cut-outs are hung without protection from glass or plexiglas. The illusion of fading is especially pronounced when the

colors are thinly painted. Also the delicate pigment particles can easily be rubbed off.

It is recommended that the paper cut-outs be exhibited under modest levels of illumination, no more than 15 footcandles of intensity,[12] with filters to eliminate the ultraviolet component, if necessary. They should be framed with ultraviolet filtering plexiglas and sealed against the passage of air, as directed under "Papers" above.

Mounting

Some of the smaller cut-outs done in the late 1940s, and *Nuit de Noël,* are not solidly mounted. The gouached, cut pieces are adhered with dabs of glue to the white support papers. On the surfaces of the cut papers are slops and smears of adhesive, which generally appears to be an animal glue discolored to a clear, light brown. Sometimes a glue-paste mixture was used which has a mixed grey-brown appearance, particularly noticeable on the white paper pieces at the top of *Le Panneau au masque,* and on *Nuit de Noël.* In thick areas, these brittle adhesives are badly cracked.

The papers on these cut-outs are cockled from differing coefficients of expansion around and between the dabs of glue. Their edges are lifting and rippling, creating a complex, three-dimensional surface effect. There are a few graphite pencil marks on the papers, sometimes in the shape of a V or X, indicating desired placements of pieces, e.g. on *Le Panneau au masque.*

Matisse feared that the adhesion of these small spots of glue would give way and damage the works.[13] Therefore, about 1952, experiments were made under Matisse's supervision to determine the best way to adhere the works. Matisse was satisfied with the method worked out, and almost all the large gouaches were sent to Paris to be mounted, most of them after his death in 1954.

When a large cut-out, pinned to the wall of Matisse's studio, was finished to his satisfaction, careful tracings were made, the placement of the pieces was reinforced with spots of glue by an assistant, and the work was taken down. Subsequently, it was sent to the mounters.

In order to do the mounting, a pre-shrunk linen canvas was stretched on a wooden stretcher, then Kraft paper was glued to this surface to ensure adhesion of the picture, then the white support paper, usually Canson, was glued to the Kraft paper.[14] The cut-out pieces were placed on this background in the correct positions by means of the tracings. Graphite pencil lines were drawn by the person or persons doing the mounting, to aid in placing the pieces correctly.[15]

The adhesive generally used was a "relining" glue made of wheat flour, rye flour, boiled linseed oil, small amounts of animal glue, and Venice turpentine. This can be thinned out with water as needed.[16]

The base structure of stretched linen and Kraft paper can be clearly seen around the edges and through tears and holes in many of the examined cut-outs, e.g. *Femmes et singes; Les Acanthes; Souvenir d'Océanie,* 1953, no. 199; and *Les Coquelicots,* 1953, no. 209.

While Matisse was working out the composition of a paper cut-out, the white support papers were unpainted. Sometimes charcoal or graphite pencil marks or sketched lines, indicating placement or composition, remain visible on these support papers. There are a number of long, free, compositional charcoal lines on *Les Acanthes,* for example, and the central area of *Femmes et singes.* When the work was finished and unpinned from the wall, if the support paper was damaged in some way (discolored by light or stained, etc.), and a new paper could not be used because there were original drawing lines on the surface, the support paper would be painted white by an assistant. Although this was done to conserve the drawing, the brushstrokes often lightly cover the charcoal lines (cf. *Les Acanthes, Souvenir d'Océanie*). Sometimes this was done just to be sure the right white background tonality would remain, even if the paper discolored in the future.[17]

The character of these white strokes is usually sketchier than those on the colored gouache and cut papers. It is sometimes not particularly noticeable that a paper is painted white, but an ultraviolet photograph, taken of *La Piscine,* clearly shows the brushstrokes (fig. 73).

Conservation

Two very large paper cut-outs are undergoing conservation treatment at present, *La Piscine* (by The Museum of Modern Art, New York) and *La Perruche et la sirène* (by the Stedelijk Museum, Amsterdam). These treatments will be briefly outlined here.

La Piscine

The white paper support and blue cut-out pieces of *La Piscine* were originally pinned to the walls of one of the rooms in Matisse's apartment. After Matisse's death, the papers were removed from the apartment's jute-covered (burlap) walls and sent to the mounters. Because the original buff color of the jute was of particular importance in the tricolor scheme of the work, the decision was made to mount the papers directly to new jute supports with a good linen stretched against the back of the jute for reinforcement and protection. This jute is now orange-brown, discolored by light and acidity. Its original tonality was noted when one of the cut-out pieces was lifted (fig. 74).

The white support papers have also discolored from light and from the acidity of the burlap and adhesive. They are entirely painted white (see fig. 75) in large, irregular strokes. An attempt had also been made to conceal random local discolorations with heavier patches of white paint. The white papers were covered with irregular, roundish, dark brown stains with darker centers (fig. 75). These stains were seen only in a few places on the blue papers pasted to the Canson support, but there were many of them on the blue papers pasted to the burlap itself. However, no stains were seen on the reverse of the piece lifted from the burlap (fig. 74), though they were on the surface.

These stains seem to have occurred only on the surface, and their distribution remains a puzzle. Ultraviolet examination and solubility tests indicate a resinous material. To date it has not been possible to identify the material more specifically, because enough sample could not be obtained safely.

The long-range conservation treatment of *La Piscine* may be to lift the papers from the burlap, neutralize and buffer them against acidity, line them with a thin, strong paper to isolate them from the rough, injurious, burlap surface, and readhere them to the burlap. Such a treatment awaits further testing of chemical treatments, space, and time.

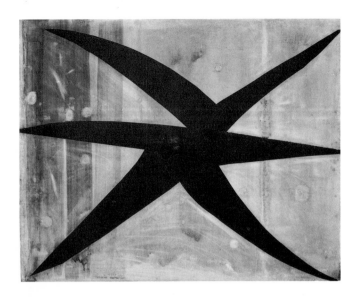

Fig. 73. *La Piscine*, no. 177, detail. Ultraviolet photograph.

Fig. 74. *La Piscine*, no. 177, detail. Discoloration of burlap background.

Fig. 75. *La Piscine*, no. 177, detail. Stains in white papers.

Fig. 76. *La Perruche et la sirène*, no. 183, detail. Discolored mounting glue.

Several textile conservators were consulted about possible treatment of the burlap; the unanimous opinion is that little can be done to arrest deterioration except to stabilize the environment.

For the present, the discolorations have been removed from the surface of the white paper, spot by spot, with an organic solvent and, for some stubborn remaining spots, with alkaline hydrogen peroxide; a residue of the discolorations remaining in the paper can be seen under ultraviolet light.

There are long scratch-like abrasions all over the surface of the blue-gouached papers which were lightly stippled with Linel ultramarine gouaches so that when viewed at a short distance they blend together in the viewer's eye. "Abrasions like this were made on the paper cut-outs when they were being moved around or shipped."[18]

La Perruche et la sirène

This large paper cut-out (340 x 775 cm.) on six panels is the subject of a complex research and conservation project under the direction of André Georges van Oort, chief paper restorer, Stedelijk Museum, in collaboration with the Central Research Laboratory for Objects of Art and Science, Amsterdam.

After the picture was purchased by the Stedelijk Museum in 1967, the background was damaged to an extent necessitating extensive restoration. In 1968, the gouached and cut pieces were remounted on a new white support paper manufactured that year especially for this work by Schut in Heelsum (l.t.c. quality, 100% cotton). This support paper has since become very discolored from the animal glue used for remounting (fig. 76). The discolorations darken year by year, and it is feared that the materials in the adhesive may ultimately harm the paint. Therefore, the picture again has to be completely remounted and conserved by Mr. van Oort, who will be working on it for the first time.

The present background on which the cut-outs are mounted consists of three layers glued together, the 1968 rag paper, white wrapping paper, and linen drawn tightly on stretchers.

The Central Research Laboratory has been testing various linen and cotton fabrics, adhesives, and sizes, in order to find those with the best properties for conserving and remounting the cut-outs.

The proposed conservation treatment is as follows: A cotton fabric will be stretched on wooden panels, over which two layers of remaining 1968 rag paper will be pasted with a starch adhesive. The top paper layer, to which the cut-out pieces will be adhered, will first be sized on the reverse with medium viscosity sodium carboxy-methyl cellulose, to prevent any adhesive penetrating to the surface.

A tracing of each original panel will be made on unsensitized mat transparent film, and transferred to the new backgrounds. The gouached pieces will then be cut off the old background, and the linen, the two layers of paper, and the animal glue will be removed from the reverse of these pieces with distilled water. Cut-out forms which are composed of several pieces glued together will be taken apart, the glue removed, and the pieces readhered. The painted pieces will then be remounted on the new background guided by the transferred tracings. A dextrin (Dextrine Gum 600 SBC) will be used to readhere the painted pieces, because it does not contain much moisture, thus preventing expansion and loss of alignment among the papers. The finished panels will be framed under plexiglas, and behind the entire work the air-conditioning system will be reinstalled.[19]

Notes

1. Letter from Canson et Montgolfier, April 27, 1967.

2. Private communication to author from William C. Krueger.

3. Private communication to author from Lydia Delectorskaya.

4. Letter from William C. Krueger, The Institute of Paper Chemistry, Appleton, Wisconsin, to John Krill, January 26, 1976.

5. Delectorskaya (see note 3 above).

6. *Ibid.*

7. *Ibid.*

8. Letter to author from Walter C. McCrone, February 1, 1977.

9. Gettens 1966, p. 164.

10. Private communication to author from Dr. Robert L. Feller.

11. Ott 1954-55, p. 1066.

12. Private communication to author from Dr. Robert L. Feller.

13. Delectorskaya (note 3).

14. Letter to author from Maurice Lefebvre-Foinet, May 18, 1976.

15. Delectorskaya (note 3).

16. Lefebvre-Foinet (see note 14 above).

17. Delectorskaya (note 3).

18. *Ibid.*

19. The author particularly wishes to express thanks to Trudy Schwartzman for her expert assistance in the conservation treatment of *La Piscine* and in many other technical aspects of this study, and to Juliet Wilson for her great help and encouragement.

Documents Appendix

The following documents are published here in the orig-
inal French and include the occasional inaccuracies of
syntax made by the writers.

1 **Matisse to Tériade,** March 7, 1944

Vence, 7 mars 1944.

Cher Monsieur
Tériade,

Je n'ai pas fait Nini Cassecou ni Joseph Cassetout—mais j'ai
fait Poses plastiques (2 beaux torses sur le verso: blanc gris
perlé presque blanc sur bleu céleste et sur le recto torse bleu
céleste sur fond blanc gris—perlé presque blanc—et: pose
plastique: la séduction sur le recto le destin cyclamen sur
fond bleu au recto groupe blanc appuyé sur fond bleu posé
sur jaune citron lui-même posé sur fond cyclamen. Encore:
C'est pour mieux te manger mon enfant—double page blanc
sur fond bleu bordé vert sur verso et sur le recto fond cy-
clamen bordé orangé. Je me suis tellement fatigué la main
et l'esprit que je n'ai pas écrit le texte sur la couleur. Au fait!
la couleur me dégoûte en ce moment et je n'ose l'écrire. Ce
joujou d'un sou me fatigue et tout mon être se révolte devant
son importance envahissante! Il me tarde de voir ce que votre
équipe parisienne en a fait. En tout cas j'en ai les yeux fatigués
je ne sors plus qu'avec des verres teintés 70%—et je compte
sur vous pour me rapporter de Paris une canne blanche—
les alcools violents sous toutes les formes me sont interdits
par la faculté"

2 **Matisse to Zika Ascher,** October 13, 1946

Paris, 13 octobre 1946.

Cher Monsieur,

J'ai reçu les photos des dessins et vous en remercie. Je suis
occuppé à faire rephotographier mes murs et à en assurer un
agrandissement précis. Ca me paraît assez difficile. Je ne
perds pas courage tant que j'aurai la preuve que cet agran-
dissement est impossible. Il serait peut-être utile que vous
veniez pour que nous causions une heure à ce sujet dans le
cas où l'agrandissement serait impossible dans la précision
nécessaire. J'ai fait une bordure complète autour du panneau
de la fée des eaux après l'avoir fait photographier sans bor-
dure en union avec la porte.

Si vos écharpes étaient imprimées vous pensez que j'aurai
plaisir à les voir. Je serai content que vous vouliez bien pré-
voir un voyage à Paris pour la fin de cette semaine commen-
çante. J'ai l'adresse d'un tisserand de Bretagne qui tisse le lin
spécialement je crois pour la décoration. Je vais essayer
d'avoir des échantillons mais le temps presse. Son adresse

est: Planeix à Uzel (C. du Nord). Je la tiens d'une fonctionnaire compétent spécial du tissage. J'apprends que ce Mr. Planeix doit venir à Paris ces jours-ci—le 17—Je demande des échantillons. Ne pourriez-vous pas venir une journée pour me voir et le voir? après que je vous aurai télégraphié son arrivée.

Ce Planeix est un tisserand à la main qui tisse en toiles de Bretagne à l'ancienne mode, en lin. Ecrivez-moi un mot à ce sujet je vous prie.

Cordialement

H. Matisse

3 Matisse to Zika Ascher, October 24, 1946

Paris, 24 octobre 1946.

Cher Monsieur Ascher,

Je m'occupe de vous procurer le meilleur cliché et un échantillon d'agrandissement aussi parfait que possible.

Le lin que vous m'envoyez n'est pas très beau—trouvez ci-inclus un échantillon de lin de Bretagne tissé à la main. J'attends le prix et la condition de livraison—je vous mettrai en rapport avec le tisserand. Il faut penser au temps; votre tissu fin conviendrait mais il est trop léger et ferait tout de suite chiffon. Vous devez considérer cette affaire comme une édition d'un livre avec souscriptions préalables. Ces souscriptions peuvent se faire par les galeries d'art. Nous pourrions nous entendre sur le caractère de la publicité.

Cette tenture que vous allez imprimer est appelée à *un certain retentissement si elle est bien exécutée*—car la galerie Thanhauser—Rosengart successeur de Lausanne la désire. Il doit souscrire chez vous. Il veut l'exposer à Lausanne entourée de mes dessins.

La *Galerie Maeght* la plus belle de Paris, galerie nouvelle, veut l'exposer en janvier. Mais il ne faut pas précipiter la fabrication pour cette date—quand l'oeuvre sera terminée, il sera très fier de l'exposer. En tout cas si en janvier vous avez une seule épreuve ça suffirait.

Art et Décoration revue d'art ancienne et une des premières de Paris va reproduire les photos des deux panneaux. C'est très important pour vous. Un panneau va paraître dans un journal d'art de Paris très répandu en Amérique dans quelques semaines. Je veux offrir une de mes épreuves au musée des tissus de Lyon. J'exposerai cette tenture au salon des décorateurs de Paris. *Mais il faut une bonne exécution sans laquelle je ne pourrai signer les épreuves.* Je désire les signer à la main avec une encre indélébile. Il serait bon de présenter cette oeuvre tirée à 30 exemplaires comme une gravure ou un livre d'art, en recevant des souscriptions. Si vous faites une bonne publicité de *caractère artistique*—vous pouvez faire une excellente affaire qui ajoutera au prestige de votre maison et au cas où l'exécution serait parfaite, je serai disposé à recommencer l'exécution avec vous.

J'ai montré vos échantillons de lin à des gens compétents qui m'ont dit qu'il fallait choisir un bon tissu—car ces ten-

tures ne peuvent être vendues qu'à un prix assez important dans lequel le prix de l'étoffe ne comptera pas beaucoup.

Aussi bien que serait la tenture si vous avez une étoffe sans tenue, molle, elle *supporterait une grande dépréciation. Pensez* que vous avez une oeuvre importante de moi, appelée à un grand retentissement. Considérez-la comme je vous dis *car j'ai raison.* C'est une chose importante pour moi mais beaucoup plus importante pour vous. Vous faites une chose qui doit être aussi respectée qu'une gravure d'art. Elle est appelée à devenir célèbre.

Je suis certain de ce que j'avance. Vous aurez le ton de fond ces jours-ci.

Je m'occupe activement à vous procurer les documents les meilleurs qui feront le mieux possible.

Sommes-nous d'accord

cordialement

H. Matisse

S'il n'est pas possible d'avoir cette toile de lin de Bretagne il faut choisir une étoffe qui ait le plus de tenue donc la plus forte de vos échantillons. Je souhaite que vous ne l'ayez pas achetée définitivement—fixez-moi à ce sujet je vous prie. Surtout ne compromettez-pas cette affaire par trop de précipitation. Si elle est bien exécutée vous êtes certain d'une bonne affaire.

J'ai retenu que vous m'avez offert une robe avec mes dessins. Vos crêpes de soie sont bien. Quelle couleur employez-vous sur le gris? et sur le blanc? Puisque vous avez emporté les couleurs décidées, bleu clair et bleu foncé, vos crêpes ne portent que sur la qualité.

4 Matisse to Zika Ascher, October 24, 1946

24 octobre 46.

Cher Monsieur,

Je reçois votre lettre du 21 octobre. Veuillez me dire à quoi vous sert l'agrandissement photographique. Vous m'écrivez "Nous pourrions les faire tracer." Quel traces? Ne m'aviez-vous pas dit que tout était fait photographiquement, donc sans interprétation—s'il y a tracé il y a interprétation de la part du traceur. Répondez-moi vite quel est le procédé avec les détails.

Cordialement

HM

Je dois recomposer *moi-même* votre *étoffe des jacinthes.* Est-ce qu'avec le cliché qui est très précis on ne fait pas la projection directement sur la matière sensibilisée devant servir de pochoir? J'ai besoin de cette précision—car notre affaire ne peut être **ratée.** Je vous envoie la lettre du tisserand et l'échantillon qu'il m'a envoyé de nouveau—il est extraordinaire et il ne faut pas manquer d'accepter—si la tenture n'arrive pas pour l'exposition de Paris en janvier c'est une minime importance.

5 **Matisse to Mrs. Ascher,** October 24, 1946

24 octobre 46

Chère Madame,

Me souvenant de votre enthousiasme devant mes murs, je suppose que vous devez être satisfaite de ce qui a été déjà fait à leur sujet—j'ai plaisir à vous écrire—ne croyez-vous pas que c'est une chose exceptionnellement artistique et qu'il ne faut pas en précipiter l'exécution—que pour qu'elle porte tout son fruit, elle doit être exécutée fidèlement et sur une toile à la hauteur des qualités de la chose qui est très importante à plusieurs points de vue. Je pense que votre mari le comprend, mais comme il a des associés il ne me paraît pas mauvais que vous fassiez contrepoids s'ils n'étaient pas tous d'accord. Je crois qu'il ne pourra pas s'offenser de cette présente lettre—qu'il n'y verra de ma part que le souci de la complète réussite de ce qu'il entreprend et qui peut-être suivi d'autres travaux. Agréez, chère Madame, mes respectueux hommages.

H. Matisse

6 **Matisse to Erik Zahle,** February 15, 1950

Je suis très heureux d'apprendre par votre lettre que le Musée des Arts Décoratifs de Copenhague a obtenu la possibilité de faire entrer dans sa collection mes trois "papiers découpés." Je vous remercie pour cette bonne nouvelle.

Je réponds avant tout à votre question concernant mes "papiers découpés" au point de vue de leur place dans mon oeuvre. Comme vous l'avez pensé ce sont des exemplaires uniques. Chaque "papier découpé" est une oeuvre complète en elle-même. Avec des ciseaux j'ai dessiné directement dans la couleur, comme la chose a été précisée dans un des texte du catalogue de mon exposition de l'été dernier au Musée à Paris. Ces oeuvres ne peuvent pas être reproduites en plusieurs exemplaires car comme un calque elles perdraient la sensibilité que ma main y a apportée . . .

7 **Matisse to Monroe Wheeler,** September 18, 1951

Je dois avant tout vous prier de m'excuser de ne pas avoir composé la couverture du catalogue en trois couleurs seulement. La chose ne m'a pas été possible et j'espère que son attrait pour le public ainsi vous permettra d'en vendre suffisament pour couvrir les frais de l'impression des six couleurs.

Voici quelques observations au sujet de son impression.

1. Pour aider l'imprimeur à trouver pour l'impression des couleurs absolument fidèles, je joins à la composition des échantillons de ces couleurs de surfaces plus grandes.

2. Le noir des yeux doit être le même que celui de la bande noire.

3. Les noms des Musées qui font l'exposition doivent être imprimés en caractères petits mais *très noirs* sur la bande blanche inférieure.

4. Les petits filets blancs entre les bandes de couleurs ne doivent pas exister: la jonction des deux couleurs est une ligne droite.

5. Pour l'épaisseur du dos du catalogue veuillez ajouter la quantité nécéssaire de jaune et de rose à la ligne indiquant la pliure de la couverture.

8. **Matisse, as quoted in Cassonari** 1950, p. 56

A l'origine le vitrail était uniquement de la lumière colorée comme le témoignent de très beaux vitraux anciens à Chartres et en Orient. Puis on a voulu raconter des histoires en vitrail, l'histoire de l'Eglise, la vie des saints. C'était par manque d'inspiration. Le vitrail montra plus d'enrichissement, mais il avait perdu la lumière. On ne peut pas revenir à la place où était son père, mais il faut remonter aux principes. Le vitrail, c'est un orchestre lumineux.

9 **Matisse to Jean Cassou,** April 9, 1952

Votre lettre touchant la *Tristesse du roi* me touche beaucoup car elle me confirme dans mon opinion sur ce panneau que je considère comme égal à tous mes meilleurs tableaux [*Zulma*] quoique de très bonne qualité, n'a ni la qualité, ni l'ampleur, ni l'expression profondément pathétique de la *Tristesse du roi.*

10 **Matisse to Alfred H. Barr, Jr.,** December 4, 1952

. . . Le vitrail de Life dont je vous ai montré la maquette est enfin parti à New York. Je l'ai eu chez moi pendant quarante huit heures ce qui m'a permis de constater que c'est une réussite. Il sera exposé pendant les fêtes de Noël au Rockefeller Centre. Si vous avez l'occasion de le voir, vous serez d'accord avec moi, qu'une maquette de Vitrail et le Vitrail exécuté, sont comme une partition de Musique et son exécution par un Orchestre.

11 **Matisse to Alfred H. Barr, Jr.,** March 12, 1954

Le 12 mars 1954

Cher Monsieur,

Je vous remercie pour les photographies qui m'ont évidemment beaucoup intéressées. Je me demande à propos de l'emplacement du vitrail "Nuit de Noël" et de sa maquette si leur voisinage ne leur est pas nuisible réciproquement car les visiteurs du Musée ne pourront peut-être pas s'expliquer la raison de la différence qui existe entre la maquette et le vitrail. Ils ne se rendent probablement pas compte que la maquette d'un vitrail est comme la partition d'une symphonie et le vitrail est la même symphonie exécutée par l'orchestre. Mais évidemment d'après la photographie je ne puis en juger.

Dès aujourd'hui j'ai fait écrire aux Ateliers des Arts Appliqués pour demander quelles conditions peuvent vous être

faites pour des chasubles sans accessoires. Dès que j'en aurai la réponse je vous la communiquerai.

Cher Monsieur, je vous prie de croire à l'expression de mes sentiments les meilleurs.

HM

12 Matisse to Alfred H. Barr, Jr., August 24, 1954

Le 24 août 1954

Cher Monsieur Barr,

J'ai vu avec grand plaisir la photographie de la salle de votre musée où se trouvent exposés chasuble et vitrail "Nuit de Noël." Permettez-moi de vous faire part d'une de mes observations concernant la présentation des maquettes et de leur executions en vitraux ou céramiques.

Il y a intérêt pour les deux oeuvres à ne pas se trouver placées de manière à pouvoir être comparées car la maquette n'est qu'une indication et il est bien évident que l'idée de la matière à employer ne quitte pas l'esprit de l'artiste lorsqu'il compose sa maquette comme le musicien entend ses instruments lorsqu'il écrit sa partition sur le papier, et pour garder mon exemple avec la musique, je dirai que la maquette reste la partition inscrite sur le papier tandis que l'oeuvre réalisée devient cette même partition exécutée par l'orchestre.

Si certains visiteurs avertis font le rétablissement, d'autres peuvent être égarés et regarder la différence entre les deux panneaux comme une faute d'exécution. Je pense souhaitable d'éviter ce malentendu et ne doute pas que vous partagiez ma réserve.

Cher Monsieur Barr, je vous prie d'agréer l'expression de mes sentiments les meilleurs.

H. Matisse

13 Matisse to Pierre Berès, January 20, 1953

Le 20 janvier 1953

Cher Monsieur,

Ma Secrétaire m'a fait part de sa visite chez vous et je vous remercie pour l'aimable accueil que vous lui avez réservé.

Dans quelques jours ma fille Madame Duthuit, qui est actuellement à Nice, retournera à Paris et se chargera de vous remettre le cahier que vous attendez.

D'autre part je tiens à vous signaler que j'ai décidé la division de la grande composition par panneaux.

En cas de besoin vous pourrez la placer sur deux murs formant un angle de deux façons suivantes:

| 3.00 | 4.72 | | 4.38 | 3.34 |

3.37

14 Matisse to J. Rubow, June 6, 1954

Je profite de cette lettre pour vous entretenir d'un sujet qui me préoccupe beaucoup. Il s'agit de la gouache "Zulma".

Si vous avez eu l'occasion de passer dernièrement au Musée d'art Moderne de Paris vous avez dû y voir ma grande gouache "La Tristesse du Roi". Comme vous avez pu le constater sa présentation est parfaite car après des années de recherches des spécialistes ont finalement trouvé le moyen de coller mes gouaches en plein d'une façon impeccable ce qui est important pour leur présentation ainsi que, et surtout, pour leur conservation.

Je souhaite donc vivement que "Zulma" revienne pour quelques semaines à Paris chez Monsieur Lefebvre-Foinet qui s'occupe pour moi de ces travaux.

15 Matisse to Alfred H. Barr, Jr., May 11, 1954

Le 11 mai 1954

Cher Monsieur Barr,

J'ai mûrement réfléchi à votre proposition d'exécuter le vitrail d'une "memorial" pour Madame John D. Rockefeller Jr. et j'ai réalisé à quel point j'étais loin du lieu de sa destination et ne pouvais par cela-même sentir l'ambiance générale dans laquelle cette rosace devait jouer. Malheureusement ma santé ne me permet plus de me déplacer comme au moment où j'ai composé la décoration pour Merion.

Il me faut done renoncer à exécuter ce projet malgré tout l'intérêt que j'y trouvais.

Mes regrets sont d'autant plus vifs que se refus s'oppose aux désirs de la famille de Madame John D. Rockefeller Jr., à vos propres souhaits, et surtout il m'interdit un geste ému à la mémoire de Madame John D. Rockefeller Jr. dont j'ai gardé un souvenir très vif.

Veuillez, cher Monsieur Barr, être mon interprète auprès de Monsieur Nelson Rockefeller pour le remercier et lui dire combien j'ai été sensible au fait qu'il m'ait choisi pour l'aider à perpétuer la memoire de Madame John D. Rockefeller, Jr., sa mère, et lui donner l'assurance que ma santé est le seul obstacle aux voeux de tous.

Cher Monsieur Barr, veuillez je vous prie agréer l'expression de mes sentiments très distingués.

Henri Matisse

16 Matisse to Alfred H. Barr, Jr., August 23, 1954

Comme vous avez pu le voir d'après mes précédentes lettres et les raisons que j'y exposais, mon refus d'exécuter la rosace dédiée à la mémoire de Mrs John D. Rockefeller Jr. n'était déterminé que par des scrupules et des difficultés d'ordre matériel. C'est donc avec intérêt que j'ai recu les photographies que Monsieur d'Harnoncourt m'a remises ainsi que le gabarit de l'architecture que vous m'avez adressé.

J'ai fait installer ce dernier sur le mur de mon atelier et j'ai ainsi vecu quotidiennement avec eux en sympathie. Grâce peut-être à ce sentiment la composition m'apparait aujour-

d'hui comme possible et j'ai du reste commencé des recherches d'harmonie à ce sujet. Assez fatigué au début de l'été j'ai voulu prendre quelques semaines de repos avant de vous donner cette nouvelle bien que je sente mon esprit accroché à ce projet.

17 Matisse to Alfred H. Barr, Jr., November 1, 1954

Le 1er novembre 1954.

Cher Monsieur Barr,

Grâce au dessin du dernier gabarit j'ai pu sur ses volumes conclure de façon heureuse le travail que je poursuivais, comme vous le verrez sur la maquette que je vais vous envoyer.

La nouveauté et le côté attachant de ce travail était pour moi de m'exprimer dans l'espace très défini, fragmenté et aussi exigu que celui compris dans les boiseries de cette rosace, tout en harmonisant ma composition avec l'architecture de la charpente apparente et l'ambiance qui doit se créer dans cette chapelle.

Veuillez encore une fois être mon interprète auprès de Mr Nelson Rockefeller pour lui présenter la maquette de ma composition et être assez aimable aussi pour me transmettre son avis à son sujet, qui me permettra, si comme je l'espère son impression est favorable, de faire parvenir immédiatement les éléments de travail au maître-verrier.

Pourrez-vous également faire ré-expédier la maquette assez rapidement afin qu'elle soit mise sur toile de façon définitive.

Avec tous mes remerciements encore et dans l'attente de vous lire, je vous prie d'agréer, cher Monsieur Barr, l'expression mes sentiments les meilleurs.

H. Matisse

18 Léonide Massine to Jack Cowart, October 16, 1976

La Danse was not only important in itself but it also had dual pictorial and choreographic values whose interrelationships Matisse strongly emphasized by using very expressive movements. This approached the craft of choreography and the technique was not an incidental process. Rather it was a profound thought resulting from a fusion of painting and choreography.

La Danse gave me the impetus to create, on the same principle, the choreography for the *Rouge et Noir*. Shostakovich's *First Symphony,* by its rhythm, variety, and abondance of thematic material admirably corresponded to the exigencies of the eternal characteristics of the city and country mentalities and life.

19 Matisse, as quoted in Brassaï 1964, pp. 305-306

[HM:] Les souvenirs de mon voyage à Tahiti ne me sont revenus que maintenant, quinze ans après, sous forme d'images obsédantes: madrépores, coraux, poissons, oiseaux, méduses, éponges.... Il est curieux, n'est-ce pas, que tous ces enchantements du ciel et de la mer ne m'aient guère incité tout de suite... Je suis revenu des îles les mains absolument vides... Je n'ai même pas rapporté de photos... J'ai acheté pourtant un appareil très coûteux. Mais, là-bas, j'ai hésité: "Si je prends des photos, me suis-je dit, de tout ce que je vois en Océanie, je ne verrai désormais que ces pauvres images. Et les photos empêcheront peut-être mes impressions d'agir en profondeur..." J'avais raison, il me semble. Il importe plus de s'imbiber des choses que de vouloir les saisir sur le vif. Tous ces éléments, je les découpe et les fixe aux murs, provisoirement. Les petits traits représentent la ligne d'horizon.... Je ne sais pas encore ce que ça donnera ...Ca fera peut-être des panneaux, des tentures murales... [B:] Toutes ces images ont disparu du mur...Et je lui demande ce qu'elles sont devenues...

[HM:] J'en ai fait de grands panneaux. Partis en Angleterre, ils seront édités là-bas: imprimés sur du lin, les motifs en blanc sur fond beige. Tirage limité à trente exemplaires...."

20 Matisse, as quoted in Verdet 1952, pp. 64-65

...la décision du trait vient de la conviction profonde de l'artiste. Ce papier découpé, cette sorte d'acanthe en volute que vous voyez au mur, là-haut, est la stylisation de l'escargot. J'ai tout d'abord dessiné l'escargot d'après nature, le tenant entre deux doigts; dessiné et redessiné. J'ai pris conscience d'un déroulement, j'ai formé dans mon esprit un signe épure du coquillage. Puis j'ai pris les ciseaux. Il fallait que la fin soit toujours vivante avec le commencement. Il fallait encore établir le rapport entre l'objet observé et son observateur. J'avais placé cet escargot dans la grande composition du *Jardin* [*La Perruche et la sirène*]. Mais le mouvement musical de l'ensemble était cassé. J'ai donc sorti l'escargot; je l'ai isolé en attendant une autre destination.

21 Matisse, as quoted in Verdet 1952, p. 24

Pour arriver à la simplicité de ces *Baigneuses* que vous voyez à la limite du *Jardin* [*La Perruche et la sirène*] il faut beaucoup d'analyse, d'invention et d'amour. Il faut être digne d'elles, les mériter. J'ai déjà dit une fois: "Quand la synthèse est immédiate, elle est schématique, sans densité, et l'expression s'appauvrit".

22 Matisse, as quoted in Verdet 1952, pp. 20-21, 28-29

Vous voyez, comme je suis obligé de rester très souvent au lit à cause de mon état de santé, je me suit fait un petit jardin, tout autour, où je peux me promener....Il y a des feuillages, des fruits, un oiseau. Mouvement modéré, apaisant. J'ai retiré ce motif que voyez là-bas, isolé, à droite; je l'ai retiré parce qu'il avait un mouvement violent. Ce mouvement faussait la partition générale. Un andante et un scherzo qui se heurtaient....C'est en rentrant dans l'objet qu'on rentre dans sa propre peau. J'avais à faire cette perruche avec du papier de couleur. Eh bien! je suis devenu perruche. Et je me suis retrouvé dans l'oeuvre. Le Chinois a dit qu'il fallait s'élever avec l'arbre. Je ne connais rien de plus vrai.

23 Matisse, inscription 1951/52? for illustration of *Chasuble noire "Esperlucat"* in Vence-Ronchamp 1955

Composition née du désir de faire du blé et de la rencontre d'un mot provençal qui veut dire dessiller—voir ou apercevoir—en réfléchissant devant une chasuble mortuaire on peut comprendre que la façon la plus rassurante de se présenter devant la mort est d'être accompagné par de bonnes actions (blé). esperlucat—(du dict[ionnaire] des synonimes Larousse)

24 René de Solier, "Matisse à Vence," *Cahiers du Sud* 289 (1948)

... Tout un mur, dans la pièce où il nous reçut, est tapissé de choses vives, qui grouillent, étincellent parmi les formes, nettes et obtenues "avec" d'immenses ciseaux, l'élément réaliste semble l'emporter. On croit reconnaître ... des dragons, la silhouette d'un pin, tel madrépore, la sauvagine qui danse. Cependant la féerie domine. Elle est comme scénique. Les formes bougent et *se meuvent dans leur élément.* Elles sont irradiées par d'invisibles projecteurs.

L'une des découvertes de Matisse réside dans *la préparation.* (Toute une vie aboutit là, dans ces papiers découpés.) Pour ses travaux, l'artiste utilise des feuilles de papier gouaché, où l'on croit reconnaître—au passage—ce dépôt, cette trace faite de fibrilles parallèles, que laisse une brosse ou le pinceau responsable.

Ces papiers aux couleurs vives sont obtenus dans l'instinctif effort de la main, qui—en maniant les ciseaux—sait se servir de cet endroit parfait et angulaire, à la rencontre des lames.

Dignes du corail, ou des plantes marines qui étincellent quand les crêtes et les nappes se couvrent d'une lueur phosphorescente, les formes obtenues ont un réel pouvoir d'incantation. Vives, frémissantes, elles s'abattent—quand la main vient d'achever son ouvrage. Puis une autre main, dévouée, et certainement obéissante, ou amoureuse et compréhensive, les dépose contre le mur, *sur un fond approprié,* en forme de panneau généralement rectangulaire; celui-ci ne détruisant jamais les voisins.

Ici intervient tout un art de fixation (la marqueterie est admirable). *Les formes ne sont pas clouées* ni collées au mur. Elles ne ressemblent en rien au pochoir des artisans et des analphabètes, aux teintes plates et mortes qu'obtiennent les fervents du lino.

Quatre ou cinq épingles (de longues épingles, peu enfoncées, mais comme invisibles et neutralisées par l'intensité de la lumière) maintiennent les formes sur leurs fonds, qui s'étagent jusqu'au plafond.

Piquées, non pas comme un insecte de collection, ces formes bougent et tournent. Elles gardent leur autonomie (ce mur ne pourra jamais être reproduit: il est unique), à partir du moment où elles sont mises en place—et, vraiment, ne vivent que par le fond et l'art du piqué.

Toute une vie, tant de recherches assemblées-là, sur un mur de Vence, une science qui jamais ne méprise l'art ou les formes claires.

Fig. 77. Paper cut-outs shown in fig. 39, identified by present catalogue numbers.

Fig. 78. Paper cut-outs shown in fig. 6, identified by present catalogue numbers.

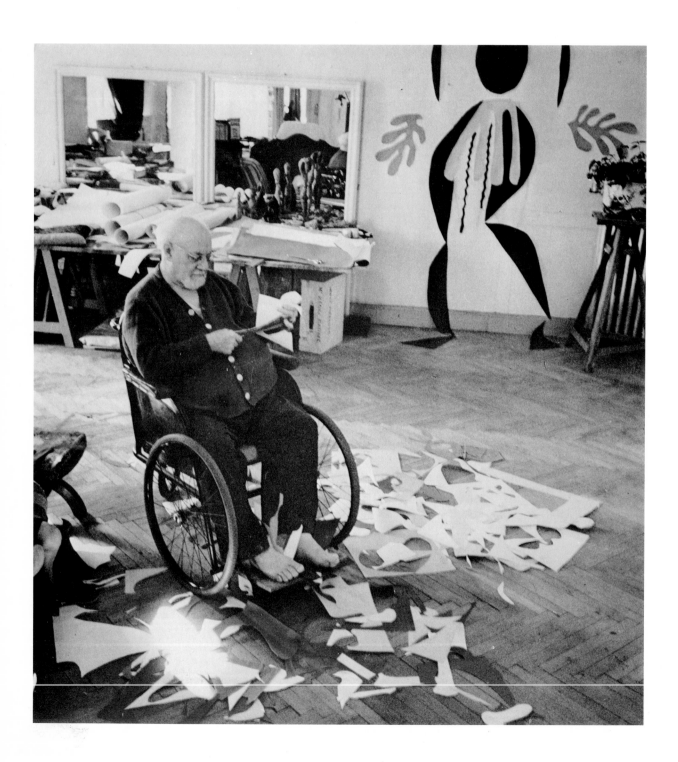

Books, Catalogues, and Magazines with Covers from Matisse Paper Cut-Outs

1936

Cahiers d'Art, 3-5 (for "exemplaires de tête" of this issue only). See no. 2.

1937

Verve I, 1. See no. 3.

1938

Illustration of *La Danse* in *Verve* I, 4. See no. 9.

1940

Verve II, 8. Dated August 31, 1939. See no. 10.

1945

Verve IV, 13. Made by Matisse, summer 1943. Issue also includes as frontispiece *Icare sur fond noir* and on the title page *De la Couleur*. See nos. 13-15.

1947

"Pierre à Feu," *Les Miroirs Profonds,* Paris: January. See no. 41.

Henri Matisse. *Jazz.* Paris: Editions Verve, September 30. Includes 146 pages, 4 leaves, 20 stencil plates (270 copies). Simultaneously, an album with the plates only was published (100 copies). Many of the cut-outs for *Jazz* were done as early as 1943. See nos. 16-35.

Art et Décoration 6. See no. 85.

André Rouveyre. *Repli.* Paris: Editions du Bélier (370 copies). See no. 86.

1948

Verve VI, 21-22. Also includes the title page *Vence 1944-48.* See nos. 92-93.

1949

Verve VI, 23. See no. 97.

Henri Matisse: Oeuvres Récentes, 1947-1948. Paris: Musée National d'Art Moderne, June-September (exh. cat.). See no. 73.

Henri Matisse. Lucerne, Musée des Beaux-Arts, July 9 - October 2 (exh. cat.). See no. 98.

Georges Duthuit. *Les Fauves.* Geneva: Editions des Trois Collines, November. See no. 100.

1950

Henri Matisse: chapelle, peintures, dessins, sculptures. Paris, Maison de la Pensée Française, July 5 - September 24 (exh. cat.). Dated by Matisse 1950. See no. 115.

1951

Roman (literary magazine), Saint-Paul de Vence, January. See no. 116.

Henri Matisse. Tokyo: National Museum, March 3 - June 6 (exh. cat.). See no. 121.

Henri Matisse. Tokyo: *Le Journal Yomiuri.* Not catalogued.

Chapelle du Rosaire des Dominicaines de Vence par Henri Matisse. Vence: Chapelle du Rosaire de Vence, June. See no. 124.

Alfred H. Barr, Jr. *Henri Matisse His Art and His Public.* New York: The Museum of Modern Art, November. See no. 122.

Chapelle du Rosaire des Dominicaines de Vence par Henri Matisse. A 10-page insert in *France Illustration,* December 1. An offprint of this insert was also published (1,500 copies). See no. 125.

Henri Matisse. New York: The Museum of Modern Art, November 13, 1951 - January 13, 1952 (exh. cat.). See no. 123.

Henri Matisse, Thèmes et Variations, Le rêve-La chapelle. Stockholm: Galerie Samlaren, December 31, 1951 - January 31, 1952 (exh. cat.). See no. 73.

1952

Program of the Festival International d'Art Dramatique, Nice, May 31 - June 2. See no. 185.

Henri Matisse Gravures Récentes. Paris: Berggruen et Cie, June 19 - July 12 (exh. cat.). See no. 184.

Matisse. Knokke-le-Zoute: Grande Salle des Expositions de la Réserve, July 12 - August 31 (exh. cat.). See no. 186.

Henri Cartier-Bresson. *Images à la Sauvette.* Paris: Editions Verve, July 22. See no. 187.

Livres Illustrés Estampes Sculptures. Geneva: Galerie Gérald Cramer, November (exh. cat.). See no. 191.

André Verdet. *Prestiges de Matisse.* Paris: Editions Emile-Paul, December (1,800 copies). See no. 195.

André Rouveyre. *Apollinaire.* Paris: Raisons d'Etre (350 copies). Matisse also made slipcase illustration. See nos. 188-189.

Echos. Book of poems by Prévert, Verdet, Hikmet, etc. Privately published (15 copies). Dated by Matisse June 24, 1952. See no. 190.

1953

Les Peintres Témoins de leur Temps Le Dimanche. Paris: Musée d'Art Moderne de la Ville de Paris, January 30 - March 1 (exh. cat.). See no. 192.

Henri Matisse Papiers Découpés. Paris: Berggruen et Cie, February 27 - March 28 (exh. cat.). See no. 197.

1954

Henri Matisse Lithographies Rares. Paris: Berggruen et Cie (exh. cat.). See no. 214.

Henri Matisse. *Portraits.* Monte-Carlo: André Sauret, December. See no. 217.

1956

Rétrospective Henri Matisse. Paris: Musée National d'Art Moderne, July 28 - November 18 (exh. cat.). See no. 210.

1958

Verve IX, 35-36. Matisse made this cut-out in 1954. See no. 215.

Exhibitions of Matisse Cut-Outs and Cut-Out-Based Projects

1939

Boston. Institute of Modern Art at the Museum of Fine Arts. "Sources of Modern Painting." March 2 - April 9. One cut-out.

1947

New York. The American British Art Center. "Ascher Squares designed by Matisse, Moore, Derain, Sutherland, Hitchens, Hodgkins, Laurencin, Cocteau and others." October 20 - November 1. The first public presentation of Matisse's *Ascher Squares*.

Paris. Pierre Berès, "Henri Matisse — *Jazz*, Tériade éditeur." December 3-20. First presentation of *Jazz*: 20 stencil printed plates, based on original paper cut-outs. The poster for this exhibition (and Rio, below) was also from a cut-out design.

Rio de Janeiro. Galeria Europa, Arte Antiga e Moderna Ltd. "Exposiçao do novo libro de Henri Matisse — *Jazz*, editado por Tériade." December 3-20.

1948

New York. Pierre Berès. "Henri Matisse — *Jazz*, Tériade editor." January 20 - February 3.

London. Lefebvre Gallery. "Ascher Panels designed by Henri Matisse — Henry Moore." Fall? The first presentation of the *Océanie, le ciel* and *Océanie, la mer* silkscreen panels.

The important Matisse retrospective held at the Philadelphia Museum of Art, spring, exhibited no actual paper cut-outs, though *Jazz* was shown. This exhibition was organized in direct collaboration with the artist, and the lack of paper cut-outs indicates a policy of their conscious exclusion from Matisse's subsequent retrospectives: Lucerne 1949, Nice 1950. The showing of cut-outs during this epoch was apparently reserved for selected smaller presentations of his recent production, generally in Paris.

1949

New York. Pierre Matisse Gallery. "Henri Matisse, Paintings, Papiers découpés, Drawings, 1945-1948." February. First showing of Matisse's paper cut-outs (probably ten), which did not seem to create much interest in New York.

Paris. Musée National d'Art Moderne. "Henri Matisse: Oeuvres Récentes, 1947-1948." June - September. First presentation of the paper cut-outs in France, showing 21. Also exhibited the *Océanie* panels; first showing of the *Polynésie* tapestries. *Boxeur nègre* on the catalogue cover. This exhibition was important not only for its high quality but also because for the first time it associated paper cut-outs with the oeuvre of Matisse both in the public and professional mind. From this exhibition Det Danske Kunstindustrimuseum, Copenhagen, through the efforts of its director Erik Zahle, purchased three cut-outs, thus becoming the first public institution to acquire works in this medium.

Lucerne. Musée des Beaux-Arts. "Henri Matisse." July 9 - October 20. Although no actual paper cut-outs were exhibited, various cut-out-based works were shown, and Matisse executed a cut-out maquette for the exhibition catalogue cover.

1950

Nice. Galerie des Ponchettes. "Henri Matisse." January - March. For the third time in a large retrospective directly controlled by the artist, no actual paper cut-outs were shown, though the *Polynésie, la mer* tapestry was included.

Paris-1. "Salon de Mai." May 9-31. First presentation of a large paper cut-out (*Zulma*), which was acquired by the Statens Museum for Kunst, Copenhagen. This museum thus became the second anywhere to possess a Matisse cut-out, in this instance through the advocacy of its direc-

tor Leo Swane, an enthusiastic Matisse supporter.

Paris-2. Maison de la Pensée Française. "Henri Matisse: chapelle, peintures, dessins, sculptures." July 5-September 24. Three large cut-outs, two shown for the first time: *Les Mille et Une Nuits* and *Danseuse créole*. Paper cut-out maquettes for the poster and catalogue cover. Two Vence chapel maquettes.

Vence. Foyer Lacordaire. "Exposition Henri Matisse, de dessins d'étude, d'une maquette au 10e, et d'une partie exécutée du vitrail destinés à l'édification de la chapelle de Vence." [1950?]

1951

Tokyo. National Museum. "Henri Matisse." March 3 - June 6. Then to Kyoto and Osaka. Four cut-outs. First showing of *Les Bêtes de la mer* Probably first showing of three Vence window maquettes. Cut-out maquettes for the catalogue cover, as well as for the cover of *Henri Matisse*, published by *Le Journal Yomiuri* on the occasion of the exhibition.

Paris. Galerie Maeght. "Sur quatre murs." Showed at least one cut-out, *Les Mille et Une Nuits*.

New York. The Museum of Modern Art. "Henri Matisse." November 13, 1951 - January 13, 1952. Then to Cleveland, Chicago, and San Francisco to July 1952. This important exhibition was the first retrospective to include paper cut-outs (two large ones plus Vence chapel maquettes of windows and vestments). Through the initiative of Monroe Wheeler, Matisse did cut-out maquettes for the exhibition catalogue cover and the dust cover of Alfred Barr's essential book, *Matisse His Art and His Public*, which appeared simultaneously with the show.

Stockholm. Galerie Samlaren. "Henri Matisse, Thèmes et Variations, Le rêve—La chapelle," December 31, 1951-January 31, 1952. A paper cut-out, *Boxeur nègre,* used on the catalogue cover.

1952

Paris-1. "Salon de Mai." May 9-29. First exhibition of *Tristesse du roi.*

Paris-2. Berggruen et Cie. "Henri Matisse, gravures récentes." June 19-July 12. Cut-out maquette for the catalogue cover.

Knokke-le-Zoute. Grande Salle des Expositions de la Réserve. "Matisse." July 12-August 31. No cut-outs shown but several cut-out-based works; cut-out maquette for the catalogue cover.

Geneva. Gérald Cramer. "Livres illustrés, estampes, sculptures." November. No cut-outs shown; cut-out maquette for the catalogue cover.

Paris-3. Galerie Kléber, "Affiches d'expositions réalisées depuis 25 ans par l'Imprimerie Mourlot et présentées à l'occasion de son centenaire." December 5, 1952-January 1953. Showed at least six posters by Matisse based on cut-outs.

1953

London. The Tate Gallery. "The Sculpture of Matisse and three paintings with studies." January 9-February 22. No cut-outs shown; cut-out for the poster design, which was reused for the Ny Carlsberg Glyptotek show later in the year (see below).

Paris-1. Musée d'Art Moderne de la Ville de Paris. "Les Peintres Témoins de leur Temps Le Dimanche." January 30-March 1. One cut-out.

Paris-2. Berggruen et Cie. "Henri Matisse Papiers Découpés." February 27-March 28. First exhibition concerned only with cut-outs, through the initiative of Heinz Berggruen. The catalogue reproduced 14 cut-outs in color; it is estimated that there were about 20 cut-outs in the exhibition. The cover for the catalogue, the publicity card mailer for the opening, and the poster for the show were based on cut-outs.

Paris-3. "Salon de Mai." First exhibition of *Nu bleu* series (most probably *Nu bleu II* and *Nu bleu III,* possibly *Nu bleu I* and *Nu bleu IV*).

Copenhagen. Ny Carlsberg Glyptotek. "Henri Matisse, Skulturer, Malerier, Farveklip." November 6-December 6. Five cut-outs.

1954

Paris-1. Berggruen et Cie. "Henri Matisse Lithographies Rares." Cut-out maquette for the catalogue cover.

Paris-2. "Salon de Mai." May 7-30. First exhibition of *La Gerbe.*

Stockholm. Nationalmuseum. "Moderne utländsk Konst ur Svenska privatsamlingar." November. Three cut-outs.

Warsaw. "Arts plastiques contemporains." One cut-out.

In 1954, with the acquisition of *Tristesse du roi,* the Musée National d'Art Moderne, Paris (director Jean Cassou) became the fourth public institution anywhere to possess a Matisse cut-out.

1955

Cambridge. Busch-Reisinger Museum, Harvard University. "The Arts of Matisse, A Museum Course exhibition." May 9-June 8. Two cut-outs and various cut-out-based objects.

1956

New York. Rose Fried Gallery. "International Collage Exhibition." February-March. One cut-out.

Paris. Musée National d'Art Moderne, "Rétrospective Henri Matisse." July 28-November 8. Nine cut-outs; *La Perruche et la sirène, La Piscine,* and *La Négresse* were shown for the first time. The *Lierre en fleur* window and the ceramic *Acanthe* were also exhibited.

1957

Paris. Musée National d'Art Moderne. "Depuis Bonnard." March-April. One cut-out.

Stockholm. Nationalmuseum. "Henri Matisse-Apollon." September 4-23. First exhibition of the *Apollon* cut-out, collection of Theodor Ahrenberg. (Theodor Ahrenberg, G. David Thompson, Tériade, and Ernst Beyeler have owned the largest collections of Matisse paper cut-outs.)

Helsinki, Helsingin Taidehalli. "Henri Matisse, Apollon, Theodor Ahrenbergin Kokoelema." December 10, 1957-January 6, 1958. *Apollon* was exhibited, and perhaps three other cut-outs.

1958

Houston. Contemporary Arts Museum. "Collage International from Picasso to the Present." February 27-April 6. Two cut-outs.

Liège. Musée des Beaux-Arts. "Henri Matisse—*Apollon,* Collection Theodor Ahrenberg." May 3-July 31. Four cut-outs.

Basel. Kunsthalle. "Kunst & Formenatur." September 20-October 19. Two cut-outs.

1959

Kassel. Internationale Ausstellung. "Documenta II." July 11-October 11. One cut-out.

Zurich. Kunsthaus. "Henri Matisse, Das Plastische Werk, Sämtliche Plastiken des Meisters sowie Zeichnungen, Graphik und Collagen als Leihgaben der Sammlung Ahrenberg, Stockholm...." July 14-August 12. Four cut-outs.

Bern. Kunsthalle. "Henri Matisse, les grandes gouaches découpées." July 25-September 20. First major exhibition of the large cut-outs, organized by Dr. Franz Meyer. Twenty-nine cut-outs.

Geneva. Gérald Cramer. "Le livre illustré par Henri Matisse." December 4, 1959-January 29, 1960. One cut-out.

1960

Göteborg. Konsthallen. "Henri Matisse ur Theodor Ahrenberg's Samling." March 16-April 10. Four cut-outs.

Amsterdam. Stedelijk Museum. "Henri Matisse, les grandes gouaches découpées." April 29-June 20. Twenty-eight cut-outs.

Aix-en-Provence. Pavillon de Vendôme. "Matisse." July 9-August 31. Eight cut-outs, listed as "collection Jean Matisse."

Zurich. Kunsthaus. "Sammlung G. David Thompson, Pittsburgh." October-November. Then to Düsseldorf and The Hague to April 1961. Six cut-outs.

Bern. Kornfeld and Klipstein. "Henri Matisse, Das Illustrierte Werk, Zeichnungen und Druckgraphik." December 15, 1960-January 1961. One cut-out.

1961

Paris. Musée des Arts Décoratifs. "Henri Matisse, les grandes gouaches découpées." March 22-May 15. This exhibition, organized by François Mathey, was the most important exhibition devoted to the large scale cut-outs. At least 39 cut-outs were shown, along with the three Vence window maquettes, several chasuble maquettes, and various cut-out-based works.

Copenhagen. Raadhus, Fredriksberg. "Moderne Verdenskunst fra Ahrenbergs Samling." March 18-April 9.

Albi. Musée Toulouse-Lautrec, Palais de la Berbie. "Exposition Henri Matisse." July 11 - September 15. Ten cut-outs, listed as "collection Jean Matisse."

New York. The Museum of Modern Art. "The last works of Henri Matisse, large cut gouaches." October 17 - December 3. Then to Chicago and San Francisco to April 1962. Thirty-seven cut-outs which had a significant impact upon the American audience.

1962

Venice. "XXXI Biennale Internazionale d'Arte." June 7 - October 7. One cut-out.

Marseille. Musée Cantini. "Gustave Moreau et ses élèves." June 26 - September 1. One cut-out.

1963

Nice. Musée Matisse, Cimiez. Inaugurated January 5, the permanent installation of four large cut-outs, twelve chasuble designs, various maquettes and project drawings, making this one of the three most important institutional collections of cutouts, along with The Museum of Modern Art, New York, and the National Gallery of Art, Washington, D.C.

1964

London. The Tate Gallery. "54/64 Painting and Sculpture of a Decade." April 20 - June 28. One cut-out.

Basel. Kunsthalle. "Bilang Internationale Malerei seit 1950." June 20 - August 23. One cut-out.

Saint-Etienne, Musée d'Art et d'Industrie. "50 Ans de Collages, Papiers Collés, Assemblages. Collages du Cubisme à nos jours." June 24 - September 13. One cut-out.

Kassel. Alte Galerie, Museum Fridericianum, und Orangerie, Internationale Ausstellung. "Documenta III." June 27 - October 5. Two cut-outs.

1965

Helsinki. Amos Andersonin Taidemuseo. "Henri Matisse." April 25 - May 16. Three cut-outs.

1966

Los Angeles. UCLA Art Galleries. "Henri Matisse." January 5 - February 27. Then to Chicago and Boston through June. Eleven cut-outs.

Brussels. Palais des Beaux-Arts. "Art français contemporain." September 16 - November 13. Cut-out maquettes for the various states of the Vence chapel windows.

New York. The Museum of Modern Art. "Henri Matisse, 64 Paintings." Two cut-outs.

Zurich. Kunstgewerbemuseum. "Die Geschichte der collage." One cut-out.

Cleveland. Museum of Art. "Fifty Years of Modern Art." Exhibited a collage entitled *Bunch of Yellow Flowers* which has not figured in other Matisse exhibitions.

1968

Stockholm. Svensk-Franska Konstgalleriet. "Matisse *Apollon* and Picasso *Femme nue au rocking chair.*" Exhibition and sale January 31.

London. Hayward Gallery. "Matisse." July 11 - September 8. Twelve cut-outs.

Baltimore. Museum of Art. "From El Greco to Pollock: Early and Late Works." One cut-out.

1969

Saint-Paul de Vence. Fondation Maeght, "A la rencontre de Matisse." Six cut-outs.

1970

Paris. Grand Palais. "Henri Matisse Exposition du Centenaire." April - September. A major exhibition with thirteen cut-outs, plus the three cut-out maquettes for the various states of the Vence chapel windows, and cut-out-based works.

Buffalo. Albright-Knox Art Gallery. "Color and Field." September 15 - November 1. Then to Dayton and Cleveland to March 1971. Two cut-outs.

Copenhagen-1. Statens Museum for Kunst. "Matisse, En retrospektiv udstilling." October 10 - November 29. Sixteen cut-outs.

Copenhagen-2. Kunstforeningen. "Henri Matisse, 1869-1954, Plakater." October 16 - November 8. At least seven posters based on cut-outs.

Basel. Galerie Beyeler. "Collection Marie Cuttoli - Henri Laugier, Paris." October - November. One cut-out.

1971

Baltimore. Museum of Art. "Matisse as a draughtsman." January 12 - February 21.

Then to San Francisco and Chicago to July. Three cut-outs.

1972

Basel-1. Galerie Beyeler. "Highlight." March - April 15. One cut-out.

Basel-2. Galerie Beyeler. "Venus to Venus." September - October. One cut-out.

1973

Paris. Grand Palais. "Hommage à Tériade." May 16 - September 3. First and only exhibition to date of the 20 cut-out maquettes for *Jazz*.

New York-1. Acquavella Galleries. "Henri Matisse." November 2 - December 1. One cut-out.

New York-2. Wildenstein Gallery. "Twelve Years of Collecting from the Carnegie Institute." November. Then to the High Museum of Art, Atlanta, as "A French Way of Seeing." One cut-out.

1974

New York. The Museum of Modern Art. "Seurat to Matisse, Drawing in France." One cut-out.

Chicago. Richard Gray Gallery. "Benefit exhibition, Chicago Wellesley College Club." April. One cut-out.

1975

Paris. Musée National d'Art Moderne. "Henri Matisse, Dessins et Sculpture." May 29 - September 7. First exhibition of the cut-out maquettes for *Polynésie* tapestries, not listed in catalogue.

Brussels. Palais des Beaux-Arts. "Henri Matisse, Dessins et Sculpture." September 27 - October 26. Two cut-outs.

Chicago. The Art Institute. "Raiment for the Lord's service: A Thousand Years of Western Vestments." November 15, 1975 - January 18, 1976. Three cut-outs.

1976

Basel. Galerie Beyeler. "Autres dimensions." June - September. Four cut-outs.

New York. The Museum of Modern Art. "Matisse-Gaudi Ecclesiastical Designs." November 15, 1976 - January 9, 1977. Four cut-outs.

New York-2. The Museum of Modern Art. "European Master Paintings from Swiss Collections, Post-Impressionism to World War II." December 17, 1976 - March 1, 1977. One cut-out.

Bibliography

Those listings regarded as essential for the study of Matisse's paper cut-outs are indicated by a scissors symbol.

Aarstiderne 1948
"Jazz." *Aarstiderne* 4 (1948), p. 127.

Ackerman 1923
Ackerman, Phyllis. *Wallpaper: Its History, Design and Use.* New York: Frederick A. Stokes Co., 1923.

Albers 1971
Albers, Josef. *Interaction of Color.* 3rd ed. New Haven: Yale University Press, 1971.

Alpatov 1969
Alpatov, Michael W. *Matisse.* Moscow: 1969.

Alpatov 1973
Alpatov, Michael W. *Henri Matisse.* Dresden: VEB Verlag der Kunst, 1973.

Althaus 1959
Althaus, P.F. "Bern; Gouaches Découpées in der Kunsthalle." *Werk* 46 (1959), supp. p. 190.

Amberg 1946
Amberg, George. *Art in Modern Ballet.* New York: Pantheon, 1946.

Apollo 1953
"Events in Paris." *Apollo* 57 (1953), p. 114 (paper cut-outs at Berggruen's).

Apollo 1972
Apollo 96 (1972), p. 158.

Aragon 1930
Aragon, Louis. *La Peinture au défi.* Paris: Galerie Goemans, 1930 (exh. cat.).

Aragon 1946
Aragon, Louis. *Apologie du luxe.* Geneva: A. Skira, 1946.

Aragon 1965
Aragon, Louis. *Les Collages.* Paris: Hermann, 1965.

Aragon 1971
Aragon, Louis. *Henri Matisse, Roman.* 2 vols. Paris: Gallimard, 1971.

Art d'Aujourd'hui 1954
"Collages." *Art d'Aujourd'hui* 5 (1954).

Art et Décoration 1953
Art et Décoration 35 (1953), p. 40.

Art et Décoration 1954
Art et Décoration 42 (1954), p. 42.

Art in America 1975
"Eight Statements: Interviews by Jean-Claude Lebensztejn." *Art in America* 63 (1975), pp. 67-75.

Art News 1956
"Matisse's Last Mural Installed in California: Tile Wall in the Brody Home, Los Angeles." *Art News* 55 (1956), p. 30.

Art Présent 1947
Art Présent 2 (1947) (special issue on Matisse).

Arts & Architecture 1949
"Series of Silkscreen Murals known as Mural-scrolls from Original Designs." *Arts & Architecture* 66 (1949), pp. 26-28.

Arts, Spectacles 1953
Arts, Spectacles 403 (March 20-26, 1953).

Bacou 1970
Bacou, Roseline, and Claude Roger-Marx. *Odilon Redon à L'Abbaye de Fontfroide.* Paris: Hachette [1970].

Ballets de Monte-Carlo 1939-1
Ballets de Monte-Carlo. Program. Monte-Carlo, May 11, 1939 (premiere).

Ballets de Monte-Carlo 1939-2
Ballets de Monte-Carlo. Program. Paris, Théatre National du Palais de Chaillot, June 1939.

Barr 1951

Barr, Alfred H., Jr. *Matisse His Art and His Public.* New York: The Museum of Modern Art, 1951.

Barron 1975

Barron, Stephanie. "Matisse and Contemporary Art: 1950-1970." *Arts Magazine* 49 (1975), pp. 66-67.

Barry 1948

Barry, Joseph. "Matisse turns to religious art." *The New York Times Magazine* (December 26, 1948), p. 8.

Basel 1970

Basel. Galerie Beyeler. *Collection Marie Cuttoli-Henri Laugier, Paris.* Basel: 1970 (exh. cat.).

Basel 1970

Basel. Kunstmuseum. *Katalog II: 19.-20. Jahrhundert.* Basel: 1970.

Baudelaire 1947

Baudelaire, Charles. *Les Fleurs du Mal.* Paris: La Bibliothèque Française, 1947 (ill. by Matisse).

Bazaine 1952

Bazaine, Jean. "Clarté de Matisse." *Derrière le Miroir* 46-47. Paris: Maeght, 1952.

Beaumont 1934

Beaumont, Cyril William. *The Monte Carlo Russian Ballet.* London: author, 1934.

Beaumont 1939

Beaumont, Cyril William. *Five Centuries of Ballet Design.* New York: Studio Publications, 1939.

Bergson 1903

Bergson, Henri-Louis. *An Introduction to Metaphysics.* Tr. by T. E. Hulme. New York: Bobbs-Merrill, 1903.

Bergson 1907

Bergson, Henri-Louis. *Evolution Créatrice.* Paris: Félix Alcan, 1907.

Bern 1959

Bern, Kunsthalle, *Henri Matisse, 1950-1954: Les Grandes Gouaches Découpées.* Essay by Franz Meyer. Bern: 1959 (exh. cat.).

Bernier 1949

Bernier, Rosamund. "Matisse Designs a New Church." *Vogue* 15 (1949), p. 76.

Bernier 1963

Bernier, Rosamund. "Le Musée Matisse à Nice." *L'Oeil* 105 (1963), pp. 20-29.

Bertin 1949

Bertin, Celia. "A Vence Henri Matisse décore une chapelle." *Les Arts Plastiques* 5-6 (1949), pp. 209-214.

Besson 1942

Besson, Georges. *Matisse.* Paris: Les Editions Braun, Collection des Maîtres, 1942.

Bijutsu Techno 1953

[Matisse: portrait and reproductions.] *Bijutsu Techno* 2 (1953).

Bird 1951

Bird, Paul. "Matisse's Chapel." *Art Digest* 25 (1951), p. 7.

Blanc 1870

Blanc, Charles. *Grammaire des Arts du Dessin.* 2nd ed. Paris: Vve. Jules Renouard, 1870.

Blanc n.d.

Blanc, Charles. *Grammaire des Arts Décoratifs.* Paris: Henri Laurens, n.d.

Boehn 1970

Boehn, Max von. *Miniatures and Silhouettes.* Tr. by E. K. Walker. 1928. Reprint. New York: Benjamin Blom, 1970.

Bordley 1951

Bordley, Rogers. "Matisse's Chapel." *Art Digest* 25 (1951), p. 9.

Bouvier 1943

Bouvier, Marguette. "Henri Matisse illustre Ronsard." *Comoedia* 80 (1943).

Bouvier 1944

Bouvier, Marguette. "Henri Matisse chez lui." *Labyrinthe* 1 (1944), pp. 1-3.

Bowness 1968

Bowness, Alan. *Matisse and the Nude.* New York: The New American Library, 1968.

Brassaï 1964

Brassaï (Jules Halasz). *Conversations avec Picasso.* Paris: Gallimard, 1964.

Brenson 1954

Brenson, Théodore. "Abstract Art and Christianity." *Liturgical Arts* 22 (1954), pp. 76-78.

Bridault 1952

Bridault, Yves. "J'ai Passé un Mauvais Quart d'Heure avec Matisse." *Arts, Spectacles* 371 (August 7-13, 1952), p. 1.

Brill 1967

Brill, Frederick. *Matisse.* London: Paul Hamlyn, 1967.

Brillabt 1935

Brillabt, Maurice. "Esprit liturgique et art moderne." *L'Art Sacré* 1 (1935), pp. 15-18.

Bromberg 1963

Bromberg, Walter. *The Mind of Man: A History of Psychotherapy and Psychoanalysis.* 1954. Reprint. New York: Harper & Row, 1963.

Buchanan 1950

Buchanan, D. W. "Interview in Montparnasse." *Canadian Art* 8 (1950), pp. 61-65.

Buffalo 1970

Buffalo. The Albright-Knox Art Gallery. *Color and Field 1890-1970.* Intro. by Priscilla Colt. Buffalo: 1970 (exh. cat.).

Burlington Magazine 1966

The Burlington Magazine 108 (1966), pp. xiv-xv.

Cahiers d'Art 1935

Cahiers d'Art 10 (1935), p. 10 ff.

Cahiers d'Art 1951

"Les Expositions d'Art Ancien et Moderne: Sur Quatre Murs. (Galerie Maeght)." *Cahiers d'Art* 26 (1951), pp. 206, 209.

Calmels 1975

Calmels, Norbert. *Matisse: La Chapelle du Rosaire des Dominicaines de Vence et de l'Espoir.* Digne: Morel, 1975.

Calvert 1907-1

Calvert, Albert F. *Granada and the Alhambra.* London: John Lane, 1907.

Calvert 1907-2

Calvert, Albert F. *The Alhambra.* London: John Lane, 1907.

Carmean 1976
Carmean, E. A., Jr. "Morris Louis and the Modern Tradition; IV: Fauvism; V: Later Matisse." *Arts Magazine* 51 (1976), pp. 122-126.

Cartier-Bresson 1952
Cartier-Bresson, Henri. *Images à la Sauvette*. Paris: Editions Verve, 1952.

Cassonari 1950
Cassonari, Bruno. "Visite à Matisse: la Chapelle de Vence." *Domus* 250 (1950), pp. 53-56.

Cassou 1952
Cassou, Jean. "La Méthode de Matisse." In *Mélanges offerts à Etienne Souriau*. Paris: Nizet, 1952, pp. 39-47.

Cassou 1953
Cassou, Jean. "Matisse va présenter au public ses papiers découpés." *France Illustration* 383 (February 14, 1953), pp. 234-235.

Char 1945-46
Char, René. "Le Requin et la Mouette." *Cahiers d'Art* 20-21 (1945-46), pp. 76-77 (ill. by Matisse).

Clay 1975
Clay, Jean. *De l'Impressionnisme à l'Art Moderne*. Paris: Hachette, 1975.

Cocognac 1963
Cocognac, A. M., ed. "La Renaissance de la chasuble." *L'Art Sacré* 7-8 (1963).

Cohen 1975
Cohen, Arthur Allen. *Sonia Delaunay*. New York: Harry N. Abrams, 1975.

Cooper 1967
Cooper, Douglas. *Picasso Théâtre*. Paris: Cercle d'Art, 1967.

Copenhagen 1964
Copenhagen. Statens Museum for Kunst. *Moderne Udenlandsk Kunst: J. Rumps Samling*. By Hanne Finsen. Copenhagen: 1964.

Copenhagen 1970-1
See exhibition list.

Copenhagen 1970-2
Copenhagen. Kunstforeningen. *Henri Matisse, 1869-1954, Plakater*. Essay by Fernand Mourlot. Copenhagen: 1970 (exh. cat.).

Courthion 1956
Courthion, Pierre, "Le Papier Collé du Cubisme à nos jours," and "Les Papiers Découpés d'Henri Matisse." *XXᵉ Siècle* 6 (1956).

Couturier 1938
Couturier, Marie-Alain. "Paramentique-Notes." *L'Art Sacré* 4 (1938), pp. 248-260.

Couturier 1950
Couturier, Marie-Alain. "Services Pratiques: Le symbolisme de la chasuble." *L'Art Sacré* 7-8 (1950), p. 31.

Couturier 1951
Couturier, Marie-Alain. "Religious Art and the Modern Artist." *Magazine of Art* 44 (1951), pp. 268-272.

Couturier 1962
Couturier, Marie-Alain. *Se Garder Libre: Journal 1947-1954*. Paris: Editions du Cerf, 1962.

Cowart 1972
Cowart, Jack. " 'Ecoliers' to 'Fauves': Matisse, Marquet, and Manguin Drawings, 1890-1906." Ph.D. dissertation, The Johns Hopkins University, 1972.

Cowart 1974
Cowart, Jack. "Books in Review." *Art Journal* 33 (1974), p. 282 (review of Matisse 1972).

Cowart 1975
Cowart, Jack. "Matisse's Artistic Probe: the Collage." *Arts Magazine* 49 (1975), pp. 53-55.

Cowart 1976
Cowart, Jack. "Matisse and Découpage." Lecture given at The Baltimore Museum of Art, March 11, 1976 (transcript).

Damase 1971
Damase, Jacques. *Sonia Delaunay, Rythmes et Couleurs*. Paris: Hermann, 1971.

Degand 1953
Degand, Léon. "Les Papiers découpés de Matisse." *Art d'Aujourd'hui* 2 (1953), p. 28.

Derrière le Miroir 1951
Derrière le Miroir 36-38 (1951).

Detaille 1954
Detaille, Georges, and Gérard Mulys. *Les Ballets de Monte-Carlo, 1911-1944*. Paris: Editions Arc-en-Ciel, 1954.

Diehl 1944
Diehl, Gaston. "La Leçon de Matisse." *Comoedia* 146-147 (1944), p. 1 ff.

Diehl 1947
Diehl, Gaston. "Contributions à l'Art Décoratif: Henri Matisse." *Art et Décoration* 6 (1947), pp. 2-10.

Diehl 1954
Diehl, Gaston. *Henri Matisse*. Paris: Pierre Tisné, 1954.

Diehl 1970
Diehl, Gaston. *Henri Matisse*. Paris: Nouvelles Editions Françaises, 1970.

Dorival 1950
Dorival, Bernard. "Bonnard, Matisse, Utrillo." *La Biennale di Venezia* 1 (1950), pp. 18-22.

Dorival 1972
Dorival, Bernard. "Henri Matisse ou le Triomphe de l'Intelligence." *Actes du 22ᵉ Congrès international d'Histoire de l'art, Budapest 1969*, I, pp. 45-57. Budapest: Akademiai Kiadó, 1972.

Du 1955
Du 2 (1955).

Du 1976
"Die Magie der gestalteten Gegenstände." *Du* 424 (1976).

Dubourg 1968
Dubourg, Jacques, and Françoise de Staël. "Catalogue Raisonné des Peintures." In *Nicolas de Staël*. Ed. by André Chastel. Paris: Le Temps, 1968.

Dudley 1934
Dudley, Dorothy. "The Matisse Fresco in Merion, Pennsylvania." *Hound and Horn* 7 (1934), pp. 298-303.

Duthuit 1949
Duthuit, Georges. *Les Fauves*. Geneva: Trois Collines, 1949.

Duthuit 1956-1
Duthuit, Georges. "Material and Spiritual Worlds of Henri Matisse." Tr. by Louise Varèse. *Art News* 55 (1956), pp. 22-25.

Duthuit 1956-2
Duthuit, Georges. *Matisse: Période Fauve.* Paris: Fernand Hazan, 1956.

Duthuit 1961
Duthuit, Georges. "Une Peinture Délivrée en Lumière." In *L'Image et l'Instant.* Paris: José Corti, 1961.

Duthuit 1962
Duthuit, Georges. "Matisse's Illuminations." *Portfolio & Art News Annual* 5 (1962), pp. 84-99.

Duthuit 1963
Duthuit, Georges. *Une Fête en Cimmérie.* Paris: Tériade, 1963.

Duthuit 1974
Duthuit, Georges. *Représentation et Présence: Premiers Ecrits et Travaux 1923-1952.* Paris: Flammarion, 1974.

Elsen 1972
Elsen, Albert E. *The Sculpture of Henri Matisse.* New York: Harry N. Abrams, 1972.

The Encyclopedia of World Art 1965
The Encyclopedia of World Art. New York: McGraw-Hill, 1965.

Escholier 1937
Escholier, Raymond. *Henri Matisse.* Paris: Fleury, 1937.

Escholier 1956
Escholier, Raymond. *Matisse ce vivant.* Paris: Librairie Arthème Fayard, 1956.

Fénéon 1970
Fénéon, Félix. "Le Décor au Théâtre—une Enquête." In *Oeuvres Plus que Complètes*, 1. Ed. by Joan J. Halperin. Geneva: Librairie Droz, 1970.

Ferguson 1954
Ferguson, George. *Signs & Symbols in Christian Art.* New York: Oxford University Press, 1954.

Ferrier 1969
Ferrier, Jean-Louis. *La Forme et le Sens.* Paris: Editions Denoël, 1969.

Finsen 1951
Finsen, Hanne. "Kapellet I Vence." *Aarstiderne* 2 (1951), pp. 58-64.

Fischer 1950
Fischer, Wend. "*Jazz de Henri Matisse.*" *Ver y Estimar* 4 (1950), pp. 42-44.

Flam 1971
Flam, Jack D. "Matisse's 'Backs' and the Development of His Painting." *Art Journal* 30 (1971), pp. 352-361.

Flam 1972
Flam, Jack D. "Matisse in 1911: At the Crossroads of Modern Painting." In *Actes du 22e Congrès international d'Histoire de l'Art, Budapest 1969*, II, pp. 421-430. Budapest: Akademiai Kiadó, 1972.

Flam 1973
Flam, Jack D. *Matisse on Art.* London: Phaidon, 1973.

Flam 1975-1
Flam, Jack D. "Some Observations on Matisse's Self-Portraits." *Arts Magazine* 49 (1975), pp. 50-52.

Flam 1975-2
Flam, Jack D. "Matisse in Two Keys." *Art in America* 63 (1975), pp. 83-86.

Flam 1976
Flam, Jack D. "Recurrent Themes in the Art of Matisse." Lecture given at The Baltimore Museum of Art, March 25, 1976 (transcript).

Fleet 1966
Fleet, Simon. "Sale Rooms." *Art and Artists* 1 (1966), pp. 72-73.

Fourcade 1972
See Matisse 1972.

Fourcade 1976
Fourcade, Dominique. "Autres Propos de Matisse." *Macula* 1 (1976), pp. 92-115.

Fox 1916
Fox, William Sherwood. *Greek and Roman, The Mythology of All Races*, I. Boston: Marshall Jones Co., 1916.

Fry 1935
Fry, Roger. *Henri Matisse.* Paris: Editions des Chroniques du Jour, 1935.

Fuerst 1967
Fuerst, René, and Samuel J. Hume, comps. *Twentieth Century Stage Decoration.* Corrected ed. New York: Benjamin Blom, 1967.

Gardner 1977
Gardner, Martin. "Mathematical Games: Extraordinary Nonperiodic Tiling that Enriches the Theory of Tiles." *Scientific American* 236 (1977), pp. 110-121.

Gasser 1960
Gasser, Manuel. "Exhibition Posters by Famous Artists." *Graphis* 16 (1960), pp. 108-119.

Georges-Michel 1954
Georges-Michel, Michel. *De Renoir à Picasso: Les peintres que j'ai connus.* Paris: Fayard, 1954.

Gettens 1966
Gettens, Rutherford J., and George L. Stout. *Painting Materials.* New York: Dover Pub., 1966.

Giraudy 1971
Giraudy, Danièle. "Correspondance Henri Matisse—Charles Camoin." *Revue de l'Art* 12 (1971), pp. 7-34.

Glueck 1976
Glueck, Grace. "Modern Gets Huge Matisse Cutout in $1 Million Trade." *The New York Times* (March 10, 1976).

Gogh 1963
Gogh, Vincent van. *Van Gogh: A Self-Portrait.* Selected by W. H. Auden. New York: E. P. Dutton & Co., 1963.

Goldfinger 1948
Goldfinger, Erno. "Ascher Panels by Moore and Matisse." *Building* (December 1948).

Goldin 1975
Goldin, Amy. "Matisse and Decoration: The Late Cut-Outs." *Art in America* 63 (1975), pp. 49-59.

Goode 1939
Goode, Gerald, ed. *The Book of Ballets.* New York: Crown Pub., 1939.

Grand Collections of World Art 1974
Grand Collections of World Art 23. Tokyo: Kodansha, 1974.

Graphis 1954
"Galerie Maeght, Paris: Book Design and Advertising; Three Illustrations." *Graphis* 10 (1954), pp. 514-516.

Gray 1962
Gray, Camilla. *The Great Experiment: Russian Art 1863-1922.* New York: Harry N. Abrams, 1962.

Greenberg 1949
Greenberg, Clement. [Exhibition at Pierre Matisse Gallery: a review]. *Nation* 168 (1949), pp. 284-285.

Greenberg 1953
Greenberg, Clement. *Matisse.* New York: Harry N. Abrams, 1953.

Greenberg 1961
Greenberg, Clement. *Art and Culture: Critical Essays.* Boston: Beacon Press, 1961.

Grimal 1963
Grimal, Pierre. *Dictionnaire de la Mythologie Grecque et Romaine.* 3rd ed. Paris: Presses Universitaires de France, 1963.

Guichard-Meili 1967
Guichard-Meili, Jean. *Henri Matisse, son Oeuvre, son Univers.* Paris: Fernand Hazan, 1967.

Hamilton 1967
Hamilton, George Heard. *Painting and Sculpture in Europe 1880-1940.* Baltimore: Pelican Books, 1967.

Hempstead 1974
Hempstead, L. I. Hofstra University, The Emily Lowe Gallery. *Diaghilev/Cunningham.* Hempstead: 1974 (exh. cat.).

Herrmann n.d.
Herrmann, Erich S. "Matisse: Photographs of the Artist and his Studio." Unpublished manuscript, intro. by André Rouveyre, n.d., in The Museum of Modern Art library, New York.

Hess 1951
H[ess], T[homas] B. "Matisse at his Best." *Art News* 50 (1951), p. 40.

Hoctin 1957
Hoctin, Luce. "Renaissance of Church Art in France." *Graphis* 13 (1957), pp. 224-235 (esp. pp. 226-229).

Holm 1951
Holm, Arne E. "Matisse's Kapell i Vence." *Kunsten Idag* 4 (1951), pp. 32-51.

Humbert 1954
Humbert, Agnès. "Recent Acquisitions of the Musée National d'Art Moderne, Paris." *The Studio* 148 (1954), pp. 10-17.

Hunt 1971
Hunt, Roland. *The Seven Keys to Colour Healing.* 1940. Reprint. London: The C. W. Daniel Co., 1971.

Hüttinger 1962
Hüttinger, E. "Neuerwerbungen des Kunsthauses Zürich aus den letzen zehn Jahren." *Werk* 49 (1962), pp. 325-333.

Huyghe 1953
Huyghe, René. *Henri Matisse.* Paris: Flammarion, 1953.

Illustrated London News 1968
"The Most Conservative Revolutionary." *The Illustrated London News* (July 27, 1968), pp. 26-27.

Italiaander 1951
Italiaander, Rolf. "Henri Matisse Baut Eine Kirche." *Kunstwerk* 5 (1951), pp. 52-53.

Jacobus 1972
Jacobus, John. *Henri Matisse.* New York: Harry N. Abrams, 1972.

Janis 1962
Janis, Harriet, and Rudi Blesh. *Collage: Personalities, Concepts, Techniques.* Philadelphia: Chilton Co., 1962.

Jardin des Arts 1970
Jardin des Arts 186 (1970).

Jones 1880
Jones, Owen. *The Grammar of Ornament.* 1856. Folio ed. New York: J. W. Bouton, 1880.

Joseph 1939
Joseph, Emily. "Craftsmanship at San Francisco." *Magazine of Art* 32 (1939), p. 402.

Jungmann 1959
Jungmann, Joseph A. *The Mass of the Roman Rite.* New York: Benziger, 1959.

Kahnweiler 1940-44
Kahnweiler, Daniel-Henry. "Art Conceptuel et Papiers Collés (1)." *Cahiers d'Art* 15-19 (1940-44), pp. 179-185.

Katzenbach and Warren 1949
Katzenbach and Warren, Inc. *Mural scrolls, no. 1: Calder, Matisse, Matta, Mirò.* New York: 1949.

Kaufmann [1950]
Kaufmann, Edgar, Jr. *Mimosa by Henri Matisse.* New York: Alexander Smith and Sons Carpet Co. [1950].

Knigin 1974
Knigin, Michael, and Murray Zimiles. *The Contemporary Lithographic Workshop Around the World.* New York: Van Nostrand Reinhold Co., 1974.

Kochno 1954
Kochno, Boris. *Le Ballet.* Paris: Hachette, 1954.

Kochno 1970
Kochno, Boris. *Diaghilev and the Ballets Russes.* New York: Harper & Row, 1970.

Kuenzi 1959
Kuenzi, André. "Henri Matisse." *Gazette de Lausanne* (August 8-9, 1959).

L.D. 1964
Delectorskaya, Lydia. Commentary on the images of *Jazz* on the occasion of her donation of the album to the Musée National d'Art Moderne, Paris: 1964.

L.D. 1976
Delectorskaya, Lydia. Interviews. Paris: 1976.

Lacaze 1950
Lacaze, André, and Walter Carone. "Matisse . . . sacrifie 800 millions pour soeur Jacques dominicaine." *Paris Match* 59 (May 6, 1950), pp. 15-18.

Lacotte 1953
Lacotte, René. "Le Papier Découpé par Matisse." *Les Lettres françaises* (1953).

Lane 1952
Lane, James. "Matisse: Painter into Architect, his Venture at Vence." *Liturgical Arts* 20 (1952), pp. 61-62.

La Revue des Arts 1952
La Revue des Arts 2, 1-4 (1952) (covers by Matisse).

Larousse 1959
Larousse Encyclopedia of Mythology. New York: Prometheus Press, 1959.

L'Art Sacré 1951
L'Art Sacré 11-12 (1951) (Vence issue ed. by M.-A. Couturier and P.-R. Régamy).

Lassaigne 1959-1
Lassaigne, Jacques. "La peinture sans limites." *Les Lettres françaises* (1959).

Lassaigne 1959-2
Lassaigne, Jacques. *Matisse.* Geneva: A. Skira, 1959.

Lebensztejn 1974
Lebensztejn, Jean-Claude. "Les Textes du Peintre." *Critique* 324 (1974), pp. 407-408.

Lejard 1951
Lejard, André. "Propos de Henri Matisse." *Amis de l'Art* 2 (1951).

Le Journal Yomiuri 1951
Henri Matisse. Tokyo: *Le Journal Yomiuri,* 1951.

Lemaître 1950
Lemaître, Henri. "A Masterpiece of Modern Religious Art." *Blackfriars* (January 1950).

Le Point 1939
Le Point 21 (1939), pp. 99-142.

Lettres françaises 1970
"Le Second Siècle de Matisse Commence." *Les Lettres françaises* 1330 (1970).

Lévêque 1968
Lévêque, Jean-Jacques. *Matisse.* Paris: Club d'Art Bordas, 1968.

Leymarie 1959
Leymarie, Jean. "Les grandes gouaches découpées à la Kunsthalle de Berne." *Quadrum* 7 (1959), pp. 103-114 (English summary p. 192).

Leymarie 1967
Leymarie, Jean. "Evoluzione di Matisse." *L'Arte Moderna* 10 (1967).

Liberman 1960
Liberman, Alexander. *The Artist in his Studio.* New York: Viking Press, 1960.

Lieberman 1951
Lieberman, William S. "Illustrations by Henri Matisse." *Magazine of Art* 44 (1951), pp. 308-314.

Lieberman 1956
Lieberman, William S. *Matisse. Fifty Years of His Graphic Art.* New York: George Braziller.

Life 1954
"Last of a Master." *Life* 37 (December 13, 1954), pp. 42-44.

Life 1957
"Henri Matisse." 2 pts. *Time-Life* captioned filmstrip no. 297-298.

Linde 1957
Linde, Ulf. "Matisse's 'Apollon.'" *BLM* 26 (1957).

London 1968
London. Hayward Gallery. *Matisse, 1869-1954.* Intro. by Lawrence Gowing. London: The Arts Council of Great Britain, 1968 (exh. cat.).

London 1977
London. The Tate Gallery. *Catalogue of the Foreign Paintings, Sculptures and Drawings in the Tate Gallery.* By Ronald Alley. London: 1977.

Los Angeles 1966
Los Angeles. University of California. *Henri Matisse.* Text by Jean Leymarie, Herbert Read, and William S. Lieberman. Berkeley: University of California Press, 1966 (exh. cat.).

Los Angeles 1972
Los Angeles. Los Angeles County Museum of Art. *Two Books: "The Apocalypse of Saint-Sever" 1028-1072; Henri Matisse: "Jazz" 1943-1944.* Text by Avigdor Arikha. Los Angeles: 1972 (exh. cat.).

Lübecker 1955
Lübecker, Pierre. *Matisse.* Copenhagen: Gyldendal, 1955.

Luz 1952
Luz, Maria. "Témoignage: Henri Matisse." *XXᵉ Siècle* n.s. 2 (1952), pp. 55-57.

Luzi 1971
Luzi, Mario, and Massimo Carrà. *L'Opera di Matisse dalla Rivolta "Fauve" all'intimismo, 1904-1928.* Milan: Rizzoli, 1971.

M.D. 1972
Duthuit, Mme. Marguerite. Interview. Paris: December 21, 1972.

Maeght 1952
Privately-made film sequence of Matisse later incorporated into "Du côte de chez les Maeght: Matisse-Giacometti," 1972-73, directed by Jean-Michel Meurice. Bry-sur-Marne, Institut National de l'Audiovisuel, video cassette no. 73893.

Magne 1913
Magne, L., and H.-M. *Décor de la Terre.* Paris: Henri Laurens, 1913.

Man 1954
Man, Felix H. *Eight European Artists.* London: William Heinemann, 1954.

Marchiori 1955
Marchiori, Giuseppe. "Papiers Découpés." *La Biennale di Venezia* 26 (1955), pp. 28-30.

Marchiori 1967
Marchiori, Giuseppe. *Henri Matisse.* Paris: La Bibliothèque des Arts, 1967.

Marmer 1966
Marmer, Nancy. "Matisse and the Strategy of Decoration." *Artforum* 4 (1966), pp. 28-33.

Martin 1955
Martin, Paule. "Il mio Maestro, Henri Matisse." *La Biennale di Venezia* 26 (1955), pp. 6-8.

Martin 1956
Martin, Paule. "Henri Matisse Herrscher in Reiche der Farbe." *Schweizer Wochen Zeitung* 11 (March 1956), pp. 10, 12 (May 1956), p. 16.

Massat 1961
Massat, René. "Matériologie et Désir d'Absolu." *XXᵉ Siècle* 23 (1961), pp. 93-100.

Massine 1939
Massine, Léonide. *Rouge et Noir.* 5 reels of film, Museum of Performing Arts Library, Lincoln Center, New York Public Library.

Massine 1968
Massine, Léonide. *My Life in Ballet.* London: MacMillan & Co., 1968.

Massine 1976
Massine, Léonide. Interview. Paris: 1976.

Matisse 1943

Matisse, Henri. *Dessins—Thèmes et Variations, précédés de "Matisse-en-France" par Aragon.* Paris: Martin Fabiani, 1943.

Matisse 1946-1

Matisse, Henri. "Comment j'ai fait mes livres." In *Anthologie du livre illustré par les peintres et sculpteurs de l'école de Paris*, pp. xxi-xxiii. Ed. by Albert Skira. Geneva: A. Skira, 1946.

Matisse 1946-2

Matisse, Henri. "Océanie: tenture murale." *Labyrinthe* 2 (1946), pp. 22-23.

Matisse 1947

Matisse, Henri. *Jazz.* Paris: Editions Verve, 1947.

Matisse 1951-1

[Matisse, Henri.] "La Chapelle du Rosaire des Dominicaines de Vence." *France Illustration* 320 (December 1, 1951) [pp. 561-570]; reprinted as "La Chapelle de Vence, aboutissement d'une vie." *XXe Siècle* special issue (1970), pp. 71-73.

Matisse 1951-2

Matisse, Henri. *Chapelle du Rosaire des Dominicaines de Vence.* Vence: 1951.

Matisse 1954

[Matisse, Henri.] *Portraits par Henri Matisse.* Monte-Carlo: André Sauret, 1954.

Matisse 1955-1

Farbe und Gleichnis; Gesammelte Schriften. Ed. by Hans Purrmann. Zurich: Verlag der Arche, 1955.

Matisse 1955-2

Matisse, Henri. *Carnet de Dessins.* Text by Jean Cassou. 2 vols. Paris: Huguette Berès, Berggruen et Cie, 1955.

Matisse 1955-3

Die Matisse Kapelle in Vence; Rosenkranz Kapelle der Dominikanerinnen. Intro. by Gotthard Jedlicka. Frankfurt am Main: Suhrkamp Verlag [c. 1955].

Matisse 1957

Matisse, Henri. *Jazz.* Foreword by E. Tériade. Munich: Piper, 1957.

Matisse 1970

"Correspondance Matisse-Bonnard, 1925-46." *La Nouvelle Revue Française,* XVIII (July 1, 1970).

Matisse 1972

Matisse, Henri. *Ecrits et propos sur l'art.* Ed. by Dominique Fourcade. Paris: Hermann, 1972.

Matisse, P. 1955

Matisse, Pierre. "Henri Matisse mio padre." *La Biennale di Venezia* 26 (1955), pp. 4-6.

Maywald 1949

Maywald, Wilhelm. *Artistes Chez Eux.* Paris: Editions de l'Architecture d'Aujourd'hui Seine, 1949.

Mellquist 1961

Mellquist, Jerome. "Paris: Advances in Sculpture and Painting." *Apollo* 74 (1961), pp. 148-151.

Mercier 1964

Mercier, Georges. *L'Art abstrait dans l'art sacré.* Paris: E. de Boccard, 1964.

Michaut 1955

Michaut, Pierre. "Matisse e il Balletto." *La Biennale di Venezia* 26 (1955), pp. 43-45.

Michelson 1958

Michelson, Annette. "Paris . . . Matisse Exhibition at Bernheim-Jeune and Berggruen" *Arts* 33 (1958), p. 15.

Mizue 1953

"Matisse Contre les Abstraits." *Mizue* 57 (1953), pp. 43-47.

Mondrian 1976

Mondrian, Piet. "Le Jazz et le Néoplasticisme." *Macula* 1 (1976), p. 82.

Montherlant 1944

Montherlant, Henry de. *Pasiphaé, Chant de Minos.* Paris: Fabiani, 1944 (ill. by Matisse).

Morris 1970

Morris, George L. K. "Matisse: Exhibition in Paris Celebrates 100th Birthday with Report on Meeting with the Artist." *Life* 69 (August 28, 1970), pp. 30-44.

Moulin 1968

Moulin, Raoul-Jean. *Henri Matisse Dessins.* Paris: Cercle d'Art, 1968.

Mourlot 1959

Mourlot, Fernand. *Les Affiches Originales des Maîtres de l'Ecole de Paris.* Monte-Carlo: André Sauret, 1959.

Muller 1956

Muller, Joseph-Emile. *Le Fauvisme.* Paris: Fernand Hazan, 1956.

Murcia 1955

Murcia, M. "Homage to Henri Matisse." *Marg* 8 (1955), pp. 91-94.

Murphy 1970

Murphy, Richard W. "Matisse's Final Flowering." *Horizon* 12 (1970), pp. 26-41.

Neff 1972-1

Neff, John Hallmark. "An Early Ceramic Triptych by Henri Matisse." *The Burlington Magazine* 114 (1972), pp. 848-853.

Neff 1972-2

Neff, John Hallmark. "Matisse's Forgotten Stained Glass Commission." *The Burlington Magazine* 114 (1972), pp. 867-870.

Neff 1974-1

Neff, John Hallmark. "The Literature of Art." *The Burlington Magazine* 116 (1974), pp. 161-162 (review of Flam 1973).

Neff 1974-2

Neff, John Hallmark. "Matisse and Decoration, 1906-1914: Studies of the Ceramics and the Commissions for Paintings and Stained Glass." Ph.D. dissertation, Harvard University, 1974.

Neff 1975-1

Neff, John Hallmark. "Matisse and Decoration: an Introduction." *Arts Magazine* 49 (May 1975), pp. 59-61 (June 1975), p. 85.

Neff 1975-2

Neff, John Hallmark. "Matisse and Decoration: The Shchukin Panels." *Art in America* 63 (1975), pp. 38-48.

Neff 1976

Neff, John Hallmark. "Matisse and the Role of Decoration in his Art." Lecture given at The Baltimore Museum of Art, March 4, 1976 (transcript).

Neve 1968

Neve, Christopher. "Matisse on the South Bank." *Country Life* (July 11, 1968).

New York 1961

New York. The Museum of Modern Art. *The Last Works of Henri Matisse: Large Cut Gouaches.* Text by Monroe Wheeler. New York: 1961 (exh. cat.).

New York 1966
New York. The Museum of Modern Art. *Henri Matisse: 64 Paintings.* Text by Lawrence Gowing. New York: 1966 (exh. cat.).

New York 1968
New York. The Museum of Modern Art. *Dada, Surrealism, and their Heritage.* Text by William S. Rubin. New York: 1968 (exh. cat.).

New York 1969
New York. The Museum of Modern Art. *Twentieth-century Art from the Nelson Aldrich Rockefeller Collection.* New York: 1969 (exh. cat.).

Newton 1950
Newton, Eric. "Modernism and Religious Art." *Liturgical Arts* 18 (1950), pp. 88-90.

Olivier 1964
Olivier, Fernande. *Picasso and his Friends.* Tr. by Jane Taylor. London: Heinemann, 1964.

Ooka 1972
Ooka, Makoto. *Bonnard-Matisse.* Tokyo: Shueisha, 1972.

Ott 1954-55
Ott, Emil, Harold M. Spurlin, Mildred W. Grafflin, eds. *Cellulose and Cellulose Derivatives.* New York: Interscience Pub., 1954-55.

Ozenfant 1952
Ozenfant, Amédée. *Foundations of Modern Art.* Tr. by John Rodker. New York: Dover Pub., 1952.

Palais Galliera 1972
Palais Galliera, Paris. *Succession de Madame Lang Tableaux.* March 4, 1972 (sales cat.).

Paletten 1952
Paletten 4 (1952).

Paris 1949
Paris. Musée National d'Art Moderne. *Henri Matisse: Oeuvres Récentes, 1947-1948.* Unsigned notes by Matisse. Paris: 1949 (exh. cat.).

Paris 1950
Paris. Maison de la Pensée Française. *Henri Matisse: chapelle, peintures, dessins, sculptures.* Preface by Louis Aragon. Paris: 1950 (exh. cat.).

Paris 1953
Paris. Berggruen et Cie. *Henri Matisse Papiers Découpés.* Intro. by E. Tériade. Paris: 1953 (exh. cat.).

Paris 1961
Paris. Musée des Arts Décoratifs. *Henri Matisse: Les Grandes Gouaches Découpées.* Essay by Jacques Lassaigne. Paris: 1961 (exh. cat.).

Paris 1962
Paris. Galerie Jacques Dubourg. *Henri Matisse, Aquarelles, Dessins.* Paris: 1962 (exh. cat.).

Paris 1967
Paris. Musée National d'Art Moderne. *Robert et Sonia Delaunay.* By Michel Hoog. Inventaire des Collections Publiques Françaises 15. Paris: Réunion des Musées Nationaux, 1967.

Paris 1970
Paris. Grand Palais. *Henri Matisse Exposition du Centenaire.* Intro. by Pierre Schneider. 2nd ed., revised and corrected. Paris: Réunion des Musées Nationaux, 1970.

Paris 1975
Paris. Musée National d'Art Moderne. *Henri Matisse: Dessins et Sculpture.* Intro. by Dominique Fourcade. Paris: 1975 (exh. cat.).

Paris 1976
Paris. Musée National d'Art Moderne. *Hantaï.* Essay by Dominique Fourcade. Paris: 1976 (exh. cat.).

Paris Match 1954
Paris Match 294 (November 13-20, 1954).

Parke Bernet 1960
Parke Bernet, New York. *Fifty Modern Paintings and Sculpture Especially Donated for the Benefit of the 30th Anniversary Fund of the Museum of Modern Art.* April 27, 1960 (sales cat.).

Penrose 1958
Penrose, Roland. *Picasso: His Life and Work.* London: Victor Gollancz, 1958.

Percheron 1974
Percheron, René. *Vence et la Chapelle du Rosaire.* Paris: Dessain et Tobra, 1974.

Pernoud 1952
Pernoud, Régine. "The Chapel of the Rosary." *San Francisco Museum of Art Quarterly Bulletin* 2nd ser., 1 (1952), pp. 13-20.

Philadelphia 1948
Philadelphia. The Philadelphia Museum of Art. *Henri Matisse Retrospective.* Foreword by Henry Clifford, essay by Louis Aragon. Philadelphia: 1948 (exh. cat.).

Pierre à Feu 1947
Pierre à Feu. January 1947. *Les Miroirs Profonds.* Ed. by Jacques Kober (cover by Matisse).

Pittsburgh 1973
Pittsburgh, Museum of Art, Carnegie Institute. *Catalogue of Painting Collection.* Pittsburgh: 1973.

Pleynet 1971
Pleynet, Marcelin, *L'Enseignement de la Peinture: essais.* Paris: Editions du Seuil, 1971.

Poncins 1946
Poncins, Gontran de. *Esquimaux Voyage d'Exploration au Pôle Magnétique Nord (1938-1939).* Paris: Arts et Métiers Graphiques, 1946.

Porte 1939-1
Porte, Pierre. "La Création de Rouge et Noir." *L'Eclaireur de Nice et du Sud-Est* (May 1939).

Porte 1939-2
Porte, Pierre. "Dans un Atelier de la rue Désiré-Niel, à Nice, le Célèbre Peintre Matisse et le chorégraphe Massine ont conçu un Ballet Abstrait." *L'Eclaireur de Nice et du Sud-Est* (May 1939).

Preston 1961
Preston, Stuart. "Current and Forthcoming Exhibitions: New York." *The Burlington Magazine* 103 (1961), p. 526.

Quadrum 1957
Quadrum 4 (1957).

Radulescu 1974
Radulescu, Neagu. *Matisse*. Bucharest: Meridiane, 1974.

La Rassegna d'Italia 1948
La Rassegna d'Italia 3 (January 1948), p. 47.

Réalités 1954
"Matisse Mystery." *Réalités* 44 (1954), pp. 16-23.

Reed 1949
Reed, Judith Kaye. "Modern Decoration." *The Art Digest* 23 (1949), p. 9.

Reff 1976
Reff, Theodore. "Matisse: Meditations on a Statuette and Goldfish." *Arts Magazine* 51 (1976), pp. 109-115.

Régamy 1947
Régamy, P.-R. "L'académisme contemporain." *L'Art Sacré* (1947), pp. 276-277.

Reif 1976
Reif, Rita. "Matisse, Gaudi Church Works at Modern Art." *The New York Times* (December 11, 1976), p. 13.

Revir 1936
Revir. "L'évolution de la forme du calice." *L'Art Sacré* 9 (March 1936), pp. 83-87; 10 (April 1936), pp. 112-117.

Rockefeller 1956
The Abby Aldrich Rockefeller Memorial Window. Note by Steven R. Kidd. Pocantico Hills, New York: Union Church of Pocantico Hills, 1956.

Rockefeller [1965]
The Abby Aldrich Rockefeller and John D. Rockefeller, Jr. Memorial Windows. Pocantico Hills, New York: Union Church of Pocantico Hills [1965].

Rosing 1975
Rosing, Larry. "Matisse and Contemporary Art: 1970-1975." *Arts Magazine* 49 (1975), pp. 68-69.

Rotzler 1954
Rotzler, W. "Recent Examples of Christmas and New Year's Greeting Cards; with German and French Texts." *Graphis* 10 (1954), pp. 276-291.

Roussakov 1975
Roussakov, Y. "Une Série d'Esquisses de Matisse." In *L'Art de France du XV-XX Siècles*. Leningrad: State Hermitage Museum, 1975 (Russian text; French résumé).

Rouveyre 1947
Rouveyre, André. *Repli*. Paris: Editions du Bélier, 1947.

Rouveyre 1956
Rouveyre, André ."Matisse Evoqué." *La Revue des Arts* 6 (1956), pp.66-74.

Russell 1969
Russell, John. *The World of Matisse, 1869-1954*. New York: Time-Life Books, 1969.

Salles 1952
Salles, Georges. "Visit to Matisse." *Art News Annual* 21 (1951), p. 37.

San Francisco 1975
San Francisco. John Berggruen Gallery. *Henri Matisse: An Exhibition of Selected Drawings in Homage to Frank Perls*. San Francisco: 1975 (exh. cat.).

San Lazzaro 1954
S[an] L[azzaro]. "Découpages de Henri Matisse." *XXe Siècle* n.s. 4 (1954).

Schneider 1961
Schneider, Pierre. "Art News from Paris." *Art News* 60 (1961), p. 44.

Secolul 20-1970
Secolul 20; Revista de Literatura Universala (1970).

Seherr-Thoss 1968
Seherr-Thoss, Sonia P., and Hans C. *Design and Color in Islamic Architecture: Afghanistan, Iran, Turkey*. Washington, D.C., Smithsonian Institution Press, 1968.

Selz 1965
Selz, Jean. *Henri Matisse*. Paris: Flammarion, 1965.

Seuphor 1949
Seuphor, Michel. *L'Art abstrait: ses origines, ses premiers maîtres*. Paris: Maeght, 1949.

Shattuck 1969
Shattuck, Roger. *The Banquet Years: The Origins of the Avant-Garde in France,*

1885 to World War One. Revised ed. London: Jonathan Cate, 1969.

Slivka 1956
Slivka, R. "Matisse Chasubles Designed for the Vence Chapel." *Craft Horizons* 16 (1956), pp. 22-25.

Soby 1949
Soby, James Thrall. "Mural Scrolls." *Arts & Architecture* 66 (1949), pp. 26-28.

Solier 1948
Solier, René de. "Matisse à Vence." *Cahiers du Sud* 289 (1948).

Sordo 1963
Sordo, Enrique. *Moorish Spain: Cordoba, Seville, Granada*. Tr. by Ian Michael. London: Elek Books, 1963.

Sotheby 1966
Sotheby & Co., London. *Catalogue of Impressionist and Modern Paintings, Drawings and Sculpture*. June 22, 1966 (sales cat.).

Sotheby 1968-1
Sotheby & Co., London. *Catalogue of Impressionist and Modern Paintings, Drawings, and Sculpture*. July 3, 1968 (sales cat.).

Sotheby 1968-2
Sotheby & Co., London. *Catalogue of Costumes and Curtains from Diaghilev and de Basil Ballets*. July 17, 1968 at the Scala Theatre, London (sales cat.).

Sotheby 1969
Sotheby & Co., London. *Catalogue of Costumes and Curtains from Diaghilev and de Basil Ballets*. December 19, 1969 at The Theatre Royal, Drury Lane (sales cat.).

Sotheby 1970
Sotheby & Co., London. *Catalogue of Impressionist and Modern Drawings and Watercolours*. April 16, 1970 (sales cat.).

Sotheby Parke Bernet 1966
Sotheby Parke Bernet, New York. *G. David Thompson Collection*, Sale 2420, March 23-24, 1966 (sales cat.).

Steegmuller 1950
Steegmuller, Frances. "Chapels on the Riviera." *Cornhill* 985 (1950), pp. 22-27.

Stockholm 1957
Stockholm. Nationalmuseum. *Henri Matisse: Apollon.* Essay by Bo Wennberg. Stockholm: 1957 (exh. cat.).

Strachan 1969
Strachan, Walter John. *The Artist and the Book in France: The 20th Century Livre d'artiste.* New York: George Wittenborn, 1969.

Strasbourg 1969
Strasbourg. *Les Ballets Russes de Serge de Diaghilev, 1909-1929.* Strasbourg: 1969 (exh. cat.).

Svensk-Franska Konstgalleriet 1968
Svensk-Franska Konstgalleriet, Stockholm. January 31, 1968 (sales cat.).

Teilman 1972
Teilman, Herdis Bull. "Matisse." *Carnegie Magazine* 46 (1972), pp. 186-188.

Tériade 1952
Tériade, E. "Matisse Speaks." *Art News Annual* 21 (1952), pp. 40-77.

Tériade 1976
Tériade, E. Interviews. Paris: 1976.

Thirion 1967
Thirion, Jacques. "Musées de Nice: l'enrichissement des collections modernes de 1958 à 1964." *La Revue du Louvre* 17, 1 (1967), pp. 55-61.

Tillich 1954
Tillich, Paul, and Theodore Greene. "Authentic Religious Art." *Art Digest* 28 (1954), p. 13.

Time 1948
"Beauty and the Beast." *Time* 51 (April 5, 1948), p. 52.

Time 1949
"What I Want to Say; work on the Dominican Chapel at Vence." *Time* 54 (October 24, 1949), p. 70.

Time 1952
"Vestments for Vence." *Time* 59 (April 7, 1952), p. 75.

Toca 1974
Toca, Mircea. *Retrospective de Arta Moderna.* Cluj (Hungary): Dacia, 1974.

Tokyo 1951
Tokyo. National Museum. *Henri Matisse 1951.* Tokyo: *Le Journal Yomiuri*, 1951 (exh. cat.).

Tribune de Genève 1959
K., A.-A. "Les Grandes Gouaches Découpées d'Henri Matisse." *Tribune de Genève* (August 6, 1959).

Tucker 1975
Tucker, William. "Matisse's Sculpture: The Grasped and the Seen." *Art in America* 63 (1975), pp. 62-66.

Tzara 1931
Tzara, Tristan. "Le Papier Collé ou le Proverbe en Peinture." *Cahiers d'Art* 6 (1931), pp. 61-74.

UNESCO 1953
UNESCO. *Catalogue of Colour Reproductions of Paintings, 1860-1952.* Paris: 1953.

Vence-Ronchamp 1955
Couturier, Marie-Alain, A.-M. Capellades, A.-M. Cocagnac, and L.-B. Rayssiguier. *Les Chapelles du Rosaire à Vence par Matisse et de Notre-Dame-du-Haut à Ronchamp par Le Corbusier.* Paris: Les Editions du Cerf, 1955.

Verdet 1952
Verdet, André. *Prestiges de Matisse.* Paris: Editions Emile-Paul, 1952.

Verve 1938
Verve I, 4 (Autumn 1938).

Verve 1940
Verve II, 8 (Summer 1940) (cover by Matisse).

Verve 1945
Verve IV, 13 (Winter 1945) (frontispiece by Matisse).

Verve 1948
Verve VI, 21-22 (Autumn 1948) (cover by Matisse).

Verve 1949
Verve VI, 23 (Summer 1949) (cover by Matisse).

Verve 1952
" 'La Tristesse du Roi' par Henri Matisse." *Verve* 27-28 (Winter 1952), pp. 17-20.

Verve 1958
"Last works by Matisse 1950-1954." *Verve* 35-36 (Summer 1958). Includes Duthuit, Georges, "Le tailleur de lumière," and Reverdy, Pierre, "Matisse dans la lumière est le bonheur."

Ver y Estimar 1955
Ver y Estimar 2nd ser., 3 (1955), pp. 2-12.

Vigorelli 1954
Vigorelli, Don Valerio. "La Lezione di Vence." *Arte Cristiana* 42 (1954).

XXe Siècle 1952
XXe Siècle 2 (1952).

XXe Siècle 1956
XXe Siècle 7 (1956).

XXe Siècle 1970
"Hommage à Henri Matisse." *XXe Siècle* special no. 3 (1970).

Vogue 1938
"Ballets à Monte-Carlo." *Vogue* (French ed.) (June 1938), pp. 25-33.

Washington, D.C. 1975
Washington, D.C. National Gallery of Art. *European Paintings: an Illustrated Summary Catalogue.* Washington, D.C.: 1975.

Watt 1961
Watt, Alexander. "Paris Commentary." *The Studio* 162 (1961), pp. 22-25.

Wellesley 1964
Wellesley. The Wellesley College Museum. *Catalogue of European and American Sculpture and Paintings at Wellesley College.* 2nd ed. By Curtis H. Shell and J. McAndrew. 1964.

Wescher 1955
Wescher, Herta. "Collages." *Graphis* 11 (1955), pp. 52-58.

Wescher 1968
Wescher, Herta. *Collage.* Tr. by Robert E. Wolf. New York: Harry N. Abrams, 1968.

Wind 1953
Wind, Edgar. "Traditional Religion and Modern Art." *Art News* 52 (1953), p. 18.

Woodcock 1950
Woodcock, George. "Objects like Words: Aragon and the Art of Collage." *Lugano Review* 3-4 (1965), pp. 207-210.

Yale Literary Magazine 1955
"Homage to Matisse." *Yale Literary Magazine* 123 (1955).

Zervos 1945-46
Zervos, Christian. "Peines d'Esprit et Joies de Matisse." *Cahiers d'Art* 20-21 (1945-46), pp. 162-164.

Zervos 1949
Zervos, Christian. "A propos de l'Exposition au Musée d'Art Moderne de Paris." *Cahiers d'Art* 24 (1949), pp. 159-170.

Zervos 1950
Zervos, Christian. "Les Expositions à Paris et Ailleurs: Henri Matisse. (Maison de la Pensée Française)." *Cahiers d'Art* 25 (1950), pp. 387-388.

Zurich 1959
Zurich. Kunsthaus. *Henri Matisse: das plastische Werk*. Zurich: 1959 (exh. cat.).

Fig. 80. Henri Matisse, Hôtel Régina, Nice, c. 1952. On wall: various decorative cuttings surrounding an antique marble lavabo.

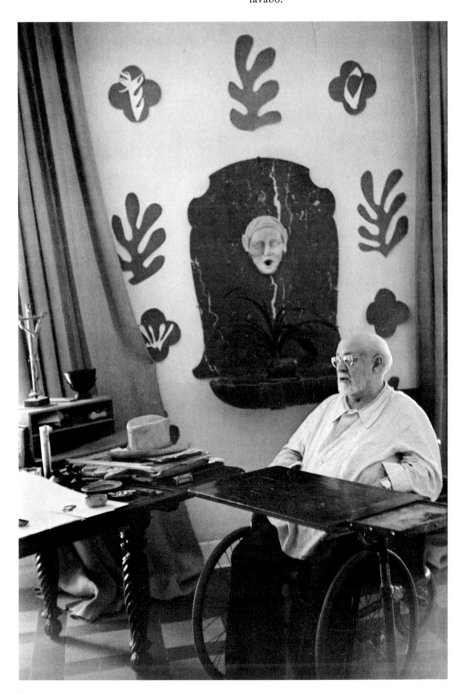

Index to Catalogue

Photo Credits

Fig. 81. Matisse studio, Hôtel Régina,
Nice.